❧ MERRY CHRISTMAS! ❧

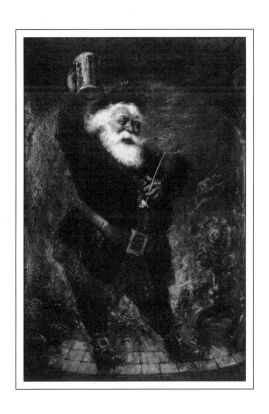

MERRY CHRISTMAS!

Celebrating America's
Greatest Holiday

KARAL ANN MARLING

HARVARD UNIVERSITY PRESS
Cambridge, Massachusetts
London, England
2000

Many of the designations used by manufacturers and sellers
to distinguish their products are claimed as trademarks.
Where those designations appear in this book and Harvard
University Press was aware of a trademark claim, then the
designations have been printed in initial capital letters
(for example, Tylenol).

Frontispiece: Thomas Nast, *A Jolly Good Fellow* (1874).
Courtesy of The Strong Museum, Rochester, New York, © 1999.

Designed by Gwen Nefsky Frankfeldt

Library of Congress Cataloging-in-Publication Data

Marling, Karal Ann.
Merry Christmas! : celebrating America's greatest holiday /
Karal Ann Marling.
p. cm.
Includes bibliographical references and index.
ISBN 0-674-00318-7 (alk. paper)
1. Christmas—United States—History.
2. Christmas decorations—United States—History.
3. United States—Social life and customs. I. Title.
GT4985.A1 M37 2000
394.2663'0973—dc21 00-031935

✳❧ CONTENTS ❧✳

CONTENTS

✖ PREFACE ✖

This book about the visual and material culture of Christmas in America began at a pre-Christmas cut-and-color session with Stan, my hairdresser. Gossip exhausted and the crumbling marriages of the stars thoroughly dissected, the conversation turned to shopping and presents. His worst Christmas as a child, Stan said, came the year he bought his mother the syrup pitcher—one of those little glass pitchers with the screw-on plastic tops and a metal slide built into the handle to dispense one perfect, continuous dribble of maple syrup, with no mess whatsoever. Restaurants used to have them but ordinary home kitchens did not. And they were very cool.

So Stan contrived to buy one for his Mom. He saved nickels out of his allowance and did extra chores. He found a pitcher for sale in a downtown store. And he wrapped it up and waited for Christmas, envisioning the family's pride in owning such a slick item and his mother's gratitude to the loving son who bought it. Imagine little Stan's horror, then, when he came home from school one day that December, just before Christmas vacation, to find his Mom admiring a new syrup pitcher (just like the one stashed upstairs, under his bed!), a corporate holiday gift from the man in the gray uniform who delivered the home heating oil.

There has been no shortage of books on Christmas. Historians have been especially active: Stephen Nissenbaum's *The Battle for Christmas* and Penne Restad's *Christmas in America*. Theologians, too: Leigh Eric Schmidt's *Consumer Rites: The Buying and Selling of American Holidays*. And American Studies with *The Modern Christmas in America* by William Waits. Admirable books, all of them—and I am much indebted to these and a host of older works on aspects of the history of Christmas, as the following chapters will show. But somehow, these books have left out Stan and his mother, and the aspect of Christmas that I wanted to talk about.

Last year I found myself in eastern Poland in the springtime, separated from my boxes of Christmas stuff by a large ocean, and desperate for something to read in English. A friend at the U.S. Embassy in Warsaw kindly sent me a bunch of new books from Amazon.com: novels, best-sellers, some scholarly offerings. And a few ratty paperbacks from her bathroom bookshelf. Now I'm sure I was unnaturally fixated on tinsel and holly at the time, but every single one of those books contained a major Christmas riff. Jane Tomkins, a prominent professor of American literature, remembered her father reading *A Christmas Carol* aloud and making up a serial adventure called "How I Used to Work for Santa Claus." Rick Bragg, Pulitzer Prize–winning reporter for the *New York Times*, wrote about getting a warm coat, a pair of shoes, a football, and a transistor radio when, as a boy of twelve, he was one of the charity cases entertained by a college fraternity under the biggest Christmas tree he had ever seen. Suzanne Strempek Shea, in a novel about the trials of a Polish-American girlhood, told the story of her fictional self, designing homemade Christmas cards so beautiful that her seventh grade teacher sent them off to the Hallmark people in Kansas City.

And so it went. Hard-boiled detective yarns, a history of the trial of an anarchist for a 1905 bombing in Idaho, John Updike and Ed McBain without their covers: not a book without a telling Christmas aside. Not a single life without Santa Clauses, toy-store windows, strings of colored lights, trees, carols, snow (or snow-in-a-can), Christmas cards, Charles Dickens, holly, popcorn chains, and deco-

rations made out of red-and-green crepe paper. The European edition of *Time* for April 13, 1998, when I found a dog-eared copy at a newsstand in a former Intourist hotel, contained a short article on the late Eva Peron of Argentina. "As First Lady," *Time* noted, "Evita was revered for her glamour and largesse. On Christmas in 1947, she gave away 5 million toys."

Coincidence? Pine-scented serendipity? I think not. Christmas is the universal memory, one of the few rituals on the calendar of life that virtually everybody has played a part in. Weddings, funerals, First Communions, Bar Mitzvahs, and Labor Day picnics can all be avoided without much trouble. But not Christmas. In America, Christmas is everywhere. At the mall. On TV. In the closets and under the beds. In the cupboard, where Stan's mother's syrup pitcher still lurks in shame, behind a pile of chipped dinner plates.

I went to an antiquarian book fair recently, on a cold, snowy day in the dead of a Minnesota winter. In a booth devoted to children's literature, I opened the cover of one much-abused Golden Book only to have a faded green Christmas tree pop up from the endpapers. It was my Proustian Christmas moment. I had owned that book when I was a little girl—with sweet herald angels in pink shifts trimming the three-dimensional tree that blossomed whenever the cover was lifted. *The Golden Christmas Book,* published in 1947: I must have found my copy under the tree that very year. Without turning a page, I could still see the recipes for stuffed dates and popcorn balls, the instructions for making paper chains and cutting five-pointed Christmas stars. And a little Christmas tree fashioned from two sheets of construction paper, that could stand up all by itself. Ornaments rolled out from lumps of pink and green wallpaper cleaner (does anybody still sell wallpaper cleaner?). The story of old Granny Glittens, who dyed her yarn with lemon drops and chocolate bars and candy canes, and made Christmas mittens that you could actually eat! Already, at age four or five, I had learned that Christmas was something you made, something painstakingly created out of scissors and paste and sheets of red paper.

I bought *The Golden Christmas Book* that day for a princely sum.

And when I got it home, I began to look at the literary selections with a critical, grownup eye: the Cratchits' dinner scene from Dickens's *A Christmas Carol;* "A Visit from St. Nicholas," subtitled "the poem by Clement Moore which you already know"; topical verse by Eugene Field; carols; a flatfooted retelling of the Bethlehem story, purged of biblical language; and "The Peterkins' Christmas Tree" by Lucretia P. Hale, sister of Edward Everett Hale, the famous nineteenth-century Unitarian minister and author of *The Man Without a Country.* Lucretia Hale's short story, which involved the Christmas preparations of a family so clueless that they had to cut a hole in the floor of an upstairs bedroom to accommodate a much-too-big tree, had not been one of my childhood favorites. In my family, we knew how to gauge the height of Christmas trees! But I had just found the Hale story in an 1876 issue of *St. Nicholas Magazine* and was stunned to discover how much at home it was in a 1947 anthology that stressed how to make a proper Christmas—what supplies were needed, what skills, what advance planning. The Peterkins were eternally funny because they were inept, because they didn't know how to cut five-pointed stars out of cardboard and tinfoil.

I remember how my grandmothers made Christmas. Creamed onions. Oyster stew. Tins of salted nuts, without peanuts. Ribbon candy. Packages wrapped in white tissue paper, with our names written right on the wrappings in a delicate, Palmer-method hand. One grandmother, a widow who lived in an apartment building, hung red collapsible bells made of folded tissue paper in every doorway and got out her Christmas records: a white album with Bing Crosby on the cover, his smiling face stuck through a Christmas wreath, and a green one on which Eartha Kitt purred the contents of her wish list to "Santa Baby." My other grandma, until she moved into a house that had a real one, always hung up a crepe-paper chimney for our stockings; in private, my brothers and I speculated on how Santa managed to enter her living room through what was, after all, a *picture* of a fireplace. But when I see Christmas in my mind's eye, it is as a series of pictures. The Three Wise Men on the side of the box of hard candy each of us got at school, the day before the Christmas

holidays began. The pictures on the Christmas cards that we counted and played with and reread and finally cut up to make tags and five-pointed stars and pretty paper baskets. The lighting of the Rockefeller Center Christmas tree on TV. My grandmother's fireplace, which was only a picture of one, but no less real because of it.

This book is about pictures and syrup pitchers and all the other things that make Christmas Christmas. It's about images and the feelings they arouse—the shining ribbons of hope and memory that connect people to themselves, their families, and their sense of nationhood through the ornament chest in the attic, a collection of Christmas village houses, or a green-frosted cookie shaped like Dr. Seuss's Grinch. And it's about grandmothers and mothers. Several years ago, when I had just finished a book on the visual culture of the 1950s—a book that looked at clothes, hairstyles, body language, and the preferred colors for household appliances—one reviewer allowed as how he didn't think much of the project but that his Mom would probably like it. Well, this is another one for the Moms! Although I have looked at a great deal of textual evidence, the material culture of Christmas (or what Moms generally do while the rest of us watch *It's a Wonderful Life*) is the heart and soul of this book and of the holiday it examines.

As a writer who prides herself on having no particular ideological axes to grind, I was startled to discover how few students of the phenomenon have openly acknowledged the creative role of women in inventing, sustaining, and ultimately changing Christmas. Studying Christmas would turn anyone into a card-carrying feminist! Popular culture—the movies, TV—is heavily invested in denying that women and Christmas have any special relationship at all. Jimmy Stewart and the Grinch are the Christmas heroes; Mrs. Santa is relegated to the photo booth in the department-store Toyland. When the manipulation of "stuff" takes precedence over the use of words and documents, when traditional women's skills at shopping or cooking or home decorating take center stage, then the whole subject falls off the radar screen of "important" scholarship. Christmas is OK in its way—the stuff of memoirs, but not of serious research. At best, it is

politically incorrect, a pleasant diversion for the few remaining stay-at-home Moms. At worst, it is mere trivia.

But Christmas is not just a Moms' festival. It is a domestic one. Christmas reminds everybody of home truths, of the particular sense of comfort and joy that Christmas cards represent with their pictures of ornaments and presents and snug little houses nestled in the snow, a curl of smoke arising from the chimney. It is the one occasion in the fitful progress of the year that calls upon us to consider domesticity and continuity seriously, to ponder the good in the goods arrayed beneath the Christmas tree. If home is less important than the workplace, then Christmas isn't very interesting. If the items in the glossy holiday catalogs are viewed as so many examples of consumerism run amok, then Christmas is a pig's feast of capitalist greed. To look seriously at Christmas is to embrace the possibility that quotidian realities, like pleasure and purchase, might be defensible aspects of the human condition. The syrup pitcher in Mom's kitchen cupboard is a text, a memory, a lesson, and a part of the essence of Christmas for as long as you and Stan and I continue to tell the story.

It is difficult to get a fair hearing for pictorial and artifactual evidence if one's attention is elsewhere. By that I mean that the objects of this study have their own stories to tell, within the contexts in which they were made. The picture on a Christmas card, for example, is not simply an illustration of some abstract point, a confirmation of an insight derived from other sources. The products of popular culture have their own histories, which are often wretchedly difficult to reconstruct. This book is less an effort to plug the contents of the national Christmas stocking into the socket of orthodox historical discourse than it is an attempt to recover the truths inherent in the things themselves. That, surely, is one worthy task of the cultural historian: to find "lost" objects and to submit them for eventual inclusion in the ongoing saga of American life.

I have occasionally been baffled by the scraps of Christmas detritus turned up in the course of my search: in the late nineteenth century, for instance, white, middle-class households apparently en-

joyed looking at popular images of poor Southern blacks celebrating the holiday in ways that were meant to amuse their magazine-reading betters. Why *this* kind of picture? Or all the dancing polar bears carrying Christmas trees and plum puddings? Why were these pictures funny and particularly well suited to the season? Why was a syrup pitcher the ideal Christmas present for a kid to give his mother, circa 1956? Was the "Tickle Me Elmo" doll just a fad, the greatest advertising success story of the 1990s, or was there something else about that furry red doll that set off the biggest-ever stampede of Christmas shoppers? Where feelings are involved, definitive answers are hard to come by. And Christmas is about feelings.

I had a Christmas vision once, when I was eleven years old—too old to believe in Santa Claus and reindeer any longer. I woke up on Christmas Eve in the middle of the night and heard a strange little sound, a kind of faint tinkling noise downstairs. "I sprang from my bed," just as Clement Moore recommended, tiptoed to the top of the staircase, and peered down at the shadowy outline of the Christmas tree below. Just then, it happened again—the tinkling—and it came from the tree! Startled, I looked up and saw a shower of tiny silver snowflakes, dancing in the air all around me. Thrilled and terrified (lest Santa be scared off by an impious agnostic), I raced back to my room, pulled the covers over my head, and, while waiting for morning to come, fell fast asleep again.

It must have been the furnace. The heat cycled on, the warm air stirred the tree branches, and the old glass bells—ancestral ornaments from Germany, brought out every year with great solemnity and unveiled from their shrouds of ancient tissue paper like relics of the True Cross—rang out again. The air sent a flurry of dust motes skittering up the stairwell: my magic indoor snowflakes. But it felt just like a miracle, and it still does. Miracles are made of warm air on a chilly night, trees that tinkle, cards that glitter, boxes that rattle, mysterious lumps under the bed, dancing mechanical bears in a store window. That's all part of Christmas.

Incidentally, this book would make a great Christmas present for your Mom!

MERRY CHRISTMAS!

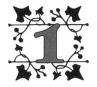

WRAPPING PAPER UNWRAPPED

Holly Boxes, Tissue Paper, and Bows

A recent survey reveals that 96 percent of all American households wrap their Christmas presents—an average of thirty-seven gifts per home, muffled in printed paper and wads of Scotch tape.[1] Devotees of house-and-home guru Martha Stewart sometimes make their own wrappings out of old grocery bags, stippled with metallic paint, or cheap corrugated paper rolled into flattened tubes and cinched with expensive taffeta ribbon.[2] In other houses, the trick is to open the package without spoiling the paper and then save it for next year, along with only-slightly-squashed bows and like-new ribbons. Rewrapping in the name of conservation gets the nod in the most recent edition of *Emily Post's Etiquette*. The author doesn't mind receiving a gift in used paper, even if it is a little the worse for wear, so long as the package looks as if some "thought went into it."[3]

But most members of those 96 percent of American households that wrap are probably not thinking too clearly about the aesthetics of disguise when they hit the drugstore on Christmas Eve, desperate for gift wrap of any description. According to the same statisticians, 25 percent of all the wrapping paper sold annually is snatched from the shelves during the week before Christmas. Women outnumber men in the tags-and-wrappings aisle by a ratio of ten to one, and

given a choice—if there is still a last-minute choice to be had at the local Wal-Mart or Target—women prefer to buy paper featuring pictures of Santa Claus.[4]

The pile of wrapped packages under the tree seems to be an intrinsic part of the holiday ritual, like Santa himself, an ancient custom with origins veiled in the mists of time. The box with the perky bow and the pretty paper is a shorthand symbol for Christmas, and wrapping a gift with one's own hands has, in some circles, taken on an aura of feminine virtue. The rich wife of a famous TV producer sets aside two rooms in her Hollywood-chic mansion every December for wrapping; she does everything herself and buys her paper in hundred-foot rolls.[5] Because it seemed to reflect her self-sacrifice and the seasonal martyrdom of a busy First Lady, Nancy Reagan liked the official White House Christmas card for 1981, a Jamie Wyeth painting of the Executive Mansion on a snowy Christmas Eve with a single light burning on an upper floor. The picture looked, said Mrs. Reagan, as though "everyone else had gone to bed and I was still up in my dressing room wrapping presents."[6] Men, on the other hand, have generally been assumed to be inept with paper and scissors. The illustrator Richard Sargent got a cheap laugh in 1959 with a *Saturday Evening Post* holiday cover showing a frazzled male wrestling with a box, a sheet of holly-strewn wrapping paper, and a vast length of uncooperative red ribbon.[7]

No matter who wraps the presents, they have got to be wrapped. A prominent sociologist who has studied American gift-giving habits in this century has formulated what he calls the "Wrapping Rule," according to which all legitimate Christmas gifts must be covered and adorned before they are presented.[8] But the Wrapping Rule dutifully observed in 96 percent of American households today is not a time-honored practice. A comparatively recent addition to the list of prescribed Christmas tasks, wrapping is a modern phenomenon which, like many examples of work left mainly to women, lacks a coherent history. If women are the gift-wrap buyers and the late-night wrappers of today, they were also the principal shrouders, sealers, and decorators of Christmas surprises in the 1870s and 1880s, when the

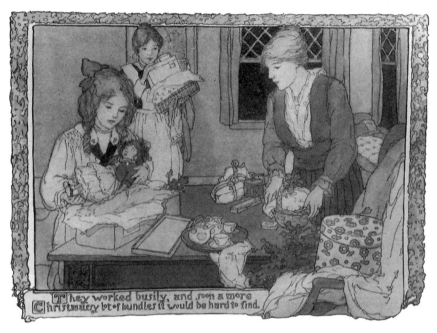

They worked busily, and soon a more
Christmassy lot of bundles it would be hard to find.

Girls and women do the wrapping, 1915. *St. Nicholas* (December 1915), 145.

idea of exchanging gifts in ornate packages first took hold. And it is in popular literature by women and for women that the story of the Christmas present with seals and bows and tags and ribbons unwraps itself in a colorful litter of hints and clues.

In the 1860s, when gifts and trees moved toward broad national acceptance—and Santa emerged as a national icon in the seasonal illustrations of the cartoonist Thomas Nast—wrapped presents were unknown. In Nast's first Santa image for *Harper's Weekly*, Union troops receive small wooden packing boxes from home, filled with warm socks and pipes, courtesy of Old St. Nick.[9] On the domestic scene, however, Christmas gifts were primarily for children, and thanks to *Godey's Magazine and Lady's Book* the games and treats formerly stuffed into their stockings were now being hung on the branches of a fragrant fir. *Godey's* first promoted the Germanic custom of trimming a tree in 1850 by publishing a beguiling picture of

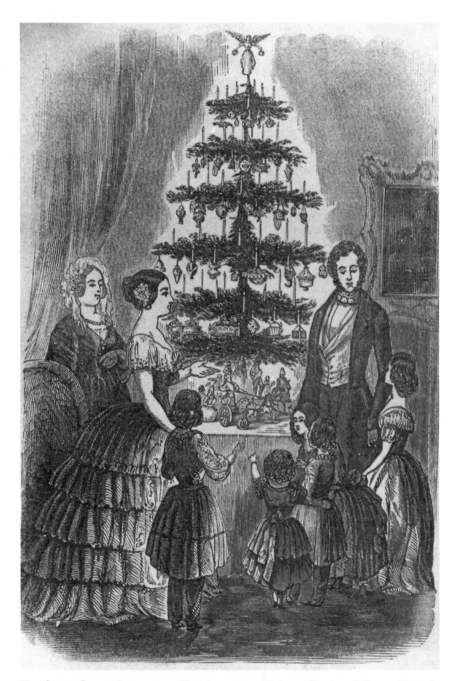

The first influential American Christmas tree: Prince Albert and Queen Victoria shorn of their royal trappings. *Godey's Magazine and Lady's Book* (December 1850), 327.

Queen Victoria, her consort, and her children gathered around a little Christmas tree. The Royal Family was purged of the most obvious trappings of nobility—her tiara and his medals disappeared—and the scene came to represent the ideal American family, engaged in experiments with a newfangled method of dispensing gifts.[10]

Before there was fancy paper, stockings hid the Christmas booty from sight. Stockings were wrappings of a kind, and children—the naughty ones—could sometimes encounter unpleasant surprises inside. Bad children were cautioned to mend their ways between Thanksgiving and Christmas, lest they find switches and lumps of coal instead of toys in their stockings. Marion Harland, a much-published writer of fiction and nonfiction for women, confessed to the readers of *Godey's* in 1865 that she had once reached into her stocking on Christmas morning, full of joy and hope, only to find a switch, deposited by a visiting jokester. Decades later, she still shuddered at the memory. "Never deny the babies their Christmas!" Harland urged. And "the delicious mystery" surrounding it: "the solemn parade of clean, whole stockings in the chimney-corner; or the tree, decked in secret, to be revealed in glad pomp upon the festal day."[11] The custom was for mothers, kindly aunts, and big sisters to decorate the tree in the dead of night, in a closed chamber. So the room was the metaphorical wrapping paper, preserving the essential element of surprise until the fateful hour when the candles would be lit, the doors flung open, and the fruits plucked from the branches as quickly as possible.

Images of Christmas festivities published in the 1860s are uniformly innocent of wrappings. Santa's sled is full of dolls and drums, various pull-toy animals on wheels, balls and books, all exposed to view.[12] Lumpy stockings dangle from the mantelpiece: if the doll or the bugle is too big for the little sock, it hangs nearby, in plain sight.[13] Christmas trees carry ornamental flags and candles along with a crop of toy boats, musical instruments, jumping-jacks, and French dolls with beautiful porcelain faces.[14] Nothing comes in a fancy package—or any package at all. Items too large to be displayed on the tree—Noah's arks, hobby-horses—are arranged on a table underneath, just as is, brazenly undressed.[15] In an 1860 story in

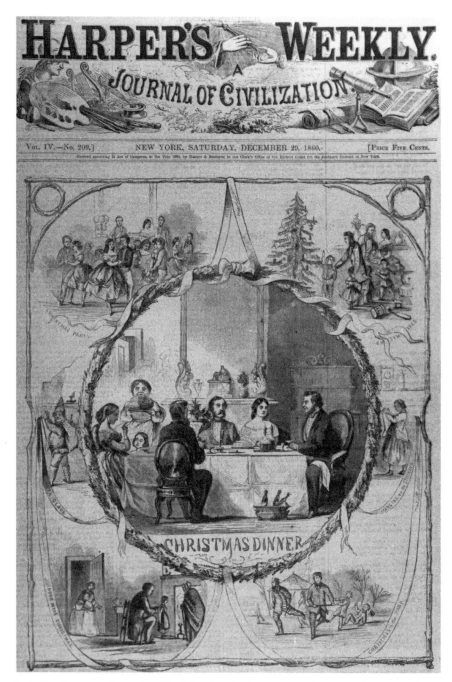

In 1860 the gala dinner is still at the heart of American Christmas festivities, but Santa, stockings, and the tree are gaining visual prominence. *Harper's Weekly* (December 29, 1860), 817.

Godey's designed to teach the novice how to set up her first Christmas tree, a character faced with a heap of large and cumbersome gifts constructs "a basket work . . . [of] gay-colored ribbons" looped over the branches, a catch-all sturdy enough to support a cart, a team of toy horses, and a whole family of dolls.[16]

Almost as a postscript, the same story alludes to several gifts for the grownups in the family, set aside in the excitement of making Christmas for the children. These adult presents are "packages, wrapped in paper," and marked with the names of the intended recipients.[17] One of the first mentions of what seem to be Christmas gifts done up in holiday wrappings, the presents in question were probably simple white paper packages, of slightly irregular shape, held together with straight pins, sealing wax, or both.[18] This kind of package, embellished with string or tinsel cord and various pasted labels, was the norm during the 1870s and 1880s. Although gifts from Santa Claus, strictly speaking, still required no special packing materials—except for the tool sets and ten-pins that came in their own little wooden crates—wrappings suddenly became fashionable. In an 1876 story for children in *St. Nicholas* magazine, Santa himself arrives with a pack full of "mysterious-looking parcels" which he proceeds to hang on the tree, one by one.[19] A little girl complains, in the same journal, that her Christmas doll (which came done up "in paper, with a cord") also came without dresses or shoes.[20] On Christmas Eve, a poor boy contrives to find gifts for his treeless siblings, "six small packages, all neatly wrapped, and tied with long loops, so that they could be hung on doorknobs."[21] A make-believe poem about children who visit Santa at his workshop concludes with them asleep on Christmas Eve, with ". . . a package under each head / Tied up with a silver label; / And 'Cakes from Santa Claus's oven,' it read."[22] An 1886 story designed to foster holiday charity toward the less fortunate has an anonymous benefactor playing Santa to a family down on its luck. The startled father wakes up on Christmas morning and peers in disbelief into a dining room "piled with Christmas presents. . . . It was just as if Santa Claus had emptied his bundles right into the room."[23]

Since wrappings are, by nature, ephemeral, it is difficult to piece

together an accurate picture of what the ideal present looked like in the later nineteenth century. But there was an important distinction to be made between bundles, on the one hand, and parcels or packages, on the other. Bundles, which for the most part were shapeless lumps, were generally made up in the stores or street-corner booths where the Christmas trade was conducted and consisted of heavy brown or white paper loosely fastened around one or several items with a prodigious amount of string. An 1885 Christmas scene in *Frank Leslie's Illustrated Newspaper* shows shoppers on 14th Street in New York, weighed down by what are clearly bundles: rounded, paper-covered shapes bound together by spider webs of string.[24] A similar *Harper's Weekly* plate from 1884 also depicts metropolitan shoppers, carrying Christmas bundles tied together into convenient bunches by means of long carrying loops or handles of twine.[25] Dolls came in a different kind of bundle—a sort of paper mummy wrap, tightly bound around the body, with the head sticking out at the top.[26] But a bundle was not a package. Despite its wrappings, the bundle tended to be a utilitarian rather than a decorative object, a substitute for the old-fashioned market basket, a protective skin for purchases being transported between store and home.

Parcels and packages were indoor bundles, dressed up for the occasion in white letter paper and bound with greater care for symmetry and neat appearance. The latter may have been just a bit fancier than the former. A holiday gathering in New York in 1876 called itself a "Christmas Package Party" to whet the jaded appetites of high society. The gimmick was this: the gentlemen bid on wrapped items, sight unseen, much to the amusement of their friends—when the winner opened his prize package to find a lovely doll inside.[27] The rendering of the packages in question shows ill-shaped parcel-like agglomerations of paper, albeit nicely tied in string. But thanks to the Victorian habit of gilding every lily—and the period's obsession with proper decorative containers for a wide variety of household objects—packages rapidly became prettier, tidier, and more regular in outline.[28]

In the 1870s, as the pace of Christmastime giving increased, so did

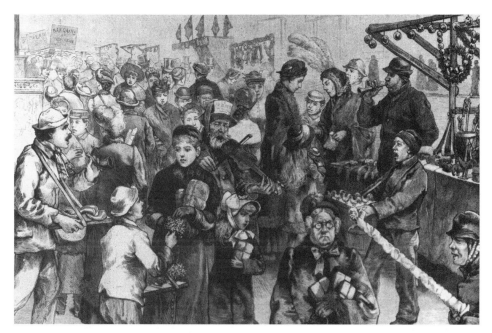

14th Street, New York City, 1885: sidewalk merchants hawk their wares and customers carry off their purchases in brown paper bundles tied with string. *Frank Leslie's Illustrated Newspaper* (December 26, 1885), 309.

the volume of advice about gifts suitable to the age and station of both giver and recipient. Despite the modern belief that Christmas used to be an affair of modest, homemade offerings, the vast majority of gifts were purchased. The exception was the handicraft item made specifically for sale at the Christmas fair or bazaar. Staged for charitable purposes, such fairs were often important social occasions in the community, the urban equivalents of the country fair, at which slippers and bookmarks made by local women were exclaimed over and purchased for holiday giving. The tides of fashion periodically swept through the nation's charity fairs, too: in 1878, there was a craze for pen-wipers and pin-cushions decorated with tiny mice made from apple seeds.[29] The source for the sudden burst of interest in apple-seed art was the mass-circulation magazine. Magazines for women had always contained recipes and instructions for doing fancy-work in one's leisure time, but in the 1870s, columns spe-

A "Christmas Package Party" in New York, 1877. *Frank Leslie's Illustrated Newspaper* (January 13, 1877), 312.

cifically devoted to making Christmas presents became an annual feature of periodicals pitched at children and adolescents. Since women had been elevated to the ranks of shoppers who, from time to time, produced embroidered goods for family members or bazaars, this left youngsters (along with a few grandmothers and Santa's elves) as the only remaining fabricators of Christmas presents.[30]

Of the gifts they were taught to make—often by such towering figures as Candace Wheeler, a leader in the American Arts and Crafts movement—the clear majority were boxes, bags, and other coverings for things liable to be found in the average home.[31] In 1875 *St. Nicholas* magazine offered a list of one hundred easily made, sure-to-please Christmas presents, most of which were containers of some kind: scent cases, kettle holders, slipper bags, needle boxes, work cases, spectacle cases, wall baskets and pockets, Bible covers,

match holders, and cabin bags for stowing odds and ends during long ocean voyages.[32] *Godey's* in 1879 recommended making a case for holding postal cards and envelopes and a box for hanging candy on the Christmas tree.[33] Other gift ideas promoted by *Harper's Young People* and its rivals included heavily embellished bags for stockings, scraps, buttons, and sachet; cases for court plasters and handkerchiefs; holders for hairpins, stamps, letters, photographs, and visiting cards; pockets and stands for umbrellas; covers for shaving papers; and miscellaneous boxes decorated with real autumn leaves.[34] So important was this class of artifacts that Wheeler devoted the entirety of one of her lessons to the proper technique for bag-making and the delightful prospect of organizing a Christmas "bag fair" in one's own neighborhood.[35]

This relish for Christmas gifts predicated on the principles of containment, concealment, and decoration has important implications for understanding how and why presents came to be given in boxes wrapped with fancy paper, bows, and bits of appended greenery. The gifts children were supposed to make for their elders were, in every sense of the word, packages in their own right, designed to enhance the spare buttons or the month's supply of shaving papers inside. They made a ceremony out of depositing a wet umbrella in the foyer. They turned the act of discarding a used matchstick into an occasion for remembering the thoughtfulness of the child who made the holder and glued a leaf on the outside because it was beautiful. The gift was a glorified box at a time when boxes for hiding gifts had not yet become necessary ingredients in the recipe for the ideal holiday.

Fancy boxes were necessary forms of ornamentation for Christmas trees, however. As long as the tree was a kind of gift-holder, then containers for small quantities of candy, nuts, raisins, and the other confections bestowed on children were a mainstay of the decor.[36] Instructions for making simple cornucopias from triangles of cardboard covered with colored paper appeared in magazines and local newspapers in the 1870s; fringed versions, adorned with pictures of angels and Santas, were also available cheaply in the stores and were highly recommended for holding marbles, thimbles, jacks, and

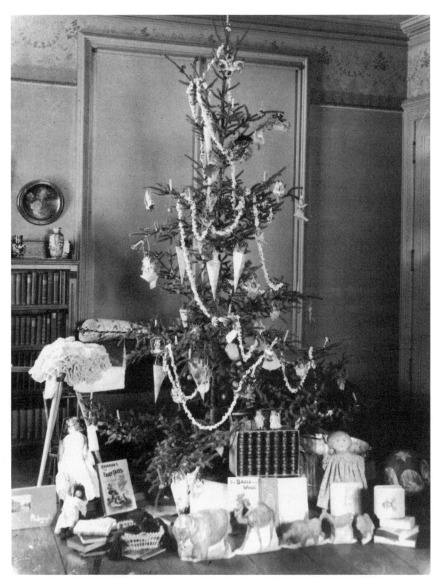

A Christmas tree in Stillwater, Minnesota, circa 1898, decorated with paper cornucopias and paper angels cut from "scrap" and decorated with tinsel. Minnesota Historical Society.

other little toys as well as the usual sweetmeats.[37] In 1877, *Erich's Fashion Quarterly* advertised paper cornucopias for sale by mail, in four graduated sizes: the smallest were 35 cents a dozen.[38] In the same decade, *Godey's* suggested boxes for "Sweets for the Christmas-Tree" made from cardboard, velvet, and feathers in the shape of a fez and a tall witch's hat.[39] And *The Youth's Companion* printed plans for candy boxes shaped like drums (for boys) and muffs (for girls).[40]

Around 1880 a new type of manufactured ornament-container appeared on the American Christmas tree. "Dresdens," as they were called, were two-sided, three-dimensional paper ornaments made in or around Dresden, Germany. They were exported to the United States in quantity; firms like Erlich Brothers, a New York toy wholesaler, advertised the fashionable Dresdens for sale as early as 1876.[41] A by-product of the "luxus-papier" industry, Dresdens were hollow containers made of damp cardboard in two distinct halves.[42] At the factory, each half was embossed or stamped into the desired form with a powerful press and then cut free of the sheet by a second machine. After the cardboard dried, the halves were glued together and finished—lacquered, painted, and decorated—by cottage workers in their own homes. The goal was to produce objects which, as one 1896 manual on paper-making put it, "appear as if they had been manufactured of sheet metal."[43] Although they came in the shapes of hearts, violins, bears, mice, satchels, and purses, many Dresdens were simply gift boxes in which to hang candy from the Christmas tree: round boxes, oval ones, rectangles, and squares.

The aesthetic of containment represented by Dresden ornaments was such a crucial design principle in the 1870s and 1880s that the widespread adoption of the pasteboard box seems almost inevitable. But industry historians cite hard economic reasons why boxes suddenly became a necessity of life around 1890. In the old general store, quality was the responsibility of the merchant and goods were displayed willy-nilly, in burlap bags and barrels. In the new, large-scale retail establishments, brand-name merchandise guaranteed quality, and the brand was displayed on tidy containers already

packed and filled at the factory.[44] When factory-made goods had to travel long distances from producer to seller, the use of individual boxes for each item gave added protection in shipping. And the value of some classes of merchandise was enhanced if, for example, items of intimate use, like toothbrushes, handkerchiefs, toilet articles, and ready-to-wear garments, were offered to the consumer in sealed or "original" boxes. Soap and candy (both major growth industries in the period) as well as fancy food products proved far more attractive to buyers—and better preserved—when packed in paper boxes at the point of origin.[45]

Mail-order houses and department stores alike used boxes as a selling point in advertising. A china tea set or a working steam engine packed in an old-fashioned wooden box was more likely to arrive at its destination intact, and such crates were always mentioned in toy catalogs. Around 1889, however, many more playthings—and less expensive ones—began to come in what were called "pasteboard boxes."[46] Paper dolls and soldiers, once presented in envelopes, now resided in handsome boxes decorated with appealing chromolithographs of the contents. Whole classes of toys which consisted of boxes or required them—nesting blocks, multipartite maps and jigsaw puzzles, and board games—suddenly proliferated in the 1890s, as by-products of the box industry.[47] Sets of furniture for a doll's house acquired special luster in Butler Brothers' toy catalog for 1895 because they were packed in cardboard boxes that were "handsome" and "elaborate," finished off with an "elegant label."[48] Other boxes for heavily advertised toys and games were described as "nicely lithographed." In the eyes of the retailer, then, the box had become almost as desirable as the present inside.

The assembly of boxes was one of the so-called "sweated trades," like the toy industry, candy-making, the preparation of holly wreaths, and many other occupations related to Christmas. The work was rushed and seasonal, the wages appalling, and the finishing of the product—begun in a factory—took place in urban tenements, where whole families sometimes labored in squalid conditions to turn out the necessary dolls, bonbons, and fancy paper

boxes in time for holiday sale.[49] Progressive reformers used box-makers as poster children for the evils of American industrialism: in numerous reports about their plight, the picture of Christmas in the big city takes on the bleak, Dickensian overtones of London, before Scrooge's conversion. Workers paid by the piece picked up the cut and scored cardboard sheets at the factory and, working at home with glue, string, paper tape, and other supplies which they were forced to provide, finished off the boxes: they joined the sides, made the tops, and sometimes covered the box with shiny paper or lined it with satin and lace.[50] The aged and infirm, the mentally impaired, widows, and orphans toiled for wages which a New York State factory commission study in 1913 deemed grossly inadequate. "No woman," wrote the chairman, "can live properly" on the proceeds of box-making.[51] Furthermore, investigators questioned the practice of delivering candy and toys for children in containers made in blatantly unsanitary conditions.

In the twenty years ending in 1899, the per capita consumption of paperboard increased threefold. An automatic machine for making set-up (or fully assembled) boxes was introduced in 1894, but demand continued to outstrip technology. So mothers still glued boxes at the dining room table and trundled them back to their employers piled in the baby's carriage. The growing clamor for cheap, throwaway packaging doubled the volume of activity in the paper-box industry every ten years between 1849, when there were only 718 workers making boxes in the United States, and 1899, when there were more than 30,000. "It has become so commonplace for articles of every sort to be enclosed in a neat and attractive pasteboard package that we scarcely think of the ingenuity and expense involved," concluded another report on the continuing exploitation of the women who still finished fancy boxes by hand in their dank apartments until the end of World War I.[52]

Della Young opens a wrapped Christmas package from her husband in O. Henry's famous 1905 short story, "The Gift of the Magi," tearing at the paper and the string. Inside she finds a coveted set of tortoiseshell combs, bought from a holiday display in a Broadway

show window. Although the author doesn't say so, the chances are good that Della's beautiful combs rested in an ornate box with a plush lining made by an underpaid woman who never quite managed to get the glue off her fingers.[53] Social workers tracked what happened to boxes like Della's after they left the tenements in which they were made. They followed them to department stores, where children were hired as parcel-wrappers who stood by the day at long tables, boxing up purchases on the double, wrapping those boxes in heavy brown or white paper, and binding them with string or cord. The work caused terrible nervous tension, according to published reports: a girl named Anna, just fifteen years old, was found crying from weariness, her hands raw "from doing up so many boxes and tying so much string."[54] Macy's advertised the speed and efficiency of its wrapping desks in 1878.[55] By 1906, the store had begun to herald its "fancy" gift wrapping, with distinctive boxes and labels that told the recipient a Christmas gift had come from Macy's.[56]

The pasteboard box, wrapped to hide its drabness or its brand-name labels, might still hang on the tree, like a Dresden ornament, if it was small enough. But the prettier the presents, the greater was the temptation to put them on special display somehow, in a place of their own. *Good Housekeeping,* in 1896, suggested that readers abandon the American custom of fastening every gift to the Christmas tree, however awkward the result. Instead, the writer counseled, "cover the floor immediately surrounding the tree with white paper . . . [and] arrange the gifts around the base."[57] By 1900, the Christmas tree was surrounded with stacks of boxes of various shapes and sizes. The boxes were wrapped in tissue paper—white tissue, for the most part, although Sears, Roebuck was selling Dennison's red and green tissue, imported from England, in 1897.[58] The tissue was crisply folded to follow the angles and contours of the box, cunningly pleated at the ends to square off the corners, and held in place by a length of metallic tinsel cord that divided the package into quarters. Beginning in 1901 and 1902, gummed seals in the shape of green holly leaves with red berries were also used to secure the tissue, as well as to provide decoration for the plain, monochromatic papers.[59]

The new method of present-giving made it important for writers and illustrators of topical fiction to describe wrapped packages accurately. Beginning around 1897, the wrapped gift became the centerpiece of a spate of seasonal fiction devoted to changing Christmas customs. A *St. Nicholas* story from that year, concerned with a mixup in gifts sent by an elderly cousin to her young relatives, dwelt upon the double suspense of first undoing an express box, secured with brown paper and string, and then finding the gift inside, shown in the accompanying picture: a box wrapped in white tissue with a wide satin ribbon and a sprig of holly tucked under the bow.[60] By 1900, the white box was the norm—the definition of a gift. Thanks to the authors of juvenile adventure stories, children stranded on homebound trains or snowed in at remote farmhouses on Christmas Eve manage to make a Christmas for themselves out of a little tissue paper and ribbon.[61] By 1910, there was no other kind of present. As the holiday approached, mothers retired to their sewing rooms in "a whirlpool of holly, ribbon, tissue paper" and mystery.[62] "Piles of pretty gifts, all hidden under snowy wrappers and bound about with shiny ribbons" tantalized potential recipients.[63] "Help me tie [the gifts] up . . . in white tissue-paper!" cries a fairy teaching a rich child the true meaning of Christmas. "Use the prettiest ribbon!"[64]

In 1908 the *Ladies' Home Journal* acknowledged that trees and gifts and preparing a hearty dinner (or getting the material signs of Christmas right) were what gave women the most cause for holiday jitters. But gifts were also the source of their greatest pleasure, as shoppers anticipated the happiness of the person who would soon tear off the ribbons and open the package. "With the approach of Christmas," wrote an experienced wrapper, "reams of white paper are provided, and yards and yards of dainty ribbons, charming boxes to fit each gift, little tags, cards, seals."[65] Crafting a pretty package was almost as important as choosing the perfect gift; fussing with paper and seals was one of the true joys of Christmas. Or so it seemed to the women who read the *Ladies' Home Journal.* Some men, left out of the wrapping and shopping business, became seasonal Scrooges, railing against "the fetich [*sic*] worship of presents"—

(*A Christmas Story.*)

Christmas boxes and bags, 1897. *St. Nicholas* (December 1897), 113.

and the neat white packages of cigars or suspenders they were liable to receive from the wives and daughters in their lives.[66] They would rather get money, or something they could exchange for what they really wanted. But a surprising number of husbandly objections to the annual holiday uproar focused on the holly seals and the cord and the tags. A *Good Housekeeping* forum for men on the subject of Christmas irritants decried the propensity of women to ignore the quality of the cigar and look instead "for those in handsome boxes." Men don't like presents "wrapped or 'fussed' in tissue paper, ribbons, or tinsel," fumed a dyspeptic professor.[67] Christmas presents! Holly seals! Bah, humbug!

But another article objecting to the waste of time and money encouraged by the custom of "enveloping our Christmas bundles in layers of tissue paper, tied with ribbons, and sealed with fancy seals" met with a ringing defense of "fussed" packages.[68] Wrapping added a mystery, a superfluity missing in a common-sense age of dollars and cents: "The lavishness of care that can be interpreted as the interest of the giver in the receiver, and the affection wrapped up in the package" were not commodities calculable by the square inch of white tissue paper. "What a cold, bare thing is a gift given by hand, unwrapped, and thrust, as it were, naked upon the understanding, without any appeal to the fancy or the sentiment!" argued a woman

who clearly knew her way around the local stationery store at Christmastime.

Why did our grandmothers and our great-grandmothers seek out just the right boxes and stickers and paper? Why did they worry themselves into a giddy frazzle about ribbon? Why did they wrap Christmas presents? The consensus among historians seems to be that they wanted to hide the commercial origin of the gifts. Stephen Nissenbaum believes that wrapping paper disguised the commodity and added a layer of authenticity and personal feeling missing from marketplace transactions.[69] William Waits sees both wrappings and the mechanism of Santa Claus as strategies for purifying merchandise plucked from the realm of business and retailing, so it could be used in a home-centered ritual. "Because the gift-wrapped item was singled out as special," he writes, "it was not as contaminated by the market as were unwrapped items."[70] Penne Restad agrees: "Americans moderated the relationship between commerce and giving . . . by wrapping the gifts they gave."[71]

One problem with these explanations is that Americans, as a whole, did not wrap gifts: women did—women with a broad, common expectation of what the formal elements in their world ought to look like. They wrapped packages, in other words, out of a whole range of impulses and motivations intimately related to the dominant Victorian aesthetic of containment, enhancement, and disguise. Just as they put buttons in pretty bags and bought Dresden boxes to hang on the Christmas tree, they also decorated the cardboard boxes that held the presents. The proliferation of the paper box—a regular shape conducive to knife-edge folds and surgical precision in the construction of corners—was another powerful impetus to wrap. Nada Gray, in her account of the objects made by Victorian women to celebrate holidays in Pennsylvania, stresses their delight in paper and their ability to coax it into infinite varieties of shapes, with the help of instructions printed in the newspapers and magazines they read.[72] Wrapping thus had a validity and a meaning in its own right, independent of the origin of the gift and the character of the wrapper.

The conventional explanation of wrapping as an act of decontamination is loosely based on the conclusions of the anthropologist Claude Lévi-Strauss, who saw paper and bows as a means of overlaying a commodity with sentiment and the identity of the giver. But this reasoning assumes a conflict between home and the expanded nineteenth-century marketplace which may not have existed as a functional reality in the minds of Christmas shoppers and wrappers.[73] On the contrary, merchants seem to have provided more elaborate store-made wrappings as a way of adding value and appeal to the transaction. So did manufacturers who, around 1910, began to offer some gift items for purchase pre-wrapped and ready for presentation. A humorous story in *Good Housekeeping* about ways of beating the Christmas rush described the highly efficient cook who made her legendary fruitcake months before the holiday. "She put it in a beautifully decorated pasteboard box, all over holly and mistletoe, tied up with scarlet ribbons," and discovered, when she sent it as a gift, that mice had set up housekeeping inside the lovely box.[74] That already-wrapped or printed box—informally known as a "holly box"—had become the latest Christmas fashion in the marketplace.

One of the first products to come done up in a Christmas gift box was the fountain pen. In 1908 the Conklin Pen Co. of Toledo, Ohio, began to ship its wares in "handsome Christmas boxes," or boxes in cardboard sleeves covered with pictures of holly, mistletoe, and poinsettia blossoms.[75] More elaborate was the Waterman fountain pen box advertised in *Leslie's Illustrated Weekly* in December 1910.[76] A major selling point of the Waterman pen was the package, shown twice in the same ad for emphasis—once being offered to the reader by a smooth, feminine hand and a second time displayed in the mittens of a smiling Santa. The package was not actually wrapped, although the box was printed in color to give the impression of the perfect present: it resembled a box wrapped in white paper (in this case, embossed with all-over holly designs), tied with a bow, and sealed with a fancy sticker that read "Waterman's Ideal Fountain Pens." Leaves of printed holly surrounded the bow. There was a tag printed in place, too, with "From" and "To" lines for the name of the giver and

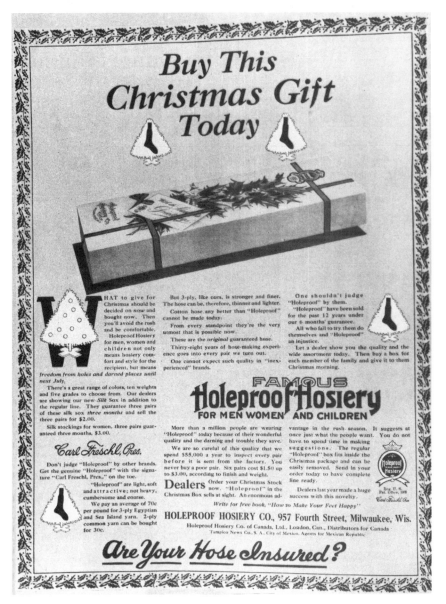

Ready-made holly boxes identified utilitarian goods as suitable presents; this 1911 box imitates a present wrapped in white tissue paper, tied with a red ribbon, and decorated with sprigs of fresh holly. *Saturday Evening Post* (December 9, 1911), 2.

recipient. The Waterman Christmas package was a picture of the archetypal present, inscribed on the outside of a box.

The Christmas box caught on rapidly. Between 1910 and 1912 countless products, from pens and pocket knives to garters, shaving soap, studs, hosiery, raingear, cookstoves, and ostrich plumes, left the factory in holiday dress.[77] Although a few such packages were decorated with poinsettias, winter scenes, or even art prints, most were variations on the familiar holly box, with the brand name of the product tastefully featured on make-believe stickers. The Holeproof Hosiery box, for example, looked like a package wrapped in white tissue with the customary ribbons, tags, stickers, and a spray of holly on top. The box for the ShurEdge pocket knife had an all-over holly pattern, printed in full color against a white background. From the point of view of the manufacturer and the merchant, the holly box—and ads associating socks or garters with Christmas motifs—was an excellent method of showing shoppers everyday items in a new light, as possible presents.[78]

Hosiery, umbrellas, pens, and other utilitarian items of the always-needed but often worn-out, lost, or broken sort had been among the first items advertised in the 1860s as making ideal Christmas presents. But the humble sock clearly acquired new status with the advent of the pre-wrapped holly box.[79] Most of the items sold in Christmas boxes straight from the factory were men's gifts: perhaps the modern, ready-made package answered masculine demands for less fuss and more efficiency. Evidence on how such gifts were presented is sparse, however. The ads show disembodied hands or Santas holding out the decorated box so that the prominent brand-name label is plainly visible. In practice, however, it seems likely that the printed box was often wrapped again, if for no other reason than to surprise the grumpy Dad about to receive his umpteenth pair of Christmas socks.

How merchants reacted to holly boxes is better documented. One of their number, recalling the good old days in a trade journal article published twenty years later, remembered working in a little store at Christmas time, back around the turn of the century. One epic shop-

ping season, all the popular gift items were snatched up early "so we hied ourselves to a neighboring department store, where we bought all the holly boxes we could get"—and filled them with ties, shirts, pots and pans, and almost anything else on the shelves. The merchandise in the pretty boxes sold out overnight: "We ran out of boxes and could get no more, so we wrapped things up in holly paper." And when the supply of paper was exhausted, they tied Christmas tags to kettles and carpet sweepers and sold those, too. "About this same time," the old retailer admitted, "manufacturers began to dress their regular merchandise in Christmas regalia. . . . The holly box, the spray of artificial holly, and the Christmas tag soon accomplished marvels in winning holiday patronage for industries that had never received much of it."[80]

The holly boxes and paper that transformed the look of Christmas—and worked wonders at the cash register during the Christmas rush—were both made by the Dennison Manufacturing Company of Maine and Massachusetts. The business began in 1844 at the Dennison family homestead in Brunswick, Maine, with the specialized goal of making cardboard boxes for jewelry. The company experimented with new machinery and, in the 1860s, with headquarters now established in Boston, also began to produce jewelry tags and display cards. At the very beginning of the vogue for paper crafting, in the 1870s, Dennison imported tissue paper from England, first for jewelers only, and later, in a variety of intense colors, for novelty companies and for sale to the general public through Sears, Roebuck and Dennison's own growing chain of stationery stores.[81] Crepe paper, a crinkled, stretchy material with many of the properties of fabric, was another important Dennison import. By 1905, display ads for Dennison crepe paper began to appear in women's magazines, inviting readers to make lamp shades, waste baskets, whisk holders—the whole range of late Victorian giftware—as well as curtains, artificial flowers, doll clothes, and home decorations for holidays. Free booklets included patterns and step-by-step diagrams of how to produce "Art and Decoration" with mere pennies' worth of paper.[82] Dennison's pamphlets, with their emphasis on the observance of

holidays, helped to make the company a leader in establishing the iconography and the material requirements of a proper Christmas in the twentieth century.[83]

Because the crepe paper business was so closely associated with holidays, its success led Dennison to create an independent line of Christmas supplies, including tags and seals for packages. The gummed holly seal, used to fasten down the folds of paper wrappings and to decorate white tissue paper packages, was the first such product to reach the market. Advertisements directed at the home package-wrapper make it clear that Dennison was also the source of the holly boxes used at the wrapping desks of the big department stores. A 1906 inventory of Dennison's Christmas Novelties includes, along with a few shipping tags adorned with Santa and his sleigh, all manner of holly stickers and cards, holly labels and seals, and "magnificent paste board gift boxes covered with holly to hold gifts of any size or kind."[84] In addition, Dennison developed what it called "Handy Boxes"—holly boxes fitted with compartments holding glue, string, tags, holly seals, and all the other supplies needed "for the busy housewife" with presents to wrap. "If you want a *real* Christmas," said one of the firm's holiday messages to the consumer, "you must let Dennison help you." Every well-regulated household needed "pasteboard gift boxes showered with holly, in red, green and gold."[85]

Dennison's holly paper—tissue printed with the same holly pattern that already graced the boxes—was advertised for the first time in 1908, although it seems to have been available to the trade somewhat earlier. Now there was a name for all the products packed in the convenient Handy Box: Dennison called them "gift dressings," and the list included "beautiful holly and mistletoe covered wrapping papers" and "white and holly pasteboard boxes." "The true spirit of Christmas giving implies more than mere giving," the breathless copywriter insisted, "—more than intrinsic value. It should convey the 'thought' inspiring the gift—the thought lavished upon the selection, upon the very appearance and outward dressing of the package."[86]

But why holly boxes, a term that had already become synonymous

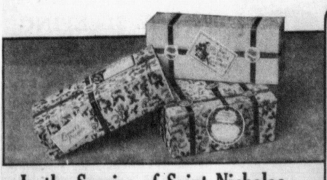

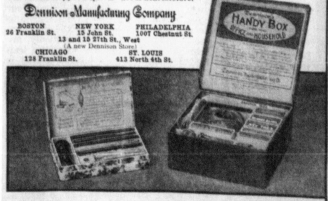

Dennison's holly boxes, produced with the company's "Handy Box," 1908. *Saturday Evening Post* (December 5, 1908), 42.

Rolls of holly paper in use, 1929. *Saturday Evening Post* (December 14, 1929), 1.

with Christmas presents? Why not the bells, the Santa Clauses, the wreaths, and the candles that would soon begin to serve as alternative decor for "gift dressings"? Why was holly the primary symbol of the season for so long—and to such an extent that companies were still shipping their alarm clocks and cutlery in holly boxes as late as 1929, and showing pictures of customers in their ads, happily wrapping those same boxes in rolls of holly paper?[87] Tradition is one reason for the predominance of the holly motif. In *A Christmas Carol,* the most significant Christmas text of the nineteenth century, Charles Dickens has the Cratchits' plum pudding arrive at the table "bedight with Christmas holly stuck into the top."[88] Before Santa Claus or twinkling trees ever made regular appearances in the end-of-year issues of the illustrated magazines, holly already stood for Christmas in America, too.

Holly was associated with the rites of ancient Christmas, the holiday as it was thought to have been observed in Merrie Olde England before the Puritan ascendancy. A nostalgic "History of Christmas" in the seasonal number of *Leslie's* in 1857 extolled the virtues of the English Christmas, celebrated in the old-fashioned style with greenery, Yule logs, and puddings.[89] *Leslie's* depictions of contemporary American Christmas parties in the English manner show the same lavish use of greenery, with "holly festooned along the walls, holly in the windows, holly over the doors, and holly about every picture-frame in the house."[90] (A crown of Christmas holly on a family portrait was a mark of respect and reverence.)

A *Harper's Weekly* story from 1875—an extended caption for a cover illustration showing a former slave selling branches of holly on the streets of Richmond—argued that the use of Christmas greens was a hallowed English custom, restricted in America mainly to churches.[91] But recently "the practice of adorning our houses with wreaths and garlands of the unfading evergreen has become common among us." In past ages, the green leaves and the red berries of the holly tree reminded squire and peasant alike that hope could flower, even in the depths of winter: because it bloomed in the snow, the holly plant further symbolized the birth of Christ, commemo-

rated in December, at the winter solstice. The notion of making decorations with evergreen branches may have been late in coming to America, *Harper's* speculated, because the British forefathers of our stern New England ancestors objected vociferously to Popish notions like this one (and to Christmas itself!).[92]

Throughout the 1880s Thomas Nast's popular Santa Claus pictures for *Harper's,* images that helped to define the modern iconography of Christmas, were awash in holly leaves. The houses in which his children await their visits from St. Nicholas are decked out with holly branches, tucked into every conceivable nook and cranny. The telephone is topped with holly.[93] It lies along the edges of shelves and peeps out of Chinese bowls and vases.[94] It forms a wreath around a fine-art print of the Nativity hanging in a parlor where a brother and sister plot out Santa's route from the North Pole to New York City.[95] Louis Prang's beautiful chromolithographed Christmas cards, made in Boston and first sold in the United States in the 1870s, were full of holly, whatever the scene: a church steeple, a cozy hearth, a Santa arriving by bicycle.[96] Buttonholes, hatbands, storefronts, and street-corner stalls all sported holly leaves in the 1880s and 1890s.[97] The making of wreaths and garlands—a home industry for country women and children in holly-producing states, like New Jersey and Maine—was held up as an example of rural entrepreneurship.[98] Or decried as another example of the exploitation of the poor.[99]

But even stories that questioned whether little girls ought to be selling holly on the streets of New York were full of hints about the wonderful array of decorations in "fancy greens" that could be made from it, by clever little fingers. "Buy my wreaths, my crosses, my anchors, my stars!" cries a farm lass planted at a busy intersection.[100] The green market for New York City was set up every year in lower Manhattan, at the Hudson River docks.[101] The work of the greens-makers was on display there; patrons could also buy the raw materials for fashioning their own Gothic arches, ropes, banners, and mottoes out of holly. Indeed, like paper craft, making decorations from greenery for use in a home or church setting—or for marking the

graves of loved ones at Christmas time—was a sign of womanly virtuosity and good taste.[102]

Holly came to market in large boxes, to protect the delicate berries, and was generally snapped up by shoppers as soon as the crates were opened. In the 1890s, however, when the advent of new paper goods standardized and simplified the manner in which presents were wrapped, the arrangement of greens also took on a more uniform character. Holly passed into the hands of the florists, at least in large cities. It was no longer necessary, or desirable, to wire one's own greens at home. And in time, the wreath and the spray supplanted all the homemade mottoes and all the anchors sold on street corners by shivering children. "At this festive season of good cheer, no home can afford to be without a bunch of greens. Let it be a small branch of holly, . . . or a bit of evergreen—whatever the decoration may be, the home will seem the brighter and the better for it," wrote an expert in household decor who favored the professional touch.[103]

There were many possible reasons why holly became a ubiquitous Christmas emblem: it brought a touch of nature and the country into growing cities; it was churchly without being overtly religious or sectarian; it was homey without the naughtiness associated with mistletoe, which, according to English usage, licensed indiscriminate kissing during the holidays; it was a simple design, one unfreighted with the cultural complexities of Santa Clauses and Christmas trees; and it belonged, at first, to the domain of women, whose business it had been to orchestrate the proper observance of holidays with a symbolic vocabulary of their own devising. Whatever the reasons, holly, with its perky berries and shiny, scalloped leaves, continues to color the red-and-green celebration of Christmas today.

Materials for wrapping presents were undergoing rapid changes in the first decade of the twentieth century, however, and holly would soon loose its virtual monopoly on the trade in gift dressings. In 1907, for example, with the sponsorship of the Red Cross and the encouragement of the Progressive journalist Jacob Riis, the first official Christmas seals went on sale; the object was to raise money

to combat lung disease, but the effect was to add new options to the decoration of Christmas packages.[104] Stores—especially those that catered to the carriage trade—outdid one another in the drive to create distinctive, luxurious gift wraps. A full-page picture in the Christmas issue of *Leslie's* in 1909 shows the interior of a New York subway car on the evening of December 24th. Ladies clutch their parcels. An old gentleman brings out Christmas toys to amuse a youngster. And the delivery man in the foreground slumbers over a gift box wrapped at a department store, with striped satin ribbons and huge metallic seals, as well as the usual spray of holly.[105] Magazine articles from the same decade speak of a new type of "holly ribbon" with designs printed on its shiny surface.[106] But the most crucial innovations in the art of gift wrapping did not take place in New York. It was in Kansas City, Missouri, in the modest shop of Joyce C. Hall, a one-time postcard salesman, that the holly pattern finally met its demise.

The future founder of Hallmark Cards, Joyce Hall later looked back on the Christmas of 1917 or 1918 as a decisive moment in his career. "Gift wrapping paper—or as we called it then, 'gift dressing'— in those days consisted of only plain white, red and green tissue and one holly pattern," Hall remembered. "Most packages were tied with tinsel cord." Hall, like other stationers, sold all these Dennison products in his store, on 11th Street. That Christmas—sometime during the Great War, at any rate—they ran out of tissue and holly paper. Hall's brother went back to the plant to look for something else to use as gift wrap and returned with an armful of French envelope linings, printed in fancy patterns. At ten cents a sheet, the new wrappings flew out of the store; the next year, the enterprising Halls displayed the linings in packages of three sheets, and sold out again: "For all practical purposes, an entire new industry was born."[107]

Until then, Hall had manufactured greeting cards. Now, he began to make paper, along with matching tags, seals, and ribbons. Among the oldest samples of Hallmark papers preserved in the corporate archives are sheets of tissue from the early 1930s printed in saturated tones of cobalt, sienna, purple, yellow, and a reflective silver, far dif-

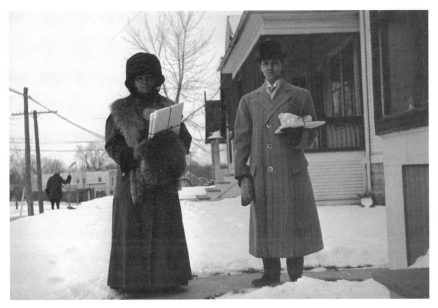

Delivering presents wrapped in white tissue and ribbons: Christmas Day in Minneapolis, 1910. Minnesota Historical Society.

ferent from the Christmasy reds and greens of the canonical holly motif. Plaid or checkerboard papers were paired with foil seals depicting candles, lanterns, stars, houses in the snow, or President Roosevelt's Scottie dog, Fala. Wrappings came in sets that included everything needed to finish several stylish packages; just enough tinsel ribbon was wound around flat cardboard reels and held in place with a pinch of heavy tinfoil. "The happy combination of new materials and one's own ingenuity" made for made a gift which, despite the manufacturer's provision of supplies that could not fail to match, said something about the taste and goodwill of the donor. "Your Packages Reflect Your Personality," read the title of a Hallmark booklet full of directions for using the kits to best advantage.[108]

Alongside a new generation of sailing ships, Madonnas, and, eventually, Disney characters, however, even ultra-modern Hallmark wrapping paper preserved the memory of the old holly pattern. Sometimes it reappeared as a stylized, abstract design, sometimes as

a shadowy background, sometimes as a tiny detail on a "To—From" tag cut out in the shape of a wrapped Christmas present. But the day of holly boxes, of "plain white paper and red ribbon," was over, wrote one prominent purveyor of household advice in 1928. Although the Depression had not yet begun, she detected a movement toward Christmas thrift: shorter gift lists, more economical presents. Yet "the wisest folk refuse to economize on the frills and furbelows that go toward making a successful Christmas present." Instead, armed with sheets of the new gift wrap and rolls of "the new gummed ribbon at 10 cents a roll in holly or poinsettia designs," gift-givers were tailoring the package to the preferences of the recipient. A traditionalist? A group of Dickensian carolers, perhaps, or a family from a bygone era gathered around the Christmas tree. A madcap modern? The silhouette of a tea table, printed over and over again, in striking black and white, or "a modernistic wrapping composed of orange, blue, and red diagonals." Candles for Grandma. An evergreen forest for Uncle Bob. Santa for the children.[109]

Is the package about the personality of the one who gives it, as Hallmark insisted, or is it about the donor's consideration for the age, station, and character of the one who gets it? Or a little of both? Begun in the 1920s, the quarrel over what, or whom, modern gift wrapping (and greeting cards) ought to express goes to the heart of the question of why Americans have continued to wrap presents ever since, in overwhelming numbers. The fun of surprising somebody has always been paramount in the transaction: in common with today's drugstore "gift boxes" of perfume or shaving lotion, holly boxes from manufacturers served to designate an item as something special and suitable for giving but did nothing to hide the gift. Hence, the rewrapping of pre-wrapped presents. Surprise! Surprise!

The element of surprise puts the spotlight squarely on the giver, the wrapper, the chooser of wrappings, the contriver of the pleasant shock that comes when the package is finally undressed. So there is some justification for thinking that wrapping reveals something about the donor, or constructs an identity that the gift-giver would like to assume. Of course, it is easy to dismiss the whole idea of self-

expression through packages as another capitalist sham, wherein pseudo-choices come down to Hallmark's Santa wrap or the other guy's version. But the trouble with small pleasures—the giving and the getting of them—is that they are not small, simple matters at all. They are about nuance, aesthetics, time, feelings, memory. "Gift wrapping," wrote a 1950s humorist, "has produced a rich literature in the service magazines and manufacturers' brochures. A [woman] must choose between no less than fourteen approved methods of looping a piece of . . . ribbon around a box. . . . As Christmas nears, she is hounded by memories of the loving efforts her forebears spent" on the task.[110] Although the commentator exaggerates for comic effect, wrapping *is* a matter of choices, beginning with the decision to bother with the whole business in the first place. As such, wrapping is a communicative, expressive act, with a range of meanings enhanced by the fact that, after 1917 or 1918, all gifts no longer needed to hide themselves in the same holly paper and tinsel ribbon.

If anything, the hard times of the 1930s tipped the scale in the direction of more elaborate and more expressive wrappings, which often concealed small tins of food, dime-store trinkets, and homemade gifts. Sentiment mattered, and when the thought counted, so did the wrappings. Scotch tape, in a home dispenser, went on the market in 1932; cellophane film, colored tape, and transparent ribbon followed. Curling ribbon was introduced—and glittering foil papers. The last word in gift packages was a compensatory sparkle in a poor, drab world. DuPont's Christmas brochure for 1936 showed Americans with more time than money "How to Make Every Gift Gay and Personal" with cellophane products.[111] Other experts suggested that the wrappings should fit the gift, negating the notion of surprise in favor of appropriateness—and spotlighting the wrapper's ingenuity. So a cheap travel book might be wrapped in a map-printed table mat, or a roadmap from a gas station.[112] Alternatively, the adventurous might design and fabricate their own wrappings by hand, with ink or paints, in order to "have the right appeal and express the right ideas."[113]

In 1937, the Sears Christmas Book advertised complete wrapping

packs for forty-nine cents, including several yards of the new cello-phane ribbon. The 1939 set, with twice as much of everything and a "professional" instruction booklet, was guaranteed to "thrill your friends with the sheer loveliness of your packages." But World War II called a temporary halt to sumptuous wrappings. The ad for the 1942 Sears assortment, with colored as well as silver foil, reminded families to stock up on servicemen's gift mailers of sturdy corrugated board for shipping presents overseas.[114] Accounts of GIs going with-out trees and turkeys suddenly made "fancy gift wrapping seem terrifically unimportant these days when materials . . . needed to produce and distribute such packages are so direly needed for the essentials that will help to bring those boys back home again," in the words of a trade journal for the makers of boxes and wrapping paper.[115]

Prewar glamour was out for the duration, in any case: manufac-turers of paper and ribbons were now doing government jobs, raw materials were rationed, and most stores were making do with left-over supplies from former years. Macy's, for example, combed ware-houses for forgotten stockpiles of its familiar red boxes. Department stores were forbidden to sell set-up boxes even if they had them in stock, and fees were now imposed for wrapping—once a free service to customers. A few firms managed to print new papers with patri-otic designs, Army and Navy insignia, or plain colors, suitable for use on any gift-giving occasion. Folding cartons, which could still be manufactured in numbers comparable to 1941 levels, were litho-graphed with holiday motifs: cigarettes and toiletries packaged in these gift cartons were seldom rewrapped during World War II.[116] A wartime ad for Whitman's chocolates recommended that those who still felt compelled to wrap its pretty boxes should use homemade wrapping paper (odds and ends of kitchen shelf paper), tied up in scraps of yarn.[117]

Along with stationery, underwear, and cigarettes, candy was one of the simple, useful gifts recommended for the serviceman or woman. "This year, as usual, the greeting cards and the bright packages will be piled high," the *Saturday Evening Post* predicted in an article on

choosing presents in time of war that showed happy soldiers clutching gift-wrapped parcels from home.[118] But the presents weren't always so bright. Metallic gold ribbon succumbed to the rationing of aluminum and tin; for the duration, a nasty yellow-orange color called "tango" sufficed.[119] Makers of gift wrap ran holiday ads full of fervent hopes that next Christmas, it would be business as usual in the world of printed papers.[120] For industry-watchers during World War II, the 1930s—the Great Depression—took on the luster of a Golden Age, when cellophane, foil, new patterns, and gold ribbon had all been available. Neiman Marcus, of Dallas, Texas, had become a legend among retailers by starting a unique wrapping service in 1932 with a small stock of conventional supplies. By the time the war intervened, the Neiman gift department was famous for packages that could cost hundreds of dollars for the wrappings alone. A cattle baron once asked the gift service to create a full-size Neiman's Christmas window in his living room, with mannequins to display the fur coats and jewelry his wife was getting that year. Another memorable job was a seven-foot cellophane snowman with a zipper that opened to reveal a cache of expensive gifts inside. In the 1940s, the parcels were smaller but no less imaginative. Some packages had themes based on the Broadway musical *Oklahoma:* using cardboard and oilcloth, Neiman's created a perfume box in the shape of a miniature "Surrey with the Fringe on Top." Gifts from the kitchen department were wrapped in packages that looked like chefs wearing real cloth hats, made of unrationed fabric scraps.[121]

Pictorial wrappings and wrappings exclusive to a particular store remained popular in the postwar era, when prosperity made Neiman-style packages accessible nationwide. Halle Brothers of Cleveland and Carson Pirie Scott of Chicago were among forty top department and specialty stores to join the Susan Crane Gift Wrap Service, launched by a Dallas firm that developed gift wraps for special occasions and supplied partially finished packages to members. A Susan Crane Mother's Day kit for 1952 featured a three-dimensional cut-out of a woman doing her baking in an antique stove, against a background of old-fashioned recipes. The Christmas ideas

were just as clever and just as complicated. And, at 35 to 50 cents a package, with a 100 percent markup for the store, the Crane service was much less expensive than commissioning one's own special parcel design.[122] Some stores stuck with plain paper and a bow, but by 1949, personalized wrappings as an expression of corporate identity and consumer prestige had become big business. Wrapping was free advertising; however understated for the rest of the year, bags, boxes, and paper always dressed themselves up for the Christmas holidays.[123]

The do-it-yourselfer had lots of help in the 1950s, too: feature articles, manuals, and courses offered guidance lest the amateur make a bad impression. "A sloppily wrapped package, or one too gaudy or too skimpy, indicates poor taste, indifference, or lack of skill—and inevitably detracts from the pleasure intended," said one arbiter of rules for wrappers.[124] "Few seasons of the year afford a better opportunity for the individual art-craftsman than do the Christmas holidays"—the season for finger-painted wrapping paper, wrote a Cleveland artist determined to make the package outdo the gift.[125] Whole families were encouraged to wrap together, making boxes from sheets of cardboard, and wrappings from torn paper bits the arrangement of which could stimulate the creative bump in children.[126] Just follow the directions and unleash your hidden artistic potential!

Togetherness and do-it-yourselfism are both familiar buzzwords of the 1950s.[127] Just as the appetite for expensive, store-wrapped packages parallels the prevailing postwar taste for chrome-laden, two-tone cars, so the vocabulary of the happy household describes how wrapping Christmas gifts resembled other family activities of the period. But that analysis doesn't really address the question of whether the meaning of wrapping had any independent, agreed-upon existence. What did it mean to wrap a gift in the 1920s, when the new wraps first appeared? In the thirties, when pretty wrappings compensated for less costly gifts? In the wartime forties? In the prosperous fifties?

Thanks to the fact that the popular appeal of its cover art kept the

magazine in business, the *Saturday Evening Post* provides some of the answers. Published throughout the years in question, the *Post* was one of the major contributors to the codification of American holiday iconography. Its much-anticipated covers marked off the passage of the year with topical symbols that potential readers found arresting, amusing, often comforting, and sometimes inspirational. J. C. Leyendecker, whose Santa Clauses are as important to defining St. Nick's twentieth-century persona as Thomas Nast's were to fixing his nineteenth-century attributes, was the Christmas artist of choice at the *Post* until Norman Rockwell began to share the honors in 1919. In the early years of his ascendancy, Leyendecker paid little attention to presents or wrappings. From about 1905 to 1919, however, when packages were pictured on Christmas covers by Leyendecker and his rivals, they were always the familiar pasteboard boxes, clad in white tissue and adorned with red ribbons and, occasionally, a sprig of holly.[128] The covers indicate that the wrapped present had become a comprehensible symbol for the Christmas celebration—and that Americans expected packages to be decorated in the manner pictured. In the 1920s, candy-striped papers appeared alongside plain tissue, at just about the time when new designs from Hallmark and other firms began to turn up in real life.[129]

Leyendecker's 1936 cover—entitled "Twas the Night before Christmas" in illuminated Olde English script—makes the modern-day trappings of the holiday the ironic focus of the vignette. The time is Christmas Eve. In full sail through a busy department store comes the great American family. Oblivious to a display of bargain giftware, Mother breezes by, checking off names on her Christmas list. Junior, ignored by his elders, is having a temper tantrum. And Father bustles along in their wake, with a wreath of holly over one arm, balancing a tower of packages that threatens to topple at any moment. One box is wrapped in holly paper, another in a red and gold stripe, a third in white tissue with a red cord. There are packages with red and green tissue; an expensive set-up box from some fancy emporium; and a store-wrapped box in midnight blue.

While it pokes fun at the retail rites of Christmas, Leyendecker's

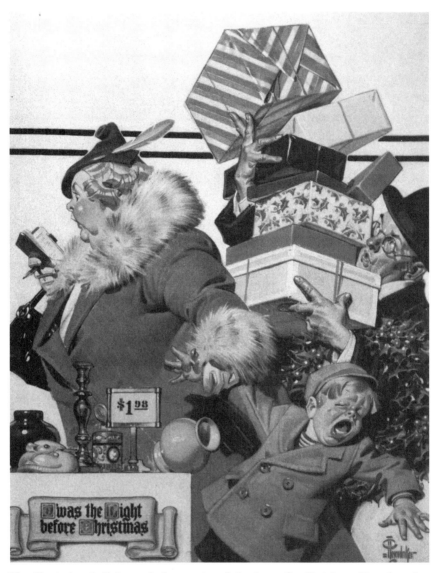

The illustrator J. C. Leyendecker captured the joys of a Christmas Eve shopping spree in 1936; the boxes include store-wrapped presents, a manufacturer's holly box, and cardboard boxes tied with cord. *Saturday Evening Post* (December 26, 1936), cover.

picture also seems to discount the very notion that the Depression might have an effect on the national Christmas list. There are plenty of presents in the *Post*'s America on Christmas Eve, 1936—presents proudly decked out in a variety of wraps, ranging from holly boxes and tissue to the last word in store-bought elegance. Indeed, from the point of view of Leyendecker's viewer, the wrappings make the present. Norman Rockwell's Christmas cover for 1937, perhaps conceived in rivalry with Leyendecker's, takes up the same theme: Rockwell depicts a grandfatherly figure (with a wreath of holly around his neck) who has taken a spill on a snowy sidewalk, scattering presents everywhere.[130] Most of them are unwrapped toys—a doll, a drum, a hobby horse. The wrapped packages are done up in white paper, in the traditional way, as befits the age of the giver. But the broad satin ribbons, the artificial holly, and the poinsettia-decorated tags are all strictly up-to-the-minute accessories of the type now available in matching sets.

One of Rockwell's children recalls that his father generally painted Christmas covers in the heat of summer. "My brothers and I," he writes, "have startling memories of people dressed in Santa suits wiping the sweat from their faces and drinking iced tea, and our mother hunting all over the house for Christmas wrapping paper in July."[131] In addition to his natural conservatism, the problem of finding Christmas wrappings in July may be one reason why Rockwell made do with plain white Christmas paper in his pictures long after its day had passed. His *Post* cover for Christmas, 1940, shows a little boy staring in wonder at an off-duty department-store Santa on the subway. According to the poster behind the erstwhile Santa Claus, he is appearing at Drysdale's store; the little boy clutches an armload of white-wrapped packages frosted with prominent Drysdale's stickers.[132]

The 1944 Rockwell holiday cover, painted from sketches made in Chicago in the heat of summer, shows soldiers, sailors, and civilians bustling through a crowded railroad station toward Christmas reunions with loved ones. The picture is subtle in its invocation of the season. Garlands and crepe paper bells dangle from the clock. A

drunk staggers past with a tree and a wreath of holly. A skinny Santa rings a bell. But it is the presents that serve as strong visual punctuation marks, identifying the time of year and pointing out each poignant anecdote within the teeming drama. Since the scene is set in 1944, it is not surprising that most of the gifts are white, with red or multicolored ties: printed papers have disappeared from the stores for the duration of the war. Here and there, with some difficulty, the viewer can spot parcels wrapped in what may be the new patriotic designs, with big gold stars, or a leftover piece of red tissue. But the white packages speak of rationing even as they evoke better days gone by, before World War II separated families at holiday time.[133] Subsequent Rockwell efforts, in 1947 and 1948, use wrappings for the opposite reason: a pile of gifts in lacy ribbons, foil, and new holiday designs full of prancing reindeer hint, by their own lavishness, at peacetime prosperity, just as the scraps of multicolored wrapping paper—bells, snowmen, doorways in the snow—discarded by a frazzled salesgirl celebrate choice and assert that wartime privations are a thing of the past.[134]

From the late 1940s until the *Post* gave up cover illustrations in favor of photographs in the early 1960s, the fronts of the Christmas issues provided a window on the status of presents and wrappings. The wrappings, over time, got more colorful and sparkly. And the gifts themselves, thoroughly disguised in their impenetrable dressings of foil, became mysteries to be solved at all costs. For husbands and wives as well as boys and girls, suspense was the quality most readily associated with the wrapped Christmas gift. A recurrent theme of the period was the closet scene: somebody is hiding heaps of beautiful packages and someone else is contriving to get a peek at them—a lady in curlers, shaking parcels in the middle of the night while her mate slumbers nearby; a snoopy child, buried under the winter coats and boots as his parents stash the gifts; a mother caught by her kids in the act of stowing presents from Santa on the highest shelf.[135]

An exception to the *Post*'s mood of happy anticipation is a Stevan Dohanos cover picture for 1952. A sour reprise of Leyendecker's

1936 shoppers, the Dohanos scene depicts the bus stop outside the department store at the height of the Christmas rush. People of all ages clutch their gifts and peer anxiously out of the picture, watching for an overdue bus. Christmas is a chore, and the packages, like the faces of the shoppers, are almost identical: pinched, somehow, and tense. Red ribbons fasten themselves around white packages with dour, totalitarian precision. Tasteful store wraps, in patterns of wavy gray stripes, and store boxes, with shiny gray surfaces, seem incapable of conveying a festive mood. The hard edges of the boxes match the lined faces of the shoppers, scowling to catch a glimpse of the bus. More trials surely lie ahead, when they try to jam themselves and their booty inside. But nobody will raid the closet to rattle these leaden presents.[136] Christmas, 1952. Oh, no! Not again!

Over the past several decades, wrapping strategies have tended to re-emphasize the feelings of delight, suspense, and surprise that are notably missing from the Christmas experience of Stevan Dohanos's gloomy shoppers. Packages painstakingly crafted to hint at the contents have flourished, for instance; they acknowledge the modern practice of piling gifts under the tree before the holiday arrives, all the better to tantalize the recipients.[137] Massed quantities of presents set up in this way, in a kind of domestic display that amounts to a secular crèche, lend credibility to the complaints of those who rail against Christmas as a "National Festival of Consumption" or a coast-to-coast, mallized potlatch ceremony.[138] But 96 percent of all American households still wrap anyway. The shopper's annual murmur of discontent with the impersonal materialism of it all may account for a fresh groundswell of enthusiasm in recent years for homemade wrappings. Wrappings and packaging which are useful gifts in their own right, Martha Stewart's pathologically creative suggestions for wrapping gifts in glorified paper bags, and the spasms of eco-friendly *angst* expressed through presents wrapped in old newspaper and biodegradable hemp respond to a persistent national sense of satiety and waste.[139]

But Americans wrap regardless. Even men wrap, alongside the women, if their special-interest magazines are to be believed.[140] We

wrap, but we don't iron out the ribbons and fold the old paper away for another year. We indulge ourselves. Wrapping is an indulgence, a willful excess of goodwill, an extravagant act, however modest the cost of this year's crop of angel and Santa Claus paper, fresh rolls of tape, and glow-in-the-dark ready-made bows. We wrap in good times and bad—especially in bad times, when families are scattered, when money is tight, and when the outsides of packages must carry the gentle burden of affection across miles and generations. We wrap because Christmas is extravagance and mystery and feeling, just like a pretty package with a sprig of holly tucked under the bow.

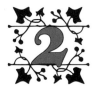

THE CHRISTMAS BUSINESS

Greenery, Lights, Ornaments, Toy Villages

I t's hard to read a newspaper or visit a mall after the first of November without seeing signs of a massive Christmas industry. Sales of cards and wrapping paper are in full swing by Halloween; lights, decorations, and Christmas gift items appear immediately thereafter, along with alluring mail-order catalogs full of similar products. The cynic might conclude that the modern-day Christmas, at the dawn of the twenty-first century, has devolved into an orgy of capitalist greed, to which the birth of Christ is largely irrelevant.

But the American Christmas has always been more secular than sacred, and since the middle of the nineteenth century, the seasonal businesses of Christmastime—the yearly cycle of boom and bust— have been the subject of intense interest in their own right. The nature of the holiday itself, with its brief flurry of presents and lavish meals, dramatizes a temporary state of blissful prosperity that the marketplace is rarely able to sustain. Yet the Christmas industries of the post–Civil War period were cottage industries, for the most part— little, homegrown enterprises regularly analyzed and examined as metaphors for this precarious state of affairs. And what was extracted from the stories of mistletoe-gatherers and toy-makers was

often a sense that the hard-working entrepreneur could still triumph, in an age of trusts and corporations, panics and business depressions, if only in a small way, during this one special season.

The first Christmas business to attract attention as a strictly seasonal phenomenon was the provision of greenery for the decoration of churches, stores, civic buildings, and private homes. Greenery had the advantage of being a nonsectarian means of observing the winter solstice: Druids, ancient Romans, Germanic tribes, even Egyptians of the time of the Pharaohs, were said to have brightened the dark days of winter with evergreens and with plants like holly that bloomed in the snow, with a bright promise of springtime to come.[1] Although Christian interpretations sometimes attached themselves to the iconography of holiday greens—the prickly holly plant, for example, was said to stand for Christ's crown of thorns and the red berries for his blood—these were by no means universally accepted. And, with the exception of Puritan New England, where the use of holiday greens in meeting houses was explicitly forbidden, churches of many denominations followed the English custom of decking their halls with evergreens around the time of the New Year.[2]

The English Puritans of the seventeenth century had denounced Christmas as a popish invention without biblical warrant. Indeed, because the holly and mistletoe of the season predated the establishment of Christianity in Britain, they also prohibited the use of evergreens in both sacred and secular contexts, regarding them as remnants of heathen superstition. In New England, hostility to Christmas persisted into the modern era: as late as 1870, classes were being held in the public schools of Boston on Christmas Day, and punishments were meted out to children who stayed home to celebrate around the Christmas tree.[3] In the 1880s, writers of Christmas fiction drew upon the dour Puritan opposition to the holiday to praise the new liberality, family feeling, and joy associated with contemporary observances of Christmas, which had become the highlight of the American festival year in the aftermath of the Civil War. A short story published in *St. Nicholas Magazine* in 1887 de-

scribes a Puritan household in Plymouth, Massachusetts, in 1635. As her crippled son lies ill in her desolate house, a widow tells him stories of a "great green bough that was lighted with tapers and hung with gifts for the good children" in the olden days, "before Mamma was a Puritan." Finally, with the child close to death, she has an evergreen bough brought to his bedside. At the end of the story, little Roger is on the mend, his lost father has reappeared, and even the stern village elders have been won over—all by the power of greenery.[4] Vivid memories of forbidden holly and mistletoe wreaths tempt another Puritan mother, in an 1894 poem in *Harper's Young People*, to make her little daughter a doll for Christmas.[5]

The retailers of Christmas greens, in stories in the same magazines, are often destitute children befriended by silk-hatted millionaires.[6] Or country innocents, shivering on a street corner in the great metropolis, to support aged mothers back home.[7] The implication is that something sweet, unaccustomed, and fresh—something natural, in other words—has made its way into the busy, artificial lives of the New Yorkers whose city is almost always the setting for descriptions of the transforming power of Christmas greenery.[8] But underlying these ritual evocations of the countryside is a real curiosity about how the business of finding, harvesting, preparing, and shipping an unusual product to market is managed by rural folk.

A 1907 story by Charles Poole Cleaves, "The Bald Brow Christmas Trees," is an account of how three young brothers from New England lease the right to chop trees from a paper company, saw the butts square, tie them into bundles, and prepare to drag them down the mountain for shipment to the city. The narrative is well advanced before the characters ever encounter the mean old farmer whose refusal to let the cargo pass through his land sets the sentimental story of Christmastime redemption in motion. If the boys don't deliver the goods by December 15th, as the contract specifies, their next year's schooling is in jeopardy; if they have to hire a crew to help them bypass the farmer's land in order to deliver on time, they stand to lose money.[9] This is a parable about the risks of capitalism. The boys' triumph, in the end, is a tribute to the kind of luck and

pluck that made best-sellers of Horatio Alger's dime novels about young men who always made good.

Greenery is alien to the city, a reminder of forests and farms, of olden times and the values of the past. A *Harper's Weekly* Christmas cover for 1880 shows a series of vignettes describing the process whereby evergreens move from snowy field to cozy hearth: in the far-away wilds of Maine and New Jersey, men in rough clothing cut and bundle the greens, while indoors, in a bare workroom, pretty country girls sit at a long table weaving wreaths, and a boy packs them into barrels for the long trip to the city.[10] Another *Harper's* Christmas number, in 1875, pictures an old black man in rags selling a fresh-cut holly bush in the outdoor market at Richmond, Virginia. The article that accompanies the picture notes the Puritan injunction against greenery, the reason why "the beautiful custom of twining the branches of the spruce, the pine, and the holly into graceful decorations for our dwellings during the Christmas season was so slow in becoming popular." Nowadays, the text continues, wagonloads of branches are a sign of the season in the city; markets are crowded with "a wilderness of wreaths ingeniously woven from sprigs of holly and pine, relieved by berries of a brilliant red color."[11]

By the time greenery was turning up regularly in urban markets, in the 1870s and 1880s, the reasons for using it had been forgotten among indoor people, who banished the seasons with central heating, and the darkness of winter with gaslight. Journals of all sorts devoted lavish attention to the meaning behind the Christmastime plants, where they came from, and how they reached the New York apartment or townhouse. Mistletoe, according to one report, grew exclusively in the apple orchards of France, where it was gathered in late November, tightly packed in wooden crates (to preserve the white berries or bells), and sent by fast steamer to New York, where it served as an excuse for holiday kissing. Why the sight of mistletoe stimulated such liberties, the author could not say.[12] By the 1890s, although the plant with the milky-white berries and dull green leaves was being harvested in quantity in the American South, the bulk of the crop still came from France, preserving a kind of link between the rituals of the Old World and the New.[13] The regular appearance of

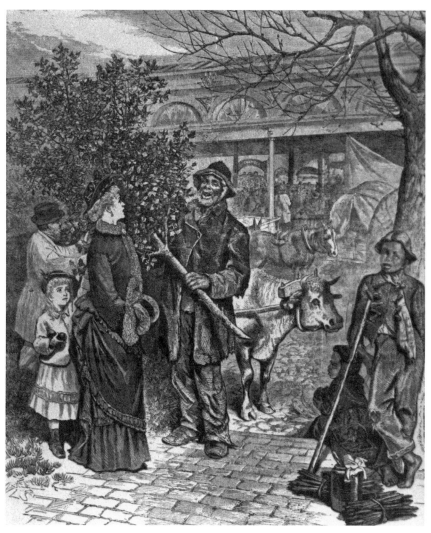

"Selling Christmas Greens—A Scene in Richmond, Virginia," 1875. *Harper's Weekly* (December 25, 1875), 1037.

mistletoe at the start of the holiday season also offered testimony to the efficiency of the modern mechanisms of international trade.

Mistletoe came by steamship, while holly arrived by the trainload. Another plant that produced berries in winter, holly was a domestic product: even the British imported most of their supply from the former colonies. And perhaps because the several varieties of holly grew

in quantity from the Canadian border to the tropics, its distinctively scalloped leaves and red-and-green color scheme became two of the earliest shorthand symbols for Christmas. English Christmas and New Year's cards of the 1870s and 1880s can frequently be identified as such only by the inclusion of the odd sprig of holly or mistletoe; otherwise, the birds, flowers, and pretty children pictured seem to have no special connection to the winter holidays. Louis Prang's American cards of the period are more sharply focused on what we would recognize today as commonplace Christmas motifs. Winter scenes, church steeples, bells, and Santas all figure prominently in the Prang repertory, but these are further linked to Christmas by large, detailed renditions of seasonal foliage. The reverse side of a card devoted to the theme of Christmas bells, for example, is decorated with a botanical drawing of interlaced branches of holly and mistletoe, while other Prang cards feature spiky tendrils of holly that wander across the paper with a will of their own.[14]

One of Prang's oddest offerings, a huge card adorned with silky fringe, shows a mechanized American Santa astride a bicycle, with the reindeer bringing up the rear, struggling to keep pace. There are a few sprigs of mistletoe in Santa's pack, and he brandishes a clump of holly like the attribute of some modern-day patron saint of the import-export trade.[15] More commonly, in Christmas-themed pictures of the period, holly and the other greens serve as framing devices for the scenes or decorations for specific parts of the domestic interior. In the 1880s, Thomas Nast's annual Christmas illustrations for *Harper's Weekly* are often recognizable as such only by the use of sprays and wreaths to add holiday luster to the rooms in which children dream of Santa and even the mice are tucked up in tiny beds awaiting his arrival. In scenes like these, the vase on the mantelpiece is always filled with mistletoe and the pictures on the wall—especially those of a sacred character—are always wreathed in holly.[16] In the absence of the Christmas tree, which was adopted gradually, by fits and starts, after 1850, many published pictures of Christmas revels are recognizable only because doorways, mirrors, and family portraits are decked with swags of holly, and mistletoe hangs from

the ceiling in secluded alcoves.[17] Taking their cue from the use of woven garlands in homes and churches, *Harper's, Leslie's,* and other journals frequently edged holiday images in evergreens to connote a special Christmas content.[18]

Christmas greenery was widely used as well in the Victorian cemetery, where "fancy greens," worked in the shape of crosses, anchors, and wreaths, were placed on the graves of loved ones, much as the ancestral portraits at home were crowned with holly.[19] Nast depicts children selling such tokens at the gate of a snowy graveyard; in the green market in lower Manhattan, alongside the Hudson River, farmers from New England and the Catskills bargained with the city retailers, who then recruited orphans and other unfortunates to peddle their wares on uptown street corners.[20] Although the custom faded as the Civil War receded into history, well-brought-up women were still expected to know how to fashion shapes—"heaven's gates ajar" was a favorite—from moss and greenery for display at Christmas.[21] Magazines supplied detailed directions for weaving fresh greens onto ready-made wire forms suitable for church or gravestone.[22] Some editors, however, denounced the practice of using the same patterns to make ornaments for Christmas trees or pious mottoes for the parlor wall on the grounds that the Christmas celebrated in the American home had nothing to do with religion.

There were secular or household greens, and then there were sacred ones. While Christmas trees occasionally cropped up in Sunday schools, as inducements for attendance, in the late nineteenth century the decorated evergreen belonged exclusively at the family hearth.[23] When the trees were still a novelty in most American homes, some efforts were made to find a religious justification for the practice of decorating them. Martin Luther was wrongly credited with bringing the tree indoors and lighting it with candles to delight his children; others tried, with less success, to equate the Christmas tree with the Tree of Knowledge in the Garden of Eden, around which the serpent twined himself when he tempted Eve.[24] In the end, however, what fascinated Americans most about Christmas trees was how they magically appeared in the city in mid-December from dis-

tant points and, for a week or two, transformed the urban environment beyond all recognition.

In the 1840s, there were sporadic reports of trees for sale in New York City. In 1851, after a payment of one dollar to the city, the first recorded Christmas tree concession was set up by a Catskill mountain man on the sidewalk at the Washington Market.[25] At a time when illustrations in magazines still consisted of woodcuts after hand-drawn pictures, a popular Christmas image traced the progress of the Christmas tree from forest to parlor in a series of vignettes dripping with icicles: the tree is cut in deep snow, dragged to the station, and loaded onto a railroad flatcar; it is offered for sale in a bustling urban market, along with wreaths and crosses; its by-products, in the form of small evergreen wreaths, are sold in the streets by vendors in shabby clothes; and, at last, a young girl and her father trim the tree with glass balls and candles in a warm, inviting home.[26]

When photographs replaced drawings, the same imagery persisted, with added scenes showing jobbers and grocers bargaining with farmers for trees to be sold at retail in the outlying boroughs, and massed quantities of trees piled up near the docks on the Hudson.[27] Like similar pictures of Christmas turkeys hanging by the thousands in the rafters of the Washington and Fulton Markets, the towering heaps of fragrant trees were signs of the approaching holiday.[28] Without the rhythms of the agricultural year to signal the turning of the seasons, city dwellers relied on the merchandise in the shops to tell them when Christmas was coming. In a 1906 short story in *Leslie's Weekly* (illustrated with posed photographs of a model impersonating the heroine), the protagonists realize that the holiday is upon them only when Santas and holly appear in store windows and "forests of Christmas-trees, which had come to the city in great train-loads, sprouted from the dingy gutters."[29] The sheer numbers of trees and other holiday trappings featured in Christmas reports at the turn of the century reinforce the sense of material well-being associated with gifts and feasting. For those few days of the year, millionaires bought wreaths from orphans, and all was

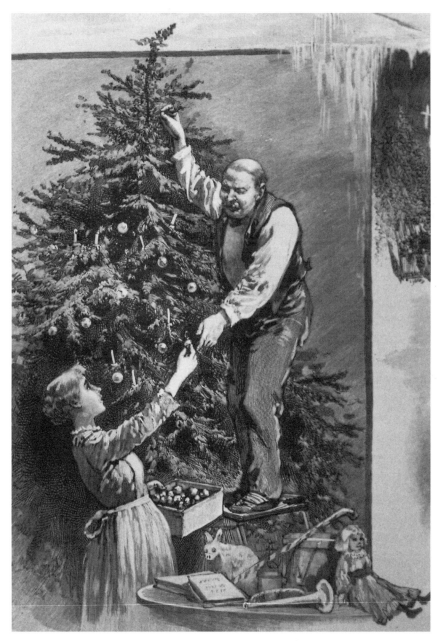

The final step in the fascinating story of the greens industry "from the Forest to the Home" came with the decorating of the tree. *Frank Leslie's Illustrated Newspaper* (December 21, 1889), 352.

well. The quantities of Christmas goods also promoted a feeling of commonality: at Christmastime, the pictures suggested, there were trees and turkeys enough for everybody.

By 1930, when the Depression brought all American industries under anxious scrutiny, it was no longer possible for most families to snag "the old, wild, free Christmas tree" in some nearby forest. Demand was high, too, because, after decades as a novelty item, the Christmas tree was now firmly established in most American homes. Furthermore, shortages in recent years had been severe, driving the price of the average $2 tree as high as $15. The solution was a new source for suitable trees—pine and spruce—in the timber country of Minnesota and the upper Midwest: 300,000 trees in the seven-foot range were shipped through St. Paul that year and another 100,000 through Duluth.[30] Depression or not, the Christmas tree had become a necessity of American life.

Trees for the East Coast market still came almost exclusively from the mountains of New England, especially from the Berkshires, where balsams were a specialty, and farm boys worked from Thanksgiving through December 15th to supply the cities, at a penny per fragrant foot.[31] But the fact that one family in every four put up a Christmas tree in the first decade of the twentieth century, essentially wasting four million trees that might otherwise have gone to paper mills and other industrial uses, troubled some experts. Gifford Pinchot, the chief United States Forester, was not among them, however. The number of trees sacrificed to the holiday was statistically meaningless, he decided: if forests were for meant for human use, then the pleasure of children was a legitimate reason for Christmas lumbering. Besides, in Vermont and other traditional timberlots, Christmas trees were being specially grown for the trade, as a renewable resource. But the profit margin was narrow, even for big tree farmers; the middlemen made most of the money. And where small, independent operators were involved, there was always the danger of opportunistic cutting that destroyed young growth and future timber in the process.[32]

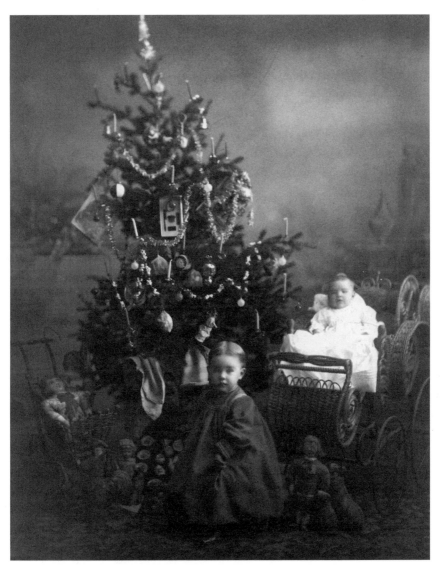

A Midwestern tree, 1904, with candles, rope tinsel, and many of the fancy new glass ornaments. Judging by the presents—dolls, china tea sets—the children are girls. Minneapolis Public Library, Minneapolis Collection.

The national debate over the ethics of displaying cut trees at Christmastime came to a head in Washington, during the presidency of Pinchot's boss and principal supporter, Theodore Roosevelt. The first White House Christmas tree had been set up in 1856 by Franklin Pierce, a New Hampshire native accustomed to trees and greenery, at a time when the practice was still unusual. By 1891, when a story about Benjamin Harrison's White House festivities described "an old-fashioned Christmas tree for the grandchildren," trees were common enough to be regarded as traditional.[33] And by the time Grover Cleveland ordered newfangled electric lights to replace dangerous candles in 1895, the Christmas tree had clearly become the norm.[34] But Teddy Roosevelt, a dedicated conservationist, had his doubts.

In 1902, according to some accounts, he forbade his children to have a Christmas tree, only to be talked out of the ban by Pinchot, who convinced him that by cutting smaller trees, Christmas tree gangs actually helped to thin the forests and encourage the growth of the surviving timber.[35] A more colorful reminiscence of the episode, written by White House clerk Robert Lincoln O'Brien, gives the credit to little Archibald Roosevelt, who smuggled a 20-cent tree into the room where the family presents were hidden, hung gifts for his parents from the branches, and set it up in a closet. In collusion with the staff electrician, he decorated his two-foot tree with tiny lights, operated by a hidden switch outside the closet. On Christmas morning, after the other packages had been distributed, Archy turned the switch, threw open the door, and made a convert of his astonished father, who cherished live Christmas trees forever afterward.[36]

Archibald Roosevelt's electric lights were among the many Christmas products that made the season increasingly essential to the health of the economy. In 1912, one report called Santa Claus "our biggest captain of industry." Conservative estimates placed Christmas spending on ornamentation and greens at an astonishing one dollar per capita. The passenger railroads and the express companies did most of their business between mid-December and January

ELECTRIC LIGHTING OUTFIT

For
Christ-mas Tree
and House Decoration

Completely made up and ready for use

Retail price for complete outfit, including 28 one-candle power miniature Edison lamps, neatly packed in handsome box, $12.00. Liberal discounts to the trade.

MAIN SALES OFFICES

Edison General Electric Company
Harrison, N. J.

Early electric tree lights, 1903. *Saturday Evening Post* (December 5, 1903), 24.

first. Whole industries—candy, toys, perfume, and fountain pens, for example—subsisted on Christmas profits; the output of candy increased by a whopping 105 percent during the holidays. "There is no single international trade feature that shows a bigger financial budget than that of Christmas," an economist concluded.[37]

Lights were one of the first manufactured items tailored especially to Christmas. Wax tapers, essential to the drama and sparkle of the tree, left whole households in a state of barely suppressed hysteria

throughout the festivities. The wires that held the candles to the branches were hard to manage, and when they slipped, the wicks sometimes came into incendiary contact with paper ornaments and dry pine needles. In many homes, buckets of sand or water sat under the tree. Or candles were lit for just a few moments and then prudently doused.[38] So the perfection of electric tree lights in the 1880s (miniature oil lamps, patented in 1887, never caught on) was a boon for nervous fathers everywhere. The first set of working lights adorned the tree of Edward R. Johnson, vice-president of Thomas A. Edison's electric company. On display in the rear parlor of his New York home, Johnson's tree elicited gasps of wonder from his visitors. It was lit by eighty glass bulbs in red, white, and blue, each one "about the size of an English walnut," and powered by a current from the Edison office. Furthermore, the tree was mounted on a motorized wooden box that made it turn around; as the tree revolved, the lights blinked on and off in series, making the colors twinkle and dance. "It was a superb exhibition," said an eyewitness.[39]

Edison's light bulb factory was acquired by General Electric in 1890, and during the decade that followed, Christmas finally became a legal holiday in every one of the states, stimulating new holiday industries. GE began to retail workable Christmas lights in 1901. A 1903 picture spread in the *Saturday Evening Post* advertised a complete "outfit" for the family Christmas tree, including "28 one-candle power miniature Edison lamps" packed "in [a] handsome box, $12.00."[40] Competing strings or festoons of lights were marketed by the Ever-Ready Company in 1903 and were greatly improved, five years later, by the introduction of sets with eight sockets to a string, wired in series. GE countered with figural bulbs (electrified Santas and snowmen), first manufactured in Austria in 1909. By 1920, the candle was rapidly disappearing from use. For houses not yet wired for electric current, battery outfits were available by mail; prices for a standard 16-foot string had fallen rapidly, too, from $12.00 in 1903 to $1.75 (with extra bulbs included) in 1914.[41] An electrified tree set up as a surprise in a New York hotel room was nothing short of "a marvel," exclaims a character in a 1909 children's story. "It shim-

Electric lights were safer than candles. Sets powered by a battery were meant for families whose houses were not yet wired for electricity in 1914. *Saturday Evening Post* (November 28, 1914), 46.

mered and glittered with tinsel ropes; it sparkled with shining orna-
ments; it trembled with hundreds of tiny electric lights of all colors.
. . . [We] had never seen a Christmas tree electrically lighted!" A small
child, speechless with delight, gazes at the apparition, "her eyes as
bright as the electrics themselves."[42]

In the 1920s, round and pear-shaped bulbs were replaced with the
cone or flame models. Although it did not come into universal use
until after World War II, GE pioneered a parallel wiring system for
Christmas lights in 1927, which meant that if one bulb burned out,
the string still remained lighted. The bubble light, developed late in
the 1930s, also failed to catch on until the 1950s. If the Depression
dampened consumer enthusiasm for items not strictly necessary to
the perfect Christmas tree, defense work and wartime shortages took
an even heavier toll on Christmas decorations during World War II.
1945 ads for GE's lamp division emphasized that for this "Victory
Christmas" tree lights would finally be produced again, but "in very
limited quantities."[43] Only in 1947, when outdoor lights began to be
featured heavily in promotional material, did GE assure buyers that
more tree lamps would be available than ever before. But, because of
pent-up demand, "you may not be able to buy all you want."[44]

In addition to beauty and convenience, electric tree lights were ini-
tially sold on the basis of safety. Albert Sadacca, a Spanish immi-
grant who claimed to have been the true inventor of the battery-oper-
ated, eight-socket string, said that he had been inspired by a 1917
newspaper report about a terrible Christmas blaze in a New York
City apartment started by tree candles. His new lights were fireproof!
By 1918, Sadacca reported, the sets were being demonstrated at
Macy's, where they helped to overcome initial customer resistance to
the hazards of anything electrical.[45] Artificial trees were also adver-
tised as a safer, more responsible alternative to the fresh-cut ever-
green. First produced in Germany but later manufactured in the
United States when World War I stopped the flow of imports, the
artificial tree addressed the concerns of fire marshals and conserva-
tionists alike. In the 1890s, German trees made from green-dyed
goose feathers attached to wire branches wrapped around a wooden

dowel trunk were all the rage. First used exclusively by immigrants, who brought them from Europe and frugally kept them for years, early feather trees varied in height from several inches to six feet or more. Many had branches finished off with red artificial berries or beads, which doubled as candle holders.[46] Widely separated branches kept the candles from scorching the feathers and invited the lavish use of hanging ornaments.[47] Feather trees didn't shed needles on the carpet. And best of all, once purchased they were always ready to use, without the annual trip to the tree lot.

In the late nineteenth century, whether the tree of choice had feathers or needles, several fashions in Christmas tree decor came and went in rapid succession. During the 1880s and 1890s, it was the "gaudy tree," laden with multicolored ornaments of paper and glass, frosted with angel hair and tinsel, and sometimes lit with electric bulbs. From 1900 up to World War I, in reaction to the excesses of the Victorian tree, austerity reigned. Smart young moderns put up "white trees" *au naturel,* decorated with a well-chosen handful of cotton snow, silvered pine cones, and glass icicles. Some families, in an effort to keep up with the trendy Joneses, even washed the paint and lacquer off their old ornaments and bought festoons of the clear lights only recently displaced by colored ones.[48] Through all the changes in decor and wiring, however, the quasi-permanent artificial tree continued to gain in popularity. Shortages of live trees had become so acute in New York City and other big cities in the first decade of the century that a spate of editorials urged people of good sense to buy the ersatz ones, which had been heavily promoted since 1901.[49]

In 1991, according to industry figures, fake trees outsold their natural counterparts in the United States for the first time, and continue to do so today—largely as a result of new fashion trends.[50] The balance began to tip markedly in the direction of the artificial tree in the 1950s. After several decades of privation and drab uniformity, color—bright, unnatural shades—assumed enormous importance in all sorts of consumer products, from cars to cake mixes. The style in Christmas trees reflected the dominant trend in the fifties toward de-

liberate artificiality, new materials, hot pastels, and tactile surfaces.[51] The chubby "bottle-brush" Christmas tree in pink or white nylon, the glow-in-the-dark tree, and trees of lucite or tinted plastic all flourished in this atmosphere.[52] In 1956, teen idol Elvis Presley decorated his new Memphis ranch house for the holidays with a white nylon plug-in tree that came with the red ornaments and twinkle lights already glued in place—and a revolving base that played Christmas carols. A Frostee-Glow artificial pine, the Presley tree was also available in minty green or shocking pink.[53] Elvis's 1957 Christmas tree in the dining room of the just-purchased Graceland was the same kind, but a much larger model, as befitted the scale of a rock 'n' roll mansion.[54]

In the 1950s and 1960s, the object was to display a tree that barely alluded to the anatomy of the genuine article. Artificial trees were pink or purple, or made of shredded aluminum or spun glass fibers.[55] Real trees, wherever possible, were sprayed with artificial snow or dipped in vats of wax-based compounds to preserve the needles and "improve" the natural color. Dipped trees could be tinted silver, just like the new aluminum ones.[56] Flocked trees—and there were do-it-yourself flocking kits powered by the vacuum cleaner—came in winter white, a range of pinks, and a deep blue.[57] Without a close-up inspection, proud owners chortled, it was impossible to tell a treated tree from the unreal thing.

Customer surveys conducted by tree farmers found buyers remarkably clear about their reasons for favoring artificial trees. For one thing, buyers liked the fire-retardant properties of the vinyl and metal trees; during the 1970s, Connecticut actually banned natural trees under provisions of the state fire safety code, directing national attention to issues of flammability.[58] A poll taken by Michigan State University in 1975 on behalf of the state's Christmas Tree Association found a mounting interest in artificial trees on the grounds of safety, one-time-only expense, and ecological responsibility. But the majority of respondents who preferred manufactured trees liked the fact that they weren't messy. No more needles on the floor! No more rusty tree holders, dripping water on the carpet! No sap congealed on

the woodwork! Though 57 percent decried the fact that fake trees looked fake, an astonishing 39 percent liked 'em that way because, thanks to the wonders of mass production, their shape was always perfect.[59]

Americans, in other words, wanted a kind of semiotic inventory of the signs of nature and Christmas tree-ness, without the cumbersome realities of the great outdoors. In the postmodern 1990s, top-of-the-line artificial trees by Barcana, Mountain King, and the National Tree Company copied the appearance of the Douglas fir, the Ponderosa pine, and other cultivated trees in PVC (polyvinyl chloride) versions that looked, and in some cases smelled, exactly like their prototypes. The difference was that the "real-look" models came already wired for lights, perfectly calibrated to the ceiling height of the average family room, and ready to stand up like oversize umbrellas, simply by snapping the hinged branches into position. They also came in a box, via UPS, in some instances with a written 50-year warrantee.[60]

Under the artificial Christmas tree of the 1990s, if the couple who owned it were middle-aged and middle-class, there was likely to be a village of light-up ceramic houses made by Department 56. According to impressionistic company research on the millions of consumers who buy its products, fully half are men. And half of all collectors of these villages are under age 45, with annual incomes ranging from $35,000 to $75,000. They are not, as a skeptical market analyst once claimed, a coven of "fat old ladies from Milwaukee" with time on their hands.[61] Despite ups and downs—this is a seasonal business, and one deeply affected both by the secondary market and by dealers' tendencies to hoard inventory—Department 56 (once a small division or department of a larger Minnesota floral chain) was a publicly traded corporation with a $134 million profit in 1996. Since roughly 60 percent of established village collectors bought additional pieces in 1996, and new items were introduced every year, the company looked forward to continued prosperity. "I am proud of the growing role our products play in the holiday traditions of millions of families," wrote the chairman of the Department 56 board.[62]

Houses and shops from the Original Snow Village set by Department 56®.

The Department 56 holiday tradition was a relatively new one, however. "On a holiday outing many years ago," corporate legend holds, "a group of friends planned to enjoy Christmas dinner at a small country inn located in a quiet little town on the St. Croix River. The journey to the inn was delightful, as everyone recalled childhood memories and family traditions. While the group drove merrily through the snow-covered countryside they passed by frosty farm-land, peaceful churches, bustling shops, and warm, bright houses. . . . An idea occurred that night to re-create the charming little village and the feeling it inspired, scaling it down so that it could exist for everyone, everywhere."[63] In 1976, a member of the expedition had four such buildings designed by a family friend. Six more followed in 1977.[64] Thus the "Original Snow Village" series began. Every year, there was a handful of new houses, churches, and stores. Beginning in 1979, there were annual "retirements" of older models, a practice which created an aura of exclusivity and collectibility around the buildings.[65]

The reasons why Americans collect Christmas villages are proba-bly as numerous as the collectors themselves. But one powerful in-ducement is the notion of rarity, the idea that you own, if not exactly a one-of-a-kind item, then something that exists in quantities lim-ited enough to arouse the envy of fellow aficionados. So might mon-archs and potentates have viewed their Leonardos: to possess an ob-ject of value is, somehow, to be a person of value.[66] Furthermore, even if the hypothetical worth of a ceramic collectible will never be recovered by the average seller, the lighted house seems to be a pru-dent investment as well as a recreational hobby. The practice of "re-tiring" a given part of the series by destroying the mold so future castings cannot be made has become a key element in the success of Department 56, which currently controls 75 percent of the lucrative market for Christmas villages and accessories.[67]

The notion of producing the items as a part of a larger group is also seductive: who can resist completing a set and bringing the project to closure? The fact that the final composition of the set is never re-vealed—how many Snow Village buildings will there finally be?—

means, of course, that true closure will never be achieved. The buyer is hooked for life. And the new collector is encouraged to believe that, even if the older models are all spoken for, there will be enough new ones to make a satisfactory village. For the object of the collecting, the clubs, the annual conventions, the Web sites, the magazines, and the Department 56 jewelry for hard-core fans is the creation of a village. Or, if not a whole village, then a "vignette," a tabletop fragment thereof.[68]

One in three Americans collects something, and Christmas decorations are among the most popular items because, for many people, Christmas is the best time of the year. Like the founders of Department 56, driving merrily through the St. Croix valley, they remember the happiness associated with snow and Christmas and times long past. Even if they never lived there, they remember the villages on Christmas cards, Jimmy Stewart running through the streets of Bedford Falls, places that exist only in the nostalgic realms of memory, imagination, and longing. Simpler times. "There is nothing like coming home from a hectic day at the office, turning on the village, and just watching all the little houses light up," says a Virginia executive who collects pieces from Department 56. "Little people stand around in peace and harmony, and you say, 'Boy, things are pretty peaceful there.' You can spend hours just gazing at the scene, imagining yourself as being there."[69]

Christmas is a time when utter perfection seems within human reach: family members come home again, gifts bring joy to both donor and recipient, and goodwill pours from every lighted window. The imaginary village scene could almost be real. The village lets the collector refashion this world according to his own wishes, remake her memories of the Christmases that should have been. The Virginia executive, the Olympic ice-skater, the part-time talk-show hostess, and the other Christmas village collectors who have discussed their experiences publicly stress the magical ability to control reality or to create a fantasy that does it one better.[70] Children like dollhouses and model railroad layouts for the same reason: during playtime, little people can be in charge of things that grownups gen-

erally run. On a grander scale, Walt Disney built the lovely Victorian Main Street at Disneyland to re-create his boyhood memories of Marceline, Missouri.[71] The fantasy scenes of the Snow Village work in just this way.

Although it is the largest, Department 56 is by no means the only producer of Christmas villages. Several major retailers, seeking to eliminate the middleman, introduced their own, cheaper versions in the early 1990s. The Emporium, in San Francisco, created an eight-piece adobe village, the "Pueblo Encantado." The Target Stores introduced a Bedford Falls Village based on the 1940 film classic, *It's a Wonderful Life.* Kmart sold seven different models of an ideal village, at $29.95 each, complete. Customers came to expect villages in discount stores at the holidays, "like lights or garland," said a spokesman for Kmart.[72] Mervyn's of California's collectible replicas of mission churches were sold wherever the chain added stores.[73] Enesco, a Department 56 competitor in the ceramic giftware business, supplemented its Precious Moments figurines of big-eyed waifs with Sugar Town, a frosty-white village in which they apparently reside at Christmastime.[74] Coca-Cola, for which Department 56 had made a limited edition bottling plant as part of a corporate partnership program, augmented its own line of brand-name collectibles in 1992, with a Coca-Cola Town Square collection. By 1997, twenty-three of the first thirty-one buildings had been retired, enhancing the exclusivity factor, although the Coke houses sold at roughly one-third the cost of the average Snow Village unit.[75]

The proliferation of ceramic villages was a function of fashion and the American habit of producing desirable commodities in every conceivable price range, until the market is thoroughly saturated. Under the pressure of mounting competition, Department 56 added new villages of its own to appeal to the buyer whose image of the perfect Christmas was not predicated on the small-town architecture of eastern Minnesota. New bisque pieces in the Heritage Village Collection included New England scenes, an Alpine village, Christmas in the City (based on New York), the North Pole (where, according to nineteenth-century illustrator Thomas Nast, Santa Claus made his

home), the manger in Bethlehem, and the Dickens Village. This last collection, unveiled in 1984, included artificial smoke that rose from the chimneys when the electric lights heated the roofs and a subset of structures directly related to the dramatis personae of Charles Dickens's *A Christmas Carol*.

Other pieces based on the Dickens novels had less appeal to collectors, who had no intention of plowing through *Nicholas Nickleby* to find out why a given character had lent his name to a barn or a boarding house. Thanks to old movies on television, however, *A Christmas Carol* had become an American holiday standard. And each piece in that series came with a miniature storybook (in a "leather-like cover") recounting the designer's ideas about "what might have happened to Scrooge and the Cratchit family after the ending of the Dickens classic tale."[76] Like the sentimentalists of Dickens's own day who wanted solid assurances that Scrooge truly repented and Tiny Tim lived to a ripe old age, Department 56 collectors wanted their money's worth of happy endings. They also needed some tangible connection between themselves and the 1843 English Christmas story. Department 56 obliged by bringing Dickens's descendants to collectors' conventions to sign houses in the series and by adding supplemental figures to the village, showing the author giving a dramatic reading of his Christmas ghost story on an American tour in 1867.[77]

Whether the scene represents the England of Charles Dickens, the missions of Old California, or some cozy, generic place on a snowy evening, the village is the constant in the equation: a coherent collection of miniature buildings, lit from within, with figures and accessories just a fraction too large to fit comfortably within their fictive surroundings. The awkward scale of the choristers and sledders alerts the observer to the make-believe character of the locale. This is a toy village, requiring a childlike leap of faith on the part of the visitor— not a real place reduced in size.[78] The lyrics to the popular Christmas song *Santa Claus Is Comin' to Town*, written in 1932, describe "a toy-land town / All around the Christmas tree" which could be a Department 56 product.[79] But the song also shows that Department 56

did not invent the Christmas village in 1976. Instead, the modern lighted village draws upon an older tradition connecting clusters of little houses with Christmas and the family Christmas tree.

There were indeed Christmas villages before there were Snow Villages. Folklorists have traced the miniature representation of some scene in nature, whether imaginary or real, to the German Moravian sect of Pennsylvania. Beginning in the later part of the eighteenth century, they constructed a distinctive "putz" or decoration around the Christmas tree both in churches and in private residences. This usually took the form of an elaborate landscape with animals, which may or may not have alluded to the creatures in the stable at Bethlehem or the passengers on Noah's Ark. Carved pairs of Noah's animals were already a popular toy for children at this date, but the typical putz went beyond the limits of any biblical scene into pure, exuberant genre. Descriptions of putzes observed in Pennsylvania in 1867 mention tiny flour mills operated by hidden machinery, a miller whose pipe actually smoked, and mechanical dogs that jumped and barked, all situated in a natural landscape fashioned of moss, with running waterfalls and looking-glass lakes.[80] After 1850, organized putz parties moved from one house to another "to see the Christmas Exhibition" of room-sized displays, which had taken on a competitive edge, as one amateur architect vied with another to produce the most breathtaking show.[81]

As magazines and illustrated papers proliferated in the late nineteenth century, customs like the putz came to the attention of a national audience for the first time. The Christmas number of *Harper's Young People* for 1885 gave the reader a guided tour of the typical Moravian putz, constructed on a bed of seasonal evergreens, with a flowing stream of real water dancing in "fountain jets."[82] In 1906 *Leslie's* discussed the work of an old Moravian, a master builder whose display, augmented from year to year, now included an electric train and a sawmill operated by the water-power of the ambient stream, in addition to a Nativity scene.[83] An illustration of a typical putz, published in *St. Nicholas* in 1902, shows a snow-covered mountainside beneath the Christmas tree, punctuated with alpine

A Moravian "putz," Bethlehem, Pennsylvania, 1902. *St. Nicholas* (December 1902), 153.

huts and schlosses, a church, trees, and domestic animals, all sub-divided by a series of running fences, made in small, manageable sections.[84]

For reasons that are not entirely clear today, fencing was fre-quently set up around the base of the nineteenth-century Christmas tree. The earliest American representation of a decorated tree, a sketch of a Pennsylvania table-tree by John Lewis Krimmel dated to 1812 or 1819, puts a picket fence around the trunk of the tree, pen-ning in what seem to be figures of people and animals, including a man on horseback, and thus creating a "Christmas yard."[85] Such "yards," sometimes crammed with Christmas toys, sometimes the site of a city of substantial toy buildings, are common in photo-graphs of fin-de-siècle Christmas interiors. By 1891, ready-made lengths of cast-iron fencing for Christmas trees were being adver-tised in the *Ladies' Home Journal*.[86] The function of the fence re-mains a mystery, however: perhaps, like an altar railing in a church, it served to separate zones of greater and lesser potency, or to define the space properly belonging to the Christmas festivities.

"Christmas City," the cardboard cottages to go inside the fenced compound, could be constructed by children, following directions in the magazines.[87] But more common was the so-called "Christmas garden," a fancy under-the-tree scene made by adults that might represent a circus, an Indian encampment, a log cabin in a forest, a winter skating scene. "A little garden or farm at the foot of the tree, such as has been described as fabricated out of paper, furnishes the children much amusement," wrote the editor of a journal that rec-ommended doing family projects for the holidays. "A fence cut like palings out of paper . . . will furnish to a child an amount of gratification utterly inexplicable to the grown-up mind."[88]

It is tempting to regard such scenes as further secularized versions of the Moravian putz. In actuality, however, the putz, the yard, and the garden all seem to be descended from a common European root: many Old World cultures, particularly in Poland and the German-speaking countries of Central and Western Europe, incorporated vil-lages of small, handmade buildings into their holiday decorations in

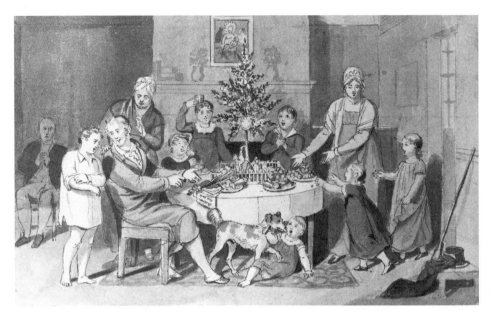

J. L. Krimmel made this picture of a Christmas tree among the Pennsylvania Germans in 1812 or 1819; the table-tree—then a rarity in the United States—is surrounded by a fence and a scene: a "putz." The Winterthur Library, Joseph Downs Collection of Manuscripts and Printed Ephemera.

the 1700s, creating a kind of microcosm of the world in which the celebrants lived. The miniaturized village, in which buildings could be manipulated and appearances improved at will, answered the need for individual empowerment while reinforcing a fixed set of social and geographic relationships between one family and another. Sometimes called Christmas gardens in their translation to the New World, these towns existed in a magical preserve under the tree only so long as the holiday lasted.[89] The patented fences of tin, wood, wicker, feathers, and wire that surrounded the gardens designated them as special, quasi-sacred places, even when they did not contain a depiction of the birth of Christ.

Some toy collectors argue that the emergence of the electric train as the gift of choice in the 1940s and 1950s helped to integrate the European Christmas garden into American life: the same families that used to build gardens now constructed train layouts under the

tree, with operating milk-can loaders, lumber cars, and other apparatus that mimicked the mechanical wonders of the Moravian putz.[90] And so the American village, until the advent of Department 56, became an accessory to the animation and movement of the toy train. In true American fashion, in other words, the new electrical marvel overshadowed the old, European tradition.

On the other hand, from the 1890s onward the manufacture and importation of fencing (illuminated electric fencing was advertised by Noma in the mid-1920s), cardboard buildings, and tiny trees never abated; indeed, the majority of such products were introduced in the 1920s and 1930s as holiday decorations, pure and simple.[91] And the buildings, mostly made in Japan, were too small to serve as satisfactory props for most electric trains. Instead, these hollow cardboard buildings, dusted in reflective mica dust or covered in silk floss, with colored cellophane pasted over the openings for windows and doors, were fashioned to take advantage of the ongoing shift from candles to electric lights. Light bulbs inserted through holes in the bottoms or backs of the buildings created the illusion of a village aglow in the darkness of a snowy night. Sold in sets by Sears and Ward's, the groupings of contemporary structures—gas stations, movie theaters, banks, the telephone company—sometimes came already glued to a cardboard base and surrounded by fencing, which further minimized their usefulness as scenery for passing trains.[92] What the popularity of these decorations implies is the ongoing importance of Christmas village-making, with or without the addition of a working railroad.

In 1907, the year the Ives Company trademarked the term "toy railroads" to include the scenery—before the electric train was much more than a novelty item—national attention came to rest on Carl A. Loeffler, a Washington bureaucrat whose hobby was the construction of an ever-more-elaborate Christmas village made of scavenged odds and ends: tin cans, typewriter ribbon boxes, cigar boxes, umbrella ribs, and pasteboard scraps.[93] On a moss-covered platform in the dining room which also supported his Christmas tree (and hid a welter of water pipes and storage batteries), Loeffler built a Swiss vil-

lage with all the usual appurtenances of waterfalls and working mills. But the people and animals in this toy town moved about on an endless chain buried in the greenery. The village had been modernized with electric lights that shone in every window and sputtering arc lights on the streetcorners. A newfangled motor car, also operated on current, ran around the village on a loop. And in tribute, perhaps, to the turn-of-the-century World's Fairs at Chicago, St. Louis, and Buffalo, there was an appended amusement park with a Ferris wheel, a whirling merry-go-round, and an exotic dancer from "The Streets of Cairo" tantalizingly hidden in her tent.

At night, when the overhead fixtures were turned out and the tree lights turned on, "a soft radiance of moonlight [fell] over the darkened village." As the silvery glow enveloped the scene, lights winked on in the houses "and from the little church on the hill pealed the deep tones of an organ. The whole . . . effect . . . is a charming demonstration of what an amateur, unaided, may accomplish with the crudest materials, given an inventive talent, artistic sense, and patient labor."[94] On a smaller scale, to be sure, Loeffler was an Edison or a Ford, an American tinkerer with a better idea. But, like other American village-makers of the nineteenth and twentieth centuries, he was giving vent to the same aesthetic aspirations that moved the window decorators and the department store display teams who transformed the empty spaces on the eighth or ninth floor into Christmas villages where Santa Claus greeted his little friends.[95]

Without the Loefflers and the other Rube Goldbergs of the holiday season, Christmas could be considered a strictly female institution, centered on shopping, cooking, wrapping, sewing, and a thousand other tasks conventionally associated with women and the domestic sphere. Martha Stewart's ubiquitous handbooks of holiday decorating assume that the craftsperson is a woman more apt to wield a glue gun and a pastry tube than a chainsaw.[96] But greens, lights, and villages add a slight masculine scent to the proceedings. While the ever-capable Martha Stewart could wrestle any recalcitrant tree into its stand without turning a hair, jobs involving heavy lifting, electricity, and construction—on however small a scale—have been

seen as men's work; even if the artificial tree snaps open with the touch of a button, even if the lights are welded in place and ready to go, that is "his" job.

The outdoor lighting displays concocted in the first ring suburbs of the 1950s were, almost without exception, do-it-yourself projects for Dads. Only the simplest kinds of plug-and-glow decorations are the handiwork of women, who are more apt to supply expertise on the placement and costuming of figures, while their husbands test the circuits.[97] Ever since President Coolidge threw the switch on the first National Christmas Tree on the South Lawn of the White House in 1923, men have been flipping switches, annoying the neighbors with megawatt exhibits of elves and reindeer, and making the night hideous with amplified Christmas carols.[98] But, as history and Department 56 research both indicate, they have also taken the lead in the collection, arrangement, and display of village scenes, even when such environments are firmly disassociated from the electric trains of every boy's postwar dream.

With time and changes in the national vision of proper gender roles, the lines between "his" Christmas work and "hers" are beginning to blur. Maria Cassano of Staten Island, New York, was raised in an Italian-American household where the tree was replaced by a "prescipio," a Mediterranean putz or crèche swollen to monstrous proportions by the addition of fences, lighted houses, duck ponds, and the rest.[99] Built in 1928 by Maria's father, the display was fleshed out every year with new figures, more sophisticated wiring, angels cut out of old Christmas cards, and stars made from the silver foil lining on the caps of milk bottles. After her father died in 1976, the prescipio went into the basement and the Baby Jesus disappeared, presumed forever lost. In 1981, however, Maria unpacked the boxes, revived the tradition herself, and eventually found the infant. What began as man's work is now his daughter's annual task.[100] Or, as is the case with buyers of lighted ceramic villages, gender is no longer an important issue, except to those who market Christmasware to a cohort of middle-class collectors evenly split between men and women.

What, in the end, do the villages mean to their owners? Is this just another baby-boomer hobby dedicated to suspending time and staving off the ravages of old age by buying back the nostalgic trappings of childhood—in this case, a better version of the old Christmas train layout?[101] Is it an obsession? An escape into a fantasy world of snug houses and pretty communities nestled peacefully in the snow, with nary a care: no potholes, no taxes, no crime in the streets? Do collectors harbor an unnatural need to make things whole, to have it all, to control their lives and their dreams? Are they reformed mall-aholics, now determined to shop purposefully with the canny skill of a hunter in pursuit of game?[102] It may be that they find an unaccountable joy in tiny things, a reminder of the tenderness and fragility of life, and the swift passage of time—the fundamental mystery of Christmas itself.[103]

Sometimes, it's hard to decide where the Christmas village ends and the decoration of the tree begins. An eight-part, floss-covered, cardboard village pictured in the 1931 Sears, Roebuck catalog was suitable, according to the copy, for a variety of uses. When equipped with internal lights, "the village len[t] a real Christmas atmosphere," whether used in conjunction with an electric train or spread out under the tree. Alternatively, the individual houses could be employed as boxes for candy and other small gifts, or "perched among the branches" of the Christmas tree, like conventional ornaments.[104] One of the earliest forms of manufactured tree ornament was the so-called candy container or favor—a hollow construction of cardboard, stiff paper, cotton, or papier-mâché used to hold the store-bought candies, nuts, raisins, and other sweetmeats that were highly favored gifts, especially for children, during the nineteenth century (when the Christmas tree was sometimes called "the sugar tree" because of the quantity of treats dangling from the branches).[105] Although they came in a variety of shapes, including Santas, musical instruments, and cunning replicas of household objects, squared-off buildings proved an ideal form for candy containers which, when empty, did double duty as toys and as ornaments for next year's Christmas tree.[106]

Made by cottage workers near the German cities of Dresden and Leipzig between 1880 and 1910, Dresden ornaments—three-dimensional figural containers made from sheets of damp cardboard that were stamped and embossed and then often finished off with gilding or silver leaf—were the most distinctive of the lot. They were also among the most expensive. An ad for Dresdens in *Ehrich's Fashion Quarterly* in the winter of 1882 lists large gold angels selling for as much as 12 cents apiece wholesale, a prohibitive price for the average wage-earner of the day.[107] As a result, Dresdens were purchased almost exclusively by wealthy families on the East Coast with ready access to foreign imports, while elsewhere in the country, ornaments tended to be homemade affairs.

Candy containers stitched and glued around the kitchen table took the form of cornucopias or bags, decorated with tinsel rope, paper lace, and pictures cut from old postcards and scraps. The embossed, die-cut, chromolithographed pictures known as scraps also came from Germany, until high tariffs on fancy "German paper" cut the supply in 1905. At 3 to 15 cents for a large sheet containing many pictures, scraps touched off the vogue for the Victorian scrapbook. Purchased by amateurs and manufacturers alike, the sentimental images of angel heads, rosy-cheeked children, flowers, and Santas featured on scraps dominated the iconography of American Christmas ornaments after 1870.[108]

By 1887, however, paper ornaments had become so popular that the modish *Ladies' Home Journal* felt compelled to reject them: "Have no paper articles on the tree except receptacles meant to hold something, such as . . . baskets and cornucopias. . . . [The] time wasted over chains, gondolas, and tinsel ornaments in recent years has been something to contemplate," thundered the tastemakers, just as Americans were turning to the new glass ornaments. Cheaper than Dresdens, prettier than paper, and requiring no gluing or cutting on the part of the lady of the house, glass ornaments had been seen occasionally before 1880. *Harper's Bazaar* in 1869 described a tree adorned with "globes, fruits, and flowers of colored glass."[109] These ornaments, in all likelihood, came from the German

town of Lauscha, in the Thuringian Forest, where the kinds of objects now known as Christmas ornaments were invented. An ancient glassblowing center, Lauscha began, early in the nineteenth century, to produce reflective panorama balls or "witches' balls" for window and garden decorations. The first recorded order for smaller, Christmas-tree versions of these thick-walled "kugels," silvered on the inside with compounds of zinc or lead, dates from 1848. And, although kugel means "ball," relatively early examples of the type took on precisely the shapes noted by *Harper's Bazaar*, including mushrooms (a German good luck symbol), clusters of grapes, and acorns.

Kugels were factory products, made in a glass kiln.[110] But the thin-walled balls and mold-blown ornaments imported to the United States in large quantities in the 1880s were made in peasants' cottages, with whole families engaged in the year-round enterprise. In factories where a new Lauscha gas works, built in 1867, provided a hotter, adjustable flame, craftsmen formed molten glass into long tubes. The tubes became the basis for the cottage industry that produced the familiar Christmas-tree "jewels." Fathers and daughters heated the tubes and blew them into fragile globes or horns or reindeer. Mothers and sons silvered the ornaments on the inside and painted them on the outside.[111] Grandparents and young children carefully toted cardboard boxes of the finished wares—twelve to a box—to the Lauscha train station, for shipment to the United States.[112]

On the dock at the other end waited F. W. Woolworth, the dime-store magnate whose fortune was based on Lauscha ornaments, sold one at a time over the counters of his first store. In the autumn of 1880, Woolworth called on a Philadelphia importer, looking for cheap Christmas toys. Instead, he was shown "a lot of colored glass ornaments the likes of which I had never seen before." He couldn't sell them, said Woolworth. Nobody would know what they were. They were sure to be smashed in transit. But the importer told the merchant that the profit was large enough to offset the breakage and, to seal the deal, guaranteed that Woolworth would sell $25 worth, or he'd get his money back. "The goods arrived a few days before Christ-

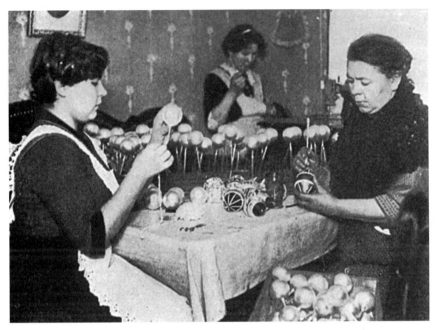

German ornament-making was a cottage industry: the mother paints the balls and the daughters finish them. *Leslie's Weekly* (December 18, 1913), 606.

mas," Woolworth later remembered, "and, with a great deal of indifference, I put them on my counters. In two days they were all gone, and I woke up. . . . The next Christmas season I was on hand with what I considered a large order, but it was not large enough. They proved to be the best sellers in my store for the holidays."[113] Woolworth made his fortune—by some estimates, $25 million—on these German Christmas ornaments from Lauscha.

Later, aiming to eliminate the middleman by contracting directly with the producers for toys and ornaments, Woolworth went to Lauscha, where the scenery was fine but the working conditions in the ornament trade were appalling. "They are made by the very poorest class there is in Europe and we were obliged to go into their dirty hovels to see what we could use," he observed in his travel diary. "One place we went into we found a man and a woman in one room with six small children, the youngest not over eight years old, and

both the man and the woman hard at work. It was the dirtiest and worst smelling place I was ever in, but they seemed happy in their filth and dirt."[114] In Leipzig, and at the other Christkindl markets of Germany and Austria, Woolworth encountered variations on the Lauscha theme: blown-glass figures of cops, tramps, clowns, and angels for the tree, all delicate as moonbeams.[115]

In the United States, this home craft was transferred to the factory and the range of shapes and colors drastically reduced. During the 1939 Christmas season, and the cessation of trade with Germany, Woolworth's established an American ornament business overnight by ordering a quarter of a million streamlined versions of the Lauscha type from Corning Glass—the kind of silvery glass "jewels" Americans meant when they spoke of Christmas ornaments. Using modern machinery, Corning was able to turn out more pieces in a minute than an entire Lauscha family could make in a twelve-hour day.[116] With clear glass "blanks"—mainly plain glass spheres—purchased from Corning, Max Eckardt launched the Shiny Brite ornament line, which suffered when wartime shortages mandated that the balls could no longer be silvered. At the end of World War II, however, many of the traditional centers for glass ornaments, including Lauscha, disappeared behind the Iron Curtain, which gave a needed boost to the struggling domestic industry. Harry H. Heim emerged as the largest maker of hand-blown ornaments. Beginning with twelve blowers making 3,000 blanks a day, his company turned out 60 million ornaments in 1948, at plants in California and Maryland. The variety was not great. Heim pieces came in four simple shapes: the ball, the lemon, the lantern, or the teardrop. In boxes of a dozen assorted ornaments, five were always red and four blue. One was green, one gold, and only one silver.[117]

In the late 1940s and early 1950s Max Eckardt was sent to West Germany to reestablish an ornament trade under provisions of the Marshall Plan, but Americans, accustomed now to less fragile home-grown ornaments sold by the dozen at low prices, balked at the old system of buying one costly ornament at a time and hoping that it would survive the trip home from the store intact. And there the

matter rested until 1983, when Christopher Radko, a 22-year-old aspiring talent agent, accidentally destroyed his parents' collection of almost two thousand vintage ornaments by putting their tree in a new deluxe holder that suddenly crashed to the floor in a shower of broken glass.[118] "Chris has ruined Christmas!" his grandmother told the relatives. "What will we do?"[119] Everything was gone: garlands of glass railroad cars, Santas, hot-air balloons with tinsel gondolas, Dresden dolls—hand-blown, hand-painted pieces from Poland and Germany and Czechoslovakia that had, in some cases, been in the Radko family for four generations. All that remained were the memories of a little boy of five or six, lying under the bottom branches of the tree, and looking up in wonder at the globes and the figures and the stars "all reflecting each other. Our new colored lights would twinkle and blink while my grandmother's Nomas and Paramounts merrily bubbled away. With just a quick whiff of our tree's fresh pine scent, I would drift away on a celestial cloud of holiday fantasy."[120]

Without those ornaments of his childhood, "it seemed that the door that linked me and my family to the memories of Christmases past had slammed shut," he said.[121] So Radko began an urgent quest to find replacements and found instead, on a trip to visit distant cousins in Poland, a glassblower who agreed to make a few ornaments from his sketches. By this date, in the mid-1980s, Polish glass workers had been collectivized for decades, churning out utilitarian tumblers, vases, and stemware. But, as friends in New York snapped up Radko's replacement ornaments and begged for more, the possibility of reviving Christmas crafts in the emerging republics of Eastern Europe began to make sense. By the end of his second year in business, Radko had sold $75,000 worth of ornaments in his spare time and was ready to quit the talent agency.

In Poland, just north of Bohemia, where Radko found his first collaborator, glass ornaments were a late addition to native Christmas trees: Poles still identify the ornaments sold in Krakow's new Christmas outlets as American creations, in fact. But descendants of one of Poland's most prolific producers of the 1930s were able to find his hand-carved molds, which became the foundation of Radko's busi-

ness. He struck similar deals in the Czech town of Jablonec—where molds for the glass garlands on the Radko tree were rediscovered—in Italy, and in Germany (using "lost" Lauscha molds).[122]

Although the earliest Radko Heirloom Ornaments were just that, replicas and adaptations of much-loved family heirlooms, the thrust of the business has been toward larger and larger ornaments, or "jumbos," almost a foot in height, depicting Disney characters, movie stars, Barbie dolls, and brand-name mascots: the icons of American abundance. Since show business personalities were among the first collectors of Radko's pricey ornaments—they range, roughly, from $19 to $125 each—perhaps the current trajectory of the business is understandable. The pieces are relentlessly upscale, in any case, sold at carefully selected "Starlight" dealers and in the catalogs of Saks, Bloomingdale's, and Neiman Marcus.[123]

Christopher Radko became the darling of the talk-show and home-shopping circuits, and his success has spawned a strong rival enterprise in Kurt S. Adler's Polonaise Collection from Czestochowa, Poland. In addition to the Campbell's soup cans, the Pillsbury doughboys, and the Coca-Cola train sets, many of the oversize Polonaise ornaments are topical in nature: a seven-inch replica of the Titanic, drawing on the popularity of the movie of the same name, appeared in time for Christmas, 1998. And, to appeal to American buying habits, many Polonaise ornaments come in themed sets, at a slight discount, packed in small wooden crates. Sets in 1998 included characters from the recently re-released films *The Wizard of Oz* and *Gone with the Wind*, but there are also groupings based on ethnicity (a British bus, barrister, bobby, and phone booth) and special interests. Like the manufacturers of ceramic villages, Polonaise appeals directly to the collectible market, with promises to break the mold and "retire" the ornament when a production run is completed.[124]

Topical ornaments are nothing new, of course: Charlie Chaplin, Mary Pickford, Harold Lloyd, and Queen Victoria's Prince Albert were all popular subjects for European glassblowers in their day.[125] Nor are the prices much higher, in constant dollars, than those of Wool-

worth's first imports. Theme trees have been around for a long time, too. And American entrepreneurs have been catering to contradictory desires for an old-fashioned but thoroughly modern Christmas since the middle of the nineteenth century. What is different today is the self-conscious determination to outdo the Victorians, to gild the lily—or the artificial evergreen—so thickly that it is no longer an object to be contemplated in its own right but rather a holiday mirror, reflecting back the heart's desire for security, plenitude, and peace. To create a Christmas that makes beautiful memories, which can be worked out in advance, given an ample store of lights, greens, and collectibles.

WINDOW SHOPPING

Department Store Displays, Santalands, and Macy's Big Parade

As the title scrolls across the screen, an old gentleman with a snowy white beard marches purposefully through the streets of New York, headed for Central Park and the Macy's Thanksgiving Day parade, the official start of the Christmas shopping season. Just as the floats and the giant balloons are about to come into view, he stops short before a nondescript gift shop. Inside the plate glass window, a clerk struggles to position a miniature herd of top-heavy reindeer on a field of artificial snow—and is doing a very bad job of it, according to the passing critic. "You're making a mistake!" he cries. "You've got Cupid where Blitzen should be!" So begins *Miracle on 34th Street* (1947), one of Hollywood's best-loved Christmas movies.[1]

This scene does not appear in the novella by Valentine Davies from which the film was adapted. In the book, Kris Kringle's further adventures as Macy's Santa Claus are introduced by a chapter showing poor Kris—who really believes he's Santa—about to be evicted from a cozy retirement home because of his delusion. Around the holidays, the erstwhile "Santa Claus" grows worse; he is given to sharp outbursts of temper when he reads the Christmas ads in the newspaper. One store offers to relieve customers of the "irksome necessity of Christmas shopping" if they will simply provide a list of recipients

and their ages. "Is this what Christmas has degenerated into?" Kris thunders. "It's pure commercialism! Is there no true Christmas spirit left in the world?"[2]

In the end, however, both the book and the film explore the nature of the commercial Christmas celebrated in America ever since the 1820s, when the first recorded holiday decorations—evergreens, flowers, and "patriotic emblems"—appeared in the window of a New York City shop. *Miracle on 34th Street* is about a specific kind of mercantile, department-store Christmas, predicated on decorated windows, parades, and rent-a-Santas in false whiskers. By telling weary mothers in line with their children at Macy's how to find the gift of Junior's dreams at Gimbel's, Kris contrives to bring the rival department stores together in the spirit of the season (thereby increasing profits for both). But the brief episode in which Edmund Gwenn, as Kris Kringle, urges the clerk to rearrange the decorations in the store window is particularly telling because it underlines the importance of the Christmas show window—the commercial display under glass—to the traditional observance of the holiday.[3]

Like the movie itself, the window display is a framed, visual narrative, a kind of entertainment. Attractive by reason of its remove from the sullied world outside the glass pane, the tableau in the window constitutes a utopian place, meant for distanced contemplation. Even if Kris wanted to, he couldn't become a participant in the snow scene he observes. We can look at the plaster reindeer, and wonder about them, but they are as inaccessible to us as Edmund Gwenn, in the home video version of *Miracle on 34th Street,* framed by the TV set and glassed in by the surface of the picture tube.[4]

The physical inaccessibility of the show window and its contents was a perennial theme of Christmas fiction, in stories that regarded the window as the locus of a social transaction from which many had been excluded.[5] An 1858 Christmas offering in *Godey's* states the premise in its simplest form: show windows (as well as the windows of private houses decorated for the season) afford the poor a cruel glimpse of pleasures they can never hope to attain. "Oh! Isn't it fine in there?" exclaims a starving little boy, as he leans over a railing on

a cold, snowy night to watch a children's Christmas party in progress.[6] A newsboy living in a packing crate in an 1874 story cannot hope for presents from Santa—only for the fun of "lookin' in the shop windles seein' the Chrismus trees an' things."[7] A wealthy girl, taken by a fairy to visit the streets of the city on Christmas Eve, spies a group of children looking in the window of a toy store: "Wistful little faces they had and their clothes told Anna they must get their fun out of just looking. Farther on, in front of the candy store, huddled another shabby crowd, gazing at the sparkling goodies."[8]

There was no surer way to create pathos in a turn-of-the-century Christmas story than to describe the great city on a chilly night, its lighted windows "decked with Christmas greenery and displaying small Santa Clauses laden with tempting gifts," while orphans cowered in the snow, staring at things they could not possess.[9] An illustrated story in *Harper's Young People* in 1884 finds two penniless waifs shivering before a store window, wishing for enough money to buy their mother a warm shawl. The show window held "everything . . . to delight a child's fancy and make it seem unlikely that Santa Claus's palace could contain anything more wonderful—great woolly dogs, horses, and tin express wagons, dolls dressed like babies, which not only opened and shut their eyes, but, if you held them in the right position, said Papa and Mama . . . [and] a great heavy black shawl, which you might have supposed had been put there as a background for the rest, if it had not had a pricemark."[10]

The show window arouses desire by denying the passerby physical access to what the eye can see: it tantalizes the person on the outside of the glass, looking in. And so the Christmas window was an excellent retail tool for selling shawls and toys. The aura of exclusion (or exclusivity) projected by displays behind glass panels was as real as the painful stories about poor children looking at dolls and wagons suggested. But, for those middle-class shoppers with the means to buy the merchandise or the imagination to think themselves into the tableaux, the glass pane was also a great source of pleasure. Some country children in a *St. Nicholas* story, for example, visit the village stores a couple of days before Christmas expressly to see the

toys and the trees on display, to point out "the things they most admired," and to wonder "what Santa Claus would bring them."[11] The pleasures of anticipation are enhanced by the items in the window. For the same reason, a would-be Santa relishes the sight of "shoppers hurrying home with their hands full of parcels, and their eyes still turning to the bright show-windows."[12] A father with a Christmas bonus jingling in his pocket stops on the way home every night for two weeks to "look into the store windows and gloat over the presents he was going to buy" for his children.[13]

But the sheer amusement value of store windows was just as important, with their vivid lights, miniaturized scenes, and moving, mechanical devices: the spectator did not need to want the objects inside—or to look forward to giving or receiving them—in order to enjoy Macy's wondrous windows of the 1880s. In another magazine story from that decade, a child raised in England talks her indulgent uncle into taking her to see the Christmas windows along Broadway and 14th Street: "Julie had never known anything so fine in London and when she came to Macy's, and saw the spectacle there, she almost danced with delight."[14]

Window glass was an impenetrable social barrier between the affluent, who shopped in stores like Macy's, and the poor, who made do with open stalls in the streets. In New York City, uptown was a glamorous panorama of glass and downtown a warren of crude stalls.[15] The temporary stalls or booths set up for the Christmas trade were makeshift, roofless versions of the great stores fronting the nearby sidewalks, and they were an endless source of fascination for writers and artists. A view of toy vendors' stalls along 14th Street published in *Frank Leslie's Illustrated Newspaper* in 1885 shows the sidewalks thronged with "fakirs" hawking mechanical chickens, tin horns, fur wraps for dolls, and mistletoe to the passing crowd.[16] Although some booths are decorated with flags, tree ornaments, or dolls suspended by their necks like dead poultry, the emphasis falls squarely on the merchandise—and the bargains to be had. The picturesque sidewalk salesmen, with their line of beguiling patter and their inexpensive gimcracks, catered to working people, hurrying

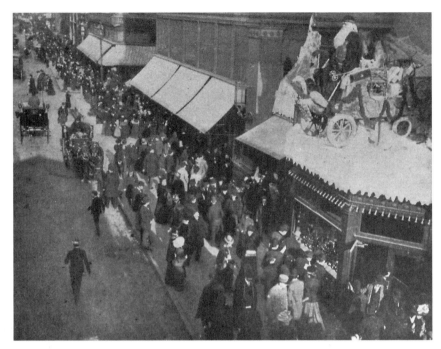

Outdoor displays in New York's shopping streets in 1903 included Santa in an automobile atop the marquee of a department store. *Leslie's Weekly* (December 24, 1903), 620.

home for a bleak holiday. "But for these street vendors of cheap wares many children of the poor in the big city would have a less joyful Christmas," wrote one defender of this largely unregulated sidewalk commerce.[17]

By contrast, the window displays aimed at uptown shoppers subordinated merchandise to visual drama. Photographs of Christmas shopping in New York published in the early years of the century show giant Santas perched atop department store marquees and windows so packed with toys as to create the impression of a "fairyland," in which no single item for purchase could be distinguished from all the rest.[18] The notion that Christmas windows were something more than mere displays of articles for sale goes back to the 1820s and 1830s, when New Yorkers made the circuit of toy and candy shops on December 24th to admire the gaslights, the festoons

of drapery, and the evergreens visible in the front windows. "As the Holiday season approaches an unusual variety of tempting wares have been . . . arranged in the show windows of the brilliant shops of Broadway," noted the *New York Evening Post* in 1839.[19]

Yet the trend, even at this early date, edged away from the "wares" and toward the sheer delight afforded by color, movement, and novelty. In the 1840s, Philadelphia stores had begun to put Kris Kringles in their windows; Boston stores welcomed Santa in the 1870s, with the addition of carriages, sleds, and a bevy of "stuffed re-in-deers."[20] In New York in 1872, crowds gathered in front of the L. P. Tibbals toy store to watch the steam trains and other mechanical toys puff, and twitch, and dance in circles.[21] The elegant Lord & Tay-

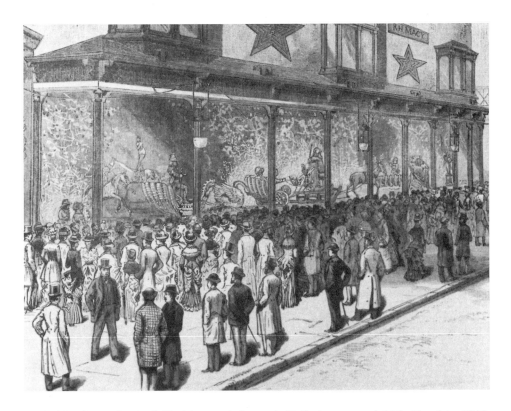

R. H. Macy's mechanized Christmas windows at Sixth Avenue and 14th Street in 1884: "A Holiday Spectacle." *Frank Leslie's Illustrated Newspaper* (December 20, 1884), 284.

Enjoying the Christmas doll windows at Macy's, 1886. *Harper's Young People* (December 21, 1886), 121.

lor was noted for its annual display of garlands and trees as early as 1874.[22] Meanwhile, Macy's had become "one of the 'institutions' of the season," famed for its Christmas display of dolls in the bank of enormous show windows at the corner of Sixth Avenue and 14th Street, next to the main entrance.

Although the dolls in the window were available for purchase, that was not the point. The enjoyment came from seeing dolls set up in tableaux or scenes, as if they were tiny people. In 1874, the theme was a "doll's croquet party," assembled from $10,000 worth of imported dolls attired in the latest European fashions. In 1876, in honor of the national centennial year, the nicest dolls wore colonial costumes. In 1878, the elevated railroad outside Macy's was forced to erect a muslin barrier on the staircase leading to the 14th Street

platform because so many people perched there to get a better look at that year's popular "Pinafore" windows, based on the Gilbert and Sullivan operetta.[23] In 1883, for the first time, Macy's added steam power to make the dollies march on a moving belt.

Perhaps because of its size and longevity, Macy's has always received the lion's share of credit for the scenic Christmas window. But illustrated reports on Manhattan doll windows in children's magazines of the 1880s make it clear that Macy's was not the sole creator of the Lilliputian scenes that captivated adults and children alike. Shoppers pressed their noses to the windows by daylight, as they made their rounds of the stores. The preferred hour for viewing, however, came just after dinner, when the streets were dark, the scenes were illuminated by gas jets, and the illusion of life was enhanced by the flickering play of light and shadow over the dolls. Thus the anonymous writer who described a series of 1881 doll windows for the readers of *Harper's Young People* found it easy to forget that the figures had stuffed bodies and heads made of wax or porcelain, as they enacted a variety of curbside dramas: a diligent milkmaid of the Colonial era at work; a circus; a reception at the Doge's palace; the beach on a summer day; and "Charity," with a golden-haired girl-doll in boots and furs giving alms to a barefoot boy-doll, dressed in rags, who has just swept the snow from her front steps.[24]

A writer representing herself as a wise old aunt inventoried the best of the 1883 windows for the same journal, beginning with a grand Santa window—"the ground white and shining with snow, and . . . the reindeer as large as life, just ready to prance, and the big house in the distance where St. Nicholas lives." But more intriguing than any Santa were the tableaux or "magnificent pictures" made out of dolls by New York's shopkeepers. Brides and grooms. Sailors bound for sea. Schools. Old ladies. Families on the way to church. Millionaires departing for Europe. "It was just like seeing a storybook come to life to walk along Broadway or the Avenues. The whole of Mother Goose, the best part of the fairy tales, and the most entertaining things which ever happen to grown-up people, were exhibited in dramas with dolls for actors."[25]

Dolls were the Christmas gift of choice for the girls of the Victorian era. The baby doll was a means of preparing a little girl for her maternal duties in later life. But most dolls were not babies. They were adult or preadolescent figures, with extensive wardrobes of furs, muffs, and bonnets. As such, they were companions for the girls who played with them, friends who shared the child's interest in new clothes and in the varied circumstances of life represented in the Christmas windows. While children came to see the dolls in Macy's windows on 14th Street, however, pictures of the crowds on the sidewalk reveal that grown men and women were in the majority, drawn to an environment in which the illusion of life created in miniature by dolls was more appealing, somehow, than the real thing.[26] Dolls were subject to human control in a way that living people, spouses and children, could not be. Thanks to clockwork mechanisms and steam power, dolls could be made to behave perfectly and predictably, over and over again. They were both profoundly modern and magical.

Macy's moving windows of the 1880s—built with the assistance of the Eden Musée, a wax museum on 23rd Street famous for its chess-playing automaton—tapped the modern interest in the machine, the tireless doppelgänger that walked and cried "Mama" even when its human counterpart had faltered.[27] With the figures in motion now, the Macy's window graduated from sedate storytelling to eye-popping grand opera. "From far and near, the rich and poor, the young and old, representing all classes and conditions in life, throng around the spacious windows and gaze in wonder and delight, upon the brilliant and attractive spectacle. . . . Mechanical skill, the costumer's taste, and the poet's fancy, have all combined to produce a panorama of exceeding beauty, variety, and brilliancy," *Leslie's* gushed in 1884. The illustration pictured hundreds of adults surging forward to see an endless circuit of parade floats gliding through the windows, wafting across their field of vision like a scene from a motion picture that had yet to be invented, with Santa and his reindeer there in the thick of it.[28]

Other stores countered with dolls picnicking at an ersatz Niagara

Falls that recirculated real water, scenes from the story of Cinderella, and a church (constructed entirely of folded lace handkerchiefs) in a snowy landscape.[29] The press also heralded a window containing a toboggan slide said to have been designed by a "well-known artist" after the model of the ice palace at Montreal's Winter Carnival. So realistic was this display that the same dolls who dashed down the incline at breakneck speed seemed to pant and struggle to pull their sleds up the cardboard hill again.[30] Macy's struck back in 1889 with *Uncle Tom's Cabin:* an Eliza doll fled fuzzy bloodhounds from window to window, all the way down 14th Street.[31]

As late as 1909, manuals for window trimmers were still recommending displays predicated on the old principle of cramming as much merchandise as possible into every available inch of space.[32] At Chicago (1893), St. Louis (1904), and the other great world's fairs of the day, show cases were routinely filled to bursting with manufactured goods; agricultural products like apples, oranges, and nuts were marshaled to form giant display sculptures—a life-size *Discovery of the Falls of the Mississippi* made entirely of butter appeared in St. Louis, for example—that celebrated profusion and abundance.[33] But the story-format window, evolved from the exhibition of massed ranks of Christmas dolls for sale, represented a break with the old retail practice of using show windows chiefly to maximize profits. Sheer quantity of merchandise, like handkerchiefs or kettles, became less impressive than the quality of a given experience.

L. Frank Baum, future author of *The Wonderful Wizard of Oz,* began his writing career as the author of a treatise on store window decorating and the editor of a Chicago-based journal for professional trimmers. Although Macy's and other East Coast department stores had already begun to use mechanized displays almost twenty years before Baum took up the subject, he was a staunch advocate of machinery and motion. "People are naturally curious," Baum wrote. "They will always stop to examine any thing that moves and will enjoy . . . wondering how the effect has been maintained."[34] In his own case, the clockwork mannequins who followed Dorothy down the Yel-

This design for a Christmas window, circa 1906, features a Santa's workshop with plenty of room for the display of toys. *The Art of Decorating Show Windows and Interiors* (Chicago: The Merchants Record Co., 1906–1909), 178.

low Brick Road to Oz translated the art of window decorating into high drama. And that drama—the wonder, delight, and curiosity about how the snowflakes sparkled and the reindeer pranced—generated goodwill, more valuable to the merchant than the proceeds of any specific sale. Windows, after all, had made Macy's a civic institution. "It is advertising when Macy's fills his windows with a wonderful, costly, unsalable Christmas pageant," noted an analyst of department store strategy in 1900.[35] But the window was also an indispensable ingredient in the urban holiday season, a Christmas present to the passerby.

Christmas windows did not disappear with the turning of the century. Instead, many of the same conventions that Macy's and its competitors developed in the nineteenth century have persisted almost unchanged into the twenty-first, as a part of a "traditional" American observance of Christmas. Today's adults remember big family trips to downtowns all across the country when they were kids, excursions organized around the ceremonial unveiling of store windows, usually on the night before Thanksgiving, or on the holiday

itself, after the dinner dishes were cleared away. Mayors gave speeches. Bands played. Celebrities waved to the crowd. The children held their breath, as the red velvet curtains finally parted.

In Memphis, it was Gerber's Department Store, with four unforgettable windows: a Santa, a toyland complete with electric train sets, a scene showing a family eating a turkey dinner, and the finale, with everybody in pajamas, opening presents on Christmas morning. In Cleveland, it was the windows at Higbee's and the May Company, on Public Square. In Chicago, it was Marshall Field, where, sometime in the 1950s, an animated rendition of Clement Moore's "A Visit from St. Nicholas" seemed even better than the shows on the new TV set at home. In Scranton, the Globe Store had four windows full of busy elves, painting and sewing away in Santa's Workshop. In tiny Sterling, Illinois, Sears and the Wynn-Deaver store tried to outdo each other for the most elaborate displays.[36] A magazine story published in 1910 describes a little girl's important holiday errands. "I had to stop and look at 'The Night Before Christmas' in Hartmann's window," she tells her friends. "That window made me late at school three times last week!"[37] A half-century later, the same kinds of windows were still creating happy memories for children who wanted toy robots and portable television sets for Christmas.

In Minneapolis, a consortium of downtown businesses sponsored an annual "Lights on Downtown" or light-up night, traditionally held on Thanksgiving Eve. The Christmas lights in the shopping district were switched on for the first time at 5:30, just as darkness fell, and the animated store windows were set in motion. An endless stream of cars inched forward along Nicollet Avenue, the families inside straining to catch a glimpse of a jolly Santa patting his tummy or a circus animal balancing on a ball. The largest department store in the upper Midwest, Dayton's was the focus of attention. Every year, the store mounted a giant Christmas tree on the twelfth floor parapet and adorned its Nicollet Avenue facade, between 7th and 8th Streets, with a variety of swags, messages, and figures picked out in electric lights and evergreens.[38] But, as one business writer observed in 1966, Dayton's was best known for windows, for "the lavishness

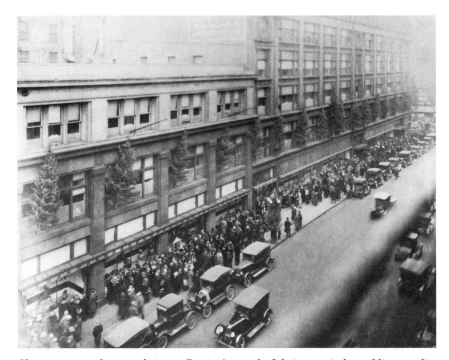

Christmas crowds struggle to see Dayton's wonderful circus windows, Minneapolis, 1923. Minnesota Historical Society.

and imagination of Yuletide display, especially the elaborate block-long display of window scenes."[39]

The tradition went back to 1920. That year, E. R. Dean joined Dayton's as its new display manager, after a decade in the window trimming departments at Marshall Field in Chicago and Kline's of St. Louis. Although the store had only been in business under the Dayton name since 1903, management had a strong sense of obligation to the community: in practice, this meant making sure that Minnesotans enjoyed every form of uplift and entertainment that big-city department stores elsewhere were bestowing upon their more cosmopolitan clientele.[40] Dean was imported specifically to bring Dayton's Christmas windows into the modern age.

In 1920, Dean became the first to use several Dayton's windows to form a coherent story. In 1921, he introduced Dayton's first me-

chanical cutout displays, a dozen gesticulating scenes from *The Rubaiyat* of Omar Khayyam, each in its own window.[41] In 1922, in the corner window on 8th Street usually reserved for Christmas toys, he installed a life-size mechanical elephant that wagged its tail, heaved its sides, and rolled its trunk. For the next thirty years, the sidewalks in front of Dayton's windows were choked with spectators, from Thanksgiving until the day after Christmas, when the curtains fell and the animated figures were promptly packed away. Dean's retirement, in 1950, was a momentous event in retail circles, one that marked the passing of an era. "Ed Dean has developed mechanical manipulation of displays to the point where display men from all over the country have come to see and learn and want to buy his ideas," a competitor told *Women's Wear Daily*.[42]

During the Dean regime, each year's offering outdid the wonders of the previous Christmas, as pirates and circus acts, Alice in Wonderland, mechanical monkeys, "'Twas the Night Before Christmas" char-

Mechanical Christmas windows with a circus theme, Dayton's Department Store, 1922–23. Dayton's.

acters, Robin Hood, Mother Goose, and television's Kukla, Fran, and Ollie all cavorted through Dayton's windows. In December of 1928, the company newsletter chastised employees who had not yet spent a lunch hour or two looking at the "toy windows" on Nicollet Avenue. "Sometimes we wonder if the decorators will ever run out of ideas, but no—each year surpasses the one before. It was Dolls this year, . . . one to represent almost every country in the world."[43] A local columnist, entranced by the "block-long, store window merriment" of the 1950 puppet windows, thanked Dayton's for the annual dose of free holiday spirit. "I refuse to believe it's all commercial," the hometown booster asserted. "To me, the holly, the tinsel, the multi-colored lights and ornaments, the Christmas trees, are still magic. Nobody deserves to be grown up in December."[44]

Thus far, the Minneapolis windows had always dealt with secular themes, geared to the interests of children and families. In 1952, in response to a customer's request for at least one Nativity window, Dayton's articulated a previously unspoken policy governing the use of Christmas iconography in what was still, despite its broader civic function, a commercial setting. The spokesman for the store drew a sharp distinction between "the religious side and the festive side of Christmas." The former included mangers and church bells. "On the other side"—the store window side—"there are Santa Claus, Christmas trees and sleigh bells."[45] That same Christmas season, perhaps emboldened by its own separation of the sacred from the secular realm, Dayton's broke with a precedent of almost fifty years and allowed the row of fourteen animated fairy-tale windows at the downtown store to be powered up on Sundays. For the time being, the building remained closed that day, no Dayton's ads appeared in the newspapers, and no employee was required to travel on business. But the windows, which had previously been darkened and curtained in observance of the Sabbath, were ablaze with color and motion.[46]

Competition was one important reason for the corporate change of heart. Nearby department stores were earning praise for their windows and in-store decorations. Dayton's executives prowled the pre-

mises, looking for ways to keep the competitive advantage over the neighboring Donaldson's store, which bought its smart new window materials ready-made from the Silvestri Art Manufacturing Company in Chicago.[47] Costs soared in the postwar period, too. Window groupings, once discarded after a season's usage, were recycled to perk up the toy department and the approach to Santaland, through an Enchanted Forest of second-hand mechanical snowmen or Babars.[48] Meanwhile, suburban shops and malls were changing the role of the old downtown stores: the Dayton family built Southdale, the first enclosed shopping mall in the nation, in a Minneapolis suburb in 1956. If the ultimate objective was to sell the Christmas items that amounted to 40 percent of Dayton's annual profits, did it still make sense to lure suburban families downtown on the night before Thanksgiving, when the store was closed, and to invite them to drive slowly past the lighted windows without ever stepping inside the front door?[49] In the 1950s and 1960s, Dayton's began to reassess its heavy investment in show windows.

While windows remained a large part of Dayton's Christmas strategy (the $30,395 spent in 1965 amounted to almost half of the total budget for Christmas trimming at the company's flagship venue), the lion's share of expenditures after 1965 went for displays that would bring potential customers into the store proper and require them to pass through a number of active sales floors.[50] The Dickens Village— "Dickens' London Towne"—set up in the eighth floor auditorium in 1966 cost as much as a ten-year run of holiday windows. But it generated traffic in the store during a bad retail slump and drew national attention to the canny showmanship of Dayton's display department. According to *Business Week*, 30,000 people, inspired by the hoopla, trooped through the store on the day after Thanksgiving to take a look for themselves.[51] During opening week, 110,000 visitors filed through the village. Thereafter, the average approached 20,000 a day, with waits of two to three hours not uncommon.[52] Dignitaries from England were invited to cut the ribbon at the opening gala.[53] Anchorman Peter Jennings acknowledged the excitement in a segment for the ABC network news, just before Christmas.[54]

The *Christian Science Monitor* saw the Dickens Village as the bell-wether of a growing movement in the trade: "Parents in the Midwest still take their children downtown to the big department stores at Christmas. But the trend is toward more elaborate displays than Santa and his sleigh. Stores are spending small fortunes to achieve holiday effects."[55] Famous-Barr in St. Louis, for instance, had marked the season with a full-scale Victorian home, constructed inside the store, with gingerbread scents wafting from the kitchen. But the Minneapolis extravaganza took the prize for cost. At $250,000, it was widely credited with being "the most ambitious Christmas [display] ever undertaken by a retail store."[56] There were 34 buildings, 25 separate scenes, and 150 characters, three-fourths life size, most of them animated.[57]

Joseph Wright, director of store presentation at Dayton's, had begun preparations for the new undertaking in 1964, with field trips to London to consult with scholars and collectors, examine original illustrations for Dickens's books, and purchase props.[58] The exteriors were constructed at Dayton's, but other details were farmed out to a variety of property masters, set decorators, and professional display makers around the country. The hollow papier-mâché figures, for instance, were made by Tommy Rowland in her Staten Island workshop, with the assistance of a crew of fourteen New York neighbors who modeled the rubber faces and painted shadows and highlights on the stiffened cloth costumes. Rowland and her company had worked for Dayton's before, on window tableaux illustrating "A Recipe for a Merry Christmas" (1961) and "The Twelve Days of Christmas" (1956)—and she did not come cheap.[59] Her preliminary bill for the Dickens furniture alone was more than $48,000; the cost of the Fezziwig group of fifteen figures (including the work of animator John Grice, who made nine of them dance) amounted to $4,500.[60]

London Towne was a walk-through, occupying 12,000 square feet of space. Without the pane of plate glass between viewer and scene, the audience was allowed to wander into the pictorial contents of a show window, walking down generic English streets and peering inside theatrical sets where moving automatons enacted Christmasy

A larger version of the Christmas village or the "putz," "Dickens' London Towne" was enormously popular in the 1960s. Dayton's.

scenes from the works of Charles Dickens. To complete the illusion of having stepped through the glass into the window, a dozen live actors in period costume also strolled the streets of the village, dispensing Pickwickian cheer and performing as jugglers and mimes.[61] While the scale was one-quarter smaller than real life, these were not under-the-tree buildings by any means. The model seems to have been the theme park, invented by Walt Disney in 1955, in which the architecture was scaled down just enough to make adults feel as if they were pleasurably in command of their environment—or the feeling enjoyed by children playing with dollhouses and electric train layouts.[62] For, although children were welcome, Dickens' London Towne was Christmas treat for grownups.

Rather than being pitched at children, the theme presupposed an extensive and sophisticated knowledge of the works of Charles Dick-

ens. The ideal viewer, therefore, was also the ideal customer: educated, affluent, and old enough to own a Dayton's charge card. The printed program listed the books and stories depicted by each scene in the village setting. Although *David Copperfield, A Christmas Carol, Oliver Twist,* and other schoolroom classics were included, so were more difficult, unfamiliar books, such as *Bleak House* and *Martin Chuzzlewit.*[63] Nor did the program, with its brief descriptions of the characters depicted, make many concessions to ignorance. On the contrary, fidelity to the texts and authenticity of period decor were noted with some pride. The Christmas tree in the final scene, for example, was no generic symbol of the holiday but an artifact painstakingly "recreated from Dickens' own description in the short story, *The Christmas Tree.*"[64]

The move to adult content in Christmas decor had been anticipated by some of the window themes of the decade, most notably the 1963 "Ogden Nash Nutcracker Suite Narrative" at the St. Paul branch store.[65] But with the increased numbers of animated units, the larger displays, and the longer periods of planning and execution needed to withstand adult scrutiny came Dayton's decision to hold the Dickens village over for another year or two: it was simply too costly to scrap after a single season. The second-year souvenir program aimed to alleviate traffic problems by allowing visitors to choose among several routes of passage through what was now called "Dickens' London Towne '67."[66] Greater numbers of guides in costume mingled with the guests. And more of the shops now offered cookies, candy, and inexpensive gifts for sale, turning a passive experience with nineteenth-century London into a personal, immediate encounter. The changes prolonged the useful life of the village, as the designer had hoped. Perhaps his stated wish "not . . . to talk down to the public," not to present "just animated figures," also helped to keep interest in the Dickens display strong. Only when the fire marshal declared the sets too desiccated for further use was the village finally broken up in 1969, after being cannibalized for parts and valuable antiques.[67]

Walk-throughs became the focal point of Dayton's Christmas pro-

gram after 1966. While some of the displays of the 1970s, like the Baltimore-built sets duplicating sections of Disneyland, were pure entertainment (with strong merchandise tie-ins to the Mickey industry), others had loftier ambitions.[68] In 1974, at the beginning of the national bicentennial celebration, Dayton's made a return to the spirit of the past, using the works of the self-taught painter Grandma Moses to reassert what management felt were values basic to the American Midwest in an idyllic, communal era, before the advent of television and the mass media. 300,000 people attended the show, in which ten Moses paintings—including the famous *White Christmas,* on loan from the songwriter Irving Berlin—were reproduced in three dimensions by a scenic artist from the Guthrie Theatre. Posters of the paintings were sold, and originals supplied by a New York gallery were on display for potential buyers. "We felt people were ready to embrace some of those values again . . . and our old-fashioned Christmas appealed to every age," said an executive delighted with the public's response. [69]

In this instance, and in later auditorium displays based on the original artwork from children's books by Dr. Seuss, Maurice Sendak, and Tomi De Paola, the department store served as a vital cultural institution, a showcase for art with a strong appeal to the general public—but art rarely, if ever, welcomed within the precincts of Minnesota's legitimate art museums. Dayton's understood that its customers did not scoff at nostalgia and make-believe as grounds for appreciating a work of art. The store's use of coordinated windows, shopping bags, graphics, and ad campaigns served as models for local museums, in fact, when they began to market exhibitions in the 1970s using these same techniques, often in partnership with Dayton's, its competitors, and its subsidiaries.

Art historians have recently rediscovered interludes of window-trimming in the careers of Andy Warhol, Salvador Dali, Jasper Johns, and a host of other "legitimate" artists who decorated show windows for Tiffany's, Bonwit Teller, and other prestigious New York stores.[70] But the cross-pollination between commercial design and the fine arts is more than a sometime thing or a topic for passing no-

tice in the biography of a "great" artist. It happened routinely behind the transparent shields of holiday windows in New York, Chicago, Minneapolis, Dallas—and Sterling, Illinois. The Christmas window, or its indoor equivalent, was art for people who didn't necessarily go to museums—grownups with children in tow, the well-off and the stereotypical freezing waif, her nose pressed to the cold, hard glass. The window was art, with all its sensory charms intact, art that was constructed of equal parts color and texture, sight and invitation to touch, wonderment and imagination, order, longing, instruction, and intense, fondly remembered pleasure.

The world of the store window was a detailed, self-contained, imaginary place—a counter-reality, something like a train layout. With unabashed nostalgia, collectors of electric trains have set down their earliest memories of the Christmas villages constructed around train sets in the windows of local department stores in the 1940s and 1950s, the golden age of the Lionel engine.[71] Hollywood, too, has used the train in the window as the identifying mark of a family Christmas during the era when today's railroad buffs were growing up.[72] The 1947 movie *The Bishop's Wife* opens with angel Cary Grant on a snowy street corner at Christmas time, inspecting the show windows of the local stores. The camera is positioned inside a series of windows, looking out at the spectators on the pavement through the holiday decorations: a group of angel-mannequins surrounding a Nativity scene (the viewer's first inkling that Grant might be a celestial visitor), and heaps of toys traversed by working electric trains.[73]

Hobbyists recall people of all ages standing five to ten deep at the glass to see similar railroad displays in real life. Beginning in 1904, the makers of Lionel toy trains had supplied special sets to large-volume retailers for use in show windows, with shiny, nickel-plated engines and motors especially adapted to run continuously for ten hours a day with no maintenance.[74] In the 1920s and 1930s, the layouts available to stores were landscaped with mountains and trees and equipped with metal "Lionelville" structures to encourage purchase of those products. In the 1930s and 1940s, professional Lionel

Window shopping in Minneapolis, 1919. *St. Nicholas*
(December 1919), 129.

"demonstrators" fanned out to stores at Christmastime to supervise installation of the fancy layouts.[75]

The long-term effect of these window layouts was to turn the electric train from a seasonal toy into a year-round pastime. But for many children, the train ran at Christmas, for as long as the Christmas tree stood in the living room, and then was put away for another year. The layout was a simple circle of track that ran underneath the branches; the scenery was a building or two, wrapped packages, colored lights, glass balls, and tinsel. For those lying on the carpet, at eye level with the train, the effect was evanescent, powerful, and unforgettable—a little Christmas world, conjured up in the glitter of foil icicles, that was far different from the gritty realism to which the manufacturers of Lionel trains aspired.[76] The layout under the tree was a kind of animated holiday display, the homemade equivalent of the show window at the downtown store. Like the window display, it was a place of beauty and enchantment, to be inhabited only in the imagination and only at Christmas.

Another extension of the window trimmer's art into places without protective panes of glass was Santaland, that perennial annex of the toy department where children come to tell a Santa Claus impersonator what they want for Christmas. Like the animated show window, the long line of youngsters waiting for their moment on Santa's knee is also a staple of Christmas movies. Little Ralphie, the hero of the 1984 movie comedy A Christmas Story, is prodded up an impressive artificial mountain in Higbee's department store in Cleveland toward the icy throne where Santa reigns—and comes swooshing down again almost immediately, on a wooden slide, thanks to a nudge from a muscular elf. In Miracle on 34th Street, Edmund Gwenn is enthroned at Macy's in a similar but less elaborate setting designed to funnel petitioners efficiently toward their goal.[77]

The essayist David Sedaris made his debut on National Public Radio in the early 1990s with "SantaLand Diaries," a satirical piece describing his job as a 33-year-old elf at Macy's flagship store, in Gwenn's former North Pole, where his major duty was to sell photo-

graphs of children sitting on Santa's lap. His description is a hilarious exposé of behind-the-scenes sex, violence, and nervous pee-pee. But SantaLand, he writes, "really is something. It's beautiful, a real wonderland, with ten thousand sparkling lights, false snow, train sets, bridges, decorated trees, mechanical penguins and bears, and really tall candy canes. One enters and travels through a maze . . . to Santa's house. The houses are cozy and intimate, laden with toys. You exit Santa's house and are met with a line of cash registers."[78]

His corrosive treatment of Christmas sales aside, Sedaris provides a remarkably accurate description of the usual setup at a large department store. Working plans for Christmas decor published in display treatises early in the century stressed the usefulness of creating a house or palace for Santa (tricked out in icicles made from cotton batting dipped in a gelatin solution), which could also be used as a setting for showing off dolls and toys.[79] In the toy department, the special "house" set gave a sense of domestic intimacy to the encounter between Santa Claus and the child. The frosting of artificial ice, on the other hand, signified the North Pole and the winter season, but also hinted at the once-a-year abnormality of a holiday when snow moved indoors, Santa suddenly appeared in the stores with his own house and furniture, and, if you were six or seven years old, almost anything could happen.

Sometimes lost in the hoopla over the new windows and other holiday novelties, Dayton's Santaland was always featured as a prominent selling point for the store in the Christmas catalog.[80] The name changed occasionally: at the St. Paul store, the fourth floor was briefly known as Santa's Merryland.[81] Elves and fairy princesses, trees laden with candy ornaments, Enchanted Forest mazes, ride-in trains, animated figures, and assorted Santa relatives came and went. But it was the part of the Christmas store that always left the display department vaguely discontented, perhaps because the crucial elements of Santaland—St. Nick, his house, a chair, a line of overheated children, and a bevy of onlookers to treasure the moment—left little room for radical innovation. At Dayton's, the usual

post-holiday critique of the year's attractions always found plenty of room for improvement in Santa's precinct. Every year, "the children just do not like being herded like cattle while they wait to see Santa." Every year, Santa's palace seemed lacking in "glamour" and other intangibles. And somebody else's maze was prettier or glitterier.[82]

Santaland and its affiliated windows were signs of the season's magic: Bob Hope, playing a streetwise Damon Runyon grifter in *The Lemon Drop Kid* (1951), loses his veneer of cynicism after he sees an animated Santa Claus in a store window. But the proliferation of department store Santas also confirmed the views of jaded shoppers who suspected that the modern Christmas was a humbug, dreamt up by Macy's and Gimbel's. During a flashback to their Alaskan gold-rush days in *Road to Utopia* (1946), Santa speeds past Bing Crosby and Bob Hope as they toil across the snowy tundra. "Say!" Hope wisecracks. "There must be a department store around here!" In the view of some, clever windows and the huckster's tricks that lured the unwary into Santaland were all part of an indecent Christmas Saturnalia created by the big stores. "At the main entrance [the window trimmer] places an effigy of Santa Claus drawn through cotton snowdrifts by reindeer of papier-mâché," complained a journalist determined to unmask the wiles of the greedy merchants.[83] Yet while store windows stirred up irrational desire by framing and glorifying the most homely products, something in the aesthetic of displays under glass—the museum case translated to the streets—was deeply satisfying in its own right.[84]

A 1911 ad for Edison Phonographs captures the appeal of the show window with a picture of shoppers with bundles (and one dawdling delivery boy) gathered at a store window to see the new machine. Cut-outs of Santa on one side of the display and an angel on the other both point at the phonograph. The shoppers, seen only from the back, are mesmerized by what they behold. Because they assume the same position within the ad that the reader takes in looking at the page, there is an immediate identification between the two. We want to join the throng, too, and see what's in the window,

and the crowd parts slightly to show us the merchandise.[85] This is a moment of revelation, an invitation to participate in a minor spectacle of novelty and its pleasures, framed by Santas and angels and Christmas.

The show window remained a popular convention of print advertising throughout the twentieth century, perhaps because it suggested the possibility of community to the reader engaged in the private act of turning the pages. The crowd of window-watchers in a Schrafft's candy ad that appeared in the *Saturday Evening Post* in 1930 pulls back politely to make room for the reader, exposing a display of little Santas and reindeer, decorated trees, and fancy boxes of chocolates.[86] A curtain with fringe and tassels forms a border for the window. Candy stores used such curtains to keep the chocolates from melting when sun struck the windows, but in this case the drapery functions in a theatrical manner, as a frame for the fictive space of the window/stage and as a means of disclosing it. The text of the ad offered musings from etiquette expert Emily Post on the place of candy in the family Christmas celebration. "You see mothers, grandmothers and aunts proffering opened boxes delectably displaying candy of every variety," she observed. So the candy box, with its fancy doilies inside the cover, functions exactly like the show window, as a formal site of display, revelation, and surprise. The window is a Christmas present, unwrapped again every time a spectator steps up to admire the electric train, the jolly Santa, or the box of bonbons.

Windows have been a popular pictorial motif for Christmas cards and wrapping paper, too. Some of the earliest American cards, the exquisite chromolithographs produced by Louis Prang in the 1880s, pictured the stained glass windows of churches aglow in the twilight, and warm candlelight pouring from the windows of cozy homes buried in the snow.[87] Because Christmas is observed during the winter solstice, a light shining forth in the night has both sacred and secular implications for the holiday; store windows designed to be seen to best advantage at night, under artificial illumination, draw upon the

WINDOW SHOPPING

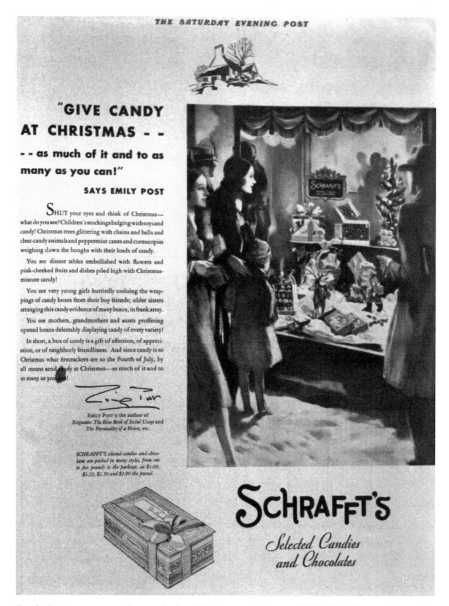

Emily Post recommends candy for Christmas giving in 1930, but the window sells the product: trees, reindeer, elaborate gift boxes. *Saturday Evening Post* (December 20, 1930), 95.

traditional associations of Christmas lights with the theology of epiphany—and with the simple act of coming home in winter's early gloom through a landscape made unfamiliar by snow.

There is a great promise in a light that shines bright in the darkness, great spiritual warmth in its radiance on a cold December night. The poignancy of many nineteenth-century depictions of children denied access to the playthings and sweets in the lovely Christmas windows arises from the fact that they are also being denied the solace and respite implicit in the fall of light across the sidewalk.[88] "How much comfort there is in our cosey [sic] houses alone,—in the clean, warm room, perhaps with a glowing fireside; the white table spread with wholesome and delicate food; the cheerful circle around the lamp at evening; the books, the sewing, the games; the sound sleep of the long, snowy night, in beds as white as the drifts outside; and the many other nameless blessings of a civilized home!" wrote a winter enthusiast in 1876, determined to teach children that cold weather was as rewarding to contemplate as the smiling spring-time.[89]

The snow-bound household celebrated by the poet John Greenleaf Whittier in 1866, and pictured on a card by Prang along with Whittier's poem, is intimate and close. The familiar Christmas-card scene of windows shining forth in a snowy night connects the viewer to Whittier's New England farmhouse or some other companionable place that he or she can only observe from afar, imagine, or remember.[90] Like the store window, the Christmas window scene is a paradox. It stirs up nostalgia for an experience denied, for a state of grace that the viewer may never actually have attained.

Norman Rockwell's "The Christmas Newsstand" of 1941, the *Saturday Evening Post*'s first Christmas cover of World War II, is a classic example of this complex genre. The newsstand is not exactly a Manhattan department store, nor is it a farmhouse in the snow—but it partakes of the conventions of both kinds of window images.[91] The enclosed newsstand was an urban icon. Rockwell found the prototype at the corner of 48th Street and Sixth Avenue where many Manhattanites bought the *Post;* extra copies of the magazine sur-

round the window of the little structure like so many stockings hung at a fireplace. Because he wanted to force the lighting—to experiment with the emotional qualities of light—Rockwell commissioned a model of the building. Then, using colored bulbs and his imagination, he painted the outside light a shivery, dramatic blue and the inside light, in which the proprietor sits, knitting away as her teakettle comes to a boil, a hot, brilliant orange.[92]

The lighting is so blatantly artificial that it conjures up memories of the strings of Mazda lights on the Christmas tree. But the effect is to redouble the sensation of a cold and lonely street versus the warmth of the tiny snuggery adorned with a Christmas wreath, a tissue-paper bell, and a brace of Santas. Although the window discloses a humble place, a private nook for the vendor, the composition creates a palpable sense of longing to be inside with her, out of the cold, safe and warm on a December night. Rockwell, as usual, painted this cover picture in July to meet the magazine's deadline. In early December, the attack on Pearl Harbor began the war for the United States. Rockwell went back, just before publication, and added a Red Cross emblem and a bond appeal to a corner of the window. Even without the extra clues, however, "The Christmas Newsstand" says a great deal about what it is like to go to war, to be far from home, to be out in the cold, all alone.

The opening scenes of the postwar Christmas classic, *Come to the Stable* (1949), take place one cold winter night in a barren, black-and-white landscape as chilly as Rockwell's New York. Two nuns wandering across the snow come upon a signpost pointing toward a town called Bethlehem. Suddenly, they see a light shining a long way off. They follow it to a barn and, peering in the window at the top of a Dutch door, they come face to face with the Nativity. In fact, the *tableau vivant* before their wondering eyes consists of neighbors posing as the Holy Family for Miss Amelia Potts, a well-known painter of religious works. On her easel stands the finished picture, in which Joseph, Mary, and the angels glow with a supernatural radiance against a background of earthly darkness.[93]

Carefully staged for the camera, the sequence emphasizes the rela-

As World War II began, Norman Rockwell contemplated the allure of the lighted
window in a darkened street. *Saturday Evening Post* (December 20, 1941), cover.

tionship between window and work of art. In the frame of the window, the sisters see what appear to be real angels and shepherds—a more compelling vision than anything Miss Potts will ever set down in two dimensions on her framed canvas. The artifice of the painter is no match for the three-dimensional truth of a cow that moos and a rambunctious angel who fusses and teases his brother. The scene also raises questions about the ways in which the various kinds of artifice shown—specifically, figures in the round and flat, painted ones—satisfy the visual appetite. The Nativity that first presents itself to the wandering nuns follows the aesthetic of the department store display: the bulk and movement of the characters on the other side of the window seem as miraculous to Sister Margaret and Sister Scholastica as the parades of moving dolls did to Macy's shoppers in the 1880s. The painting, on the other hand, is given only perfunctory attention. It is no match for a realm in which the contents of the mind's eye seem to spring to life in the frame of the window.

Theme parks, TV specials, and holiday movies have all helped to diminish the allure of the old-fashioned Christmas window. After seeing computer-controlled Nativity groups that twitch and blink their eyes, the sisters in *Come to the Stable* would probably not look twice at Miss Potts's rustic dumb show. More sophisticated versions of the animated Santas and Mickey Mouse figures that used to amaze the crowds that flocked to Thanksgiving window unveilings can now be bought at discount prices for home use. When Santa leaves the store window and goes home with the customer, however, the sense of spectacle is lost. Part of the difference lies in the public nature of the show window; it is a collective Christmas fantasy. But the window also separates audience from attraction: take away the glass wall and the mystery vanishes, along with a necessary sense of otherness, a distance from the object of vision that fosters careful regard. The aesthetic of the show window demands that the mass of ordinary viewers, like the flocks of orphans in Victorian Christmas stories, long to be inside the window, with Santa and the elves, happy and warm forever. But this aesthetic also requires them to suspect that it will never happen.

One of Thomas Nast's lesser-known Christmas illustrations, commissioned by *Harper's* in 1881, is called "The Dear Little Boy That Thought That Christmas Came Oftener."[94] A weeping child stands in front of a shop window on Christmas Day. Toys are still on display, but a wreath has been tossed away in the snow outside. All good things must end—except, perhaps, the Christmas show window. Despite fierce competition from other media and changing retail strategies, windows have survived to become a necessary part of the American holiday tradition. As such, the window is sometimes exempted from the accusations of corruption-by-charge-card that seem to surface every year. Merchants and cultural watchdogs alike claim that "holiday windows have remained an island of non-commercialism," a Christmas gift to everybody from Sony or Barney's or Lord & Taylor. The latter, in 1996, claimed to have hosted eighty-two consecutive years of totally non-commercial windows in New York City. According to the company CEO, preempting merchandise for a display of themed decor—"Songs of Toyland," for example, or the paintings of Norman Rockwell brought to life—took the mercantile curse off his windows. Entertainment for upwards of 300,000 window-watchers was not to be confused with the usual hard sell.[95]

Other sources date the merchandise-free window to November of 1936, when Lord & Taylor startled the city with a series of papier-mâché bells that swung over a winter landscape in perfect synchronization with the music of chimes ringing out over Fifth Avenue.[96] The bell windows—the first sound displays on record—were designed by Albert Bliss, whose firm, by 1950, was producing thousands of department store dioramas and mechanical figures every year. In retrospect, Bliss thought the bell windows (appropriated in 1937 by more than a hundred other stores) were as important for their content as they were for his musical innovation. While he was fabricating the bells, he asked for help in finding a suitable melody. But when a piece of religious music was suggested, Bliss bristled: this was Lord & Taylor, not St. Patrick's Cathedral. "May I refresh your memory as to exactly whose birthday these bells commemorate?" a friend remarked. The sacred music stayed.[97]

Yet for every quasi-religious display ostentatiously proclaiming its innocence of the profit motive—in a memorable 1955 Lord & Taylor window, Mary and Joseph sought shelter beneath the Brooklyn Bridge—Albert Bliss and his fellow decorators churned out armies of Santas, Grinches, and Scrooges. Bliss's biggest account in the 1940s and 1950s was Macy's, where he was responsible for the bank of mechanical windows between Sixth and Seventh Avenues whose luster had been tarnished somewhat by the advent of the store-sponsored Thanksgiving Day parade in 1924. What is sometimes forgotten, however, is the close relationship between Christmas show windows and other forms of public entertainment created under the auspices of the private sector. The Macy's parade, for example, began as a kind of oversized appendage or introduction to its radically updated 75-foot toy window on 34th Street.

In 1924, according to most accounts, R. H. Macy & Co. recruited Tony Sarg to take charge of its holiday program at a time when competition between retailers for the Christmas dollar was especially fierce. Seeking new ways of stretching the Christmas shopping season back into November, Gimbel's of Philadelphia and Hudson's of Detroit both tried parades in 1923: the usual windows were unveiled, and Santa was escorted to his perch in the toy department by a procession of circus acts calculated to draw a family audience.[98] Beginning in June of 1924, Macy's began planning for a similar event, keyed to its customary animated windows. And for that reason, Tony Sarg became the logical choice for pageant-master. The German-born Sarg, who had inherited a large collection of doll houses and tiny furniture from his grandmother, was fascinated by miniatures of all kinds. Resettled in London, he established a studio in the building believed to have been the inspiration for Dickens's *Old Curiosity Shop* and began charging admission to see the rooms.[99] The building became a sort of doll's house in Sarg's hands, with each chamber decorated in a rough approximation of the proper period and named after characters in the book. On the proceeds of his enterprise, Sarg began to make marionettes, moving figures to inhabit the miniature world of his imagination.

In 1915, fleeing the war in Europe, Sarg arrived in New York. With headquarters in the Flatiron Building, he rapidly carved out a career as an illustrator for the *Saturday Evening Post,* a cocktail-bar muralist, and a man about town, every inch the Manhattan sophisticate.[100] Six years after his first appearance in Gotham, he would become the subject of a best-selling biography with appended lessons in puppetry.[101] He launched a puppet troupe that toured the country presenting programs in which "serious" drama, enacted by eighteen-inch actors, was paired with avant-garde stage design, costuming, and effects. Billed as an "artistic genius, creator of the Marionette Theater in America," Sarg also undertook a successful lecture tour in 1923 and 1924, showing how his puppets worked, making "lightning sketches" based on his illustrations, and demonstrating the startling shadow-puppet technique which had finally landed Sarg and his wooden actors on Broadway in December of 1923.[102]

At least one writer has argued that Macy's hired Tony Sarg to assemble its parade and that his puppet show in the giant windows on 34th Street was a happy afterthought.[103] Given his particular areas of interest and expertise, however, the opposite seems to have been the case. Indeed, Sarg and his puppets had taken over Macy's Christmas windows in 1923, a year before the first parade was held. Advance publicity for the Thanksgiving unveiling that year (dubbed the "Christmas Carnival") described a "Mammoth Show—Puppet Parade on March in Wonderland's Window. . . . All the Fairy Legends of Make-Believe Fashioned into an Animate Display That Will Live Forever in the Memories of Childhood."[104] Although Tony Sarg was not mentioned by name, the twenty-six fairy tales represented by the puppets corresponded closely to the contents of his current repertory. The language describes a parade—much like the one Macy's did mount a year later—enacted entirely by animated figures inside the window.[105]

The real parade began in 1924—a circus parade with animals and clowns, which stepped off from 145th Street at 9:00 A.M. on Thanksgiving morning and ended three hours later at the marquee above the 34th Street windows, where Santa Claus, sitting in regal

splendor, raised the curtains on a "Fairy Wonderland" of Mother Goose puppets below.[106] Advertisements for the latter event, viewed by a mixed crowd of 10,000 children and adults, again failed to name Sarg, but included his distinctive drawing of Macy's frontage, Santa, the puppets (performing behind a castle-like false facade applied over the window panes), and a parade float. News articles, quick to credit Sarg with the Mother Goose show in the Wonderland windows, did not comment on the authorship of the corresponding floats and the costumes of the Macy's employees who marched in the parade dressed in matching attire.[107] The trade papers, however, stated categorically that the Mother Goose floats had originated in Macy's display department. Their arrival at the store on Thanksgiving Day was the signal for "starting the big Sarg mechanical parade in the far western part of the 34th Street front." This parade-in-the-window, a miniature version of the other one, had its own little floats, attended by puppet-like pages and retainers, that passed by continuously on a moving belt, while curtains at center stage periodically opened and closed on a fixed mechanical display.[108]

Whoever designed the show as a whole, it was a masterful exercise in the manipulation of scale. Sarg often observed that when the puppeteer emerged at the end of a show to take his bow, the audience was startled because he seemed to be a giant among the little men and women they had come to accept as the norm.[109] At Macy's, the repetition of stories and characters from the windows in the parade proper had something of the same effect: the latter was a "giant" version of the former. Or, as if by enchantment, the tiny world of the window had popped out from behind the glass and taken its place in the real world. Conversely, the windows acquired the magical ability to shrink that world to the scale of the child, or a memory of childhood preserved under glass, like a collection of fragile butterflies' wings. The combination of mirror-image windows with parade was so effective that, in mid-December of 1924, Macy's announced its intention to make the gala an annual event.[110]

In 1925, named in the pre-show publicity for the first time, Tony Sarg continued to illustrate the ads for the Christmas Parade and

served as one of the judges for a photo contest, in which snapshots of the various doings on Broadway and 34th were eligible for cash prizes. He also contributed new windows with one of his favorite puppet-show themes, the "Thousand and One Nights," brought to life by "Marvelous Mechanical Marionettes."[111] Like the windows themselves, at least one float was animated—a 100-foot caterpillar that wriggled down the line of march.[112] But things were about to change even more radically than that.

In 1926, Macy's drew a short-lived distinction between Sarg's "pageant," on view in the windows, and the parade, newly entrusted to Norman Bel Geddes, a flamboyant theatrical and industrial designer then at the start of an illustrious career as a proponent of the streamlined style.[113] There were objections that year to the timing of the show: patriotic societies and religious groups protested the parade's interference with Thanksgiving exercises, and the start was rescheduled for the afternoon to allow for church-going and turkey-eating. Bel Geddes got top billing, but Sarg's "A-B-C Antics," in which puppet-letters of the alphabet acted out children's stories, had been elevated to the status of a time-honored tradition, "the Christmas Spectacle that New York watches and waits for every year."[114] Macy's windows were still what New Yorkers turned out to see.

Bel Geddes's involvement with the Macy's Christmas spectacular ended abruptly, after a single year. In 1927 Tony Sarg was back at the helm, responsible for a new, "panoramic marionette spectacle entitled 'Adventure in the Magic Forest,'" as well as for a parade newly endowed with giant balloon-puppets (a 25-foot dachshund, a 30-foot dinosaur, and a flock of Brobdingnagian turkeys) made of rubber and more conventional floats on which Macy's salesgirls impersonated living puppets.[115] With the advent of the strange, temperamental balloons-on-ropes, the balance tipped again, in favor of the parade. In the late 1920s the city was seized with balloon fever; until the practice was condemned as unsafe, Macy's released the giant balloons at the end of every parade and offered rewards for their recovery, endangering air traffic and sending balloon-hunters tumbling into the East River in the quest for prizes.[116]

Giant Eddie Cantor balloon, in the Macy*s Thanksgiving Day Parade™, circa 1940. Macy's.

Tony Sarg's multi-story balloons created the modern Macy's Thanksgiving Day Parade out of his innovative approach to the design of animated windows and his fascination with scale. Puppet shows were nothing new, even in department stores. During the 1920s, Arnold Constable hired the Sue Hastings marionettes to perform "Peter Rabbit" in the sixth-floor Toyville.[117] Gimbel's, on 32nd and Broadway, also featured the Sue Hastings puppets, along with mechanical animals, a magician, a model railroad layout, and "4 Big Moving Toy Windows."[118] But Sarg successfully translated the puppet show from the theatrical setting to street theater by the simple expedient of reversing the scale change. Miniatures turned into monsters, feeding a modern taste for novelty coupled with extravagant excess. According to Sarg's contract with Macy's, dated September 18, 1928, he would henceforth design everything: costumes, floats, balloons, ads, windows. And everything would match. The window theme would be restated in the parade, and vice versa. Eighteen-inch puppets could just as easily be eighteen feet tall.[119]

In April of 1994, replicas of the old balloons of the 1940s sailed down Central Park West one more time, for the remake of *Miracle on 34th Street*.[120] But in the film, as in real life, Christmas windows were little more than an afterthought. The nationally televised parade defined the day—and the season. In 1959, for the last time, the New York newspapers took note of what Macy's was doing in and around its windows in advance of the annual parade. Out at Bliss Display in Long Island City, fifty-seven artists had worked for nine months on animated scenes of carnivals around the world, at an estimated cost of $100,000. Background flats were painted, and the 3-foot figures that marched and danced were sculpted out of tin. Shockingly, however, the scenes would no longer appear in the old 34th Street windows that were once the talk of the town.

Instead, they were mounted in open, self-contained panels that protruded from the facade at the second-floor level and hung over the sidewalk. Macy's director of window display got the idea, he said, from nineteenth-century peepshows.[121] The elevated stages were

easier to see, and more telegenic. For the first time, with sponsorship from Lionel trains and the Ideal Toy Corporation, all three major networks had decided to broadcast the parade.[122] The bold new scenes, everybody hoped, would show up well on TV. Because, when the cameras focused on old-fashioned store windows, all they saw was a blur of dancing reflections, a shimmer of pretty, colored Christmas lights.

OLDE CHRISTMAS

Dickens, Irving, and
Christmas Charity

I n December 1843, Charles Dickens published *A Christmas Carol.*
The first of his annual Christmas books and stories, the *Carol*
was issued as a neat little gift package, bound in festive, holiday-red
cotton and printed on green paper, with a wreath of holly and ivy
stamped in gold on the front cover, around the title.[1] All six thou-
sand copies of the original edition were gone by January.[2] The book
was a huge success from the start and has remained a Christmas fa-
vorite ever since, the inspiration for stage plays, movies, department-
store decorations, and one memorable Mickey Mouse cartoon.[3]

The issue of when and where the first Christmas tree appeared in
Britain—sometime in the 1840s, probably at Windsor Castle—is still
open to debate: royalty excepted, however, Christmas was a pretty
attenuated affair among his countrymen as Dickens began to write
his seasonal masterpiece, full of holly sprigs, plum puddings, and
prize turkeys.[4] But, because Dickens's story was launched during
the decade of the much-publicized Windsor Castle tree, with a lavish
description of the feasts and games appropriate to the season, he is
often credited with being the poet laureate of the full-blown, modern
Christmas.[5] James Barnett, in his 1954 study of Christmas as a
manifestation of American national culture, observes that many

Americans believed Dickens had actually invented Christmas.[6] "It was Charles Dickens," according to a 1904 holiday story in the *Saturday Evening Post,* "who first taught English-speaking people the meaning of Christmas day. . . . That one thing he did."[7]

Some notable eccentrics demurred from the prevailing opinion. The plangent calls for charity and goodwill were Dickens's own, to be sure. But the rest of the *Carol*—the beguiling sports, the dainties, the customs of Christmas—they argued, were strictly American. Stephen Fiske, a New York literary man, attracted notice in 1900 by charging that Dickens, among whose countrymen December 25th was a minor festival before 1843, had stolen the Christmas described in *A Christmas Carol* from American holiday rituals observed during his 1842 tour of the United States.[8] Fiske based this startling conclusion on a study of Dickens's biography: the writer had never celebrated Christmas until his return from America, Fiske noted, and, except for a brief mention of Christmas Eve in *The Pickwick Papers* (1837), never wrote about it either. Ergo, something must have happened on these shores to make Dickens love Christmas. The problem with the theory was that Dickens sailed for the New World on January 4, 1842, and returned to England the following summer, thereby missing an American Christmas entirely. But "he must have heard of the annual holiday that we inherited from our Dutch ancestors and developed and improved with the greatest of family festivals," Fiske insisted.

Other, wiser critics also revisited Dickens's American Christmas connections late in the nineteenth century. The writer Charles Dudley Warner, speaking at the Brooklyn Institute in 1893, suggested that Dickens might have borrowed his Christmas from Washington Irving's *The Sketch-Book of Geoffrey Crayon, Gent.*, published in book form in England in 1820. "Charles Dickens was his follower," Warner declaimed. "[Irving] was the creator of Christmas literature, in which he drew about that season all the homely joys and loves so dear to childhood and the hearts of all."[9] This was a plausible contention. Dickens and Irving did know each other, and each other's work. Seized by a paroxysm of dread at the prospect of giving a

speech about the British visitor, Irving had famously broken down at a public dinner held in New York in Dickens's honor in 1842.[10] On his second visit to America, in 1867, Charles Dickens made a point of recalling a meeting with Irving in Baltimore, a quarter-century earlier, when the two had passed several tipsy days together, drinking an enormous mint julep sent to their hotel by an unknown admirer. Dickens remembered the late American author for "his delightful fancy and genial humor."[11]

He surely remembered *The Sketch-Book*, too, with its five celebrated chapters describing a Christmas visit by Irving's narrator and alter ego, Geoffrey Crayon, to the venerable Bracebridge Hall, in Yorkshire, England.[12] Although "Rip Van Winkle" and the story of Ichabod Crane ("The Legend of Sleepy Hollow") from the same book are better known today, the Christmas chapters were extravagantly popular on both sides of the Atlantic, from the 1820s through 1900, when they were often extracted from *The Sketch-Book* and published as a separate volume. These little books, with titles like *An Old Fashioned Christmas Eve* or *Old Christmas,* were intended as Christmas presents. Printed on costly stock, they were embellished by some of the leading illustrators of the day—mainly British—including Cecil Aldin, Charles Brock, Arthur Dixon, and Randolph Caldecott.[13]

In their obituary notices of Irving's passing, American journals had begun to make the connection between Dickens's Christmas books of the 1830s and 1840s and Washington Irving's of 1820. On the occasion of Irving's death in 1859, *Harper's* was moved to praise the "breezy heartiness, . . . unsophisticated honesty, . . . [and] cordial reverence for traditions in themselves interesting" in the Christmas sections of *The Sketch-Book*—"the flower and beauty of conservatism." These qualities were to be found nowhere in the corpus of English literature, the article continued, "until long after Irving's words, and then in the Christmas chapters of Pickwick, and generally in the Holiday tales of Dickens."[14] Washington Irving was old Father Christmas himself, and Dickens a mere johnny-come-lately Santa.

There was, from the outset, transatlantic disagreement about the

accuracy of Irving's Christmas passages. Americans seem to have taken the Yorkshire stories for a sort of travelogue and assumed that Christmas in faraway England was just as Irving described it. An 1820 notice of *The Sketch-Book* published in an American journal, for example, treated the chapters on the Christmas revelry at Bracebridge Hall as unadorned reportage. Christmas is "a season, in England, of universal festivity, when family parties never fail to assemble in the old ancestral mansion, to partake of good cheer, and observe the venerable customs of olden times," the reviewer blandly stated.[15] But a British review which appeared in 1821 took quite the opposite approach, chiding the American observer for offering "a compilation from the histories of former times" rather than direct observation. The chapter on the dinner was "*overdone,*" in the English view—"spun out beyond all bounds."[16]

In fact, *The Sketch-Book* was a self-conscious literary creation, in which Irving assumed the pose of a wide-eyed provincial while trying out some of the most fashionable cosmopolitan attitudes of the day. Medievalism was one of them. Among Irving's first stops in Britain was Abottsford, a neo-Gothic castle then being built in the Scottish Highlands by Walter Scott. Scott, who was writing *Rob Roy* during Irving's four-day stay, had already painted a picture of the hearty, Merry England of long ago in his poems and novels.[17] Lacking a chivalric history of their own, Americans were especially susceptible to Scott and the cult of the picturesque, in all its forms. Eventually Washington Irving, when he became a famous author, would take "a little cottage on the banks of the Hudson"—so called in a letter to Dickens—and embellish it with a series of fantastic towers and quaint Ichabod Crane–style Dutch gables to create Sunnyside, the American Abbotsford.[18]

In 1817, however, Irving was still Scott's student, afflicted with the same nostalgic longing for a simpler, kindlier past, before the advent of industrialism, class strife, unchecked competition—and the Declaration of Independence. Scott celebrated a time when "England was merry England, when / Old Christmas brought his sports again."[19] In the sixth canto of *Marmion,* set in those imaginary, by-

gone times, he laid on the yule log, the squire, the plum puddings, the mince pies, the roasted meats, the wassail bowl, the mummers, the masquers, and the ale, or most of the requisite Christmas apparatus that Irving would later pretend to discover, alive and functioning, in Bracebridge Hall.[20] In fact, Irving did his own homework. His notebooks are peppered with extracts from old documents on Christmas, including a 1652 pamphlet entitled "The Vindication of Christmas," written in response to the Puritan injunction against traditional observances of the day. The effect of the ban, wrote the nameless seventeenth-century polemicist, was to bring further misery to the destitute: Christmas dinners were always "the best feasts where the poor are relieved, for the rich can help themselves."[21]

In Irving's account of his Christmas visit to Yorkshire, feasting counted for more than sermons on Christian charity. Granted, the Squire was "a little particular" about sending his household to church on Christmas morning. But most of the rites and rituals observed at Bracebridge Hall were of a purely secular nature, based on custom or Irving's researches. The Squire, according to his son, was "a strenuous advocate for the revival of the old rural games and holiday observances," dredged up through his own antiquarian inquiries.[22] The object of his open-handed Christmas hospitality was to reunite the social classes in common pleasures. "Our old games and local customs . . . had a great effect in making the peasant fond of his home, and the promotion of them by the gentry made him fond of his lord," the senior Bracebridge insisted. "They made the times merrier, and kinder, and better."[23] So, while Irving pretended that the customs in question were being rediscovered in England circa 1819, the revival was actually a pretty fiction. Bracebridge Hall was another Abbotsford, a vivid dream of a society with values superior to those of present-day England.

Bracebridge Hall is a kind of wishful Shangri-la, a utopia of the imagination. "When Irving was reproached for describing an English Christmas which he had never seen," noted George William Curtis of *Harper's* in 1883, "he replied that, although everything that he had described might not be seen at any single house, yet all of it could be

seen somewhere in England, at Christmas."[24] As if to prove his point, Irving took Martin Van Buren, the new American ambassador to the Court of Saint James, on a tour of England in 1831 especially to give him "an idea of English country life and the festivities of an old-fashioned English Christmas," wandering from stately home to stately home, in search of the proper parlor games and menus.[25] The composite revels at Bracebridge Hall included Morris dancing, a pageant-dinner presided over by a Lord of Misrule and a giggling Dame Mince Pie, storytelling, mistletoe, games of "hot cockles," and the consumption of prodigious quantities of "brawn" (boar or pork) and sirloin. And over all of it, like the scent of evergreen boughs, lingers what a literary critic once called "the romantic, the faery quality [that] appears only to the foreigner," a sense that traditions, like old buildings, are reminders of a fabled past that puts the modern age to shame.[26] "The traditionary customs of golden-hearted antiquity, its . . . lordly wassailings," wrote Irving/Crayon in a tone of genuine regret, "have passed away with the baronial castles and stately manorhouses in which they were celebrated. . . . [They] are unfitted to the light showy saloons and gay drawing-rooms of the modern villa."[27]

The name Crayon suggests an artist, and Irving provides a whole series of pictorial vignettes which have become part of the iconography of Christmas as a direct result of the popularity of his word-sketches: the country inn; the stage, loaded down with foodstuffs; the jolly coachman; the shops, full of customers and decorated with holly; the hearth; the servants, bustling about, rosy-cheeked and joyful; the groaning board.[28] The scene is as vivid as a painting come to life, a *tableau vivant* of perfect Christmas happiness: the reader can almost taste the once-forbidden mince pies, banished by the Puritans. Perhaps it was inevitable, then, that Irving's Bracebridge Hall should live on today as the annual Bracebridge Dinner, a sumptuous, seven-course Christmas repast served in an English Renaissance manner—"old Christmas" style—at the Ahwahnee Hotel in Yosemite National Park, in the mountains of the golden, mythical American West.

There is nothing especially British about the Ahwahnee, except for

the fact that Lady Astor, a prominent American transplant to England, is said to have stormed out of Yosemite in the early 1920s, complaining that there wasn't a decent hotel within a day's journey.[29] A luxury hotel finally was built there in 1925, to serve the rich and titled, presidents and movie stars, as they toured the American hinterland.[30] It featured spectacular views of the Half Dome and an overscaled Art Deco dining room with odd touches of log cabin rusticity tempered by patterns copied from Navajo baskets.[31] In 1927, influenced by sparse holiday bookings and the ongoing popularity of Irving's Christmas chapters, the literate president of the park's concessions—a future president of Stanford University—organized the first Bracebridge Dinner.[32]

He hired San Francisco impresario Garnet Holme to create a pageant that was also a Christmas dinner, capturing the dense atmospherics of Irving's text.[33] Under Holme's direction, the Bracebridge Dinner became a sort of Yosemite sequel to Irving, in which a narrator described the author's sojourns in the manor houses of Cheshire and Birmingham, his visits to the home of Sir Walter Scott, and the effect of the Restoration on Christmas customs after the repressions of the Cromwell regime. The Puritan interlude lessened the religious implications of the day, said the narrator, and put the emphasis squarely on merry-making and feasting. Thus the entrance of the succulent roast was accompanied by a discourse on the introduction of sirloin to the British Christmas dinner by Charles II. Following the order of Irving's dinner, the peacock pie came next. The tenderhearted Squire of Bracebridge could not bear to kill his peacocks and dressed a pheasant pie in their plumage instead, but the dish was of great symbolic importance, according to the script, because it represented the knight's vow to protect his lord's domain at any cost. And so the dinner went, with its recitations and presentations, through all the various courses, until the grand finale—and the arrival of the flaming plum pudding.[34]

In the telling, the early dinners sound terribly stuffy, but those in attendance recalled high jinks and improvisation. The photographer Ansel Adams, who lived and worked in the park, close to the scenery

he immortalized, played the jester on one occasion, in cap and bells, and climaxed his performance by shinnying up one of the 34-foot stone piers in the dining room, to the cheers of the guests.[35] "My exploits were discussed for years afterwards," gloated Adams, who took over the revels upon the death of Holme in 1929 and ran things until 1972.[36] Under Adams, the pageant gradually lost its Irvingesque qualities. Or rather, they were submerged in a welter of carols, liturgical music, madrigals, and costumes borrowed from the court of Henry VIII, via old movies.[37] Only the name remains, and an outline based on the order in which the dishes appear in *The Sketch-Book,* to link the timid, retiring Washington Irving, squire of Sunnyside, to the wild nature of Yosemite, and a luxury hotel.[38] "It's vaguely Elizabethan," says the present director of the annual Bracebridge Dinner, "but actually belongs to no historical period."[39]

What the Bracebridge Dinner is not is Dickensian. Charles Dickens, when he took up the theme of "happy Christmas" in 1837 in *The Pickwick Papers,* was less concerned with comestibles than with issues of memory and homecoming. His four Pickwickians, "as brisk as bees," assemble for a ride on the Muggleton coach to Dingley Dell, where they will attend a wedding and then play games around the punchbowl in the kitchen on Christmas Eve. The coach scenes come straight from Irving: Dickens delights in embellishing upon the comic dilemma of travelers at Christmastime, who must cram themselves, their greatcoats, their carpetbags, and vast quantities of holiday goodies into small spaces at some inconvenience. Mr. Pickwick's oyster barrel and his unwieldy codfish are fitted into the Muggleton coach only by a liberal application of hot brandy and water, all around.[40] But when Pickwick and his friends arrive at their destination, there is no lingering description of a formal dinner, of pomp and ritual. Instead, Dickens concentrates on the homely games—blindman's buff, snapdragon—the dancing, and the songs that show an extended family gathered together again for Christmas, and willing to extend the hospitality of the house to others.

The coach scene is crucial for Dickens because it establishes the holiday as an occasion for goodwill, for homecoming. "How many

families whose members have been dispersed and scattered far and wide, in the restless struggles of life, are then reunited," he declares. "Happy, happy Christmas, that can win us back to the delusions of our childish days, that can recall to the old man the pleasures of his youth, that can transport the . . . traveller, thousands of miles away, back to his own fireside and his quiet home!"[41] There are mistletoe, holly, wassail, coaches, and inns in *The Pickwick Papers*, but none of the quasi-liturgical ceremony of the Bracebridge Christmas.[42] Irving's Squire wants to bring the past back again—to repair a rupture in history—while Mr. Pickwick and his friends merely enjoy the cyclical feelings that the holiday brings: pleasant memories, and the blurred connections between all the Christmases of one's life. Irving remains the observer, a historian, a stranger at Bracebridge Hall. Dickens is at home at Dingley Dell.

What Dickens and Irving share, however, is a sense that Christmas has an important historical dimension, whether it be national or personal and familial. The things that are done at Christmas, the codfish packed in baskets, the games and the songs unique to every home, provide points of entry into a state of happiness and abundance that transcends the present and stretches back endlessly into the past. Christmas is a special time, a suspension of the workaday order of things, but it is also a doorway connecting the present to earlier eras, when the significance of mistletoe was not something to be learned about in a book of folklore. As Washington Irving discovered when he set out to recover its splendors, Christmas is very old indeed.

It was important to Americans at the end of the nineteenth century to believe in the antiquity of their Christmas rituals. Perhaps they insisted on making boiled puddings from yellowed English recipes because their Christmas was so self-evidently new, a recent discovery of Mr. Irving, the tree growers, the merchants, and the publishers of illustrated editions of the Bracebridge stories. Perhaps they were persuaded that in this matter, as in other questions of good taste and refinement, England would always take the lead by virtue of her greater age. In America, everything was new—even Christmas. In

any case, an immense body of literature, which began to appear in the 1880s, justified the material excesses of the American Christmas by looking back at the Olde Christmas, as it was celebrated in England at some hazy point in history between 1066 and the first Bracebridge dinner.[43] "Then were there twelve long days of merry-making, and honest men had honest appetites," wrote one gourmand, smacking his lips over "spicy brawn in rolls, and good roast beef in great, thick joints, the firm red flesh streaked and o'erlaid with yellow fat, all gay with greens and streaming ribbons, to fit the hearty tastes of hearty times."[44]

Those who looked to the English past expressed a healthy disdain for American ways of celebrating the holiday. Precocious children in Christmas fiction long for "real old Christmas customs" to take their place alongside the newfangled stockings and trees—boar's heads, carolers, wassail bowls brimming with toast and roasted apples: the old symbols, they say, will act as a counterbalance to the frantic hucksterism of the cities on Christmas Eve.[45] Other little heroes and heroines pine for a Lord of Misrule in place of Santa, for the high church "holy-day" condemned by the Puritans, for the Twelfth-Night custom of serving elaborate pies, in the shape of buildings, with live animals and birds concealed inside.[46] Stories about Christmas doings at court in the time of Elizabeth I and her predecessors were a mainstay of magazines for young people.[47] So were suggestions for tableaux and pageants—junior versions of Irving seasoned with a merry dash of Dickens—replete with scenes of feasting, caroling, and bringing in the yule log.[48] In the pages of *St. Nicholas Magazine*, one parent described her family's valiant effort "to reproduce an Old English Christmas, as far as was possible in modern America and with the resources at our command." Marked by many comings and goings with a papier-mâché boar's head, and a jester playing the fool for his squire, the Eaton family Christmas for 1920 sounds a great deal like a Bracebridge Dinner in Yosemite, around 1929.[49]

Judging by the covers of the *Saturday Evening Post*, admiration for the Olde English Christmas reached its apogee in America in the 1920s and 1930s. J. C. Leyendecker, whose Christmas covers helped

"OLD BOND, THE BUTLER, BEARING THE PLUM-PUDDING ALOFT IN SOLEMN MAJESTY."

Irving resurrected: "Bearing the Pudding Aloft in Solemn Majesty," 1896. *St. Nicholas* (February 1896), 317.

to define the meaning of the holiday for a mass audience, specialized in pictures of Christmas revels in England, in the spirit of Irving. Waits and serving wenches, pages, m'ladies, jesters and squires, all self-consciously dressed in their Hollywood best, capered and gamboled as if following a script written by Ansel Adams. Most of Leyendecker's Bracebridge-style covers were created in the decade between 1924 and 1934.[50] This period also marked the height of the Colonial Revival movement in the United States: neo-Georgian houses, furniture, typography, and the archaeological recreation of Colonial Williamsburg funded by John D. Rockefeller provide ample evidence of a passion for the traditional, British-influenced precincts of the American past.[51] A counterbalance to the strident modernity of the Jazz Age, colonialism spilled over into Olde Englishism, until only the extra *e*'s at the ends of words distinguished the one from the

other. Norman Rockwell, who had built himself a colonial manse in New Rochelle, New York, in the 1920s on the proceeds of *Post* covers depicting the antics of freckle-faced kids, turned his attention to Ye Olde English Christmas in 1921, in a spirit of friendly rivalry with Leyendecker.[52]

While Leyendecker's Christmas came from Irving, Rockwell's came from Charles Dickens. One of the artist's favorite childhood memories was of his own father, sitting in a pool of lamplight at the dining room table at the turn of the century, reading Dickens aloud to his children. "I would draw pictures of the different characters," Rockwell remembered. "Mr. Pickwick, . . . Uriah Heep. . . . I was very deeply impressed and moved by Dickens. . . . The variety, sadness, horror, happiness, treachery; . . . the sharp impressions of dirt, food, inns, horses, streets; and people . . ."[53] In 1945, Rockwell told the *New Yorker* that his parents had agreed to send him to art school after seeing a drawing of Ebenezer Scrooge that Norman had made while listening to his father read *A Christmas Carol.*[54] His most effective Christmas covers drew upon his love for the world of Dickens and the pungent scent of realism Rockwell associated with the Olde England of his childhood memories.[55]

Rockwell did eight Dickens covers for the *Post* (which had serialized *Dombey and Son* in the nineteenth century) between 1921 and 1938. Most of the holiday designs took as their theme the coach, its driver, the passengers, or the heart-warming trials involved in going home again for Christmas. The first in the series, for example, is a head-and-shoulders portrait of a genial, apple-cheeked coachman. Related covers include a close-up of another coachman on the box of the London stage, with a schoolboy at his side, clutching a carpetbag and a tin box of Christmas treats; a full-length rendition of a portly driver cracking his whip; a figure in a greatcoat and mittens toting two baskets loaded with Christmas fare; and a plump passenger, with carpetbag, basket, and umbrella, seated under an announcement for a forthcoming departure of the Muggleton Stage-Coach. All the men in the pictures wear holly in their hatbands. Each of the compositions bears the legend, "Merrie Christmas."[56]

Rockwell's "The Muggleton Stage-Coach" of 1938 takes its iconography from *The Pickwick Papers* by Dickens. *Saturday Evening Post* (December 17, 1938), cover.

Rockwell's "Merrie Christmas" series comes from the imagery of *The Pickwick Papers,* with its splendid, bustling description of Mr. Pickwick and his companions, "well wrapped up in great-coats, shawls, and comforters," on the way to Dingley Dell, surrounded by luggage and groceries. The little boy on the box of the London coach may be Paul Dombey. The ubiquitous goose protruding from the wayfarers' baskets may be the one the Cratchits will baste for their meager Christmas dinner, when Scrooge and the spirit come to call. As a cover artist, Norman Rockwell was seldom called upon to illustrate someone else's text.[57] But, by choosing to take his cues from Dickens in this group of covers, Rockwell produced some of the most convincing work of his career. In contrast to his often dispirited Santas, his Dickensian characters draw vitality from the carefully delineated period costumes they inhabit. Their gaiters and shiny buttons add to the aura of palpable presence that cloaks them like an eighteenth-century greatcoat.

There is some evidence that Rockwell also drew upon well-known illustrations of Dickens's works. The 1928 "Merrie Christmas" cover shows a jolly couple of mature years, dressed in the manner of the late eighteenth century, dancing beneath a candle holder wreathed in holly and mistletoe. The mincing poses, the disposition of the garments, the prominent seasonal centerpiece, and even the squat face of the gentleman-dancer pay tribute to the famous John Leech frontispiece to the first edition of *A Christmas Carol,* published by Chapman and Hall of London in 1843.[58] The scene is old Mr. Fezziwig's ball, which the first of his nocturnal visitors, the Ghost of Christmas Past, shows to Scrooge. Leech chose the priceless moment when Old Fezziwig took to the floor for the "Sir Roger de Coverly" and danced so deftly that "a positive light appeared to issue from Fezziwig's calves."[59] Similarly, Rockwell's Tiny Tim cover of 1934, entitled "'God Bless Us everyone,' said Tiny Tim," takes the pose of Bob Cratchit, as well as the body types, the treatment of Bob's long scarf, and Tim's compacted pose, from a Frederick Barnard steel engraving published in the 1885 *Character Sketches from Dickens.* E. A. Abbey, a British illustrator whose work Rockwell admired, had provided

Rockwell does Fezziwig, 1928. *Saturday Evening Post* (December 8, 1928), cover.

John Leech, frontispiece to *A Christmas Carol*, 1843: old Fezziwig's dance.

wood engravings for an 1876 edition of Dickens which may also have influenced the stance of Bob Cratchit in the *Post* picture.[60]

The enormous popularity of Rockwell's Dickensian illustrations (which later became best-selling greeting cards) surely rests on their fidelity to the spirit of the Olde English Christmas that Dickens helped to enshrine in the American psyche—a spirit of adult nostalgia for one's childhood, for home, for bygone times, and a universal good cheer, benevolence, and simplicity that stood in strong contrast to the commercial bustle of the modern, Santa Claus holiday.[61] Nor was Rockwell the only purveyor of such imagery. An independent series of Hallmark cards and wrappings, inaugurated around 1925 and popular through the 1930s, also used the coach in a snowy landscape, the jolly coachman, the dapper passengers, and carolers to wish the recipient "An Old Time Christmas."[62] For the 1920s, the message was one of sincere good wishes, offered with pictorial assurances of absolute authenticity. For the 1930s, it was one of hope for the restoration of the world that ought to be.

As Rockwell's covers suggest, Dickens was a central figure in the making of the American Christmas. In 1867, after exhaustive serialization of his work by *Harper's* and the *Post*, Charles Dickens made his second trip to the United States to begin a three-month course of dramatic readings, just as Christmas was beginning to define itself.[63] In Boston, 10,000 tickets were sold weeks before the date of his scheduled appearance.[64] In New York, 150 people stood in line in the cold all night for good seats at Steinway Hall.[65]

The reason for their persistence was the prospect of hearing Dickens read *A Christmas Carol*. According to those who attended the readings, they were highly dramatic events. Although Dickens appeared on a bare stage, equipped only with a podium for his book and a glass of water, he managed to bring Scrooge and the Cratchits and old Marley to life for his audience by using the text as a rough guide to a series of impersonations that changed every night. Kate Field, a Boston journalist who followed the Dickens tour, transcribed every word, along with notes on the tone of voice, the inflection, and

Dickens does a dramatic reading from *A Christmas Carol* in the United States, 1867. *Harper's Weekly* (December 7, 1867), 777.

the gestures with which the author turned himself, as if by magic, into his wonderful characters.[66]

People of all sorts joined the half-mile ticket queue in Boston: "truckmen, porters, clerks, 'roughs', clergymen, merchants, gamblers, gentlemen, loafers, white men, black men, colored men, boys and *three* women."[67] Some were scalpers, some were pickpockets, but most were genuine fans for whom *A Christmas Carol* carried an important social message. The Christmas Eve reading in the Tremont Temple took on the emotional aura of a revival meeting. A couple who owned a business in Vermont decided to close the factory on Christmas Day for the first time in its history and send the workers home to their families, after hearing Mr. Dickens.[68] "They took it so tremendously last night," wrote Dickens of the same Christmas Eve

show, "that I was stopped every five minutes. One poor young girl burst into a passion of grief about Tiny Tim and had to be taken out."[69]

What people found compelling about *A Christmas Carol* was the so-called "carol philosophy," or Dickens's insistence on the need for a new spirit of benevolence in the face of class divisions and widespread poverty—for kindness, generosity, and brotherhood at Christmas. At the same time, *A Christmas Carol* was a secular narrative, almost totally lacking in conventional religious references which might have offended one constituency or another: Scrooge, the modern, tight-fisted businessman, learns from his memories and from the trials of his own past that charity is expedient.[70] William Makepeace Thackeray, Dickens's chief competitor in the production of special stories for the Christmas season, surrendered the field to his rival in the 1840s for that reason.[71] "Was there ever a better charity sermon preached in the world than . . . *Christmas Carol?*" he asked. "I believe it occasioned immense hospitality throughout England, . . . caused a wonderful outpouring of Christmas good-feeling; of Christmas punch-brewing; an awful slaughter of Christmas turkeys, and roasting and basting of Christmas beef."[72] Kate Field ended her eyewitness account of Dickens's readings with this fervent summation: "Talk of sermons and churches! There never was a more beautiful sermon than this of *The Christmas Carol.* Sacred names do not necessarily mean sacred things."[73]

A Christmas Carol, as Dickens scholar Paul Davis observes, linked the Christmas of Irving's rural squires and manor houses with the new English city: the Olde Christmas still managed to flourish in Scrooge's business-driven London.[74] The little book depicted the cruelties of the new industrial order forcibly enough—Bob Cratchit's mended clothes, Tim's illness, the hardships of the miners and sailors, the terrifying appearance of Ignorance and Want in the guise of two wretched children—but ended on a note of repentance and cheer. Looking back upon his past and reflecting upon his present blessings, the tight-fisted Scrooge is moved to mend his ways. After Scrooge's brush with the three spirits, Dickens declares, "it was al-

ways said of him that he knew how to keep Christmas well."[75] G. K. Chesterton, in one of his many essays on Dickens, called the *Carol* "a kind of philanthropic dream, an enjoyable nightmare."[76] No longer a "Humbug," at the end of the *Carol* Christmas is the occasion for a gleeful orgy of goodwill.

To nineteenth-century readers of the *Carol*, the Cratchits' Christmas dinner was the heart and soul of the book. Despite the smallness of the goose and the pudding, despite grinding poverty and sickness, Bob and his family come together in the spirit of the day—and even manage to toast the "stingy, hard, unfeeling" Scrooge.[77] The Cratchits' feast was all the grand, ceremonial banquets of the Olde Christmas rewritten on a small, cozy, domestic scale, and for that reason alone, the dinner scene was compelling to the Victorian family. Tim's blessing, the toasts, the bubbling potatoes, the hissing saucepan of gravy, and Mrs. Cratchit's anxiety over her little pudding were ingredients that might have come from anyone's Christmas repast; they were vivid physical details that appealed with equal force to rich and poor, Londoner and Bostonian.[78] And just as Irving's Christmas chapters were made into independent gift books, so this passage from the *Carol* became a tiny volume entitled *Their Christmas Dinner.*[79]

In America, beginning in the 1880s, public dinners were one of the most visible forms of Christmas charity. *Frank Leslie's Illustrated Newspaper,* which both promoted such events and exploited their pathos, attributed the practice to Olde Christmas, Charles Dickens, and the Cratchits. "It is the traditional English Christmas," proclaimed an 1887 editorial, "when no man should go hungry. From the banquets and generous alms of mediaeval times to the feasting of rich and poor pictured by Dickens . . . the English Christmas tradition has crowned the day with good cheer. . . . The 'realistic' writer who would picture Christmas in New York must tell of Christmas charity and Christmas wassail going hand-in-hand."[80] In the 1870s, private charity at Christmastime was discussed and applauded. Louisa May Alcott's *Little Women,* published in 1868–69, includes a crucial chapter in which Marmee's daughters forgo the delicacies

planned for their Christmas breakfast and, at evident cost to themselves, bring the goodies to a poor family in the neighborhood.[81] Another Alcott story about a little girl who is tired of Christmas compares the heroine to Scrooge; in the final pages, after rereading *A Christmas Carol*, the girl learns to love Christmas by taking dolls to the inmates of an orphan asylum.[82] *Godey's* opened the Christmas issue for 1870 with the exhortation to "Remember the Poor." The companion picture showed a wealthy couple alighting from a carriage in front of a crumbling hovel and delivering a Christmas basket (with a plump turkey on top) to a widow and her children.[83]

But even fictional accounts of Christmas giving disclosed conflicted feelings about the efficacy of direct charitable giving. One story featured a wealthy, modern-day Scrooge with a tender-hearted daughter. Indiscriminate charity "demoralizes the poor," he thunders when his little girl wants to help others at Christmas. The poor have "delightful charitable retreats provided by the State."[84] The *Leslie's* editorial in praise of feeding one's fellow man during the holidays goes on to wonder if the benefactor who spreads a feast for the destitute is not guilty of "merely selfish enjoyment," whereas the businessman who sends a check to a reputable organization devoted to the welfare of the deserving poor makes the more useful gift. *Leslie's* spoke out in favor of professional charities, charged with the ultimate welfare of clients at risk of being reduced to permanent dependence by well-meaning handouts: "There are beautiful instances of individual charity which provide lodging-houses or what not with . . . Christmas dinners, but there must be association and organization, as well as charitable impulse."[85] Dickens himself, in his later Christmas stories, satirized the benevolent bullies who would presume to tell the poor how to live in exchange for a slice of pudding.[86] Whether Dickensian dinners in America were organized by professional do-gooders, self-seeking politicians, or millionaires who loved the warm glow of the spotlight, however, they were—like the emerging Christmas itself—big, subject to careful scrutiny, and the cause of much cultural indigestion.

Charity dinners were already common by 1889, when the minister

and orator Edward Everett Hale, in an essay on Christmas in Boston, included a note of thanks "from a little humpbacked boy" who had attended such a function at the Christian Union Hall the previous December. Written in the dialect of the streets, the grateful letter was the prelude to a list of similar functions, all for newsboys, orphans, and other youngsters in dire circumstances. Institutions sponsored the dinners and the ice-cream socials, but the good cheer was provided by kindly Bostonians who attended the functions and paid special attention to individual children.[87] A Children's Christmas Club founded in Portland, Maine, in 1882 involved middle-class boys and girls in planning and raising money for an annual feast attended by six hundred other, indigent children. Despite the gifts from Santa, the heaps of turkey, and the slabs of pie, the mass feeding in Portland was as tightly regimented as a boot camp. The guests marched and ate and sat and stood following musical cues. The most presentable among them were called upon to recite, or to sing for their supper. And while the guests were seated in the atrium of City Hall, most of the little hosts and hostesses sat upstairs, in the gallery, in their party finery, and watched them dine.[88]

The Children's Club movement rapidly spread to Washington, D.C., where Miss Nellie Arthur, the President's daughter, was the moving spirit behind a series of feasts in the mid-1880s, attended by important government dignitaries. As the latter watched, the lucky children chosen from the ranks of the poor attacked their turkey and cranberries and cake, and out on the sidewalk a group of the uninvited waited in hope that there would be something left over for them.[89] The unwitting cruelty of such public dinners was wasted on the public, however. News reports about charity dinners are uniformly self-congratulatory in tone. Magazine stories quoting the ragged children in attendance at such events adopt a tone of weary, matter-of-fact gratitude. "It's a sight to see us fellows eat," says one little chap in an 1884 Christmas fable about dinner at a lodging house in the slums. "Some of us only gets two square meals in the year, and those is the dinners we gets Thanksgiving and Christmas."[90]

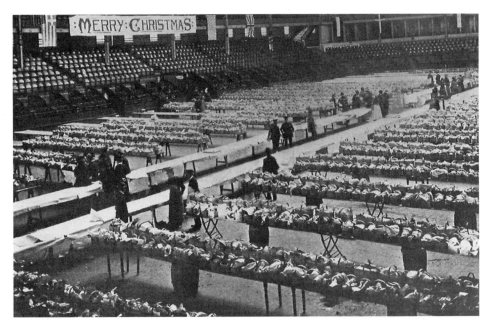

Preparations for the Salvation Army Christmas dinner for the poor, Madison Square Garden, 1901. *Leslie's Weekly* (January 12, 1901), 32.

As one of the first popular magazines to make extensive use of photographs, *Leslie's* discovered that pictures of charity dinners had a certain voyeuristic appeal, especially when they were juxtaposed with shots of well-dressed shoppers, arms full of parcels, elbowing their way into Macy's past a window full of bobbing mechanical Santas.[91] In 1901, the magazine published a balanced report on the combined efforts of private philanthropists, organized charities, and public institutions to alleviate the distress of the hungry at Christmas. But the picture spread lingered over shabby garments and unwashed hair, as if to invite the reader's arm's-length pity, and the poor were shown waiting in rows or endless lines in the Five Points district for dinners and presents, like inmates in some vast urban prison.[92]

The largest annual Christmas dinner held in the United States was that staged by the Salvation Army in New York, at Madison Square Garden: in 1901, at the height of the public appetite for news of

mass feedings, 25,000 men, women, and children attended the event, which was paid for by the contents of the Army's ubiquitous red kettles.[93] An evangelical group organized along military lines, the Salvation Army had been founded in 1865 in the slums of London to help what founder William Booth called "the underprivileged, hopeless, and Godless masses" described in Dickens's Christmas books.[94] In 1880, seven of Booth's uniformed "Hallelujah Lassies" landed in New York City and began preaching outside Harry Hill's Variety saloon, at the corner of Crosby and Houston Streets: their first convert, one Ashbarrel Jimmy, was named for his former place of residence, adjacent to the Variety. In 1891, the first kettle—a real crab pot—appeared on a San Francisco street corner, under the slogan, "Keep the Pot Boiling!"[95] The organization maintained shelters, soup kitchens, and programs for training and rehabilitation, but the kettle money went for free Christmas dinners, in the spirit of the holiday, despite the fact that the Army did not generally favor handouts without compensatory work.[96] In urban America, women in bonnets ringing bells beside "gypsy" kettles during the two weeks before Christmas became one of the recognized signs of the season.[97]

Leslie's and the other illustrated papers were drawn to the Madison Square Garden dinner like moths to the candles on a Christmas tree: pictures of the immense hall, filled with ranks of tables, and the crowds outside, waiting patiently in the snow, proved irresistible to editors in search of a heart-warming Christmas story.[98] Served under the glaring scrutiny of electric lights, the 1898 Salvation Army dinner was a true media spectacle, with tickets sold to wealthy New Yorkers who wished to observe the scene from the boxes and galleries.[99] But the report on the 1901 dinner filed by Frederick Booth-Tucker, the Salvationist official in charge, makes it clear that the Army's intention was not to make a show of the sufferings of paupers. Quite the opposite, in fact, according to Booth-Tucker: "Our officers and soldiers wait upon them personally, . . . treating them with loving heartiness." And those too ill or too ashamed to eat their dinners of beef and turkey in public were provided with baskets of food to carry away.[100]

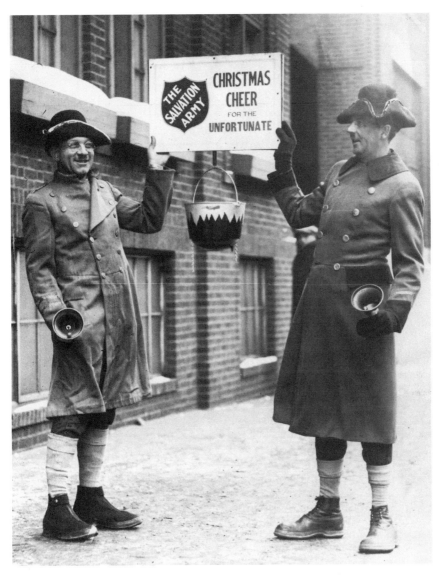

The Salvation Army's bell-ringers, circa 1935, are dressed in Dickensian costumes. Minnesota Historical Society.

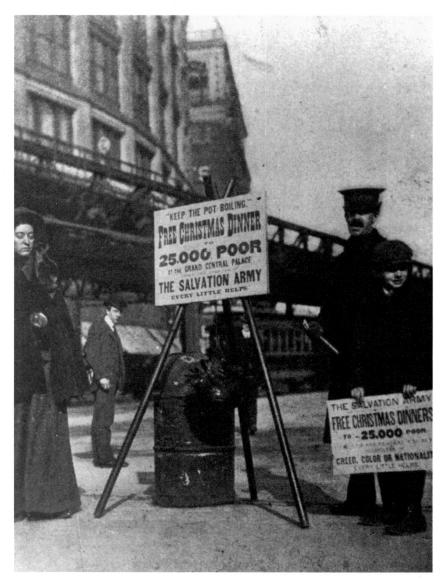

In 1903, the Salvation Army's "gypsy kettles" appeared on most busy corners of most busy American streets during the two weeks before Christmas. *Leslie's Weekly* (December 24, 1903), 620.

In 1897, Mrs. Bradley Martin, a member of New York's social elite, read about the ongoing economic depression and the sufferings of the poor. In order "to give an impetus to trade," as she put it, the Bradley Martins gave a $369,200 ball for their friends: the costumes were wildly expensive, the wines were rare, and the affair gave a terrible black eye to Blue Book charity. The party went down in the annals of infamy as a prime example of the unfeeling selfishness of the rich. The Bradley Martins were forced into exile.[101] Another result of the infamous ball was a dramatic increase in hands-on giving by high society. But the would-be angels of mercy could not resist spreading word of their own good deeds.

Mrs. Howard Gould's 1901 Christmas treat for "a hundred little children from New York's homes of barest poverty" typified the extravagant self-promotion so often attached to private charity. Mounted at the Tuxedo restaurant, at 59th and Madison, Mrs. Gould's party was distinguished by the rich attire of the Goulds and their friends, which was described in the papers as a noteworthy contrast to "the plain, thin, dark clothes" of the guests. The afternoon began with thick sandwiches and cocoa and progressed through magic acts, marching, singing, and a ministerial quiz on the meaning of Christmas to—at last!—a tree loaded down with practical presents. For each girl, there was a length of "heavy, woolen material for a dress, and besides this a doll and a little wooden bird in a cage." The boys got "shoes, mittens, tops, or drums." The generous Goulds, meanwhile, got lots of publicity.[102]

Other socialites made their mark with doll dinners, given exclusively for little girls from the tenements. After the meal, each "little mother" received a lovely new dolly.[103] But the most famous Christmas dinner in New York was not put on by a lady bountiful in a fancy dress. It was the big Bowery dinner, hosted by Tammany Congressman Timothy D. Sullivan—and his son after him—for their down-at-the-heels constituents for more than twenty-five years.[104] The Sullivan machine maintained clubrooms on the Bowery for political skulduggery, where patronage, turkey, and potato salad were distributed on Christmas Day along with pipes, tobacco, socks, and

coupons good for a free pair of waterproof shoes. There wasn't a chair in the place; the guests ate standing up, as they did in the typical Bowery saloon, and "Big Tim" or "Little Tim" shook hands with everyone who came.[105] In 1911, at the sixteenth annual Bowery dinner, 6,000 partook of the feast.

That Christmas, canny denizens of the Bowery could have spent the whole day gorging themselves on free victuals: in addition to the Sullivan feed, there was a pre-dawn breakfast at the Bowery Mission just down the street, as well as the usual Salvation Army fetes (now decentralized and scattered about the city). There were separate dinners for newsboys, "little mothers," patients in the charity wards of the city hospitals, orphans, and residents of various homes for the aged and the infirm, for Catholics, Protestants, and Negroes. "If there was a single family who lacked a Christmas dinner," said the *New York Times*, ". . . it was not the fault of the various private charitable organizations, and the individual philanthropists, big and little, of the town."[106] But splashy, once-a-year dinners were beginning to draw criticism. By laying too much stress on impulsive almsgiving and feeding the poor at Christmas, "Dickens did more harm than anyone else," the *Saturday Evening Post* decided. "A great Christmas dinner, in the minds of many, cancels the charity obligations of the entire year."[107]

The alternative was systematic modern charity, dispensed year-round through agencies qualified to assess the needs of the poor. Under the new system, there would be no more mass Christmas dinners, with ladies and gentlemen idling in the galleries. Or rather, no one would pretend that a single holiday dinner sufficed to meet the needs of those unfortunate enough to require feeding.[108] Instead, case workers would try to find ways to extend the bounty of Christmastime over the rest of the year. In 1912, the *New York Times* began to run narrative descriptions of the "100 Neediest Cases" in the city, asking for donations to cope with their specific, long-term needs. The New York Association for Improving the Condition of the Poor weeded out the grifters, chose the cases, and prepared their stories.[109]

In contrast to "the old charity," in which a Scrooge might make a personal contribution to a Cratchit, this money was to be funneled through reputable organizations to the worthy individuals and families profiled. The process ensured that recipients could maintain their self-respect and that professional social workers could allocate the funds in the most beneficial ways.[110] But old habits and "the old charity" died hard. One reader wrote to the *Times* demanding to see Case 63 (a "mentally backward" boy in need of tuition for a special training school) in person. At first, the names of contributors—or lists of their gold-plated initials—were also printed daily.[111] But whatever the faults of the system, the public at large began to learn that people were not in need because of their own indolence or criminality.[112]

At the end of the 1912 drive, Case 2, a widow going blind from work in a brush factory, had her rent paid for the year. A little girl who wrapped Christmas packages in a department store, the sole support of a family of ten, got some help with food and winter clothing. Victims of tuberculosis, St. Vitus' Dance, and leprosy received medical attention. The stories reminded New Yorkers of their own good fortune. Children from wealthy families rushed to the offices of the *Times* with stockings, toys, and candy for "the neediest" of the needy. Other girls and boys sent in their dimes and nickels and pennies. "All over New York to-day, in institutions . . . and in the tenement quarters of the poorest," the *Times* chortled on Christmas morning, "there will be some 1912 Tiny Tims to call out the immortal blessing of the day, 'God bless us every one.'"[113]

In 1913, Case 87, an abused boy who needed clothes, "something to cheer him up a little, . . . [and] half a chance," had been passed over until several days before Christmas. Then he was surprised with a new suit of clothes, made for him by a little girls' sewing circle. Properly dressed, Case 87 was able to take part in the Christmas exercises at school.[114] Meanwhile, an out-of-town guest at a Broadway hotel stood in his second-floor window and threw ten dollars' worth of change down onto the sidewalk below, precipitating a near riot. The *Times* printed this story of "old charity" on Broadway alongside a

Christmas Day at the Gateway Mission, Minneapolis, circa 1940. Minnesota Historical Society.

letter congratulating the editors on their modern approach to a timeless problem. With the 100 Neediest Cases, the correspondent declared, the *New York Times* "has asked not the giving of Christmas dinners, but the things that warm and satisfy the needs of body and mind long after Christmas. . . . Because of this, I have changed my feelings about Christmas giving."[115]

Every December, stories of suffering and penury tugged at the nation's purse strings. But side by side with news of the neediest, tasty dinners and readings from Dickens continued to constitute the menu for a truly merry American Christmas. During the 1840s *A Christmas Carol* had outsold the Bible in American bookstores, and as the decades passed, its popularity grew. One scholar explains the

longevity of Dickens's tale by calling it a "culture-text," a story subject to frequent oral and visual reinterpretation as a consequence of its own resounding success. The tradition of variant readings like the author's own also persisted. A century after its publication, the meaning of *A Christmas Carol* continued to change, as it was recounted by storytellers from a world stalked anew by the miseries of war and the Great Depression. "In the thirties and forties," writes the literary historian Paul Davis, "we knew the story through Lionel Barrymore, Ronald Coleman, and the Roosevelts."[116]

The classic Barrymore version was performed on the radio in the 1930s, with the star in full Scrooge makeup. Sponsored by Campbell's soup—hot, cheap, and just the thing to fill put a pared-down, 1934 bill of fare—the broadcast began at 5:00 P.M., when most Americans had just finished a Christmas dinner not unlike the Cratchits'.[117] The Barrymore version was short and radically compressed. Nephew Fred and sister Fan all but disappeared in order to concentrate on the fate of the poor Cratchits. Downtrodden Bob becomes the main character and, like the hero of a Horatio Alger story, improves his station in life thanks to Scrooge's visit with the spirits. The extended radio family, fresh from its own dinner table, was brought into the story as so many auxiliary members of the happy family of Bob Cratchit.[118]

During the economic hard times of the Depression, Barrymore's audience could empathize with Bob's low wages, his scrawny goose, and his crippled child. But Lionel Barrymore was not the only famous interpreter of Dickens in the 1930s. It was well known, for example, that President Franklin Roosevelt read, recited, and acted out passages from the book at the White House for his own family every Christmas Eve, before the stockings were hung. Eleanor Roosevelt (who recorded her version of the *Carol* in 1957) remembered that her husband was particularly spirited in his account of old Fezziwig's holiday ball and that "he always put a great deal of drama into his reading of the parts about the ghosts."[119] In 1936, several days before the annual Barrymore broadcast, FDR made a radio address at the lighting of the community Christmas tree in Washington. In the

Lionel Barrymore played Scrooge on the radio in full stage makeup during the 1930s. *Saturday Evening Post* (December 28, 1935), 25.

speech, he alluded to the Dickens ritual in the Roosevelt household and went on to quote the reformed Scrooge who pledged to honor Christmas ever afterward in his heart. When the CBS head office heard the speech, the network invited the President to share his Christmas Eve interpretation of the *Carol* with the nation, like a father reading a story to a nation of his struggling children. "It seems to me," wrote a radio executive, "that this would have a happy psychological effect. . . . In a moment of wars and dread of wars, it would, throughout the world, emphasize kindliness, humanity, and peace."[120]

The White House declined the invitation; Roosevelt's interpretation of Dickens was lost to history. But the Hollywood version of *A Christmas Carol*, released by MGM in time for the 1938 holiday season, survives to suggest what Dickens's tale of Victorian poverty, hunger, and charity meant to the 1930s. At the time of the film's release, some critics were taken aback by the relentless cheerfulness of the production, starring the twinkly Reginald Owen as a Scrooge whose snarls seemed bogus from the start. To the modern eye, the Cratchits' house is a bit too splendid and their meal too bountiful, as if the studio did not want to remind moviegoers that times were tough outside the theater. Although this was not characteristic of commentary on earlier and later productions, many Depression-era reviewers also emphasized foodstuffs. Over and over again, articles about the movie discussed turkeys, puddings, and plump geese.[121] One critic disliked a scene showing the Cratchit clan fingering the goose hungrily before it went into the oven.[122] Another was outraged by the omission of Fezziwig's party because its absence meant that Dickens's "luscious descriptions of savory foods and Christmas trimmings" were also missing from the film.[123]

Thanks to all the good things to eat, the movie was, in the words of the film historian Frank Thompson, "as bright and cheerful as a Christmas card."[124] The casting of the Lockhart family as the principal members of the Cratchit family reinforced the impression: the genial Gene, playing Bob, was as plump as a Christmas goose himself, and the little Cratchits were well-fed, nicely dressed, and wreathed

in smiles.[125] Their Christmas dinner, which might have been affected by the fact that Scrooge had just fired Bob, was as cozy and joyful as a dinner could be. Indeed, the only cloud on the horizon was the absence of Lionel Barrymore, the popular choice for Scrooge.

Barrymore *was* Scrooge in the 1930s and, according to reports in the trade papers, had been signed to play the film role in the spring of 1938. But suddenly, when production got under way in the fall, he was no longer in the cast. The actor had withdrawn because of crippling arthritis, and he went on to create the memorable character of an American Scrooge, the grasping Mr. Potter, in Frank Capra's *It's Wonderful Life* (1946). But Barrymore's identification with Scrooge in the public mind was so complete that MGM felt compelled to explain his absence. Studio press releases maintained that the producer had offered to postpone shooting until Barrymore was better, but the actor declined. In the year in which Adolf Hitler was named *Time*'s "Man of the Year," Barrymore's insistence that the production go forward is instructive: "If ever the world needed Dickens's message of peace on earth and good will toward men, that time is today," he is supposed to have said. Furthermore, Barrymore canceled that year's radio program so as not to compete with the movie and even appeared in a special trailer endorsing the film.[126] Entitled *A Fireside Chat with Lionel Barrymore,* the preview neatly wrapped Dickens, Barrymore, MGM, Franklin Roosevelt, and the national interest into one pretty package, with a bow on top.

In Melville's *Moby-Dick,* the Pequod sails off in search of the whale on Christmas Day; the industriousness of Ahab is a Puritan rebuke to the sentimentality of Dickens and the "carol philosophy."[127] Yet the Victorian Christmases invented by Irving, with his Bracebridge sirloins and pies, and endorsed by Dickens with his Cratchit dinner, appealed strongly to Americans of the generation of Lionel Barrymore and Franklin Roosevelt.[128] That Christmas-card picture of once-upon-a-time abundance, peace, and tender family feeling seemed tantalizingly real, as it was recreated in the movies or in the imagination of a reader or a listener.[129] The palpable pleasures of the Olde Christmas justified a once-a-year revival of hope that the future might turn out as well for today's Americans as a dismal Christmas

"The Goddess of Our Kitchen" carries in a plum pudding in 1884; by this date, many American homemakers had forgotten how to make the steamed puddings popular in an earlier day. *Harper's Weekly* (December 13, 1884), 819.

in the 1840s had for Bob Cratchit and his dear ones. In the shadow of the breadline, Roosevelt's contemporaries no longer took much satisfaction from looking on while poor newsboys consumed their one good meal of the year. Massive government relief programs had reformed the "old charity" overnight. But the tradition of Christmas giving—the legacy of Scrooge with his prize turkey—persisted. Giving and getting coexisted in a tight, reciprocal relationship: in the economy of Dickensian charity, a turkey given was a sort of guarantee that the donor would enjoy a goose of one's own, with all the trimmings.

J. D. Salinger's 1951 bestseller, *The Catcher in the Rye,* is a Christmas story that takes up the old themes of Dickens's *Carol.* Set in prosperous, postwar New York in late December, the novel sees Christmas through the eyes of sixteen-year-old Holden Caulfield, a refugee from an upstate prep school, as he attends the Christmas show at Radio City Music Hall, observes bell-ringers on street corners, and debates the merits of going to a girlfriend's house on Christmas Eve to "trimma goddam tree for ya." The holiday allows Salinger's schoolboy-hero to wander the city freely, but the season is also the source of Caulfield's mounting conviction that the world of grownups and holidays and Christmas is stupid and phony. When the chorus sings "O Come All Ye Faithful" at Radio City and "it's supposed to be religious as hell . . . and very pretty and all," Holden is disgusted. When the characters in the movie that follows talk about Dickens, and the lady in the next seat begins to cry, he observes that she won't take her own little boy to the bathroom: "You take somebody that cries their goddam eyes out over phony stuff in the movies, and nine times out of ten they're mean bastards at heart."[130]

The Radio City movie is not *A Christmas Carol.* As Caulfield recounts the plot, it is a wartime melodrama set in a British hospital for wounded soldiers. Like the Christmas fiction in nineteenth-century magazines, the film is full of pathos and improbable coincidences, all leading, of course, to a happy Dickensian ending, "with everybody at this long dinner table laughing their asses off. . . . All I can say is, don't see it if you don't want to puke all over yourself." A

minor-league version of Scrooge, Holden resents the fakery of the movie, with its genteel references to Dickens. Freely translated into Victorian English, his frequent references to wanting to puke at the hypocrisy of it all might be read as one large, emphatic "Bah, humbug!" What especially bothers him about the Radio City Christmas movie is that the audience can weep piously over the kindly acts depicted—and then behave abominably to one another when the lights come up. That is the essence of grownup phoniness: to admire Dickens and the Christmas spirit strictly in the abstract.

In the railroad station, just after arriving in the city, Caulfield strikes up a conversation with two nuns. They "had one of those straw baskets that you see nuns and Salvation Army babes collecting dough with around Christmas time. You see them standing on corners, especially on Fifth Avenue, in front of the big department stores and all." Although these women are not collecting money, he presses a ten dollar donation on them. The rest of his funds have already been earmarked for a date, but he regrets his stinginess the minute the nuns leave: "Goddam money. It always ends up making you blue as hell." Days later, on Fifth Avenue, he looks for them again, in the natural habitat of sidewalk solicitors. "It was fairly Christmasy," he says, defining the holiday by the appearance of charity kettles and baskets. "All those scraggy-looking Santa Clauses were standing on corners ringing those bells, and the Salvation Army girls, the ones that don't wear any lipstick or anything, were ringing bells too. . . . Anyway, it was pretty Christmasy all of a sudden."[131] Good deeds and generosity—the bells and the baskets—bracket the novel, marking the beginning of Holden's lonely trek through the city and its sad finale. And it is here that Salinger makes an important distinction between make-believe and falsity. Although the costumes of the Fifth Avenue Santas leave something to be desired, the charity workers are the only players in Holden's New York Christmas who aren't phony.

The ersatz Santas standing beside their cardboard collection chimneys were working for the Volunteers of America, an offshoot of the Salvation Army.[132] In 1903, their wagons were already making the

rounds of the fashionable apartment houses of New York, picking up
toys and clothes for distribution to tenement families on the East
Side; wherever the wagons stopped, crowds of children gathered,
hoping for new Christmas balls and dolls.[133] The Volunteers began
supporting their work with the collections of Santas in 1917. Like
their spiffier counterparts in the department stores, the street-cor-
ner Santas were a source of much confusion to children, who won-
dered which man in a red suit was the real Mr. Claus and which
were the phonies. They were the butt of jokes, too, based on the con-
trast between the image of the kindly saint and the character of the
actual personage behind the cotton whiskers. The Volunteers, for ex-
ample, recruited their Santas from the residents of their rehabilita-
tion centers for indigents and alcoholics. In 1988, they paid each
Santa $15 a day plus room and board and a 15 percent commission
on his take. The money was an incentive, said a staff member in the
New York office: "It helps them to be really jolly St. Nicks!"[134]

The questionable sidewalk Santa is the mechanism that drives the
plot of *The Lemon Drop Kid,* Bob Hope's 1951 comedy.[135] Best re-
membered as the movie that introduced the popular Christmas song
"Silver Bells," *The Lemon Drop Kid* was based on a Damon Runyon
short story, featuring his usual cast of urban bums, sharpies, and
"characters." In this case, Hope plays the Kid, a fast-talking race-
track fixture who runs afoul of a mobster in Florida and is given until
Christmas to pay him $10,000. The Kid's solution is simple: he re-
cruits an army of confederates, dresses them up in cheap Santa
suits, and stations them beside bogus charity kettles all over New
York City. "Adjust boots, bellies, beards," they chant, as they march
to their assigned corners to bilk the public: "Silver bells, silver bells,
let's put some dough in the kitty. Chunk it in . . . or Santa will give
ya a mickey." Before the final credits run, morality prevails. The
wisecracking Hope and his squad of Santas repent and the money
goes to support a legitimate shelter for old ladies. But the contrived
ending cannot disguise the residue of real poverty represented by the
street people who form the background for the story: the lady selling
sprigs of mistletoe for 10 cents apiece, the chestnut vendor, the old

woman in her newsstand, the hatcheck girl. New York at Christmas could use a few more Scrooges.

Dickens comes down to the twenty-first century as a story so familiar that its outlines can be discerned in bad Bob Hope oldies or in sour Christmas-vacation comedies like the 1988 *Scrooged,* which seems determined to exalt the postmodern trappings of the yuppie-hero's success at the expense of any signs of transformation.[136] *A Christmas Carol* puts unhappiness, misery, and human wretchedness on the Christmastime agenda, in a sharp and dynamic contrast to the remnants of Irving's Olde Christmas—the pies, the homecomings, the sense of security and continuity in a warm place on a snowy winter night. Yet Dickens respects the importance of turkeys and puddings and holly and the other signifiers of Christmas, or the means whereby most Americans learned to mark the importance of the day in the nineteenth century. In search of that warm, holly-strewn place of long ago, the twentieth century put little Dickens Village houses under the Christmas tree and dredged up recipes for strange boiled puddings impossible to make from mixes.[137] Hence the paradox: the most materialistic and nostalgic of all holidays is also the year's primary occasion for considering the harsh realities of the world, and those who have no trees and puddings. A family holiday, Christmas also demands attention to outsiders and strangers, like the phony Santas ringing bells beside their cardboard chimneys.

O TANNENBAUM

Indoor and Outdoor Christmas Tree Spectacles

J ust where the first American Christmas tree was erected is the subject of no little wrangling. Although he acknowledges that it was not actually the first tree of any kind to have been set up for the holiday on American soil, Stephen Nissenbaum argues that Charles Follen's 1835 tree, in the drawing room of his house in Cambridge, Massachusetts, was the first important one. A Harvard German professor who had learned about the custom abroad, Follen merits attention because British visitor Harriet Martineau wrote about his tree in the context of abolitionist politics, thus linking antislavery sentiment to a new, empathetic attitude toward another group of powerless Americans—namely, children, for whose pleasure the trees and gifts were primarily intended.[1] In Nissenbaum's reading, the Follen tree—the first historically significant American Christmas tree—stands for benevolence toward the weak, the poor, the unfortunate.

A second, fictional tree of the same vintage also interests Nissenbaum. Catharine Sedgwick, a member of the intellectual circle of Martineau and Follen, wrote a short story in 1835—it was published in a book specifically intended for Christmas giving—featuring a tree set up at the behest of a German serving girl. That tree, ac-

cording to Sedgwick's literary conceit, bore "multifarious fruit" in the form of toys, books, and candies, all made or embellished by the eldest sister of the household. The family Christmas tree of the 1830s, Nissenbaum concludes, stands in opposition to the commercial bustle of the marketplace.[2]

But the harder question is how the Christmas tree came to be an immutable American tradition, with its origins lost in the mists of time, before the end of the century. If Follen and Sedgwick were the Christmas tree pioneers of the 1830s, the decorated evergreen was already old news in 1891. Benjamin Harrison, telling reporters about his holiday plans on December 22nd of that year, said that he and his wife were going to "have an old-fashioned Christmas tree for the grandchildren upstairs" in the White House.[3] What touched off the national mania for Christmas trees that made them "old-fashioned" by the 1890s? How did Americans learn to decorate trees for Christmas and to use them as an increasingly cumbersome gift delivery system?

Trees hidden away in private homes, like Follen's, did not inspire the rest of the nation to adopt the practice; descriptions in stories and memoirs of the intellectual elite, however vivid, did not offer sufficient guidance in the crucial step-by-step details of evergreen transformation. Public trees or spectacle trees, on the other hand, provided concrete examples of precisely what needed to be done to erect a successful Christmas tree. A tree set up in the front room of a rented house in York, Pennsylvania, in 1830 by the Dorcas Society, a group of women engaged in good works, may be the earliest recorded public tree. Described in the local newspaper as "a famous CHRISTMAS TREE," the York tree was the centerpiece of a Christmas Fair or bazaar, scheduled to open on Christmas Eve for the sale of fancy articles made by the members. Admission tickets—6¼ cents each—entitled the bearer to gape at the tree and buy the items in question, presumably for holiday giving.[4] Receipts went to charity.

In Germany, where a minor tradition of the seventeenth and eighteenth centuries became a national custom in the 1830s, the Christmas tree was often of table-top size, one little tree per child, deco-

rated with his or her own gifts; taller trees, also hung with "beautiful presents," were the occasions for parties at which the branches were undressed with due ceremony.[5] The newspaper in York, however, referred to the Dorcas Society's Christmas tree as "famous" not because actual trees like these were common among the German-speaking populace, but because the novelty of the German Christmas tree had received much recent attention in the American press. Catharine Sedgwick's story is one example, but throughout the antebellum era accounts of trees and their use in Germany were widespread.[6] In Rochester, New York, a Protestant church celebrated the holiday in what the congregation took to be the German manner in 1840 by erecting a 12-foot tree hung with toys and sweets in the nave of their sanctuary.[7]

The tree was new, exciting, a novelty of more than passing interest to readers of local newspapers. In York and elsewhere, curiosity was so great that people were willing to pay to see a Christmas tree. Public trees set up for profit were common throughout eastern Pennsylvania in the 1840s. In Boston, by some accounts, the decorated "evergreen shrub" was what attracted patrons to Christmas Antislavery Fairs in the 1830s and 1840s.[8] At one such fair, organized under the leadership of the energetic Maria Weston Chapman, the tree was adorned with wax candles, colored lamps, "gilded apples, glittering strings of nuts, tissue paper purses filled with glittering egg baskets and crystals of many-colored sugar, with every possible needlebook, pincushion, bag, basket, cornucopia, penwiper and doll that could be afforded for ninepence."[9] At a fictional Christmas fair which is the only holiday joy of a little girl in an 1878 story, the tree is a fairyland of "pen-holders with spiders . . . on them, cushions representing the old lady who lived in the shoe, and needlebooks made like wheelbarrows."[10]

The image created by these giddy descriptions is one of abundance, profusion, and well-being, but it is also a picture of a Christmas tree that amounts to a display rack for elaborate homemade products. As Beverly Gordon points out in her study of fund-raising fairs, the ornamental qualities of the useful objects offered for sale

contributed to the enjoyment of a ladies' charity bazaar.[11] Whether the cause was the welfare of the poor or the abolition of slavery, the means to the end were the sensual pleasures afforded by material things—including the Christmas tree. The trinkets on sale could readily double as glittering baubles to ornament the branches. And the tree itself was an event, as much as a beautiful entity—something to be plundered of its fruits at the proper dramatic moment.

Thus, in the parlance of the 1830s and 1840s, having a Christmas tree meant using the tree to display objects—wares, gifts—in a kind of holiday spectacle of merchandise. The tree was also a way of distributing seasonal largesse, often with a party or special viewing for that purpose: when the proper moment arrived, the tree was summarily stripped, down to the bare branches. Magazine articles about Christmas, especially those published when trees were still out of the ordinary, portrayed the Christmas tree as the requisite scenery for a kind of performance. "It was the custom in the Reade family to have the Christmas tree on Christmas morning, because then the little ones were bright and able to enjoy it," states an 1881 story, which conflates the tree with the act of plucking its treasures.[12] In other inspiring tales for the holidays, neighbors take up subscriptions for a poor family, so that they will have "some nice things to put on the 'Tree'"—and to take from it.[13] Little girls beg their kind fathers for permission to attend holiday frolics organized around the exhibition and subsequent denuding of a tree. "They are going to have a Christmas tree," cries one excited young lady, "and Molly has written twice for me to come."[14] The Christmas tree is both an object of wonderment and a joyous ceremony of sanctified greed.

Given the genteel prose in which this complex muddle of ideas was expressed, the average mid-century reader might be forgiven for wondering what a Christmas tree was supposed to look like. *Kriss Kringle's Christmas Tree,* an 1845 children's book published in Philadelphia, had an embossed picture of Santa and a tree on its cover: the tree was a stunted, leafy bush from which depended two lonesome balls and a doll, hung by the neck like a convicted murderer. The editor's introduction to the 1847 edition stated that "fashions

change, and of late Christmas trees are becoming more common"—
and then went on to recommend that aunts and uncles hang copies
of the volume on whatever newfangled trees they might encounter
that Christmas.[15] As a guide to the dimensions, placement, and
adornment of a proper tree, however, *Kriss Kringle's Christmas Tree*
was next to useless.

For eminently practical advice on Christmas trees, the latest fash-
ions from Paris, or the steaming of a plum pudding, Americans
turned, as they so often did, to *Godey's Lady's Book.* Editor Sara
Josepha Hale is best remembered for her crusade to make Thanks-
giving a national holiday. From 1846 until President Lincoln pro-
claimed a day of gratitude and reconciliation in 1863, Hale had used
her magazine as a platform from which to argue that the old New
England feast could serve to reunite a divided country.[16] Every au-
tumn, directions on how to stuff a turkey and make a mince pie ap-
peared in the pages of *Godey's;* as much as any editorial or procla-
mation, the establishment of a common nationwide menu for a ritual
meal served, in turn, to create the holiday on which the dinner was
avidly consumed. Things—in this case, golden-brown turkeys and
fragrant pies—supported and sustained ideas.

Less well known is Hale's pivotal role in the creation of the Ameri-
can Christmas. Here, too, she relied on things to convey the warm
family sentiments and benevolence that *Godey's* associated with
Christmas. And her chosen totem was the fashionable yet mysteri-
ous Christmas tree. On December 23, 1848, the *Illustrated London
News* printed a picture of Queen Victoria, her husband, and five of
their children gathered around a Christmas tree at Windsor Castle.
Prince Albert of Saxe-Coburg-Gotha, Victoria's German-born con-
sort, had begun to set up small children's trees in the couple's pri-
vate quarters some years before. In 1848, with mistrust of his foreign
origin at its height, the sketch of Albert's table-tree, sanctioned by
the monarchy, was meant to show him to the public in a kindly light,
as a tender British husband and father, providing new Christmas
pleasures for his family.[17] Sarah Josepha Hale edited out the crown
jewels on Victoria's person, Albert's sash and mustache, and some

boxes of German biscuits under the tree. In December of 1850, she published the expurgated picture in *Godey's* as a rendering of the modern, middle-class American family, gathered around the Christmas tree (see illustration in Chapter 1).[18]

In an odd way, the *Godey's* Christmas tree was the ultimate public tree. Conceived as a piece of political propaganda by the British throne, it became an example to Americans of what a respectable tree was all about. In fact, the former Prince Albert tree looked somewhat artificial—perfectly shaped, with branches arranged in widely separated tiers or layers so that the candles stood free of foliage and the ornaments hung down without impediment. There was an angel at the top of the tree. Most of the decorations were baskets, boxes, and other containers for little gifts. Beneath the lowest branches, some larger presents—all unwrapped—were casually grouped: several dolls, a mounted cavalryman, a figure driving a chariot pulled by a pair of fine horses. The Christmas story in the same issue of *Godey's,* a potboiler full of coincidence, mistaken identity, lost brothers, and holiday miracles, makes no mention of a tree. Instead, the day is marked with the burning of a yule log and the consumption of prodigious feast: "Wonderful the poultry and the eggs, the pastry and the fruit, the sugar, the lemons, the spices, the sauces . . ."[19]

In 1860, with Civil War imminent and families about to be separated by the call to arms, Hale printed the picture again, with the same title: "The Christmas Tree."[20] But this time, the caption directs the reader's attention to a short story meant to accompany and explain the illustration. The story, again, is a predictable exercise in Victorian melodrama, in which a father bearing a grudge against a dead rival for the hand of his wife (also deceased) seems determined to thwart his daughter's engagement to the rascal's son. It all comes right in the end, of course, as the father relents and the dashing young lover steps out from behind the Christmas tree to claim his bride. The story, however, is little more than an excuse for *Godey's* to issue detailed instructions on what to do with a Christmas tree: how it should be made to stand upright (in a large stoneware jar filled

with damp sand and disguised with moss and a skirt of green chintz), how it should be "dressed" (hung with the various tea-sets and work-boxes coveted by the children), and how it ought to be displayed (at an evening party for the exchange of presents called "a Christmas tree").

The tree in the *Godey's* story is much taller than the pictorial example provided in the same issue. It reached almost to the ceiling because "*all* the family presents were to be placed upon it." Avoiding the untidy collection of odds and ends beneath the Prince Albert tree calls for ingenuity on the part of the heroine; Christmas Eve finds her locked in the parlor with the tree, constructing "a basket work" of colored ribbons looped through the branches to hold the heavier, bulkier gifts, including a live canary in a cage and "a large cart . . . with two horses prancing before it."[21] Only a few wooden animals were left over, set down to graze on the moss underneath the lowest branches.

Much of the story reads like a how-to-do-it book, as the protagonists pause in the course of their troubles to string holly berries on a cord and loop them around the tree, or to thread wires through candles to bind them to the branches, all the while cautioning the reader to rub the wicks with a little alcohol for a quick, even light. "Strings of bright berries, tiny flags of gay ribbons, stars and shields of gilt paper, lace bags filled with colored candies, knots of bright ribbons . . . made a brilliant show at a very trifling cost," the author continues as if she were writing a column of household advice. Indeed, the *Godey's* story treats the Christmas tree as it does stuffing a Thanksgiving turkey or sewing lace along the brim of a bonnet: the tree is women's work, trimmed under a veil of breathless secrecy. The closed doors were necessary because the presents, unwrapped except for candies in dangling containers, were openly exposed, as decorations on the tree. The secrecy was also necessary in order to achieve the proper theatrical effect: when the candles were lit and the back parlor was finally thrown open to view, the visual impact of the Christmas tree was all the greater because the spectacle always came as a surprise, especially for the children.[22]

Godey's remained an influential source of guidance on matters

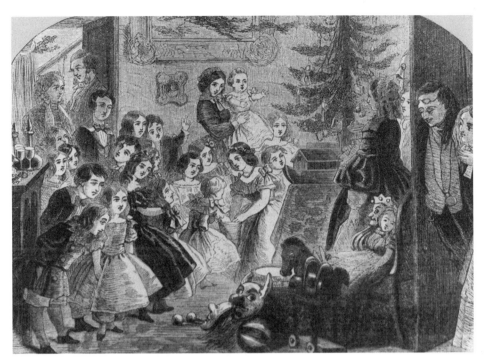

In 1861, "Christmas Tree" meant a party centered on denuding the branches of gifts. *Godey's Magazine and Lady's Book* (December 1861), 457.

pertaining to the Christmas tree throughout the Civil War era (thirteen states took action to make Christmas a legal holiday between 1861 and 1865). During this time the tree was gradually taken up by other magazines as a symbolic contrast to war and a sad reminder of families divided by the call to arms.[23] A full-page illustration of "The Christmas Tree" published in *Godey's* in 1861 shows a children's party in progress around a table-tree. The grownups in the scene, parents and doting aunts, peer around doorways to watch the fun, but there are few adult males present. This is a family festival from which the traditional grouping of Victoria, Albert, and the children is oddly absent. The function of the tree seems to have changed slightly as well. The guests at the party have all but ignored the little items on the tree. Instead, they are interested in the big toys heaped up underneath or on nearby chairs and stools: a Noah's ark, a drum, a horse-on-wheels, and a Punch and Judy set.[24]

This Christmas illustration was adapted from a British journal by the simple expedient of adding stars and stripes to the flags. *Harper's Weekly* (December 28, 1867), 825.

An 1867 Christmas tree picture in *Harper's,* again adapted from the *Illustrated London News,* shows three little girls awakening on Christmas morning to the sight of a decorated tree at the foot of their bed. The ornaments consist of candles, glass balls, stars, and a plethora of flags, with no obvious toys or gifts. In the American version, the flags all show the stars and stripes, as if to celebrate the end of the Civil War and the restoration of the Union. The gifts at the head of the bed (a fancy doll and the ubiquitous horse-on-wheels), shadowy presences in the original, are spotlighted in the American adaptation.[25] The tree is no longer large enough to carry the burden of the elaborate gifts required in bulk for an adequate observance of Christmas.

Given the "borrowing" of engravings from foreign periodicals by *Godey's* and its competitors, it might seem hazardous to conclude

much about American Christmas customs from looking at illustrations. Yet these same pictures were the means by which the reader developed her own mental image of a tree, the quality and quantity of suitable presents, and the means of dispensing them. So it makes little difference, in the end, whether an 1877 *Godey's* plate of a fashionably garbed lady "Dressing the Christmas Tree" originated in England or the United States. What matters is that her table-tree is far too small to hold the heaps of store-bought toys intended for the naughty baby, peeping at the proceedings from the background. Of the many boats and carts and wagons scattered on the floor and arranged under the tree, only one gift, a jumping-jack, is being hung from the branches of the Christmas tree. An 1876 engraving of a tree featured in the handiwork column of *Godey's* shows a tree in a jar all but overwhelmed by the bounty displayed on a bed of moss beneath it. That mossy precinct, according to the text, "form[s] a border for the apples, oranges, gilded nuts, and bags of muslin and tarlatane, containing sweetmeats, together with the books and larger toys which could not be conveniently suspended from the branches of the tree."[26]

Harper's Weekly made its most enduring contribution to American culture during the Civil War with the invention of the definitive Santa Claus by the illustrator Thomas Nast. Throughout the next forty years Nast would draw Santa hundreds of times, but his was almost always the figure described in Clement Clarke Moore's 1832 poem, *A Visit from St. Nicholas.* The identifying marks of the Nast Santa Claus are the ones described by Moore: a sleigh, the reindeer, and, above all, the stockings "hung by the chimney with care."[27] Moore never mentions a Christmas tree, however. And, with the exception of a famous double-page engraving of Santa's year-round activities at the North Pole, Nast rarely includes trees among the attributes of his hero.[28] When the Nast Santa Claus does trim a tree, in 1866, it is with American flags and ornaments; whatever gifts cannot be stuffed into the stockings are deposited on the hearth immediately underneath them. In practice, this amounts to most of the elaborate, factory-made presents on display, including a hobby-horse, a wheelbar-

Mother "dresses" the tree, 1877, hanging all but the heaviest items to serve as ornaments. *Godey's Magazine and Lady's Book* (December 1877), 455.

Thomas Nast shows Santa Claus trimming the tree; since the trimming was generally done in secret in the 1860s, this became part of the Santa legend. *Harper's Weekly* (December 29, 1866), 824.

row, a French doll, a boxed tool set, picture books, a Noah's ark, and a set of alphabet blocks.

A Nash illustration that was the centerpiece of *Harper's* 1863 Christmas offering depicts a family reunion, entitled "Furlough." It is a homely scene, without any traces of the Santa legend. At the center, under the mistletoe, a father on leave from the Union army kisses his wife as the children look on and happy relatives arrive to greet the returning hero (whose photograph, hanging on the back wall of the parlor, has been crowned with Christmas greens). The familial character of the vignette is underscored by the presence of a table-top Christmas tree, with presents scattered around its base. There is a nicely finished box, bound in fabric or leather, and a shapeless bundle, tied with cord. Most of the gifts are military toys—

a drum and a bugle—and the soldier's little boy has already received a toy rifle.[29]

Like Nast's image of the wartime "Furlough," *Harper's* Christmas tree pictures of the 1860s and 1870s tend to replicate *Godey's* seminal grouping of father, mother, children, and tree. The 1860 cover, entitled "Christmas Dinner," is ringed by subsidiary scenes of Santa filling stockings and children hanging them, the wealthy giving alms to the poor, and a Christmas tree—a large one—shown in the context of a family gathering, with children clinging to their father as drums and other gifts are systematically removed from the branches.[30] A second *Harper's* Christmas scene for the same year, entitled "Santa Claus," shows a sleeping boy, the stocking, and Santa and the reindeer on the roof, but the principal subject is a busy shopping street, with patrons gathered around the window of a toy store in which a decorated tree presides over shelvesful of novelties and geegaws.[31] The 1865 "Christmas Presents," by Sol Eytinge, is a reprise of Nast's "Furlough." The war is over; the father's sword and cap hang above the mantelpiece as he cuddles the new baby. In the shadowy background of the scene is a full-size Christmas tree. In the foreground, children play with a host of gifts that clearly came from the store: paint and tool sets, a baby carriage, a china doll, and a stack of illustrated books.[32]

Frank Leslie's Illustrated Newspaper featured its first Christmas tree in an 1857 article about old-fashioned English ways of celebrating the holiday. Although the author credited "the mysterious exhibition of the Christmas Tree" to very recent times, the editors could not resist adding an appealing picture of an extended family gathered around a tree proportioned very much like Prince Albert's—a measure of the growing popularity of Christmas trees in America.[33] The Albert/Victoria conceit appears again in *Leslie's* pictorial survey of a wartime "Christmas—1863." With Union soldiers pausing to decorate their snowbound camp with holiday greenery, the family back home gathers about a Christmas tree in perfect domestic harmony.[34]

Taken as a whole, the popular Christmas tree pictures of the Civil War era stand firmly apart from the fantasies of the Santa Claus

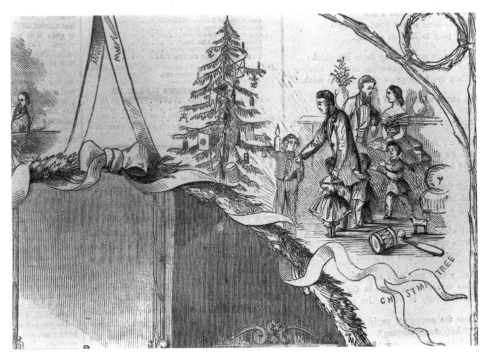

The Christmas tree, 1860. *Harper's Weekly* (December 29, 1860), 817.

myth. Instead, they present an idealized picture of family life in the United States, anchored by the symbol of the decorated tree.[35] There is nothing miraculous about these families and their activities: the gifts that appear in greater and greater profusion under and around their Christmas trees come from real stores and factories and importers' warehouses. Or from the "Great Exhibitions" of Christmas gifts, from the advertisements of mail-order chemistry sets, jumping-jacks, rocking horses, and games in the pages of *Harper's* and the other journals, alongside their annual Christmas illustrations.[36] By fits and starts, those illustrations point to a new economy of gift-giving, geared to manufactured goods, a torrent of gifts that rapidly outgrew the capacity of both the stocking and the tree.

Stockings were the traditional present containers, gradually relegated to the nursery or to the symbolic trappings of the past because of their insufficient size. For gift-giving of significant modern propor-

The connection between the home front and the army encampment in this illustration entitled "Christmas—1863" is the lavish use of Christmas greenery. The presents have multiplied and grown in size: many of them can no longer be hung on the branches. *Frank Leslie's Illustrated Newspaper* (January 2, 1864), 232–233.

tions, the tree—with its adjacent colonized territories—was superior to the old-fashioned stocking. When gifts were mere ornaments on Christmas trees, both presents and trees tended to be modest in size.[37] But as gifts proliferated and became more substantial, trees grew taller; the spreading space beneath their branches afforded a better stage for the display of gifts.

The aesthetic of the Christmas tree is closely related to that of the nineteenth-century store window, in which the aim was to show off merchandise in an appealing way. The American mother and father were not in the same business as Macy's, but they used the Christmas tree to demonstrate and celebrate their prosperity and, not incidentally, their devotion to the material well-being of their children. A bountifully "fruited" tree was the ideal; the orphans and waifs of

Christmas fiction always long for the glittering tree that stands for home, family, and the good things that come to good children at Christmastime.[38] Rebecca Harding Davis, in an analysis of old-time Christmas rites written in 1904, argues that the new zeal for Christmas reflected in the proliferation of trees and presents had its origin in the national prosperity of the early 1860s. "When Christmas drew near," Davis hypothesizes, "the stay-at-homes spent their . . . affection in packing boxes for the boys at camp. . . . There was more meaning in these Christmas gifts than we shall find in ours."[39] The Christmas tree was the product of abundance, spiced with pangs of anxiety.

Today's Christmas tree is one of the few purely aesthetic objects created by families and individuals. It is possible to buy a tree, pre-trimmed and ready to go, but most households still rummage in the attic for the old decorations, add a few new ones, and create an annual display which is just that: something to be admired, observed, enjoyed. The tree is "dressed" with care; due consideration is given to symmetry, balance, and harmony. Thus the tree is a strong periodic statement about taste, family traditions, conformity to established practice, and the social continuities or discontinuities important to the trimmers. Unlike the Christmas trees of the Civil War era, which only gradually gave up their function as convenient places for displaying the season's plunder, today's tree is not about presents, except insofar as piles of pretty wrapped boxes under the tree complete the artistic ensemble.

Today, stockings and trees coexist nicely. Stockings are minor elements of a Christmasy decor. If used according to Clement Moore's instructions, they hold trinkets and trifles, the kind of gifts copywriters describe as "stocking-stuffers." The tree is the focus of attention, with the adjacent carpet the place where the toasters, the snowflake sweaters, and the electric trains are to be found. In the nineteenth century, however, there was often a hard choice to be made between stockings and trees—a determination based on custom and breeding. "My husband's people always have a tree," remarked a Brooklyn lady in 1893. "But I was brought up to celebrate in the other fashion,

and so . . . we hang up our hosiery."[40] The triumph of the tree, virtually complete by 1890, represented a kind of inversion of the older fireside Christmas. What had been an intensely private affair of sleeping children visited by a mythical being—the Stocking Christmas—became a quasi-public ceremony conducted within the home, or the Tree Christmas. The Tree Christmas was a great, once-a-year familial show, a drama equal to anything seen in a store window: light, color, reflection, glitter, artifice, and merchandise, all arranged according to the preferences (and income) of the household, with a little help from *Godey's* or *Leslie's.*

The family Christmas tree was a spectacle, albeit on a modest scale. The diary of a New York woman who adopted the ritual in 1860 refers explicitly to the showmanship involved in decorating and displaying the Christmas tree. She put hers in a bay window and adorned it with sixty little gifts; the rest were deposited on a nearby billiard table. When the company arrived, she turned out the lights and suddenly "the darkened rooms were brilliantly lighted [and] the sliding doors thrown back, exposing to our view the lighted tree: it was certainly a beautiful sight . . . and glee filled the room."[41] What happened in the family circle was magnified when Christmas trees were set up in public places or venues of public significance. In 1855, *Godey's* depicted a charity Christmas tree party in progress in a huge hall, with scores of children clamoring for the treats arrayed on the branches.[42] The first White House Christmas tree, set up in the East Room in 1856, the final year of Franklin Pierce's term, went unrecorded in the pages of *Godey's.* But the fact that the President and his wife had a tree, around which the children of the New York Avenue Presbyterian Church had been invited to sing Christmas carols, gave legitimacy to the symbol as the locus for holiday drama.[43]

As trees and gifts began to multiply in the 1850s, with the help of a huge influx of German immigrants, Protestant churches struggled to integrate fashion with theology. Ministers reminded their flocks that the Magi brought presents to the Baby Jesus; in just that spirit of charity should they bestow gifts upon their loved ones. An 1845 genre painting by Carl August Schwerdgeburth, depicting Martin Lu-

THE SUNDAY SCHOOL CHRISTMAS TREE.

OUR INFANT CLASS GOING UP.

COMING BACK.

Children attending a "Christmas Tree"—a public distribution of gifts—at Sunday school, 1885. *Harper's Young People* (December 8, 1885), 89.

ther's family gathered around a lighted tree, was often reproduced in church tracts; the legend that Luther had invented the Christmas tree enlisted a wholly secular symbol in the service of religion.[44] Finally, in the 1850s and 1860s, clergymen brought the tree into the church, as the cornerstone of Christmas exercises for Sunday school classes.[45] Nativity pageants staged around the tree ended in a mass distribution of toys, candy boxes, and warm mittens.[46]

In the public schools of New York and other cities, poor children of immigrants from southern and eastern Europe were taught about the Christmas tree as a part of citizenship exercises at the turn of the century. Kindergarten pupils selected trees, carried them into

The sixteenth annual program of the Christmas-Tree Society, Brooklyn, 1908; 4,000 poor children were fed, entertained, and showered with gifts. *Leslie's Weekly* (January 9, 1908), 41.

the classroom, and made decorations with paper and paste. Later, they were taught "the use of the toys" left beneath the tree by kind teachers and wealthy benefactors.[47] In the ghettos of New York, the Salvation Army established places of refuge for poverty-stricken mothers and children. Called "crèches," after the Christmas manger at Bethlehem, they too featured Christmas trees hung with gifts as instruments of Americanizing their charges while providing needed sustenance to body and soul.[48]

Of all the noteworthy nineteenth-century trees, however, the one that took hold in the popular imagination was the grand forty-five foot tree set up in the iron and glass nave of the Music Building at the 1885 New Orleans Exposition. Otherwise known as the World's Industrial and Cotton Centennial, the New Orleans fair attracted over three million visitors during the course of its two-year run. But the most memorable exhibit in New Orleans had nothing to do with industry or cotton. It was the big hemlock, brought all the way from Edgewood, the New Haven, Connecticut, estate of comic writer "Ik Marvel."[49] Accounts of the lighting vary. Some reports contend that

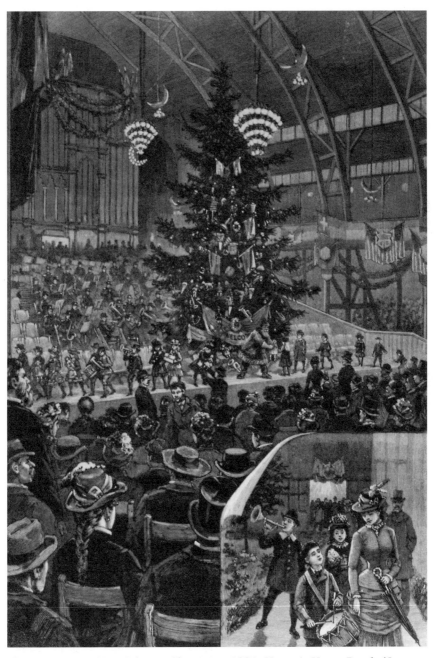

The great tree in New Orleans, Christmas, 1884. *Harper's Young People* (January 13, 1885), 169.

the tree was illuminated solely by "the glow of the incandescent lights" mounted in the ceiling. Others state that, in addition to the "dazzling line of Edison electric lights" in the rafters, "every twig flashed with electric lights," too.[50] However the lights were managed, everyone agreed that the tree was a stunning sight, every branch laden with "dolls, chairs, wardrobes, clocks, watches, tables, all sorts of [doll] furniture, guns, pistols, jumping-jacks, wooly dogs, sheep, bird-cages perched among the boughs, all jolly and agreeable, and fancy-dressed dolls, swans, ducks, geese," and more.[51]

The presents were the brainchild of a local woman who enlisted one of the venerable state commissioners to the exposition—the one with the snowiest whiskers—to play the part of Santa, wearing Arctic gear used on several government expeditions to the polar regions. On Christmas day, to the blare of trumpets, Santa appeared before the tree and distributed gifts to a waiting throng of children. So numerous were the presents tied to the tree, however, that he was forced to come back the next day, and the next, until the giant hemlock refused to yield up one more sugar-plum or satin-lined workbox.

The Christmas tree in New Orleans startled no one: although the kinds of trees usually selected for the purpose were Yankee varieties, not native to Louisiana, the spread of the custom from Eastern cities to the rest of the country was taken as a given in 1885. Magazines and railroads had already helped to break down sectional differences, and the Christmas tree was an excellent example of an idea—a mere picture, a shadowy description—imported from abroad and nurtured into vigorous reality by the free flow of goods and images. Like the New Orleans Exposition itself, there was something intensely modern and commercial about the American Christmas and the big American Christmas tree. One of those national magazines commended the fair for pausing, in the midst of its commercial mission, to become "a children's pleasure ground. . . . Whatever good the New Orleans Exposition accomplishes—whether it helps business, or encourages manufactures, or binds the North and South more closely together—it can do nothing more useful and admirable than

this. Every boy and girl has heard it said that the Americans are a material, . . . money-getting people, and that where trade is in question they do not stop to indulge in sentiment or romance."[52] Perhaps the great, public tree in New Orleans would prove that business could do the good work begun in the stable at Bethlehem.

Topped by an electric Star of Bethlehem, the first community Christmas tree was erected in New York's Madison Square Park in 1912, in the generous spirit of the tree at the New Orleans fair. Early reports about the planned Christmas tree in Manhattan state that organizers had two goals in mind. The first was "the joy and delight of youngsters whose stockings would otherwise hang empty." And the second was to serve as an example to other cities, encouraging them put up holiday trees to bring "cheer to the people."[53] Led by Mrs. J. B. F. Herreshoff of Central Park West, a committee of modestly anonymous citizens secured a fine specimen of a tree—it was almost seventy feet tall—from the forests of the Adirondacks, begged free passage on the nearest railroad, and obtained the necessary permits and permissions to stand the noble evergreen upright in the center of the park, secured in a great block of cement.[54]

The Edison Company was enlisted to wire the tree with 1,200 multicolored bulbs, in addition to the bright star on top. "It is hoped by those who have worked for it and hope to personify the great Christmas spirit that the placing of a great outdoor Christmas tree may become a National custom, taking the place in America of the older customs of older lands," the city's benefactors stated. "The tree is typically modern and American, for it would not be possible for it to appear in all the beauty of an illuminated Christmas tree without electric lights."[55]

At first, there was some confusion about the placement of the tree. New Yorkers assumed that it was inside Madison Square Garden or one of the other embryonic skyscrapers skirting the park and that admission tickets would be required to see it. Only with difficulty did the committee convince the city that the tree was for everybody, rich or poor—that the "Tree of Light" and the musical program planned for the lighting ceremonies on Christmas Eve were absolutely free.[56]

Despite these uncertainties, 25,000 people turned out in a snow-storm to hear carols sung by settlement house choruses, an operatic tenor (using a megaphone), and various ethnic singing groups. The newspapers made much of an old lady from Brooklyn, suffering greatly from the cold, who was given a seat by a kindly policeman on a heated platform reserved for performers. Ignoring her discomfort, she refused to go home with the escort provided by a troop of thoughtful Boy Scouts until midnight came and the crowd, the musicians, and the Scouts all sang "My Country 'Tis of Thee" in unison to close the program.

"This was a real Christmas for me," a shabby woman was overheard to tell a companion. "Those rich people who give so much money away on Christmas always get the idea that the poor need something to eat. They forget that we also like to look at nice things and hear lovely music."[57] The evident delight of the onlookers gave organizers reason to hope that the city would let them plant a living tree on the spot, as a monument to New York's first public tree and a way of perpetuating "the spirit of peace and good-will the whole year through." One of the cops who patrolled Madison Square hoped they would get their way. "It's the loneliest place at night in all New York," he said. "There's nothing but loneliness there!"[58]

The Madison Square tree was universally praised. Committees and mayors in Hartford, Philadelphia, Boston, and Buffalo adopted the outdoor city tree as their own, with the modifications suggested by the New Yorkers who had struggled to adapt a familial institution to public usage. Originally, for example, the Madison Square tree was to have been strung with toys and candy as well as lights, but the crowds promised to be vast. How could the donors possibly determine which children needed gifts and which did not? In the interests of public safety, the presents were scrapped. Charity was left to the Salvation Army, and the public tree justified its existence on the grounds of its beauty alone. But parts of the parlor ritual survived. The old domestic drama in which the room was darkened and the tree suddenly illuminated proved just as effective in Madison Square Park. Trumpets sounded. The bright star was lit. Dim, at first, it

New York City's "Tree of Light." *St. Nicholas* (December 1917), 146.

grew in brilliance as the moments passed. Caught up in the moment, the crowd gasped—then cheered, as the colored lights winked on, too. It was a old-fashioned "Christmas Tree" ceremony on an immense scale.

One of the prime movers behind the Madison Square tree was the reformer Jacob Riis. A Danish immigrant, Riis had begun his career as a police reporter for the *New York Tribune*. His photographs of tenement dwellers came to the attention of Theodore Roosevelt, at that time the police commissioner of New York, who became a

staunch supporter of Riis's crusade to battle the injustice and poverty of the slums, armed with stark, documentary images of the suffering he found there. Riis's book, *How the Other Half Lives,* published in 1892, revealed him as one of the most prominent social thinkers of his era. Perhaps because he recognized the power of images and symbols, he was also deeply interested in Christmas. A charming little volume, entitled *Is There a Santa Claus?,* issued in 1904, encouraged children's faith in the miracles of the season. Heavily embellished with line drawings of holly, stockings, evergreens, mistletoe, and other signs of Christmas, the book had a trick ending, in which Riis's kindly host for the perfect holiday was revealed to be President Teddy Roosevelt. "I had to pinch myself," Riis writes, "to make sure the President was not Santa Claus himself."[59]

The point of Riis's book was to remind his readers that Santa and the other trappings of Christmas were metaphors: they stood for the love of the child born in a humble stable and for the sentiments that ought to soften the heart at Christmastime. The Tree of Light in Madison Square was another potent symbol of the values attached to the Christmas story. Riis was careful to note that these were not material values. Calling gift-giving "a barbaric cult . . . a nightmare to the shopper and the clerks in the big stores," he stressed instead the intangible, spiritual side of the holiday: the fellowship of dinner with the poor at a settlement house, the caroling, the beauty of a tree, shining bright in the darkness. The community tree, Riis wrote, was "for the big cities with their many forgotten poor and lonesome rich. The Christmas tree will help them to get together, which is what they really need."[60] For his own part, Riis volunteered to organize a "sane and sober" New Year's Eve celebration on the final night of the illuminations at the Madison Square tree. The loveliness of the tree and the company of others might put a stop to the drunken despair that marred the holiday season in many working-class households.[61]

The public Christmas tree had been enlisted in the cause of Progressive reform: it was a benefaction to the poor, a means of uniting social classes, a call to virtue, and a distinctively American symbol—

the newcomer's best introduction to the customs and beliefs of the nation. The National Community Christmas Tree in Washington, D.C., was meant to be the culminating expression of those ideals. The inspiration behind a National Tree came from several quarters simultaneously. In November 1923, an official of the Washington public schools had written to the President's secretary to suggest the placement of a permanent Christmas tree on the south lawn of the White House.[62] Meanwhile, President Coolidge had already been approached on the same subject by Frederick Freiker, a representative of the Society of Electrical Development, a group dedicated to promoting the use of electricity. Although reports disagree about how the Potomac Electric Power Company came to erect a 60-foot fir on the Ellipse, adjacent to the White House lawn, the tree came from a preserve owned by Middlebury College in the Green Mountains of Vermont, the President's home state. On Christmas Eve, 1923, just as darkness fell, Coolidge pressed a hidden pedal with his foot and lit the 3,000 electric lights on the tree. He had refused to speak at the ceremony, but the message was clear enough.[63] With the sanction of the White House, Christmas—embodied in the twinkling Christmas tree from Vermont—had become an official national event, with important economic, social, and spiritual consequences for Americans.

The White House itself had been extravagantly decorated for the holiday. The Oval Office was awash in holly. And while some newspapers reported that the austere Coolidges had never had their own Christmas tree and did not intend to start that year, two Norway spruces did appear, in the Blue Room and the family quarters, in time for the arrival of the two Coolidge boys from boarding school. They trimmed the trees with their mother's help, went shopping with their father, and, in the full view of the press corps, provided a living example of how Christmas ought to be observed. But Mr. Coolidge, like Theodore Roosevelt before him, had second thoughts about cutting down good, useful trees for symbolic purposes. In 1924, he expressed his reservations to the American Forestry Association, which undertook to plant a living tree on Sherman Square. The 1924 light-

ing ceremony took place there—and the tree eventually succumbed to bad weather, hot lights, and the stress of being assaulted with ladders and heavy ornaments every December.[64]

After several waves of conservationist fervor, and several unsuccessful attempts to keep a Christmas tree alive all year somewhere near the White House, Franklin D. Roosevelt, a Christmas tree farmer by avocation, ordered two spruces planted on the south lawn, to serve by turns as the National Christmas Tree. On December 24, 1941, seventeen days after the Japanese attack on Pearl Harbor, he rededicated the year's designated tree in the teeth of stiff opposition from the Secret Service. In consultation with the Roosevelts' bodyguards, civil defense officers had imposed a blackout on the city and banned Christmas lights for the duration. But Roosevelt chose to ignore the order because he understood the value of symbols.

The war was being fought to preserve an elusive national ideal, the American way of life. What better symbol of home, of generosity, of freedom of worship, and of material prosperity than the Christmas tree? With British Prime Minister Winston Churchill, America's staunchest ally, at his side, Franklin Roosevelt set the National Christmas Tree ablaze with colored lights, as millions listened to the carols and the speeches on the radio and imagined a beacon of joy and hope shining over a darkened Washington. "Let the children have their night of laughter . . . before we turn again to the stern tasks and the formidable years that lie before us," Churchill told the nation.[65] And then the lights were hastily turned out again.

The National Christmas Tree still exists today, but in open competition with other institutional or governmental trees that share a piece of the amorphous good feeling attached to lights and evergreens. In 1954, the old White House tree moved to the Ellipse for good, as the focus of an annual Pageant of Peace that began when the tree was lit. Until court cases challenged the legality of using religious symbols in government-sponsored displays, the Pageant of Peace included caroling choirs, an ever-burning yule log, live reindeer, a Nativity scene, and fifty-seven smaller trees representing the states and territories all featured in the gala.[66] Bigger was better: before 1978, when a

giant-sized tree successfully took root on the site, a competition had developed among the states as they vied to provide the tallest cut tree ever to become the National Christmas Tree.

The National Christmas Tree has survived changing attitudes toward the management of natural resources, ongoing skirmishes over the separation of church and state, and threats to the safety of the Chief Executive. General Electric designs the decorations, the Park Service provides a stage, the President throws the switch (usually from the comfort of his office), and the tourists gasp in delight. At the Capitol, a more modest ritual unfolds itself, under the auspices of the Forest Service, with a cut tree, lights, and ornaments that jingle in the wind. And all across the land, similar trees are trimmed and lit at ceremonies that seem to take place earlier and earlier each year, to mark the beginning of an extended Christmas season—the Christmas shopping season—that used to begin on the morning after Thanksgiving but now seems to start sometime in late October or early November, depending on the projected pace of retail sales.

Bravado, commerce, and the promotional zeal of the electric power industry have all played a part in creating memorable public trees. The "General Grant," a 267-foot, 4000-year-old Giant Sequoia in Sandor, California, was designated the "Nation's Christmas Tree" in 1926, boosting California tourism. The second-largest living Christmas tree, a 300-year-old water oak in Wilmington, North Carolina, was named a national monument in 1929 and regularly attracted crowds of 10,000 or more during the 1930s.[67] Among the giant cut trees, the Madison Square Tree was a fine advertisement both for the incandescent bulb and for New York City. The immense Tree of Light stood directly in front of the Metropolitan Life Insurance tower, then the tallest building in the world. Nicknamed "the skyscraper tree" from its proximity to the architectural landmark, it was another unmistakable sign of the city's modernity and rocketing energy. Its successor was erected in 1926 by the New York Electrical League in the heart of Times Square. Hung with 3,500 colored lights, the effect of the Electrical Tree was magnified by electrical loudspeakers, blaring carols into the surrounding streets.[68]

The conjunction of skyscraper, electric lights, and tree is a New York formula of proven worth. When Rockefeller Center opened on Fifth Avenue in 1933, in the depths of the Depression, tenants were few and far between. As an advertisement calibrated to the giant size of the complex itself, the Center's management put up a tree of its own in the sunken plaza in front of the RCA Building, where the skating rink was later built.[69] Purists insist that the first tree on the site dates from 1931, when construction workers picked up their wage envelopes under a balsam fir crisscrossed with tipsy garlands, set up in the vacant lot at Fifth Avenue and 50th Street, where the Maison Française building was about to rise.[70] But it hardly matters. Other trees came and went—and the Rockefeller Center tree became an instant tradition and a New York institution.

The first official Rockefeller Center tree, in 1933, was decorated with 700 blue and white lights. In the 1990s, trimmers used 26,000 bulbs on five miles of wire. Celebrities, Rockettes, and weathermen have claimed the tree as a scenic backdrop. It is a tourist magnet: 500,000 visitors came every weekend of the season in 1996, obliging the management to set up one-way traffic corridors to control the crowds. It is an always-fashionable tree, which has been flocked (in the late 1940s) and decorated with Scottie-dog ornaments (during the Roosevelt years, to honor FDR's dog, Fala). The city delights in news of the annual search for the perfect tree, of sufficient size and presence to stand up to the seventy-story building at its back. The magic lies in that evocative juxtaposition of tree and building, nature's proudest offspring set against Manhattan's man-made cliffs. For a few weeks at Christmas, they coexist in beauty and in perfect harmony.

Size also plays a part in the enormous amount of sentiment and goodwill attached to certain famous trees of long standing. The annual appearance of the giant Rockefeller Center tree and the Great Tree in Chicago's Marshall Field store on State Street bridges the generations and kindles warm memories in the hearts of urban pilgrims in a way that lesser Christmas trees cannot. Always placed in the Walnut Room restaurant on the seventh floor, the traditional

Marshall Field tree dates back to 1938, when the first 48-foot balsam fir was spirited into the building through the disassembled revolving doors at Randolph and State, hoisted up through a light well, and wrestled into the basin of an empty fish pond in the middle of the dining room. Until the early 1960s the Great Tree was always real, a natural fir cut from the top of a larger specimen somewhere near Lake Superior in deepest secrecy, shipped to Chicago by rail, and delivered to the store by truck under cover of darkness on the Saturday night before Thanksgiving.[71] Within three hours, a crack crew from Field's maintenance and display sections had coaxed the four-story monster into position and, suspended in dangling boatswain's chairs, began the task of placing 1,500 handmade ornaments in accordance with a master chart diagraming the position of every ball and icicle.

The ornaments—and they were entirely new, every Christmas—were the pride and joy of the display department; Annette Lewin, the designer and manager of interior display at Field's who labored over the tree trimmings for more than thirty years, prided herself on annual trips abroad to find German tinsel of genuine silver, delicate Parisian paper lace, and other rare materials for decorations.[72] Behind the ornaments, twined around the trunk of the tree, was a system of extinguishers, ready to douse a fire with chemical retardants. Firemen stood watch over the tree all day and all night, alert to the faintest wisp of smoke. In the 1970s, because of the omnipresent danger of fire in the crowded interior of the old building, the strings of 12,000 electric lights were taken down and the tree illuminated by spotlights shining on reflective ornaments.[73]

This was one major change in the Marshall Field Great Tree. There have been others. The current model is artificial and reusable, with branches that detach for easy storage. The tree goes up on the first Saturday in November now, to kick off a much longer shopping season. Chicagoans, for whom the Great Tree helps to define the public face of the holiday, remember an even larger tree, one of "mythic proportions," although it has always been about the same size it is today. They insist that the tree of their childhoods—that bigger, greater

Great Tree—stood in the courtyard on the main floor, because it could never have fit in the Walnut Room upstairs.[74] In memory, the Great Tree is the Ur-tree, the primal tree, the Old Adam of all Christmas trees—the biggest, the prettiest, the best.[75] As a restaurant reviewer once suggested, "it just isn't Christmas . . . without at least one holiday lunch at the Walnut Room . . . [under] the massive Christmas tree."[76] When the store changed hands in 1990, many Field's customers felt as though their past, their memories, their sense of personal identity were under direct attack. "It's that fantasy-rich, bauble-laden Christmas tree in the Walnut Room," wrote a columnist for the *Chicago Tribune,* "that make[s] so many Chicagoans and visitors alike feel possessive about Marshall Field's at this time of year."[77]

What makes a Christmas tree so compelling? Is it size—four stories at Marshall Field, or ninety feet at Rockefeller Center in 1996? Is it the arresting incongruities—a tree brought indoors (or into the heart of the city), a product of nature bedecked with blatantly artificial ornaments? Is it the once-a-year disruption of the established order of the home or the place of business by this bulky, green, alien artifact? Is it the smell? In the nineteenth century, when the Christmas tree was still an innovation, writers who struggled to describe it properly were struck by its blatant variousness and unaccustomed sparkle. Charles Dickens's 1850 holiday story, "A Christmas Tree," rattles on for pages listing the objects apt to be nestled in the branches, beginning with tapers and "rosy-cheeked" dollies and ending with gilded apples and pears. "This motley collection of odd objects, clustering on the tree like magic fruit, and flashing back the bright looks directed toward it from every side . . . made a lively realization of the fancies of childhood," he muses, "and set me thinking how all the trees that grow and all the things that come into existence on the earth have their wild adornments at that well-remembered time."[78] The Christmas tree is every childhood wish and fantasy fulfilled, and a reminder to every grownup of a time when dreams really could come true.

William Dean Howells's *Christmas Every Day,* a story written in

1892 as a tribute to a much-beloved daughter who had recently died, surrounds the "big Christmas tree, lighted and standing in a waste-basket" with every imaginable delight: "breastpins, and dolls, and little stoves, and dozens of handkerchiefs, and ink-stands, and skates, and snow-shovels . . . and little easels, and boxes of water-colors, and Turkish paste, and nougat, and candied cherries, and dolls' houses."[79] A little girl who wishes that every day were Christmas learns that trees and presents are best when they are rarities that appear only once a year.

Whatever the moral of the story, however, writers found an inventory of the decorations and presents irresistible. The unsigned text that appeared beneath the picture of Prince Albert's tree in the *Illustrated London News* for 1848 set the tone for the later word-portraits of Christmas trees. "Pendant from the branches," says the caption, "are elegant trays, baskets, . . . and other receptacles for sweetmeats of the most varied and expensive kind. . . . Fancy cakes, gilt gingerbreads and eggs filled with sweetmeats, are also suspended by variously-colored ribbons from the branches. The tree . . . is supported at the root by piles of sweets of a larger kind, and by toys and dolls of all descriptions."[80] The undisguised delight in the quantities of rare and pleasing treasures associated with the Christmas tree can be chalked up to the same avaricious aesthetic that cluttered the Victorian parlor with curios and bric-a-brac. But the descriptions also suggest an awareness that toys and expensive candies did not really grow on trees. Christmas was a time for children who still believed that wishes could materialize among the branches on this special holiday. It was a time for parents to remember their dreams and to deny, for as long as the tree kept its needles, the harsh economic laws that dictated which boys and girls would have a Christmas tree.

Hamlin Garland, Howells's friend and contemporary, moved to Mitchell County, on the Iowa prairie, in 1869, when he was ten years old. Times were hard. Although, in Garland's teen years, Christmas gifts sometimes appeared in the family's stockings, "the thought of a family tree remained the luxury of millionaire city dwellers."[81] Then, when he was about sixteen years old, a preacher brought a Christ-

mas tree to the local schoolhouse. "I don't think the tree had many candles, and I don't remember that it glittered with golden apples," he writes in full awareness of the conventions of Christmas tree prose. "But it was loaded with presents." Forty years later, Garland still remembered the bag of popcorn he was given, a gift plucked from that simple "shining pine" in a country schoolhouse on the frontier.

The tree is the presents hung from the boughs—or was, when gifts were still delivered in that way. The tree is the ornaments, whether they are presents or not. The candles. The lights. The strange beauty of an evergreen that bears "magic fruit." "It's nothing more than *reasonable* that Christmas-trees grow wild with the presents all on 'em!" cries a naive little boy in an 1888 story meant to promote holiday charity among the well-to-do young. "They come up every spring, and they all blossom out about Christmas-time, and folks go hunting for them to give to the children."[82] A series of poems published in *St. Nicholas* in the 1890s plays with the same pretty conceit, in full knowledge that the child-reader will recognize a literary device when she sees one. "At night we planted the Christmas tree / In the pretty home, all secretly," begins one ditty.[83] The blossoms of a Christmas tree, according to another, "are blue and yellow and red / All shining with silvery hue. / There are stems of golden and silver thread, / And candles that glisten like dew."[84] But the crop to be harvested on Christmas morning was always the same: the branches drooped under the burden of "wonder that men call 'toys,' / Blooming and ripening . . ." in a million American living rooms.[85]

Nothing else would do at Christmas—not the grab-bags, or the tendrils of ribbons to be followed through the house until the present was finally found. Nor the peculiar, life-size flannel elephant on wheels, with a howdah full of gifts on his back, contrived by a New Jersey family in 1887 in lieu of the usual tree. "As young people advance in years and lose their childish enthusiasm for showy and inexpensive toys and candies, and their annual gifts must necessarily be of a more practical and substantial character," wrote the correspondent who provided instructions for making a similar creature of

one's own, "it is often puzzling to contrive an acceptable and appropriate substitute for the time-honored Christmas tree."[86] But there was no acceptable substitute. Americans did not adopt the Christmas elephant. Instead, presents came down off the tree, glass ornaments took their place, and the magic tree became magical now by virtue of its beauty and its enduring claim on memory.

Poets and novelists have struggled to define the essential mystery of the Christmas tree. "O Tannenbaum! O Christmas Tree!" exult the words of the old German carol, "With faithful leaves unchanging!" The tree is wonderful because it is untouched by time and the seasons, an ever-green symbol of the eternal virtues celebrated at Christmas.[87] In Hans Christian Andersen's nineteenth-century tale, the fir tree, always anxious for something better than its current circumstances, reaches the splendid apogee of its existence as a Christmas tree, bedecked with stars, dolls, and paper nets "filled with sugarplums," but fails to realize the fact.[88] In the end, the tree is chopped into pieces and burned for a fire, filled with regrets that he did not enjoy life while he was living it. The moral of Andersen's story is that his young readers should appreciate the gifts of this and every Christmas to the fullest.

Robert Frost's famous 1929 greeting card to his friends, a poem specially printed in a little pamphlet published by the Spiral Press, was titled "The Christmas Tree."[89] A wry, slightly curmudgeonly piece, the verse tells of a stranger who offers to buy Frost's stand of fir trees for thirty dollars—for resale in the city as Christmas trees. Suddenly, in the last few lines, the narrator realizes that he has a thousand beautiful *Christmas* trees on the snowy slope behind his house, "Regular vestry trees whole Sunday Schools / Could hang enough on to pick off enough." And somehow, those Christmas trees, whole, uncut, and standing in the woods, are worth much more to him than 3 cents apiece.[90] Truman Capote, writing in 1956, remembers a trek into the forests of rural Alabama with his eccentric spinster cousin, Miss Sook Faulk, to find the perfect Christmas tree. As the elderly woman and the boy drag it home in his old baby buggy, a rich lady leans out her car window and offers them 50 cents for the

A family Christmas in a large Catholic household, Mankato, Minnesota, in the early 1950s: the secular Christmas tree stands in front of an image of the Sacred Heart. Minneapolis Public Library, Minneapolis Collection.

tree. After all, she says, they can get another one. "I doubt it," says Miss Sook. "There's never two of anything."[91] Or of anything magical, at any rate. To the contemporary novelist Oscar Hijuelos, in *Mr. Ives' Christmas,* the Christmas tree is a domestic miracle, "its spectacular forest smell and pagan benevolence filling not just the living room but all the rooms" of his protagonist's shabby apartment on the upper East Side of Manhattan.[92] The scent reminds Ives of himself, as a little boy, crawling under the tree to run his train set in the 1950s, "exploring the lowest branches of the Christmas tree, strands of tinsel, lights and ornaments glowing like majestic stars above him, . . . eyes wide."[93]

When the mean-spirited Grinch, in Dr. Seuss's 1957 *How the Grinch Stole Christmas!* decides to put an end to his neighbors' annoying holiday revelry, he dresses up like Santa, creeps into their houses, and systematically steals the stockings, the pretty packages, and the food.[94] The *pièce de résistance,* his last, best act of villainy, is the theft of the tree, without which Christmas surely cannot come. Caught in the act by little Cindy Lou Who, the wicked Grinch claims that he's just taking the tree back to his workshop, to fix a broken light. Then, fairly quivering with evil glee, "HE went to the chimney and stuffed the tree up!"[95] Christmas does come, in the end, without the parcels or the tree, because, as the Grinch comes to suspect, "Maybe Christmas . . . *doesn't* come from a store."[96] But the tree— the ultimate plundered Christmas symbol—comes back to Whoville on the contrite Grinch's sleigh, the most visually prominent part of the loot because Seuss surrounds it with other evergreens, unadorned, snow-covered, and growing on the surrounding hills. Robert Frost suddenly notices that his fir trees are Christmas trees. Dr. Seuss (a.k.a. Theodor Geisel) does not. His Christmas trees are human and artificial, perkier than their languid natural counterparts, strange new hybrids that contrive to look pitiful and uncomfortably cold anywhere but at the side of a blazing Whoville fireplace.

The tree is the ultimate Christmas puzzle, large and eye-filling, basic to the observance (except for that one memorable morning when the Whos had no trees), yet ultimately enigmatic, symbolic of ideas and ideals the culture has put away, or almost forgotten. That is the thrust of Tim Burton's surreal *Nightmare Before Christmas,* a 1993 film made in stop-motion animation. The thin, elegant Jack Skellington, Burton's hero and the controlling deity of Halloween, is obsessed with Christmas after he stumbles into Christmas Town on a walk in the woods. In Christmas Town, everything is plump and jolly: the Christmas trees, the houses, the surrounding hills, and old Santa himself. Christmas is more fun than Jack's own holiday; people adore it. So, like a kind of updated Grinch, Jack decides to steal Christmas. But he doesn't get it—or rather, he and his henchmen see a series of postmodern iconographic fragments, lacking in con-

text and meaning. They aren't sure what a tree is for, or presents—just that they produce strong emotional reactions. In his lab, Skellington struggles to figure out what the separate artifacts mean, beginning with a Christmas tree that seems to grow more spindly and crooked the longer it stays in his tower, high above Halloweenland. He plucks off the decorations, one by one, and dissects them: a holly berry, a candy cane. He shatters a glass ornament and boils it in a beaker. He tries to cut a star out of silver paper, only to produce a hideous spider. "Simple objects, nothing more," he laments, "But something's hidden through the door . . . / What does it mean? What does it mean?"[97] In utter frustration, Jack tears off the tinsel—whatever that is!—and breaks all the remaining ornaments.

His lady-love, waiting down below, plucks the petals from a dry weed to test Jack's devotion, only to find that the thistle has turned into a twisted little Christmas tree that catches fire and burns itself up. Tragedy looms as Jack kidnaps Santa and takes over his route, in a sleigh made out of a coffin, scaring children half to death with presents that consist of dead mice, body parts, and broken toys.[98] Finally, Santa is rescued, Jack learns the error of his ways, and the natural order of things has been restored. But the mystery of the Christmas tree, the tinsel, and the ornaments remains unsolved.

In the end, the appeal of the tree remains mysterious, its smell lingering like the scent of Proust's madeleine, ready to transport sober adults back into the heart of bygone Christmases. We delight in the lights, the sparkle, the presents, and the memory of our younger selves, looking up through the branches from the worn carpet in the corner of the living room.

SANTA CLAUS IS COMIN' TO TOWN

Store Santas, Kettle Santas, Coca-Cola Santas

Santa Claus is dead. In 1998 alone, he died three times, once in Tucson, Arizona, once in Burbank, California, and then again in St. Paul, Minnesota. The Tucson Santa, cited in *The Guiness Book of World Records* for the longest consecutive term of Santa impersonation, was Dayton Fouts. Fouts put on the false whiskers in 1937 and made his last appearance as St. Nick sixty years later, in December of 1997, shortly before a fatal heart attack.[1] The Burbank Santa was Robert George, a retired barber, who was buried in one of his thirty-eight custom-tailored, fur-trimmed suits upon his demise in July, at the age of 74. George wore the red suits and whiskers year 'round, and such was his eccentric fame that he became the unofficial Nation's Santa, playing the part at the White House through six administrations, beginning with Eisenhower's in 1956.[2] Donald "Doc" Johnson of St. Paul, a retired clothing salesman turned Santa, expired in February after a second career that began when he let his white beard grow out and began posing for Christmas ads and catalogs. Eventually he became a mall Santa with a fancy throne, but the job never stopped, even in the off-season. Christmas commercials were shot in the summertime, and whenever Johnson appeared in public, red suit or no red suit, he was mobbed.

"In restaurants, all the children would come up and ask, 'Are you Santy Claus?' and he said yes, he was," his widow remembered. "We had seven children, and they all believed. So did all the grand-children."[3]

The 1998 Santas were self-taught. But for those in need of "ho, ho, ho" lessons, the country's first Santa Claus School opened in Albion, New York, in 1937, under the direction of chubby, pink-cheeked Charles Howard, a former department store Santa of many years' standing. The week-long course—tuition, $150—included makeup, child psychology, the economics of the toy industry, and showman-ship. The B.S.C., or Bachelor of Santa Claus, was awarded after the student had completed the curriculum and one full season of intern-ship in a reputable department store.[4] In 1939, attracted by a little Santa Land Park with a 25-foot granite statue of the titular hero at its entrance, Howard moved his campus to Santa Claus, Indiana.[5] According to local lore, the townsfolk had come up with the peculiar name on a snowy Christmas Eve in 1852; thereafter, the post office had been the chief industry of the place, its cancellation mark much in demand for holiday mail.[6]

Once settled in Indiana, Howard launched a crusade to upgrade the profession of Santa-ing and began by mailing pamphlets to stores all over the nation asking the question, "Is Your Santa Claus Delivering 100 Per Cent Value?"[7] What bothered Professor Howard was the low esteem into which the working Santa Claus had fallen, thanks to "the bums, ham actors, and thousands of odd-job men" who donned red suits every December. He was particularly appalled by street-corner Santas; they were, he told *Fortune* magazine, revolt-ing and "unspeakable."[8] Those in the retail trade weren't much better. When Howard founded his school, most stores used down-and-out actors and carnival workers and paid them accordingly. But by the time his first graduates founded a National Association of Pro-fessional Santa Clauses in the late 1930s, a new standard had been set. Howard Santas could earn the princely sum of $75 a week. They were younger, cleaner, better educated than the rest. A survey of New York City store Santas taken in 1940 found former newspaper

The Santa Claus Monument, Santa Claus, Indiana. Santa Claus Area Chamber of Commerce.

reporters, schoolteachers, and accountants listening earnestly to kiddie requests in Gotham's toy departments. The president of the newly created Association urged employers to bar Santas lacking the proper qualifications in "manner of speech, character and general appearance."[9]

But it was not the dubious reputation of the average street-corner Santa that persuaded the Salvation Army to banish them from further kettle duty in 1937, the year in which the Howard school was founded.[10] What made the organization renounce the practice was the complaint that the presence of Santas on every corner confused and disillusioned children. By the time kids got to the certified toy-department Santa, they had already passed a dozen other assorted Santas ringing bells along the way. It was no wonder that wise tots grew skeptical. "That no Santy Claus," cried one world-weary miss, in line outside the throne room. "It's jes a man dressed up. They ain't no Santy Claus."[11]

Child-rearing experts wondered about the effects on little psyches, if parents assured their trusting offspring that Santa was a real person and then took them downtown during the holidays. Oh, the trauma when the children saw "innumerable Santa Claus[es] in stores and on street corners," and well-meaning adults tried to drag them away in order to keep their faith intact![12] Santa stand-ins were everywhere. In the words of a comic poem on the seasonal proliferation of men in red suits, "Find them throned in crowded stores / Where rapt children mingle; / Meet them on cold streets where winds / Set the blood atingle."[13] They were all frauds—the "hoary old Santa who jingled the bells; / The old hokum Santa, the cotton-trimmed Santa."[14] And yet, when they suddenly disappeared on December 26th, the city seemed dull and cheerless. "Bewhiskered, and in suits of colored gauzes / An ode is due unto our pseudo Clauses," jingled another magazine poet.[15] The multiple Clauses might be bad for children, but they were good for the grown-up soul. It was worth the big lie—telling the kids that the one in the department store was real and the rest were just his ne'er-do-well relatives.[16]

A four-year-old from faraway International Falls visits Santa in Minneapolis, circa 1947. Minneapolis Public Library. Minneapolis Collection.

Even before Charles Howard set out to reform the Santa industry, genteel retail Santas were all pretty much the same. The *New York Times* described the "standardized Santas" of 1927, alike in height (not too tall), weight (ample), and stature (stocky), with red suits and snowy white whiskers: "The pack full of toys, ruddy cheeks and nose, bushy eyebrows and a jolly paunchy effect are also inevitable

parts of the requisite make up."[17] The cream of the crop, department-store Santas traced their line of descent from James Edgar, owner of The Boston Store of Brockton, Massachusetts. In 1890, Edgar ordered a Santa Claus outfit and wore it in the store in the afternoons, when school let out. The idea proved so popular that soon his floorwalker was being measured for a second suit. People came from as far away as Rhode Island to sit on Santa's lap.[18] And the rest is merchandising history.[19]

During the 1920s, when easy-credit terms and consumer spending on Christmas both reached new heights, retail Santas multiplied. So did their tribulations. Harry Hartman, a San Diego store Santa of fourteen years' standing, estimated that in 1924 alone, he had listened to the heart's desires of twenty-six thousand youngsters from his perch in the North Pole Village at Marston's Department Store. He took his job seriously, boning up on new trends in the design of the toys he had been hired to sell. But sometimes being a Santa took its toll. What worried Hartman was not the fidgeting or the occasional wads of gum deposited in his beard but an increasing disbelief in the whole process among youngsters.[20] "You find more who are 'wise' at a younger age," he sighed.[21] Eugene Todd, Macy's first-string Santa for 1929 and a six-year veteran, was interviewed behind the scenes, during his noontime break for a revivifying pinch of snuff. Some of his juvenile visitors, he said, tried to bribe him with hard cash. "Poor little devils—I suppose their parents don't believe in anything but money. I tell them Santa Claus has no use for it; he *has* all the money in the world."[22]

The historian William Waits draws a sharp distinction between Santa school grads, in their expensive velvet togs, and what he calls "domestic Santas."[23] The former, thanks to long hours on the job and heavy-duty costumes, soon learned to play the part with theatrical gusto; even the average street-corner Santa developed a line of patter to deal with children determined to share their wish-lists at curbside. But the fathers and uncles who played Santa for their families had no such advantages. Theirs were the pillows at the waistline, the cheap cotton beards, the black oilcloth flaps that doubled as boots,

the cheesy, do-it-yourself suits.[24] "Real" Santas, without fear of being recognized, grew luxurious white beards or fastened whiskers directly to their cheeks with spirit gum. Daddies, on the other hand, were reduced to wearing gauze masks to hide their faces from their own children.

"Sandy Claws masks" of stiffened cloth or papier-mâché, imported from Germany, covered the wearer's face completely but were often terrifying affairs, with goggling eyes and huge teeth framed by blood-red lips.[25] The false-whiskers-only approach was less apt to frighten the family, which conspired in any case to pretend that the man of the house was not the face beneath the meager white beard. A staple of cartoon humor was the homeowner in Santa regalia being taken for a burglar or attacked by his own dog.[26] Norman Rockwell's first Christmas cover for the *Saturday Evening Post*, in 1916, showed a wealthy old gentleman, his pockets stuffed with gifts, trying on a Santa hat and a $1.25 beard in a novelty shop.[27] In 1956, he returned to the issue of the domestic Santa with a picture that the *Post* deliberately held until December 29th, to avoid disillusioning children. The subject this time was an astonished little boy, who has just pulled parts of a Santa outfit—including the red, fur-trimmed hat with attached beard—from the bottom drawer of his father's bureau.

One of the chief architects of modern Christmas imagery, Rockwell addressed the disguises of the commercial Santa in a pair of *Saturday Evening Post* Christmas covers. The first, painted in 1940, depicts a little boy unexpectedly meeting Santa on a homebound commuter train.[28] The child, arms full of packages from Drysdale's store, sees an old man in an ill-fitting overcoat and battered hat, slumped on a seat. Protruding from his pocket are the telltale hat and beard. The crimson legs of the Santa suit peep out from beneath the hem of his coat. Lest there be any doubt about his identity, he sits in front of a poster urging riders to visit Santa at Drysdale's. The Santa in the poster smiles and chuckles; the "real" Santa sleeping fitfully on the train does not. The second example, set in a busy Chicago railroad station during the wartime Christmas of 1944, shows a crowd of ser-

Anybody can be a Santa, with a beard and a hat! Norman Rockwell's 1916 illustration gives the game away. *Saturday Evening Post* (December 9, 1916), cover.

vicemen and civilians, rushing home for the holiday.[29] Right in the middle of the mob, his back to the viewer, stands a Santa bell-ringer with a collection tripod. Even from the back, it is apparent that this Santa Claus is slight, round-shouldered, and lethargic, no match for the splendid jollity of his department-store cousins. The bands of cotton "fur" around his costume are fake—and so is he.

Waits sees the professionalization of Santa Claus as another sign that the post-1900 Christmas was being taken over by powerful interest groups—commercial and charitable—with which the parent in a beard could no longer compete. But Rockwell, as a visual artist, was more interested in the dynamics of transformation and the aesthetic of the masquerade: how many marks of the true Santa does it take to make a grandfather, a father, a bum, an exhausted retiree into a convincing representation of Santa-ness? What does it take to allow a wide-eyed little boy to suspend his disbelief between Thanksgiving and December 26th?

Increasingly, however, the question came to be not whether children could be bamboozled into believing in Santa Claus but whether it was good for them. The children—or most of them—were ready to believe anything. When the curtains opened at Macy's and the "second-line Santa" strolled out to replace the morning shift, nobody batted an eye at the terrible sight of two identical Santa Clauses changing places. But there were always doubters, especially in the ranks of concerned mothers. In 1865, a debate over the matter of whether to indulge children by observing Christmas raged in the pages of *Godey's Lady's Book*, which came down squarely on the side of avoiding "gratuitous disclosure" of the Santa hoax. "Let them believe in Santa Claus, or St. Nicholas, or Kriss Kringle, or whatever name the jolly Dutch saint bears in your region," the author begged her readers.[30] In the next issue, she illustrated her point with a short story about a pair of progressive parents fiercely devoted to realism. "There is no such creature, Allison!" the mother shrieks, when the subject of Santa is mentioned by her daughter. "You are too old to believe in that ridiculous fable."[31] But six pages later the family is going "a-Christmassing" together, praising Santa, spreading goodwill,

and feeling happier than they have in years. If the figure of Santa Claus serves as a transparent disguise for the identity of the parents who provide the gifts, the Santa-inspired celebration of children and his spirit of generosity are also the essentials of a happy family life.

The conflict between spiritual and material values—the shadow cast on Christmas by the materialism Santa stood for—was the topic of frequent discussion in the 1920s, as Santas became permanent fixtures on the retail scene. Once upon a time, or so the critics charged, Christmas was all about carols and trees and the innocent delight of the young. "But that was before Santa Claus stole Christmas and turned the Feast of the Adoration of the Christ into the Feast of the Adoration of Things." Now, it was "a pretentious, nerve-racking bluff, as easy to see through as a fake department-store Santa."[32] The Christmas spirit had been hijacked by the Santa ads in every magazine, by the pricey rent-a-Santas who would come to one's home in a bright red truck, haul a sack of gifts inside, and hand them out to the kids, thus dispensing with the whole messy business for one more year.[33] "Ho, ho, ho," indeed. In the face of the prevailing cynicism, *Collier's* polled eighteen famous writers for their assessment of the Santa situation: was he a good thing or a bad one? the editors asked the likes of H. G. Wells and Joseph Conrad. When the results came in, in December of 1923, the jury was hung. Eight panelists were decidedly pro-Santa, five were neutral, and five wanted no part of the ancient fraud.[34]

Things came full circle in the 1930s, with passionate defenses of a Santa whose pack grew lighter as hard times wore on. He was an abstract personification of love and the love of the Christ Child, said his defenders. Good parents, wrote a columnist well versed in the thinking of the leading child psychologists, ought to avoid the bitterness bred in children who suddenly discover that the fellows in the red suits are not Santas, or members of his immediate family. Better never to tell them that Santa is a "real man, just like Daddy."[35] Better to tell them that the men on the street corners—90 percent of whom, in New York City, were clowns on winter hiatus from the circus—are symbols for the invisible spirit of Christmas.[36]

Psychologists who took up the subject of Santa again in the midst of the consumer orgy of the 1950s were also convinced that Santa had outlived his usefulness, in part because he was represented so poorly in the public arena. The slick, $25-a-day professional Santas, with their practiced mannerisms and splendid outfits, failed the test of the imagination. "The gross impersonation [of Santa Claus] robs him of all the charm which the child needs, without adding sufficient realism to make the pretense concrete and sufficiently credible," concluded a learned paper in the journal *Psychiatry.* The researcher had interviewed blasé Santas, past caring about the subtleties of their craft, drowning their sorrows at the nearest bar during the lunch break. He talked to Santas who thought they *were* Santa Claus, to Santas who delivered gifts door to door, to department-store and kettle Santas. He inspected Santa disguises that were too literal, too sketchy, too crude. It didn't really matter. The Santas were all so much creaky scenery in a play written by adults, in which victimized children were obliged to play the role of happy dupes to please their elders.[37]

Before movies and TV specials took over the task, Santa existed in two primary modes: as a picture in a book or a magazine, or as a live person in a costume and makeup. Where the two genres overlapped was in the local toy department. There, thanks to elaborate scenery—cardboard icicles and snow made from mica or soap flakes—Santa was seen within a pictorial context that approximated a page in a story book: Santa at the North Pole, Santa in his workshop, Santa in the Enchanted Winter Forest, and so on. *A Christmas Story,* a 1984 film set in a Midwestern city in the 1940s, shows exactly what one of these traditional settings looked like and how it was used.[38] In a sequence shot in Higbee's Department Store in Cleveland's Public Square, little Ralphie and his brother go downtown to see Santa.[39] This entails climbing a wooden mountain to Santa's throne, with the impatient assistance of a flock of elves. Once at the top, the hapless youngsters are lifted up, spun around, and carefully positioned on Santa's knee before being dumped unceremoniously into a slide that deposits them in ersatz snowdrifts at the base of the

edifice. The point of posing the children is not to facilitate their fleeting conversation with Santa. It is to allow their waiting parents a perfect view of Sis or Junior's Santa experience as a kind of *tableau vivant,* a pictorial validation of the experience. In modern terminology, the staged moment with Santa on the mountaintop is the perfect "photo-op."

Although the film does not offer an explanation for the ritual, most stores paid for Santa's services by selling photographs of "your child with Santa Claus" at the bottom of the slide. Every parent got a number as his or her child began the long climb. Elves kept the kids in line so the numbers and the pictures would match up, and made sure that every child was looking into the lens at the proper moment. In his comic essay "SantaLand Diaries," David Sedaris—who had worked as a temporary elf at Macy's in Herald Square—gives the game away. "All we sell in SantaLand are photos," he writes. "People sit on Santa's lap and pose for a picture. The Photo Elf hands them . . . a number . . . and the picture arrives by mail weeks later. So really, all we sell is the idea of a picture. One idea costs nine dollars. Three ideas cost eighteen."[40]

These SantaLand moments of pictorial ingenuity led to more and better scenic elements and subsidiary characters. In Chicago in the late 1940s—the heyday of the Santa picture—Marshall Field erected a magical Cloud Cottage on the eighth floor, where Santa's guests were greeted and primed for the all-important photo session by Uncle Mistletoe and his wife, Aunt Holly.[41] Mistletoe, a Pickwickian figure in a top hat, first appeared as a minor figure in Field's show windows in 1946 and took over the Christmas display in 1948 when other stores stole the planned window theme for that year.[42] Uncle Mistletoe and Aunt Holly, who became the official Christmas mascots for Marshall Field, are good examples of the synthetic icons created by retailers to add brand-name distinction and novelty to what is basically a dull, repetitive Santa exercise.[43] For a time, in the 1940s and 1950s, Uncle Mistletoe in his Cloud Cottage threatened to eclipse the popularity of Santa on his throne several floors below.

Mistletoe had his own radio and television shows, a club, a song. And unlike Santa, he worked all year.

The eventual merger of the various members of the Field's Christmas cast is testimony to the resilience of Santa Claus and the lure of the official Santa photo.[44] At the smaller Dayton's store in Minneapolis, the management of Santa and his pictorial environment occupied the best minds in the company for most of the year. The Dayton Santa had to be the best one in town—a Santa who was more than the sum of boots, belly, beard, and belt. Discriminating critics were sure to compare the Dayton model with others in the small downtown district: one little boy refused to tell the Dayton's stockroom employee who doubled as Santa in 1947 what he wanted for Christmas because he had just recited his list to the guy in the red suit at Power's, in the next block.[45] Dayton's kept its competitive edge through the 1960s with a succession of Enchanted Forests, fairy princesses, gumdrop trees, and other diversions aimed at keeping bored children quiet in the endless lines that led to the inner sanctum and the decisive moment on Santa's lap.[46] Glitter-strewn forests were expensive, however. Even though it brought traffic into the toy department and sold a goodly number of photographs, the annual Santa feature was not an unmixed blessing for most retailers. In 1948, Dayton's was sued by a family whose three-year-old son had broken his leg by slipping on a discarded piece of candy as he tried to clamber up onto Santa's knee.[47]

Lawsuits, inter-store competition, changing mores, and sophisticated children all conspired to complicate the professional life of the average Santa. New Santa schools have flourished accordingly: the historian Charles Jones documents the existence of three training facilities in New York alone in the early 1950s, with more in major cities elsewhere.[48] In December of 1951, a *Life* magazine survey of the season's Santas found a cowboy version, in high-heeled boots and a Stetson, at a Texas department store, along with other modern Santas who arrived at their far-flung posts via helicopter, cable car, and submarine, wearing all manner of peculiar headgear.[49] Santa

agencies and schools began to demand more of candidates for the position, including poise, impeccable credentials, physical stamina, and a close resemblance to the ideal Santa Claus.

Noerr Programs of Golden, Colorado, which contracts with shopping malls to provide Santas for Christmas photographs, claims to run exhaustive background checks on its Santas and teaches candidates not to promise specific, as-seen-on-TV toys to children—in case their parents are unable to deliver. All About Entertainment in San Diego specializes in female, black, and Latino Santas, multilingual Santas, and Santas who know sign language.[50] Santas are rated by the demanding clientele that sit on their collective laps: the Santa in a Beverly Hills mall was chosen "best in L.A." in a 1994 newspaper poll because he had a real beard and was "hip" enough to talk rock and rap with savvy nine- and ten-year-olds.[51] As the name implies, Naturally Santa of Colorado Springs sends out the résumés of organic Santas who are kindly and avuncular in real life, and look just like the genuine article without the aid of false whiskers and padding.

But how does a Santa learn to look like Santa? The best way used to be by looking at the pictures in magazines. By the early years of the twentieth century, major advertisers of branded products had already appropriated Santa Claus as a pitchman, however improbable the connection between a given commodity and the Christmas season. In 1903, for example, the makers of Shredded Wheat—"baked by electricity"—used a photograph of Santa caught in the act of stuffing stockings with packets of cereal. The children, who might have preferred candy to Shredded Wheat Biscuits, seem merely curious, as they inspect his fur-edged suit and snowy beard by the light of the fireplace.[52] The ad is a variant on a Pears's Soap layout for 1897, a full-page painting in which a similar Santa (fur, big belt, cap, etc.), discovered in the same spot by a curious little boy, is being offered a bar of soap so he can clean up after his recent trip down the chimney.[53] Waterman's Ideal Fountain Pens featured Santa in their Christmas ads for years, beginning in 1902 and 1903, under the

motto "The Modern Waterman is an 'Ideal' Santa Claus." Rather than reproducing paintings or photographs, the Waterman ads were based on crisp drawings that emphasized the salient characteristics of Mr. Claus's gear, including a close-fitting, belted suit with a fuzzy nap; fur trim at the bottom of the pants, the hem, and the wrists of the jacket; a matching cap; tall leather boots; and luxuriant facial hair.[54] It was in essentially this form that Santa made his pitch for pocket knives, condensed soup, men's socks, sterling silver coffee spoons, gramophones, shaving brushes, and Thermos bottles in the holiday pages of the *Saturday Evening Post* and the other picture magazines between 1904 and 1910.[55]

In 1908, the American Red Cross began to issue Christmas seals, gummed stamps used to fasten the wrappings of holiday packages or to decorate mail.[56] At first, as on the earliest printed wrapping paper, the lone motif was the holly plant. But in 1910, Santa Claus, in his familiar garb, became the official motif on the stamps. World War I and a subsequent national campaign to eradicate tuberculosis increased the visibility of the Red Cross and the good works supported by the sale of Christmas seals; some of the first "public service" ads that were developed by advertising councils, placed in magazines, or displayed as billboards free of charge on behalf of charities were for the long-running Santa Claus campaign.[57] Like the corporate ads of the previous decade, Christmas seals and the promotional devices that sold them also sold Americans on a specific type of Santa.

In 1923, when the Christmas season had become the central marketing event of the year, advertising executives began to wonder aloud if Santa hadn't passed his prime as a means of selling macaroni (and just about everything else!) to captive streetcar passengers through pictorial placards pasted just above the windows. "No Santa Claus—he has been done to death!" was the new rallying cry among those who hired the commercial artists to redesign the jolly old elf every year and paid the copywriters to find fresh ways to sing his praises. "The advertising man thinks of Santa Claus as an obsolete trade-mark because . . . everybody is privileged to use him," wrote a

1903: Santa sells shredded wheat. *Leslie's Weekly* (December 10, 1903), 579.

student of recent Christmas advertising in *Printers' Ink*, the profession's bible. But the few adventurous agencies which had dared to drop Santa in the mid-1920s reinstated him almost at once because every consumer recognized him and his connection to the Christmas season. The sheer ubiquity of Santa, concluded a manufacturer of electrical appliances, made him the best possible medium for introducing products to skeptical, hard-to-reach buyers. Not everybody had tried an electric toaster—but everybody did know Santa and associated his person with happiness, generosity, and childhood dreams come true. Toaster + Santa = a potential sale. The smart advertiser was the one willing to take Santa Claus "out of exile" and put him back in the magazines, in full color, wherever possible.[58]

It is fair to conclude that advertising codified the appearance of the modern American Santa Claus. Around 1900 a few street-corner Santas still wore the robes of the gaunt, European St. Nicholas, and a few Christmas cards, printed in Germany and England, still showed a stern old fellow incapable of the requisite Yankee merriment.[59] But it is not possible, as some Christmas enthusiasts have done, to assign credit for this new creation exclusively to Haddon Sundblom, the father of the Coca-Cola Santa Claus.[60] A prominent Chicago commercial artist who had also designed ads for Nabisco Shredded Wheat, Aunt Jemima pancake mix, and Whitman chocolates, Sundblom painted his first Santa for Coca-Cola in 1931 and thereafter, until 1964, did at least one a year.[61] In the beginning, his model was a friend, a retired salesman. Later, it was himself, peering into a mirror. But throughout the more than thirty years in which he contributed the centerpiece of Coca-Cola's annual Christmas campaign, Sundblom retained a clear, unwavering vision of Santa Claus and his attributes.

The Coke Santa never smoked a pipe, for instance, although many older models did, in deference to the line in the Clement Moore poem that helped to make "A Visit From St. Nicholas" into an annual event in American homes.[62] He was not the tiny, elfin figure of Moore's verse, either.[63] The Coke Santa was big and very fat because, Sundblom's biographers claim, he disliked the wasted, meager look

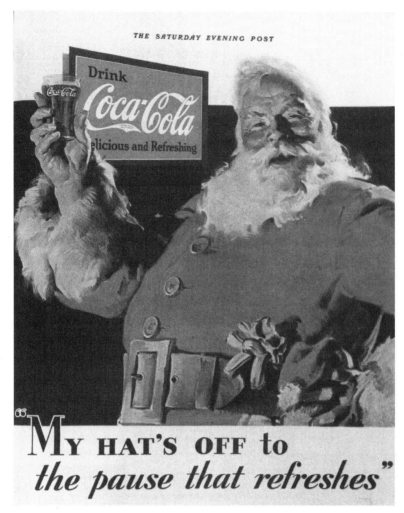

Haddon Sundblom's legendary Coca-Cola Santa, 1931. *Saturday Evening Post* (December 26, 1931), 1. Copyright © Coca-Cola; reprinted by permission.

of the department-store and charity Santas he observed in the 1930s, when jobless men who had missed more than a few meals counted themselves lucky to find temporary work in a red suit.

Similarly, the gigantic leather belt, the lush fur trimmings, and the huge boots that turned over at the tops were symbols of a hoped-for abundance as well as a tacit critique of the cheap costumes of Chi-

cago's Santas-in-the-round.[64] One of Sundblom's early Coca-Cola commissions, in 1933, showed Santa taking off a frowning mask to reveal his smiling face underneath. As an ad, the image suggested the efficacy of drinking Coke for a pick-me-up. As a picture that corresponded to the realities of the day, the work expressed Sundblom's scorn for the $1 Santa masks sold at Sears and Montgomery Ward. The Coca-Cola Santa had no need of masks and disguises because he was absolutely real. Almost larger than life in his vitality, he would banish the very possibility of disbelief through his sheer physical presence.

Whether being discovered by a wakeful child or caught in the act of doling out the presents, the Coca-Cola Santas of the 1930s were frequently shown in settings that included telling props: an electric train and a Shirley Temple doll under the Christmas tree; a refrigerator with a fat turkey inside, ripe for the plundering; and frosty bottles of Coke, of course. His mirthful demeanor seems directly related to the world he inhabits, full of every good thing. No longer the legendary present-giver, the miraculous wonder-worker, this Santa seems instead to arise like a peculiarly American genie from the land of brand-name toys and turkeys, reflecting the security and contentment of an ideal Christmas. Or Christmas as it ought to be.

Although the issue has not been studied in any detail, Christmas as Americans had celebrated it seems to have become increasingly problematic in the 1930s. Lavish spending was no longer possible or prudent. But the feelings associated with the visit of Santa Claus— the hopefulness, the satisfying plenitude of the feast—were the pressure points hardest hit by economic insecurity. In this muddle of confused emotion, the Coke Santa cheerfully stood for all the right things. In fact, Santas in general underwent a major revival in the 1930s, offering reassurance in the dark night just before the dawn of Christmas Day.

The lyrics of the sprightly "Santa Claus Is Comin' To Town," written in 1934, warn the listeners "in Girl and Boyland" not to pout or cry, because good times—and Santa Claus—were on the way.[65] Santas multiplied in popular magazines, too. While the number of ad

pages in the Christmas issues declined or remained static, advertisements for inexpensive items increased. And Santa was their lodestar. The Coca-Cola Santa sold holiday hospitality at a modest cost. The Whitman's candy Santa suggested that a fancy box of assorted chocolates, at $1 a pound, could make as fine an impression as yesterday's costlier Christmas gifts. There was, as the text beneath the Santa whispered with infinite delicacy, "a Whitman package to suit . . . every circumstance."[66]

The Whitman's Santa had everything the Coca-Cola Santa did, except the occasional narrative subtext. While the Coke Santa raided the refrigerator, the bemittened Whitman Santa Claus merely held up a "sampler" box—a package printed so that it appeared to be prewrapped and tied with a bow—and smiled knowingly at the reader, as if to share a Christmas shopping tip with a friend. Or he strode purposefully along on some gift-giving errand, carrying other, similar boxes.[67] The outfits of the two Santas are essentially the same. The Whitman's model is less florid and fleshy than the Coke Santa, with a sharper nose and a piercing glance. He is more the salesman, less the all-purpose symbol of beatitude. Often, the two Santas smiled at each other from facing pages in the same magazine. In the privileged spot, just inside the front cover, they set the tone for the seasonal stories that followed.

One of the oddities of the arrangement is that these were both Haddon Sundblom Santas, both variations on an established type. Sundblom's work for Coca-Cola is exhaustively documented; the Whitman's ads were also produced by his Chicago studio.[68] Today, the Coca-Cola Santas are everywhere. The original artwork and the magazine pages in which it was reproduced command high prices. Coke Santas have been turned into Christmas cards, ornaments, statuettes, and "collectibles" of every sort, whereas the Whitman Santa has fallen into obscurity. The reasons for the disparity are many. Coke's was a long-lived campaign, which extended into the 1960s and was revived in the 1980s and 1990s. Coca-Cola is a major American corporation, a power on Wall Street. It produces a commodity so similar to other soft drinks that the company has devel-

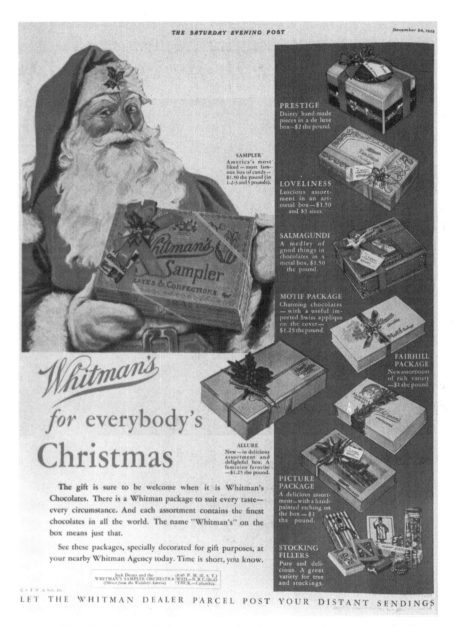

In the 1930s, the Whitman's Santa was as familiar to most Americans as the Coca-Cola version. *Saturday Evening Post* (December 24, 1932), 2.

oped a strategy of image-making to distinguish its brand from the rest and to foster consumer loyalty.[69] The Coca-Cola Santa is one of those resonant images, linked to serial memories of a holiday central to the identity of every American family.

But both Santas, in the decade of their first appearance, succeeded because they corresponded to an unspoken consensus about Santa Claus iconography. The development of that general agreement on the marks of the true Santa can be traced through the covers of the *Saturday Evening Post*, the influential picture magazine whose illustrations did much to invent the repertory of common holiday symbols. Between 1900 and 1910, Santa was not yet a dominant or even an important figure. Instead, Christmas was commemorated with a variety of scenes: a servant girl in medieval costume, plucked from the pages of Irving, carrying a plum pudding; a newsboy receiving alms from a millionaire; a pretty girl under the mistletoe; a Christmas tree, aglow with candles.[70] Another favorite subject for illustrations was gift parcels and packages and heaps of Christmas toys, all delivered without visible supernatural agency.[71] But suddenly, Santa Claus took command.

Assigned to the various holiday covers with increasing frequency as his reputation grew, the artist J. C. Leyendecker began to connect Santa and presents for the *Post* in 1910, with a picture of a child sending a letter to Santa by the simple expedient of depositing it in the fireplace. Santa himself is nowhere to be seen. In 1912, a Santa substitute appears in the person of a Volunteers of America Santa Claus, a skinny old soul in a too-big Father Christmas robe, standing beside his cardboard chimney and contemplating a donation from the stereotypical ragged newsboy.[72] It is only in 1918, with World War I dominating the Christmas imagery for the year, that Leyendecker brings the legendary Santa himself to the cover of the *Post*, wearing a military helmet and the doughboy's khaki puttees, with a Christmas tree clutched under one arm. But except for the weaponry tucked in his belt, Leyendecker's Santa is Sundblom's in training: fat, clearly innocent of padding or make-believe whiskers, sporting a capacious red coat with a big fur collar. In 1919, this

same Santa, with his civilian cap now restored, is framed by a window on Leyendecker's Christmas cover, as if peeping in to see whether the reader of the *Post* is naughty or nice.[73]

The definitive Leyendecker Santa adorned the cover of the *Post* on December 22, 1923. A kind of halo slotted in between his cap and his pack of toys shows that this is no ordinary store Santa Claus, despite his pose. He is sitting down, with a little boy on one knee—the kindly saint, apprehended in the midst of his charitable rounds.[74] His most distinctive features are his girth, his gigantic, laced-up boots, and a suit so generously cut that yards of extraneous velvet and fur lap over his ankles and wrists. The figure is shown in a radically foreshortened view, with the huge feet close to the viewer and the rest of the body diminished somewhat in size. The effect of these visual tricks is to suggest that a stocky adult male is really a sprite or an elfin creature, despite his great bulk and presence.

Leyendecker's *Post* Santa enjoyed a double life as a well-known advertising icon for Kuppenheimer Clothes in the 1920s.[75] His work for the clothier may account for Leyendecker's consuming interest in the material and cut of Santa's suit. In this dual role, however, Santa is always the same, whether he appears on the front cover as a kind of official statement, or inside the front cover, as an ad.[76] The replication of the image blurs any possible distinction between a commercial Santa who sells overcoats and a holiday symbol without ulterior motives.

As a cover-boy for the *Post,* Santa Claus reached the height of his popularity in the 1920s, when the younger Norman Rockwell began to vie with Leyendecker for the de facto title of chief illustrator. One result of this competition was a greater emphasis on Christmas subject matter: during most years, the editors ran two or even three Christmas covers, acknowledging the volume of seasonal advertising as well as the public's interest in seeing multiple interpretations of the holiday from its favorite artists. During the 1920s, stimulated by the contest with Leyendecker, Rockwell contributed a series of five distinctive Santas of his own to the *Saturday Evening Post.* Three of them are noteworthy for the introduction of a new Santa suit, or a

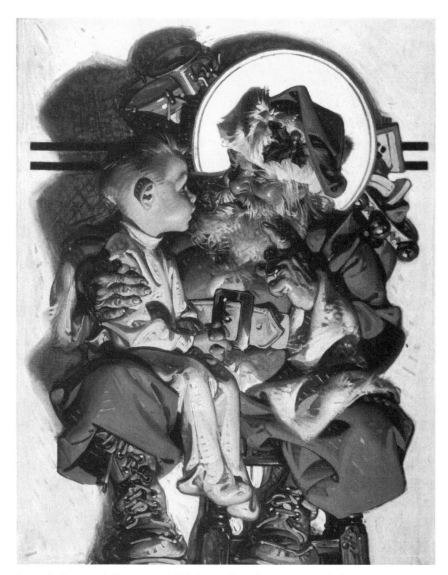

Leyendecker used this same 1923 Santa for ads, covers, and illustrations. *Saturday Evening Post* (December 22, 1923), cover.

partial outfit, only to be worn by the hero in private, in his lair at the North Pole. While correlating his global route with the list of good and bad children, while recording his annual expenses, or while napping over his sack of toys as the elves finish the work, the Rockwell Santa resembles a businessman in shirtsleeves and eyeshade, caught behind the scenes.[77] In the remaining Santa Claus covers from the 1920s, he appears among mortals in the course of his annual journey, in what had by this time become the standard Leyendecker Santa package—the full, regulation outfit with red coat, white collar and cuffs, and accessories.[78]

Rockwell, whose practice of working closely from models did not encourage flights of pictorial fancy, was uncomfortable with a mythical Santa Claus. Instead, he treated Santa as a real person, an old man with the kind of face and body type both the artist and his audience had seen before. Of Rockwell's five Santas of the 1920s, two feature the same pale, balding gentleman, with a long, thin nose, while the other three depict another recognizable model, broad-faced and ruddy, with a wide, knobby nose. In that sense—in his uncompromising naturalism—Rockwell points the way toward the all-American physical credibility of the Coca-Cola Santas. Leyendecker, on the other hand, vacillated between the kind of Santa who might have run a busy factory and the purely legendary St. Nick. Indeed, as time passed and the contrast with Rockwell's dogged verisimilitude became more obvious, Leyendecker's imaginary Santa Claus became visibly shorter in stature, cuter, a kind of comic figure not much bigger than the children he cuddles. The last Leyendecker/*Post* Santa Claus, in 1930, cowers at the top of a ladder, the Christmas tree untrimmed, trying to fend off the family dog who is scarcely smaller than himself.[79]

So the Santa who was constructed in the 1920s and refined in the 1930s is essentially the same Santa who has been delivering the nation's presents ever since—a hybrid figure, with a whiff of commerce clinging to the fabric of his big red coat, more jovial businessman than saint, more real than not, comical, perhaps, and cute, but at bottom a serious embodiment of the economy of Christmas, balanc-

ing the ledgers, delivering the goods. Since Leyendecker and Rockwell and Sundblom—along with Kuppenheimer clothes, the *Saturday Evening Post*, Coca-Cola, Whitman's chocolates, and a host of other interested parties—devised the image, it has persisted, without much deviation from the norm. George Hinke of Milwaukee, a German-American commercial painter who created Santas for the *Ideals* annuals and other clients between 1944 and 1953, is a case in point. In his *Jolly Old Santa Claus* series, Santa has the build and bonhomie of a Sundblom, the boots of a Leyendecker, the believability of a Rockwell—and all the right clothes.[80] Even the Reverend Howard Finster, the Georgia folk artist, bows to the prevailing Santa conventions in his 1996 retelling of the Moore poem, which Finster calls *The Night Before Christmas*. His ecstatic reindeer are spotted like giraffes, his skies are filled with tiny angels who hover like clouds of sacred mosquitoes, and his Christmas tree recalls the burning bush where Moses met the Lord, but Finster's Santa is a Santa Claus who would not look out of place with a frosty bottle of Coke in one hand.[81]

Like his illustrious predecessors, the Reverend Finster was at the mercy of a text: "An Account of a Visit from St. Nicholas," written on Christmas Eve, 1822, by Clement Clarke Moore, a professor at the Episcopal General Theological Seminary of New York, as a gift for his many children. Scholars believe that a family friend, Miss Harriet Butler, who was visiting the Moores for Christmas, copied the verses out in her album and took them home with her, to Troy, in upstate New York. On December 23, 1823, the Troy *Sentinel* published the ballad anonymously—and the distinguishing characteristics of Santa Claus were settled, once and for all.[82] "We know not to whom we are indebted for the following description of that . . . homely and delightful personage of parental kindness, Santa Claus, his costume and his equipage," wrote the editor.[83] But the shy poet had conjured up a serviceable pictorial image of Santa Claus—one that ended up becoming the standardized American Santa, different from all the various Old World saints of Christmastime, and all the gift-bringers honored by immigrant communities in the New World.

Charles Jones, the ranking scholar of Christmas lore connected to

New York City, saw Santa Claus as a descendant of St. Nicholas, under whose auspices prominent New Yorkers of the early nineteenth century aimed to assert their distinctive heritage: devotees of Scott and the Gothic Revival, they were actively creating an American version which might be called the Knickerbocker or Dutch Revival.[84] Washington Irving, whose Bracebridge texts are central to the emerging understanding of the modern Christmas, was a member of this circle. Irving made his first published mention of "St. Nicholas, vulgarly called Santeclaus" in 1808. The giver of cakes and cookies, this St. Nicholas, patron saint of New Amsterdam, is mentioned no fewer than twenty-five times in Irving's comic *History of New York from the Beginning of the World to the End of the Dutch Dynasty* (1809). In the *History,* St. Nicholas, or Santeclaus, comes riding over the tree tops in a wagon on his feast day—December 6th—bringing presents which he deposits in stockings hung by the fireplace. And he takes leave of old Oloffe Van Kortlandt by "laying his finger beside his nose," the distinctive gesture that forever links Irving with Clement Clarke Moore and Santa Claus.[85] Jones wonders if Moore even remembered that he was quoting Irving's *History* when he made St. Nick do the same thing, as the latter nodded to the narrator and rose up the chimney in 1822.[86]

Moore's Santa is elfin but chubby and plump, with a "little round belly," a merry disposition, a pipe, and a magical, flying sleigh pulled by "eight tiny rein-deer." Dressed all in fur, he comes by night to children already dreaming of candy treats. He carries "a bundle of toys" on his back, just like a "pedlar." But unlike conventional peddlers, he comes quietly in the hours of darkness, and fills the waiting stockings free of charge. Moore's biographers say that the sleigh came from the poet's own Christmas Eve trip from his home in Chelsea to Jefferson Market, in downtown New York, in search of a turkey.[87] That the model for St. Nick—or the source for the story— was a portly Dutch gardener who once worked on the family estate.[88] That the reindeer probably came from a little picture book, *The Children's Friend,* published in New York in 1821, the first lithographed book ever produced in the United States.[89] That the struc-

ture of the poem came from an oddly lugubrious source: "The Day of Doom," written by the Massachusetts clergyman Michael Wigglesworth in the mid-seventeenth century.[90] That the tale of "old Santaclaw" was so well known to New Yorkers that another children's book, published in 1814, had tried to discredit poor Santa in the interests of truth-telling.[91] In the end, however, the enduring popularity of the poem owes as much to Moore's flights of lyricism and thumping rhythms as it does to his acts of literary thievery.

If Clement Moore actually wrote "A Visit from St. Nicholas," that is. Although the verse had already been reprinted many times, Moore did not acknowledge authorship until he included it in a volume of his more serious poetry in 1844, apologizing in the preface for his unaccustomed lapse into levity. Under Moore's name, it appeared in anthologies. Omitting vulgar mention of Santa's round belly, school readers of the Civil War era also reprinted the "Visit" as a work by Moore. But after the death of Dr. Moore, in 1863, rumors began to circulate that something was amiss. A slender volume retelling the story of the composition of the poem with fresh information but little supporting documentation was issued in 1897; the very existence of such a book confirms the importance of Santa and the version of his story contained in the "Visit" to the Victorian Christmas ritual. Yet the book did little to quash charges that Henry Livingston of Poughkeepsie, a country gentleman with a propensity for comic verse, was the true author. As late as 1920, members of the Livingston family were still pressing their case in literary journals, with word-by-word comparisons between the vocabulary of the "Visit" and other known works by the rival claimants to authorship.[92]

The controversy is not very important in the long run. Even Moore's detractors seem to believe that he probably believed he wrote the poem. But the evocative word-pictures in "A Visit from St. Nicholas," whoever wrote it, made Santa Claus into an appealing figure and inspired artists and illustrators to translate those words into resonant visual images. Early post-Moore pictures of Santa in gift books intended for children, like the 1848 Onderdonk edition with engravings by Theodore C. Boyd, show him as a stubby Dutch-

man with knee-britches, a flat fur hat, a close-fitting fur-trimmed coat, and a short-stemmed pipe.[93] Nissenbaum uses the length of the pipe—"the stub of a pipe" specified by Moore—as an indicator of class, suggesting that Santa, from the start, was a plebeian, a working-class man of the people.[94] But he is also a specific Old Dutch type or stereotype in the process of being developed by American artists called upon to illustrate Irving's New York stories.

Washington Allston, for example, depicted the pipe-smoking Dutch burghers of colonial New Amsterdam (with the long pipes of gentlemen) as squat, chubby fellows with pungent features—figures not unlike the emergent Santa—in the frontispiece to his edition of *Knickbocker's History;* F. O. C. Darley, who had already depicted the Dutch St. Nick in this manner in a frontispiece engraving for Irving's *History,* used the same kind of grotesque typology in his drawings for the 1862 Gregory edition of "A Visit from St. Nicholas."[95] But the best examples of the Old Dutch figure occur in the work of the eccentric New York painter John Quidor. Without any known connection to the writer, Quidor began to paint scenes from Washington Irving's books in the 1820s.[96] *Antony van Corlear Brought into the Presence of Peter Stuyvesant* of 1839, illustrating an episode in the *History,* uses cartoon-like figures for its Dutch heroes, their spherical bodies shaped like bowling balls, or what Clement Clarke Moore might have called "bowl[s] full of jelly."[97]

The art historian David Sokol attributes Quidor's obsession with Dutch New Amsterdam to a prevailing nostalgia for a time of magic and tranquillity, which appealed to Washington Irving and his contemporaries in the frenetic years of the early nineteenth century.[98] In the 1820s, when Quidor was beginning his career, the last of the quaint Dutch houses in the city were being pulled down to make way for commercial development, a relentless modernization campaign that succeeded despite the protests of a sympathetic press.[99] The rotund burgher with his big, shiny buttons and his penchant for enjoying himself stood for happier days and mild domestic drama. It was this Old Dutch figural type, with its strong connections to Irving and an idyllic dreamscape of American history, that Thomas Nast would

later appropriate when he assembled the defining marks of the American Santa Claus during the national upheaval of the Civil War.

First, however, the plump burghers of Quidor, Allston, and Darley had to become Santas. The transformation began in 1837, the year in which Moore's orphan lyric first appeared under the author's name in a well-regarded anthology, *The New-York Book of Poetry.* Robert W. Weir, a lover of local folklore and tradition who was then teaching drawing at the U.S. Military Academy at West Point, was inspired to paint a portrait of the title character, called *Santa Claus, or St. Nicholas,* for the delight of his children. A highly finished work, executed in oils on a large wooden panel, the picture depicted the moment from the final verse of the poem when Santa, the stockings all filled, lays his finger "aside of his nose" and prepares to vanish up the chimney.[100] Clearly, Weir was serious about the painting; he showed it at the National Academy of Design that year and painted a second version, with minor variations, in 1846.[101]

Based on the St. Nicholas Day genre paintings of the seventeenth-century Dutch realist Jan Steen, Weir's *Santa Claus* is a miracle of close observation and delightful domestic disorder.[102] At Santa's feet lie a discarded clay pipe (short), the emblem of St. Nicholas, and a half-peeled Christmas orange, which may also stand for the House of Orange, rulers of New Amsterdam. The fireplace is rimmed with old Dutch picture tiles, in blue-and-white Delftware. A chair of colonial design and a matching footstool peep into the picture at the right and left foreground. The details, in other words, identify both Santa and the artist with the Dutch Revival. The largest, prettiest stocking, at the far right, must be for Weir's wife; it is full of yarn and needles. The other two stockings, bearing the initials of Weir's own sons, are a study in contrast: the red one on the right bulges with toys and sweets, while the blue one on the left, for little Walter Weir, is empty, save for the switch, or the wooden whip used to chastise a bad child. But Santa could not be so cruel as to leave nothing at all for poor Walter. A jumping-jack dangles by its neck from the toe of the stocking. As for Santa himself, he is short and round, in the Dutch manner, with big boots, wearing a short cape that conceals most of his

Robert Weir, *A Visit from St. Nicholas* (also known as *Santa Claus, or Saint Nicholas*), circa 1837. The New-York Historical Society.

costume.[103] His sacred character is affirmed by a rosary, dangling from his belt, and what may be the upright member of a large metal crucifix, worn like a sword on his left hip.

Despite the existence of this vigorous St. Nick in the 1830s and 1840s, Thomas Nast, the father of the American political cartoon, is widely believed to be the creator of the modern Santa Claus. According to a recent article in the *New Yorker*, he was "the man who invented Santa Claus, taking a minor Central European folk saint, dimly recalled from his German childhood, and turning him into the personification of American Materialism, coming down the chimney and shaking with joy."[104] Unlike earlier examples, with their rosaries and crucifixes, Nast's Santa Claus of the 1860s is fiercely patriotic but not at all religious; he is no St. Nicholas. Although he remains stubbornly Old Dutch in shape and build, he is a contemporary, national figure, identified with the Union Army and its sacred mission to restore the integrity of the United States of America.

In January 1863, on the basis of previous work for *Leslie's Weekly* and the New York *Illustrated News*, Nast was asked to supply holiday pictures for *Harper's Weekly*, the most influential and widely read of the era's magazines. In the North, *Harper's* was also the chief source of pictorial information about the progress of the Civil War. So Nast's cover picture—"Santa Claus in Camp"—shows Santa dressed in Uncle Sam's striped pants and a fur-trimmed jacket bearing the stars of the American flag, bringing presents from wives and mothers to Union troops at the front. Seated on a sleigh heaped with back issues of *Harper's* and wooden gift boxes from home, Santa pauses for a moment to amuse the solemn-faced soldiers with a jumping-jack that closely resembles Jefferson Davis in the process of being hanged. Meanwhile, at the far left, one man opens his box and pulls out a pair of warm socks (his Christmas stocking, far from home). In the foreground, two boys play with a conventional jack-in-the-box. A triumphal arch at the right, constructed of Christmas greenery, welcomes Santa and his reindeer. Surmounted by the letters "U S" picked out in moss and pine boughs, the picture is decorated around

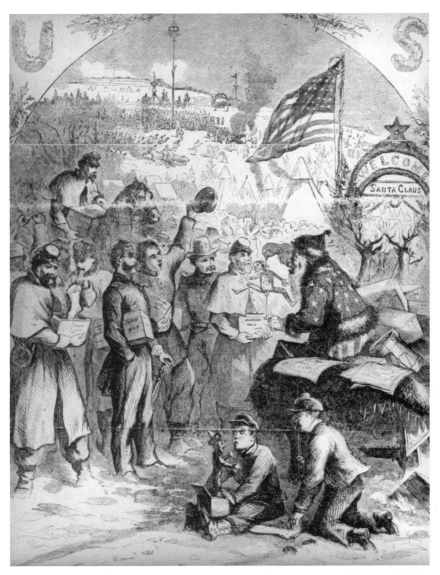

Nast's "Santa Claus in Camp," 1863: Santa as a Union partisan. *Harper's Weekly* (January 3, 1863), 1.

the edges with holly, like a framed painting or a photograph on the wall of a middle-class parlor at Christmastime.[105]

Although this was Nast's first Santa for *Harper's*, he was no stranger to the theme. He had already illustrated a full-color edition of Moore's poem and provided Santas for a volume of popular *Christmas Poems* by J. M. Gregory.[106] In addition, Nast had plenty of other pictorial prototypes at his disposal. In the Christmas issue of *Harper's* for 1857, a Dutch Santa with a clay pipe (long) and high boots with turned cuffs accompanied a narrative poem for children, set in New Amsterdam.[107] The 1858 *Harper's* Santa Claus, a pictorial anomaly riding in a sled pulled by a monstrous turkey, had few of the characteristics of the emergent Santa: followed by a battalion of dancing wine bottles and pies, he is a Lord of Misrule, in a Russian-style fur hat, mislabeled as Santa Claus.[108] By 1860, however, *Harper's* had made Santa Claus into the controlling deity of the holiday and had settled on a kind of representation that minimized his Old Dutch and Old World origins.

The *Harper's* Christmas cover in 1860, an unsigned work with a Christmas dinner scene in the center, explored the many activities of the season through a series of surrounding vignettes. These showed a Christmas tree, a young girl hanging her stocking, a gala party, a kindly woman bringing alms to the poor—and Santa Claus, the familiar roly-poly Dutchman with a short jacket and a conical hat, sticking straight up on his head.[109] In addition to the cover, there were two elaborate, full-page Santa pictures on facing inside pages. The first offered a visual comparison between two cameo-like vignettes set against a field of holly leaves: the manger at Bethlehem on the left, with the shepherds adoring the baby, and "What Santa Brought Us" on the right, with the members of an American family showing one another their gifts. Between the two vignettes, acting as the link between the scenes, is Santa poised on the chimney, as children slumber before a fireplace hung with their stockings.[110]

The second full-page picture, entitled "Santa Claus: Dreams and Reality," is divided into a bottom section showing excited shoppers looking at a Christmas tree in the window of a toy shop, and a top

"Dreams and Reality," 1860: Santa Claus vs. the store window, wishes vs. hard cash. *Harper's Weekly* (December 22, 1860), 809.

section showing a boy sleeping peacefully while a shadowy Santa and six reindeer make their rounds in his dreams.[111] In every case, Santa is man-sized but short, chubby, fur-trimmed, and thoroughly at home in the American settings provided by *Harper's*. But he was not yet American enough for Thomas Nast, who first read an illustrated version of Moore's poem sometime around 1860 and lamented the Dutch flavor of the existing pictures. Though Nast was a German immigrant who had grown up with stories of "the Bavarian Santa [and] jolly and rotund Pelz-Nicol," his grandson wrote, he was determined to make St. Nicholas into a 100 percent American.[112]

Nast's 1863 Santa-as-Uncle-Sam identifies Santa Claus overtly with the national interest. But it also makes a strong connection between Santa, as a delivery man, and home, from which the soldiers' gifts have come. What is most remarkable about this, the first of decades' worth of Nast Santas for *Harper's*, is the thoroughgoing domesticity of what is, after all, a kind of battle scene. The Christmas decorations around the edges of the picture, for example, are of the sort typical in the Victorian household, in which framed images were embellished for the season with garlands and greens.[113] The kinds of toys in Santa's pack—the drum, the jumping-jack—are just what youngsters in New York and Philadelphia and Boston would be getting on December 25th, 1862.[114] And the gift box that contains the socks (with a pipe tucked inside) points to the growing popularity of presents for grownups. Christmas hosiery began as a homemade item in boxes like Nast's but became even more widespread as a seasonal offering when manufactured items began to dominate Christmas lists in the postwar era.[115] Nast's Santa Claus endorsed the interests of the modern American householder, circa 1862.

The startling stars-and-stripes Santa is only one of two such images in the Christmas issue of *Harper's* for 1862–63. The second, also by Thomas Nast, is called "Christmas Eve 1862."[116] The illustration is a double-page spread, the left half of which is dominated by an interior view of a room in a Northern city bristling with church steeples. As her children slumber in the bed behind her, a mother prays at the window. The stockings are hung. Several large gifts—too

large to fit in a stocking—are clearly visible: a drum, a toy rifle with bayonet, a bugle, and a toy soldier. There is also a doll.[117] Wreathed in holly, a portrait of a man hangs on the wall overlooking the sleeping children. The scene on the right shows a lonely sentry examining pictures of a young woman and two youngsters by the light of a campfire in a desolate landscape. He is, of course, the man in the bedroom portrait, and the family that awaits his return from war is represented in the photographs he sadly examines.

The meaning of the composition is unmistakable: Christmas is a time for families to be together in the cozy bosom of home. Small scenes at the top and bottom of the page enlarge on Nast's theme. Santa has been caught in the act of descending the chimney immediately above the heads of the sleeping children. Above their homesick father, Santa speeds through another Union camp in his magic sleigh, tossing out little crates from home as he goes. Thus Santa Claus and his bounty are the ties that bind the family together. Santa is the guardian angel of the hearth that he adorns with drums and Christmas dollies.

Nast's second Christmas issue came in December of 1863—a complex, multi-sectioned plate showing a soldier's Christmas furlough, a joyous affair with relatives, a tree, the usual drums and dollies, and a sprig of mistletoe that encourages the returning father to kiss his long-suffering wife. At the right is "Morning," with children opening their stockings; at the left is "Eve," with a civilian Santa Claus, dressed in fur from head to toe, stealing into the room to fill those same stockings. Smaller scenes inset at the bottom depict the stable at Bethlehem, the family going to church, and the Christmas dinner, with the reunited family all seated around the table.[118] The family is the message, however—the joyous homecoming; religion is a kind of distant afterthought.

In 1864 and 1865, the Santas in *Harper's* were purely literary personages, the subjects of editorials, ads, and children's stories.[119] But in 1866, Nast returned with the pictorial statement that has influenced Santas from that day to this. A double-page picture, full of incidental detail and intriguing captions, Nast's masterpiece was

Detail, Thomas Nast's "Christmas Eve—1862." A soldier's family awaits the arrival of Santa Claus. *Harper's Weekly* (January 3, 1863), 8.

called "Santa Claus—His Works."[120] And in this collection of anec-
dotal fragments, arranged to form a single, kaleidoscopic summary
of Christmas iconography and Santa-ness, Nast established his hero
as a homebody who lives in "Claussville," at the North Pole, in a cozy
world of tea parties for dollies, toasty fires, and pleasantly cluttered
workrooms (see illustration in Chapter 5). He sews doll clothes, tal-
lies up the ledger of good deeds and bad, trims Christmas trees,
makes wooden animals for toy farmyards, and, from his icicle-
bedecked perch in the Arctic, keeps an eye on boys and girls every-
where with an up-to-date model spyglass.

This Santa is shorter than he will be in the 1880s, when Nast
ended the *Harper's* series. He wears a kind of union suit made of fur,
with a leather belt; in 1866, when Nast undertook the pictures for a
story about Santa Claus that was among the first children's books to
be published in full color, the suit was of a reddish shade, and so
presumably is the one seen in *Harper's* black and white plate.[121] His
cap is pointed, and when he sits down to put his feet up after Christ-
mas is over, he smokes a long clay pipe in front of his own hearth.
But he is equally at home in front of the typical American fireplace at
the heart of the picture, where he stands on a chair to fit the very
last toy into the toe of the last little stocking. A personification of
American materialism, he inhabits a domain full of toys and gifts
and picture books, made in his own personal factory at the North
Pole.

Some students of Christmas symbols have concluded that, if noth-
ing else about Nast's Santa Claus is wholly original, his palace at the
North Pole is.[122] Interest in the polar regions was at its height in the
years before the Civil War. In 1845, the Franklin expedition—the
British Arctic Expedition—vanished en route to the North Pole; relief
parties were sent out at regular intervals for decades afterwards, in-
cluding several that set sail from New York.[123] One illustration in the
1857 Santa feature in *Harper's,* which described him as living in a
"wonderful house of snow" somewhere in the far north, depicts
Santa Claus on a ledge of ice, overseeing preparations for his annual
trip. All around him stretches a wasteland of snowy crags; his load of

toys is arriving at the point of embarkation in the gondola of a modern hot air balloon like those which would later be used for polar exploration in the 1890s.[124] Nast may not have been entirely original in his choice of a site for Santa's realm, but he did help to turn current events into instant Christmas traditions.

In many ways, the Nast Santa was a thoroughly modern character. He took orders over the telephone in the 1880s.[125] He had himself delivered to households via express wagon, thereby avoiding a long, cold trip by sleigh.[126] Children awaiting his coming pored over new maps of the barely charted polar regions in an effort to track Santa's route.[127] In the pre- and post-Christmas seasons, Nast's professional life as a political cartoonist demanded a close attention to the preoccupations of the hour, and his Santa Claus was no less caught up in contemporary fads and fancies. But Thomas Nast was not the only commentator to credit Santa with avant-garde tastes. Throughout the 1880s, Santa was almost universally viewed as a wide-awake character with a stake in the same up-to-date conveniences that enthralled fathers and mothers and impatient children. Stories about Santa Claus had him swapping the old-fashioned reindeer team for "modern improvements" in gift delivery methods, including "steamships and railways and telegraph wires."[128] The new Santa for the industrial age pauses thoughtfully on rooftops, stymied by hot-water radiators, coal furnaces, and a growing absence of fireplaces.[129] Eventually, he flies around in airships and rickety planes—even drives a car right up to the front door.[130] Yet his willingness to adopt newfangled ideas raised the ultimate question: who needed Santa, anyway, when the modern department store stocked anything one's heart desired?

Did Thomas Nast create the all-American Santa Claus, the Santa who embraced modern technology, met with his little devotees in countless department stores, appeared in ads, and still managed to uphold the values of home and hearth? Yes and no. In the 1860s and 1870s, many artists working in the commercial media made substantive contributions to the appearance of Santa and to his story. In the hands of others, Santa grew less elfin in character, less like the

Even before Nast began his Santa series, Mr. Claus was associated with the far North and with the technology of polar exploration. *Harper's Weekly* (December 26, 1857), 821.

figure in Moore's poem and more like the English Father Christmas, a full-size adult man.[131] In the pages of *Godey's* in 1873, at a time when Nast still had Santa Claus in a fur union suit, he was already wearing what would emerge as the definitive Santa suit: a pointed cap, long pants, and a matching jacket trimmed with white fur around all its edges, a kind of highly decorated business suit.[132] The cover picture for the Schwarz Brothers' 1876 Christmas toy catalog shows a large rooftop Santa Claus in full regalia who cuts his ties to

the Moore poem by dwarfing both the tiny reindeer and the chimney from which he has emerged.[133] In a cover picture for *Harper's Young People,* in 1879, both he and the reindeer are of normal stature.[134]

When he became increasingly human, Santa acquired the appurtenances of the typical American male. The North Pole workshop envisioned by Thomas Nast was a lonely place, where Santa made the toys himself, in the craft tradition; gradually, it became a factory full of busy elves supervised by an executive Santa. A Mrs. Santa Claus, meanwhile, presided over the house. Tradition has credited Mrs. Claus to Katherine Lee Bates, the poet who wrote the words to "America the Beautiful": Bates was also the author of thirty-two forgotten books, including the 1899 *Goody Santa Claus on a Sleigh Ride,* the story of Santa's better half.[135] But Louisa May Alcott, in one of her many magazine stories, also gave Santa a wife. Mrs. Santa was an idea whose time had come. As early as 1881, she was a part of the Christmas story too ordinary to require special notice. "Good-natured" and plump, she was the supervisor of the North Pole bakery and candy factory.[136] She assumed the task of trimming hats for the dolls and complained when proper credit for her labors was not given.[137] She wore spectacles and had no children, except for those who waited for the arrival of her husband on Christmas Eve.[138]

While it is probably not fair to see this new Santa Claus as a benign version of a robber baron, as the comic poet Irvin S. Cobb and others were prone to do, his biography does resemble that of a middle-class paterfamilias, perhaps (although most toys were made abroad until World War I) an entrepreneur in charge of a little factory that made nice new Christmas sleds.[139] This down-to-earth Americanism of Santa Claus, with his toy business and his busy wife, seemed calculated to attract the interest of L. Frank Baum. An entrepreneur himself, and a major exponent of animated Christmas windows for department stores, Baum had scored a great hit during the 1900 Christmas season with the publication of his best-seller, *The Wonderful Wizard of Oz.*[140] His books for children differed from the norm because they maintained that America was an enchanted place, where a bleak Kansas landscape could suddenly melt into the

Mr. and Mrs. Santa Claus, 1937. Minnesota Historical Society.

magical Oz, with its witches and wizards. Abjuring European models, he aimed to create nothing less than a new mythology of childhood premised on familiar American figures.

His second innovative book of American fantasy, released in 1902, was *The Life and Adventures of Santa Claus.* Although, unlike the Oz books, this version of the Santa story has not become part of the ac-

cepted tradition, it was very popular at the turn of the century because Baum's story explained in some detail where Santa came from in the first place, why he brought candy and treats along with the presents, and how the department store fitted into the magical economy of Christmas. Santa came from nature, according to Baum, from an enchanted forest, the adopted son of a wood nymph. Sent into the world briefly to rejoin his own kind, he was saddened by the sufferings of mortal men and women who toiled after "bits of white and yellow metal" throughout their short lives. Their children, whether rich or poor, seemed fated to sink into misery, too, without an inkling of the joy that Claus felt among the immortals of the woodlands. And so Claus began to carve playthings for them and to leave the toys at their firesides on Christmas Eve.[141]

As he came to know the children better, he learned that there were other things they loved. Claus dispatched the fairies to the tropics to find oranges and bananas and to the Valley of Phunnyland, where "candy and bonbons grow thickly on the bushes," and added them all to his pack. He was ingenious, always tinkering with improvements in the annual arrangements: for visits to warm-weather climes, Claus added a set of little wheels inside the runners of his sleigh.[142] Made an immortal in tribute to his good deeds, Santa Claus soon found himself confronted by the harsh realities of supply and demand. To meet a growing need for toys, he recruited the elves to help with the work. When furnaces made chimneys too small for his passage, it was the fairies and sprites who zipped through the walls to trim the Christmas trees. And when the whole enterprise seemed too much for one Santa to manage, he "began to send great heaps of toys to the toy-shops, so that if parents wanted larger supplies for their children they could easily get them; and if any children were, by chance, missed by Santa Claus on his yearly rounds, they could go to the toy-shops and get enough to make them happy and contented."[143] Thus the American Santa, in the Baum version, became the founder of the toy department, where his numerous lookalikes in scarlet and fur would preside ever afterward upon their golden thrones.

The endorsement of the man who invented Oz was a powerful proof of Santa's existence: Baum gave him a mother, a childhood, a full-fledged biography. But the ultimate demonstration of Santa's hold on the American imagination came in 1897, in the pages of the New York *Sun*. Late that summer, an eight-year-old girl, Virginia O'Hanlon, daughter of a New York doctor, wrote to the *Sun*'s "Question and Answer" column, inquiring whether there really was a Santa Claus. Some of her friends had recently expressed doubts. Her father, who was "a little evasive on the subject," recommended that she write to the newspaper because, as her letter noted, "If you see it in 'The Sun' it's so."[144] The O'Hanlons' high opinion of the media seems misplaced by today's standards. In the nineteenth century, however, newspapers were the major source of facts and information on all aspects of life. "In politics, in literature, in religion the newspaper is accepted as an infallible guide," wrote *Lippincott's Monthly*, with a touch of envy.[145]

And the press took the responsibility seriously. While Virginia watched the papers and began to wonder if her question would be answered in time for Christmas, the *Sun* passed the letter along to Francis P. Church, former Civil War correspondent and son of a Baptist minister, an editorial writer who specialized in touchy theological subjects. For the September 21, 1897, issue of the *Sun*, Church wrote the famous "Yes, Virginia, there is a Santa Claus" editorial, encouraging Americans to keep the faith with Santa and all he stood for—"love and generosity and devotion." Virginia's friends were wrong, Church insisted: "They have been affected by the skepticism of a skeptical age."[146] Written in the fourth year of a national financial panic, the editorial was widely reprinted because the *Sun* was endorsing renewed confidence in the human spirit, the power of the imagination, and the promise of the future. "No Santa Claus! Thank God he lives, and he lives forever." Until the paper went out of business in 1950, the "Yes, Virginia" essay ran every Christmas, a tribute to the Santa Claus created by the nineteenth century as a mark of national distinction, of trust in a resilient economy, and of material well-being. And an act of faith in the efficacy of belief.

The country could use Mr. Church and his splendid, passionate editorial in the twenty-first century. The syndicated "Dear Abby" column still gets the "Virginia" question today. "I have a problem," writes a reader whose little great-grandson, age ten, believes in Santa so fervently that he hears hoofbeats on the roof. He's too old for these fantasies, says a desperate "Grandma in Saratoga Springs, N.Y." What to do? "The Santa Claus story is exciting and believable for very young children," Abby replies, "but when they first begin to question if there really is a Santa Claus, it's time for total honesty."[147] Shame on you, Dear Abby! May you find nothing but a lump of coal in your Christmas stocking next year!

SOMEBODY ELSE'S CHRISTMAS

Hot Christmas, Black Christmas,
Faraway Christmas

E very December, the stores are full of pretty gift books picturing
Christmas celebrations in other lands and their piquant oddi-
ties: *Christmas in Ireland, Christmas in Spain, Christmas Around the
World.*[1] Another sign of multiculturalism on the march? Expressions
of hyphenated-American pride? Maybe. But ethnic and geographic
differences have been part of the fascination of Christmas for a long
time. Almost as soon as Christmas rituals began to settle into a rec-
ognizable pattern in the United States in the second half of the nine-
teenth century, Americans began to take a keen interest in how
other people were observing the holiday. There is a certain logic to
the concern with Christmas customs (or their absence) in Germany,
Italy, and Asia: this was the Golden Age of immigration. But in other
areas of life, the newcomers' foreignness was a handicap, a mark of
Cain to be erased as quickly as possible in language and citizenship
classes. Christmas was a singular exception to the tyranny of the
melting pot.

Most of the studies of Santa-equivalents or gift-giving practices
overseas were pleasantly generic in character, telling how "they" did
things in some faraway locale. The exception was England and the
royal court, whose members' provisions for Christmas were followed

obsessively on this side of the Atlantic from the introduction of the German Christmas tree in the household of Victoria and Albert in the 1840s to the menu for the Christmas roast beef dinner enjoyed by the genial Edward VII at Sandringham in 1905.[2] *Godey's Lady's Book and Magazine* was particularly engrossed with Victoria and her decorated tree—and with good reason.[3] It was the English of the nineteenth century who were the leaders in American fashion—what to wear, how to behave, how to trim a Christmas tree. Many of the all-important pictures in *Godey's,* images that American women took as templates for action, were borrowed from the illustrated papers in London, with only the slightest of modifications to suit American needs. It was not for nothing that the era was later named after Queen Victoria, the first real international media celebrity.

Although Presidents and other world leaders were sometimes mentioned by way of contrast in dispatches on family get-togethers in the stately castles of England, Teddy Roosevelt's gift of a turkey to each White House employee and the funny steps he did in a cake-walk at the annual White House Christmas party made for mild reading alongside the gilded extravagances of the monarchy. In one sense, the annual descriptions of succulent roasts, sweet-faced carol-singers, costly presents, flaming puddings, and gigantic Christmas trees affirmed American practices, on a much larger scale. They legitimated what Americans were doing with a kind of royal seal of approval, a guarantee of fashionability. To learn that Victoria's German-born consort provided the elaborate Christmas tree for his family by way of celebration, immediately after the birth of the couple's first son, also lent a human dimension to a custom rapidly being adopted by middle-class American families.[4]

The modern equivalent of the Royal Christmas is the Celebrity Christmas. When the *Ladies' Home Journal* took up the subject of how various well-known figures intended to observe Christmas in 1984, the editors included Princess Diana and her annual command appearance at the Queen's four-day Windsor Castle festivities. But Diana's plans were juxtaposed with those of pop star Michael Jackson (a practicing Jehovah's Witness who did not intend to observe

the holiday), movie queen Elizabeth Taylor, and country singer Dolly Parton.[5] Peeps like these into the homes of the rich and famous at Christmastime are as much a part of the festivities as holly and cards. And no ghost-written celebrity biography is complete without a discussion of the subject's special Christmas rites and memories.

Brassy Broadway star Ethel Merman, in a 1978 memoir, told of leaving the Christmas tree up year-round in her Manhattan apartment: "Every night I light that little tree and get a lot of enjoyment out of it. It's so peaceful and beautiful and it gives me a wonderful feeling. Wonderful! As if nothing can hurt me."[6] Dolly Parton's life story, published in 1994, told a dismal tale of childhood poverty in the rural South, relieved only by the plastic baby dolls the Parton girls got for Christmas every year. "That may sound really cheap, and I'm sure it was," the singer remembered. "But for us, just the fact that it was plastic made it different from the ordinary things we saw in the holler."[7] Tammy Wynette "always had a wonderful Christmas," with $50 for each child pinned to the tree on a clothespin by her father, who stayed home when the rest of the family went to church for the "biggest event of the year."[8] The much-married Lana Turner symbolized her hopes for the longevity of her current match by decorating a live tree "to plant after the holidays" on the front lawn as a reminder of her fidelity.[9] All these stories serve to humanize the stars though the medium of Christmas, inviting the reader to compare one's own presents, one's own sentiments about Christmas trees and family and continuity to those of others. Christmas is a common language through which a complicated array of feelings may be discussed among people who might otherwise have nothing to say to one another.

Accounts of terrible Christmases among the Hollywood glitterati have the effect of bringing the mighty down to earth, reminding fans that the glamorous Christmas isn't always superior to the humdrum holiday in one's own living room. The ultimate case in point is *Mommie Dearest,* an exposé of bad parenting in the home of Joan Crawford, who adopted four children at the height of her movie career and, according to the eldest, used them as hapless instruments

in a public relations campaign to convince the world of her warmth and generosity. Christmas at the Crawfords' was the worst time of the year because the public expected a great show of togetherness. But the beautiful tree and the heaps of gifts were torture to the children, who were forced to feign happiness when the packages were opened—and then give the contents back to their mother when the cameras stopped rolling, for recycling at subsequent Hollywood birthday parties.[10] Christmas was a fraudulent spectacle, a sham. The transcript of a 1949 broadcast from Crawford's Brentwood mansion paints a totally fictitious picture of all-American Christmas bliss: stockings waiting to be filled, readings from Dickens (Helen Hayes sent the illustrated book), presents dispatched to needy children overseas, and a happy family singing "Jingle Bells" and reciting "The Night Before Christmas" at the end of a perfect day. When the reporter left, however, Crawford sent the children directly to bed and opened her presents alone.[11] (By the way, Joan kept *her* gifts!)

Although seamy revelations about his private life would emerge after his death, Liberace genuinely loved Christmas, and everything it stood for: spending with abandon; love of family and friends; a time-out from the year, signaled by Christmas decorations that transformed his several houses into seasonal theme parks. His home in Sherman Oaks, California, became a showplace and a tourist attraction, thanks to lighted trees, a mechanical Santa Claus with reindeer, a life-size crèche, and the amplified voice of the owner crooning carols to passing cars.[12] Cost was no object when Liberace called startled decorators and told them to do the interior over for the holidays, on a couple of weeks' notice. The downstairs ceilings were covered with twinkle lights one year. A tree on a dais in the middle of the living room seemed to rise up through the stars and into the ceiling. The effect was dazzling—except that all the ceilings had to be replaced afterwards, at huge expense.

Another Christmas, to avoid wear and tear on the house, Liberace rented a motel for his holiday party and trimmed every room with its own tree. When he saw a magnificent tree decorated with miniature toys in the Neiman Marcus department store, he ordered one just like it and built that year's Christmas around the theme.[13] 1962 was

a feather Christmas. There were other Christmases based on crateful of ornaments acquired on a world tour, on roomsful of flocked trees, on a special Nativity scene purchased from a Houston museum, with the animals covered in real skins. There were presents for every guest. His mother, for whom he bought the mink coats and Tiffany jewels she should have had "but had never been able to afford," presided in the corner, saving the wrapping paper from the parcels until the stack of discards was several feet high.

Like Elvis Presley, who turned Graceland into a Christmas card for the city of Memphis every year and gave away Cadillacs on virtually any occasion, Liberace illustrated the efficacy of the American dream. The poor boy had made good, and the clearest expression of his newfound wealth came in his observance of Christmas. If most people gave nice presents to their loved ones, he gave wonderful Christmas gifts to everybody in sight. If most people put up a Christmas tree and strung a few lights, he put trees everywhere and tore up the ceilings and rented whole buildings for the overflow crowd. Liberace's was the average American Christmas on a hyperbolic scale, and as such, provided a means of examining its unseen minutiae at close range. Newspapers in the early years of the twentieth century often used Christmas spending as a gauge of overall economic prosperity, a sign of good times for the man in the street.[14] If spending equaled happiness, Liberace's story was an object lesson in the giddy joy that money could buy for almost anybody. All it took was luck, pluck, a way with the piano, and a gold lamé Santa suit.

At the beginning of the twentieth century, the Christmas plans of actors and other entertainers tended to be of interest because they were so different from the norm. Often, as members of touring companies, they found themselves far from home when the holidays arrived. Like policemen and firemen, ingenues and male leads had to work on Christmas Day; during the week between Christmas and the New Year, in fact, impresarios were apt to add matinees and extra performances because the audience was typically at leisure. So, for most thespians, wrote an observer of the New York stage scene in 1907, "these days are about the dreariest time of the year."

A season earlier, the producer David Belasco had garnered a

healthy serving of publicity by providing gifts and a tree for members of one of his companies playing "The Rose of the Rancho" on Christmas Eve. But a backstage Christmas sounded more glamorous than it was. Even with a tree, most actors would rather have been home eating turkey. The cast of a popular Broadway farce complained about ticketholders so stuffed with their own Christmas dinners that they couldn't tell comedy from tragedy. The majority of the troupe would probably have agreed with Denman Thompson, age seventy-four, playing his umpteenth return engagement in "The Old Homestead" at the Academy of Music. "Guess stage folks gradually lose their sentiment for Christmas," Thompson sadly admitted. "Leastwise, I can't recall anything that stands out in any special way to distinguish Christmas from any other day, except that we have two performances instead of one."[15]

Pressed by the same writer for memories of better Christmases on the boards, the headliners of 1909 made short work of complaints about the hardships of life in dreary hotels and dressing rooms. Instead, they recalled the times when their movable feast had landed temporarily in some exotic clime for Christmas. For Margaret McKinney, the high point was a Christmas dinner in Tennessee: wild turkey, sweet potatoes, and a large helping of Southern hospitality, arranged long-distance by her absent husband. For Rose Stahl, it was playing Santa Claus to three orphaned children on a train bound for California on Christmas Eve.[16] The essentials of Stahl's story—children stranded in an inaccessible place without parents or a chimney for Santa to use; strangers conjuring up the Christmas necessities out of the contents of pockets and handbags—may have been pure fiction. In the first decade of the century, the outlines of that narrative were almost as familiar as the legend of Santa Claus, thanks to a glut of Christmas stories describing just such a scenario.[17] The cast of characters always included a crusty conductor, a sympathetic lady-passenger with presents in her luggage, and unescorted children traveling at Christmas. The moral of the story? Yankee ingenuity can make a Christmas tree out of an old umbrella and a few scraps of tinfoil. In a pinch, strangers can become a kindly

family. Christmas is for children, but it has lessons to teach to the grownups who care for them.

The make-do provision of the proper Christmas accessories—trinkets hastily wrapped in handkerchiefs, a tree evoked by a decorated branch or a stove-pipe—indicates just how crucial the material trappings were to the observance of the holiday, circa 1900. Without a tree, or a reasonable facsimile thereof, Christmas would cease to exist on the snowbound trains and lost stagecoaches of the national imagination. By some peculiar twist of logic, accounts of how such celebratory goods were provided under conditions of extreme hardship became very popular with both children and adults. Because it was one of the last unconquered landscapes of the world, the Arctic posed a special challenge to the modern faith in technology and consumerism; first-hand accounts of bitter winters in the icepack (and fiction based on such reports) fed a public hunger for news of the ongoing quest to reach the poles.

The struggle to live through an Arctic winter invariably raised the question of how Christmas was to be celebrated under adverse conditions. Feasting, shopping, wrapping paper, and tags seemed all but impossible on short rations in ships frozen into the ice, far from civilization. Those who had wintered within the Arctic Circle were quick to cite the distance from home and family as one of the greatest hardships of the explorer's lot at Christmas, even when Santa Claus suits, mysterious packages, and quantities of cheese, molasses, ham, and condensed milk materialized in time for a makeshift celebration.[18] An improbable tale of a little girl stranded above the seventeenth parallel for Christmas featured warm-hearted sailors making a tree-substitute out of a lifeboat, rigged with lighted candles, and gifts bartered from friendly Eskimos.[19] A more somber eyewitness account of two Christmases in the Arctic ice, written by Rear Admiral George Wallace Melville in 1901, spoke of utter desolation, finally relieved by amateur theatricals, Santa, and helpings of "plum duff," after what was, by shipboard standards, a sumptuous Christmas dinner.[20] The Arctic Christmas was a kind of object lesson in counting one's blessings: the absence of the usual holiday necessities sharp-

ened the pleasure of readers who had them and reaffirmed their centrality to the celebration.

The American West offered a parallel case study in Christmasing by the seat of one's pants. The best and earliest example of a Western Christmas story is Bret Harte's "How Santa Claus Came to Simpson's Bar," written around 1870. Set in the valley of the Sacramento River, in full flood, on Christmas Eve, 1862, the plot is a familiar one: how can Santa Claus come to a child of adversity, far from civilization? A rough-hewn miner risks his life to bring Christmas toys ("cheap and barbaric enough, goodness knows, but bright with paint and tinsel") to a sick, motherless boy in an isolated camp.[21] A junior version of the story, published in *St. Nicholas* in 1884, concerns a child, left alone in a boarding house in mining country at Christmas, and her heroic efforts to rescue her father, who is lost in an awful snowstorm on his way back to her.[22] Other plucky youngsters in the pages of the same magazine make Christmas for troops stationed at cavalry posts on the desolate prairie.[23] An 1891 holiday picture in *Leslie's Weekly* shows a rough and tumble board-front town in the West, with desperadoes shooting at the wishbone from the turkey amid a litter of discarded liquor bottles. The title? "Christmas in the Far West."[24]

The more common reason for using the West as a subject was to analyze the ways in which a celebration grounded in Dickens, history, distant memories of the Old World, and the commercial bustle of the cosmopolitan East managed to survive on the wild frontier. In 1904, 1905, and 1906, self-styled "cowboy artist" Charles Russell prepared full-page Christmas paintings for *Leslie's* showing how mountaineers and cattlemen kept Christmas. In the first picture, "Christmas at the Line Camp," cowboys visit comrades wintering with the herd, bringing fresh supplies and high spirits.[25] In the second, a pack train battling a fierce snowstorm in the foothills of the Rockies brings down a stag for Christmas dinner.[26] In the final picture, trappers encamped for the winter are visited by an Indian family, bearing gifts of game and news.[27] Russell's paintings are full of fresh air and ferocious energy, at odds with the usual hearth-and-

Christmas in the West, 1891: "Shooting the Wishbone." *Frank Leslie's Weekly* (December 5, 1891), 291.

home images of Christmas. But any picture of the romantic West would do. *Leslie's* 1909 offering from the frontier, by an illustrator of no great distinction, depicted a reservation in South Dakota, with the operator of the trading post in false whiskers giving store-bought stockings and candies to smiling Native American families dressed in full ceremonial regalia.[28] Change the clothes, and the smarmy little morality play could have been staged anywhere.[29]

Climate was a major factor in the fascination with Christmas on the frontier. Russell's paintings were harsh wintertime scenes, full of ice and snow, but when Easterners thought of the West, they more often imagined cacti, dusty desert landscapes, and scorching heat—the geographic conventions of the emerging cowboy film—or the paradisiacal fragrance of a California orange grove. Warm-weather Christmases piqued the curiosity of Easterners, who expected that, since the holiday fell in late December, it *had* to be cold on Christ-

mas. Because Western Europe had been the most immediate source of influence on American Christmas iconography, the wintertime symbols of Germany and England had crossed the Atlantic in the form of evergreen trees and the snowy landscapes of pictorial Christmas cards. Thereafter, despite the scarcity of snowstorms in Bethlehem, the true Christmas was always white and chilly, a convention that reinforces the secular underpinnings of the holiday.

The most common solution to celebrating a snowless Christmas in the sagebrush West was to import it from "home," in a Christmas box shipped by kindly East Coast relatives.[30] Failing that, settlers sought out local equivalents for each of the holiday necessities: homemade gifts instead of store-bought ones; home-dried raisins instead of bonbons from the confectioner; a wild turkey; a clump of late-blooming prairie roses for a Christmas tree.[31] That was the answer, too, when American troops found themselves sweltering in Cuba, Hawaii, and the Philippines during the holidays.[32] In 1900, a packing house advertised a "Peerless Plum Pudding" in a can, suitable for shipment to American soldiers in far-flung posts where such products were probably hard to come by.[33] What was a Yankee to do in tropical Puerto Rico on Christmas Day? asked a 1901 magazine article steeped in the rhetoric of the new American imperium. Why, dine outdoors, of course! Roast some tasty native bird, with pineapples and mangoes for side dishes. And enjoy a nice, locally rolled cigar for dessert.[34]

Christmas in Southern California has always been problematic for the people who live there. Tinsel on palm trees? Scarves and mittens in 80-degree temperatures? How should a warm-weather Christmas be celebrated? In the 1930s, when most Californians were only a generation away from howling Midwestern winters, the solution was lots of fake snow. Household expert Sibyl Thornton, in the pages of *Sunset Magazine,* advised coating California fir trees with artificial snow and then illuminating them with cold blue lights as a means of capturing the holiday spirit.[35] Other advice columnists, then and now, have counseled the use of local fruits and foliage, albeit arranged in the traditional shapes of holly and evergreen wreaths.[36]

But a kind of snow envy persists at Christmastime, when the ads in the magazines are full of winter coats, fur-bedecked Santas, and rosy-cheeked children on sleds. Muffled in their Ralph Lauren anoraks, Southern Californians yearn for the discomforts of a New York Christmas. One Los Angeles humorist recalls feeling very different from the people out there somewhere, far to the East, who romped through the snow on Christmas cards. "They weren't like me," she writes, "forced to go outside and play with my new toys on Christmas in a sleeveless holiday shift."[37] According to *McCall's*, TV personality Loni Anderson, a Christmas-lover and a native Minnesotan, survived the move to the San Fernando Valley by turning the air conditioning down to zero, setting out the pine-scented potpourri, drawing the drapes, and lighting fat red candles.[38]

The use of Christmas lights—sometimes traced back to the "luminaria" or translucent candle shell of the Latino tradition—is particularly noteworthy in Southern California.[39] Griffith Park, in Los Angeles, has an annual drive-through festival of lights, with animated Santas and toy soldiers picked out in electric bulbs.[40] In Altadena, a neighborhood association founded in 1920 works year-round to light up the tunnel of deodar cedars arched over Santa Rosa Avenue (dubbed "Christmas Tree Lane" for the season).[41] In Valencia, an ongoing "Battle of the Bulbs" pits neighbor against neighbor, in a contest to produce the most dramatically lit displays.[42] Noteworthy Christmas lightfests have enlivened culs-de-sac in Bakersfield, Woodland Hills, Santa Clarita, and elsewhere.[43] Although Southern California is by no means the only place in America to have gone gaga over outdoor decorations, they flourish in cookie-cutter suburbs where, in the clear light of day, all the houses look pretty much alike. And in California, decorations meant to be seen in the dark nicely conceal the fact that Santa Claus and his reindeer are sledding across a brilliant green lawn and that the only snow in sight is a light-up drift of white plastic attached to the base of an artificial snowman.

Las Posadas, an annual reenactment of the search of Mary and Joseph for shelter on the first Christmas Eve, is a historic element of

the holiday celebration of Spanish and Mexican Californians.[44] A procession moves from house to house until the entourage of the faithful is finally admitted and a gala fiesta commences. This parade or processional tradition of the early nineteenth century provides a precedent for events like the Tournament of Roses celebration, which began in Pasadena on New Year's Day, 1890.[45] The first Tournaments were displays of riding, fancy carriages, and beautiful equipage, in the style of the early California ranchos. Held to coincide with the mid-winter bloom of the flowers that so delighted tourists from other parts of the country, the Tournament of Roses evolved from a simple house-to-house parade into the combination of college football and televised pageantry that today marks the official end of the American holiday week.

The Santa Claus Lane Parade, staged on Hollywood Boulevard in the heart of the movie capital, began in 1924 as an event much like the Macy's Parade in New York: it was a way of drumming up business for area stores, which were located outside the old Los Angeles downtown district. The local Chamber of Commerce put imitation chimneys on the street corners, papier-mâché Santa heads on the streetlight poles, and strings of Christmas lights across the thoroughfare. And held a parade, for the duration of which Hollywood Boulevard became Santa Claus Lane. In 1928, things took a more dramatic turn with the acquisition of live reindeer: Santa Claus now led the parade in a sleigh on wheels, accompanied by a crowd-pleasing somebody from the movies. Starlet Jeanette Loff, a contract player with Pathé, became the first celebrity to ride down Hollywood Boulevard with Santa.[46]

During the Depression, as merchants felt the effects of the economic slump, the parade grew more and more elaborate in an effort to attract customers to the stores. Santa, his reindeer, and his guests now coursed down the boulevard on a motorized float, while a machine sprayed paper snowflakes over the occupants and the crowd. A newer and better float put Santa high in the air, over artificial clouds and an earthbound village. In 1932, metal Christmas trees with permanent lights set in reflectors were installed at

curbside; a P.A. system—then a novelty—broadcast carols. Until activities were suspended for the duration of World War II (the metal trees were donated to a scrap drive), the royalty of the motion picture industry made the Santa Lane Parade into a must-see event, natural fodder for newsreel cameras. Bob Hope, Bing Crosby, Bette Davis, Jack Benny, and Mary Pickford all made guest appearances.[47] When the parade started up again after the war, Gene Autry, the singing cowboy, was the 1946 Grand Marshal. As he cantered down the parade route atop his horse Champion, excited children bounced up and down on the sidewalks, shrieking "Here Comes Santa Claus!" Autry went right home and wrote the hit Christmas song of the same name:[48] "Here Comes Santa Claus . . . Right Down Santa Claus Lane."[49]

The modern-day version of the parade is pure Los Angeles, a spectacle staged strictly for television and billed as "the largest annual spectator event in the City of Los Angeles." There are eight pages of celebrity participants listed in the glossy pages of the program, figures mainly drawn from the ranks of up-and-coming TV actors or yesterday's notables. The vintage cars in which they will appear are given almost as much space in the official program as the game-show hosts and the perennial talk-show guests slated to ride in them.[50] And the weather, of course, is always California-perfect: warm, sunny, and wonderful.

The prospect of a sultry Christmas Day has always conjured up visions of the South. "How can St. Nicholas come in his sleigh," asks a child in an 1876 poem about a family's Christmastime visit to a Southern town, "If all the snow is melted away?"[51] Dixie became America's own foreign land after the Civil War: even if snow chanced to fall there on Christmas, the ways in which the natives celebrated the holiday were strange enough to warrant special mention. Unlike the Puritan North, the South had harbored no religious objections to Christmas. In the seventeenth and eighteenth centuries, Virginia and the other crown colonies kept a kind of Olde Christmas, in the English manner, centered on caroling and the traditional feast.[52] Indeed, writers in the antebellum South actually used Washington

Irving's word sketches of Christmas at Bracebridge Hall as the basis for their descriptions of Virginia and Carolina Christmases in colonial times.[53]

Dixie Christmas was an outdoor celebration, with holly, mistletoe, and roses everywhere, practical jokes, hunting, fireworks, and the shooting of guns to announce the coming of the big day. The English Lord of Misrule and social inversion seemed to live on in local customs, like the "Christmas gif!" especially popular among African-Americans: whoever cried out the phrase first on Christmas morning was entitled to tribute in the form of a present.[54] A carryover from the days of slavery, when those in bondage were allowed considerable liberties during the Christmas season (and the fields lay fallow, in any case), the "Christmas gif" of finery and extra rations and other carnivalesque aspects of "ol' Christmas" on the plantations persisted well into the modern era.[55]

In the 1894 Christmas issue, *Leslie's* presented a picture of Christmas Eve on a Louisiana plantation: suitable for framing, it was a contemporary scene with overtones of the past, as a well-dressed white landowner and his guests are entertained by a black orchestra, the antics of black children clog-dancing merrily to the music, and a punch bowl tended by a stereotypical mammy figure in a headrag.[56] "An Egg-Nogg Party in Richmond, Virginia," drawn by W. L. Sheppard for the same journal in 1892, is similar. Sheppard, who specialized in Southern imagery, had tackled this subject for *Harper's Weekly* in 1870.[57] In the earlier version, the lady of the house mixes the potion, while black figures look on with approval. The later version is set in a room hung with portraits of Confederate heroes wreathed in mistletoe. A group of fashionably dressed white people observes the final mixing of the drink, while "an aged colored servitor" stands by with the punch cups.[58] In genial images like these, the Civil War seems never to have happened.

Yet in some respects, the War Between the States was the crucible in which Christmas was forged. Nast's Santa assumed his definitive form as a sort of go-between, carrying news and presents from home to Yankee troops on the front lines. The physical separation of fami-

lies encouraged the proliferation of Christmas gifts as tangible symbols of connectedness and affection. Manufacturing enterprises stimulated by the conflict created the surplus of consumer goods that touched off the explosion of Christmas giving in the 1870s and 1880s. But before Thomas Nast's Santa Claus ever went South with the Union army, the ways in which slaves celebrated Christmas were already a matter of concern in the North.

Leslie's, in December of 1857, published an unsigned engraving called "Winter Holidays in the Southern States: Plantation Frolic on Christmas Eve." In the distance stands a white mansion with tall columns; in the foreground, a hovel in the slaves' quarter. Although Harriet Beecher Stowe paid no attention to Christmas in her epoch-making novel, the scene in *Leslie's* mirrors the pointed dualisms of *Uncle Tom's Cabin,* published five years earlier. In the picture, blacks of all ages, some dressed in handsome hand-me-down clothes from the big house, dance, feast, drink, fight, and make music under the benevolent gaze of the owner and his family.[59] In 1907, *Leslie's* reprinted the picture as a wistful reminder of life in the South fifty years earlier, "before the war." The Christmas celebration in those days, said the explanatory paragraph, "had a picturesqueness which has largely departed since the advent of freedom, with its attendant responsibilities, although it must be confessed that these weigh but lightly upon the average colored citizen of the South."[60]

The belief that the "colored citizen" was a fundamentally different kind of person, carefree, improvident, and picturesque, was supported by the illustration, in which a careful pictorial distinction is drawn between blacks and whites. The latter have the faces of Winslow Homer's paintings: bland and classical, matched with small, restrained gestures of the body. The former are gross caricatures, with rolling eyes, exaggerated facial expressions, and unfettered postures. They fling their arms and legs about and assume poses unacceptable in polite society, whether in 1857 or 1907. Nor is the *Leslie's* picture of Christmas among the antic "coloreds" an isolated phenomenon. During this same half-century, a new genre of Christmas imagery emerged in the popular media from sources like the *Leslie's*

"Winter Holidays in the Southern States," 1857. *Frank Leslie's Illustrated Newspaper* (December 26, 1857), 64.

engraving. What might be called the "Black Christmas" picture became a staple of pictorial journalism during the period, and it defied changes in medium. When engravings and ponderous full-page halftones went out of style around 1900, the iconography of the Black Christmas survived in the form of rotogravure photographs. What bells and wreaths and snowmen are to today's inventory of appropriate Christmas symbols, these troubling Black Christmas scenes were to the holiday repertory of our grandparents and great-grandparents.

In his consideration of the political overtones of Christmas, Stephen Nissenbaum discusses the treatment of the defeated South in Northern newspapers of the immediate postwar period. He argues that their emphasis on the desperate poverty of former slaves underlined fears of potential racial violence. On the other hand, Christmas—when even slaveowners were generous and kind—had once

been a period of bonding between the races, as the happy 1857 Christmas picture in *Leslie's* purported to show. So the *New York Times* and other papers could use Christmas as a suitable occasion for urging reconciliation between North and South.[61] Visual images of slaves and freemen intended for use at Christmas carry more complicated messages, however. In these pictorial statements, the commonality of human feelings and the debt of kindness owing to the poor gradually displace the sharp political content of the earlier editorials.

Caricature is sometimes hard to identify, especially in crude wood engravings in which most of the figures already have the exaggerated ears or noses or the distinctive stances that allow them to be identified readily as types. "Christmas in Camp," in the 1864 *Godey's* holiday issue, is an example of mild caricature. A Nast-like Civil War scene without a Santa, the plate represents Union troops standing before a row of tents. They open boxes from home and take out a variety of holiday offerings, including socks and dressed poultry. The soldiers are all of a type, stoic and dignified, their facial features almost concealed by huge mustaches. In the center, cavorting about, with his straw hat flung over his head, is a black man, holding a plucked Christmas goose in one hand.

He is as different from the white men as the anonymous artist could possibly make him. He dances; they stand in neat rows. He gesticulates wildly; they extract presents from Christmas boxes with the solemnity of priests celebrating the Eucharist. The soldiers have straight noses that terminate in geometric swaths of facial hair. He has a snub nose and huge, protruding lips. The racial stereotype—the physiological differences between black and white—is the point of the picture. Christmas brings unrestrained joy to the ex-slave, anticipating the feast ahead. To the Union soldiers, it is a solemn reminder of home.

Similar facial distortions appear in "Preparing for Christmas" by Thomas Worth, from *Harper's* 1868 Christmas number.[62] A rural image, contrasted with a view of the game stall at New York's Fulton Market, the Worth picture shows a black man preparing to execute a

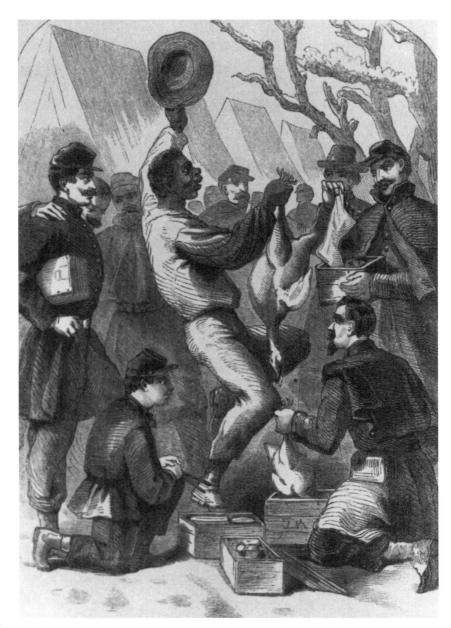

1864: "Christmas in Camp." *Godey's Magazine and Lady's Book* (December 1864), 477.

turkey as three solemn white children look on. Again, they stand tall
and straight while he assumes a kind of half-crouching, minstrel-
show pose, with his head thrust comically forward and his buttocks
protruding. In neither of these works of the 1860s, however, is there
an effort to define a separate Black Christmas. Although the black
figures respond to the prospect of the coming holiday with a greater
vigor, the pictures are about the Christmas that everyone will ulti-
mately celebrate together, with the same appurtenances.

The change came in the 1870s in *Harper's Weekly*, in the work of
three of that journal's stellar artists: W. L. Sheppard, the student of
eggnog recipes; Walter Satterlee; and Sol Eytinge, Jr., best known for
his wood engravings in the 1869 American edition of Dickens's *A
Christmas Carol*, the first edition in English to include a picture of
Tiny Tim.[63] These artists began to shape a distinctly Black Christ-
mas, sometimes humorous, sometimes full of pathos, a Christmas
that served as a wordless commentary on the way in which the rest
of the country observed the holiday. The series opens in 1872, with
Eytinge's "Wide Awake—Christmas-Eve": in a tiny one-room cabin, a
Negro mother struggles to hide a few humble gifts from her wakeful
child. Like his other depictions of a Southern Christmas among freed
slaves, this one makes much of bone structure and physiognomy,
analyzed so closely as to stress the profound otherness of blacks, in
the world of conventional white figures shown in the other pictures.
But the Eytinge plates are not intended to make fun of blacks. In-
stead, the pictures praise their subjects for a laudable hopefulness
and cheerfulness in the face of poverty.[64]

The second picture, the 1874 "Christmas-Time—Won at a Turkey
Raffle," takes the viewer inside another bare cabin where a grand-
mother, a young mother, and five children (of indeterminate age and
gender) greet the man of the house, who has brought home a tiny
turkey and a pocketful of vegetables. "De breed am small," he says in
Stephen Foster dialect, "but de Flavor am Delicious."[65] What seems
to be his portrait, or that of his father in the same oversize top hat,
hangs in the place of honor above the table (where the Confederate
hero hangs in white households), crowned with Christmas greens.

Sol Eytinge, Jr., "Wide Awake—Christmas-Eve," 1872. *Harper's Weekly* (December 28, 1872), 1029.

With his hat, his swallow-tail coat, and his impressive brass buttons, the effect is oddly Dickensian: Bob Cratchit in blackface, in the bosom of his family, before Scrooge's conversion to Christmas good-will. This very picture—man, woman, children, little turkey—hangs over the table in a second Eytinge treatment of the subject, published in 1876 but clearly meant to be seen alongside the earlier image. Now, the bird is immense and everybody seems overjoyed: "No Small Breed fer yer Uncle Abe dis Chris'mas! Ain't he a Cherub?"[66]

Sheppard's illustrations of life among the former slaves of Virginia contain no hint of Dickens. In both style and content, they present themselves as documentaries: crisp, linear renditions of figures seen in action, playing out familiar Christmas scenes in the rural South. Sheppard concentrated on two such episodes: hunting meat for

Sol Eytinge, Jr., "De breed am small," 1874. *Harper's Weekly* (January 3, 1874), 8.

Eytinge's "No Small Breed fer Yer Uncle Abe dis Chris'mas!" of 1876. On the wall behind the table is the same artist's 1874 Christmas picture, showing the same family with a pitifully small bird. *Harper's Weekly* (January 1, 1876), 5.

W. L. Sheppard, "Done Cotch Him!" 1874. *Harper's Weekly* (January 3, 1874), 5.

Christmas dinner and shopping for the trappings of the holiday. Two hunting pictures, *Harper's* covers in 1873 and 1874, detail the adventures of a pair of ragged black men trying to snare a rabbit in a homemade trap. In the first picture—"The Christmas Dinner Gone!"—they are left goggle-eyed and slack-jawed when the rabbit contrives to escape from the trap.[67] In the second, they have caught him, or, as the caption reads, "The Christmas Dinner Safe—'Done Cotch Him!'"[68]

In themselves, the pictures strike the modern viewer as less demeaning to their subjects than the captions; like Eytinge's, these lines of text are rendered in a dialect full of mispronunciations which must have been amusing to white, middle-class readers—a "foreign" speech, indicative of the divide separating the urbanizing North from the rural South. A later Sheppard rendition of the same hunting scene appeared in *Harper's Young People* in 1887.[69] This time the hunters are two boys, one black and one white. Pictorially, the Negro child is a darker, plumper version of the white boy, and is spared the indignity of the looking foolish as the rabbit escapes. But the dialogue under the picture—"Kitch He Hoof, Marse Grex! Kitch He Hoof!"—remains the same.

In 1880, with the publication of *Uncle Remus: His Songs and His Sayings*, Joel Chandler Harris would embed the dialect attributed to a black Southern storyteller in the folklore of American childhood. The gentle Uncle Remus, with his comical tales of animal-tricksters, was invented by Harris as Union troops were finally withdrawing from the South. One scholar calls Remus "the perfect figure to allay Northern uneasiness about the abandonment of the Negro." No less a personage than Theodore Roosevelt praised Harris's work for the "blotting out of sectional antagonism."[70] Despite the occasional excursion into the blackface humor of double-takes and bewilderment, W. L. Sheppard is close to Harris in his fondness for the folkways of the South: the hare that so often contrives to escape the trap on Christmas morning could be Brer Rabbit himself, and the hunters accord him the respect due to a wily adversary.[71]

In 1875, Sheppard changed gears. Instead of hunting scenes set in

the countryside, he moved his characters into town, into the bustle of mercantile preparations for Christmas. "Selling Christmas Greens—A Scene in Richmond, Virginia" shows a busy marketplace, an arcade where the sellers of rural produce meet eager city buyers (see illustration in Chapter 2).[72] The vendor is an old black man in tattered clothes, with a large holly bush for sale. The buyers are members of a well-dressed white family in search of holiday greenery. As a counterpoint to the little white daughter, standing shyly beside her mother, Sheppard offers a black boy with a crutch—a Southern version of Tiny Tim—selling kindling sticks. Although Sheppard undoubtedly observed the transaction in Richmond, the market could be anywhere; save for the color of their skin, the figures and faces are interchangeable. The black protagonists are different only because they are equated with hardscrabble poverty in the countryside; the issue spotlighted by the picture is economic rather than racial. In Sheppard's 1882 cover for *Harper's Weekly*, the proprietor of a small-town store in the South hangs Christmas toys outside the window to advertise his seasonal wares.[73] A crowd of school children gathers to watch with hopeful eyes: black children, white children, all neatly dressed and politely behaved, watching the toys with the same sweet yearning.

The last of the pertinent *Harper's Weekly* images, by Walter Satterlee, is more interesting, perhaps, for the lengthy text that purported to explain the engraving than for the picture itself: six little black children and a cat, all cute as buttons, peering up the chimney to look for Santa Claus.[74] The house is poor and bare, but the tattered stockings hang bravely in the fireplace. "An African Christmas, with the mercury at the top of the thermometer, seems as much out of place as the Fourth of July at the north pole," the explanatory note opines. "But these little Ethiopians seem to enjoy the merry season with as much zest as the fair-skinned children of the North. . . . Old Father Christmas may distribute his gifts rather unequally among the rich and the poor, but he is very rarely so unfeeling as to withhold them altogether."[75] If Christmas was no longer marked by the boisterous jollity of the English or colonial Christmas, it was still the

greatest holiday of the year, one observed by rich and poor alike. As such, *Harper's* concluded, it was a time for benevolence and charity toward all.

This group of pictures of the Black Christmas illustrates a discernible change in attitude toward African-Americans in the period between Stowe and Harris—between the prelude to the Civil War and its long aftermath. At first, the slave was always shown as being profoundly different from the landowners and soldiers around him, so different that it is hard to credit him with the same feelings about Christmas. But in the 1870s and 1880s, in the pages of *Harper's*, Black Christmas became an appealing aspect of the strange and distinctive culture of the South, newly uncovered by the War Between the States. In the end, Black Christmas was a means of giving poverty a fresh and compelling face: a meaner, leaner version of everybody else's Christmas, it proved that the sentiments of the holiday were universal, even if the material means of expressing them were not. Black Christmas was White Christmas without the surfeit of gifts and goodies that threatened to bury the holiday in tinsel in the 1880s.

Although its illustrators provided the most consistent and sympathetic treatment of the theme, *Harper's* was by no means the only source for pictures of Black Christmas. In the 1880s, *Leslie's Weekly* veered wildly between two moral poles in its pictures of holiday observances in the South: the Negro as spiritual leader, and the poor black as sly thief. In an 1887 plate, for example, Parson White encounters a member of his flock pushing her dollies in a homemade carriage on Christmas morning.[76] One doll is black and the other white. "A black lady an' a white lady ridin' side by side in de same carriage!" the minister chuckles. "Whar am de color line gwine to, now?" In an 1888 illustration by Joseph Becker, a black farmer hunting with a rifle on Christmas Eve faces terrible temptation: "No rabbit, no coon; but dis chile isn't goin' ter be lef'," he decides. "Pig am better than nothin'; so here goes."[77]

In the 1890s, with a series of paintings reproduced in large-format halftone plates, Howard Helmick became the Southern specialist for

Another "comic" Christmas hunting scene, 1888. *Frank Leslie's Illustrated Newspaper* (December 15, 1888), 280.

Howard Helmick, "Uncle Ned's Dilemma: 'How Shall the Christmas Stockings Be Filled?'" 1894. *Frank Leslie's Weekly* (December 13, 1894), 384.

Leslie's Weekly; between 1893 and 1896, he contributed four works describing the Christmas preparations of Old Mammy, Uncle Ned, Aunt Sally, and the members of their extended family.[78] It is not entirely clear if the time is before the war or after it; Mammy still works in the white lady's kitchen. But while Helmick sometimes veers into stereotypes, as in his treatment of a little black boy terrified by a ghost story, he is usually respectful of his subjects, even when their poverty is evident in their clothing and furnishings. Helmick's masterpiece is based on the standard imagery of the Last Supper, with a bountiful Christmas dinner on the table and the patriarch of the family, in the position of Christ, praying fervently over the turkey.

At the end of the 1890s, *Leslie's* introduced photographs; within a few years, staff artists had been reduced to providing decorative frames for those photos. So photographers went South to capture a

"The Last Supper in the South" by Howard Helmick, 1895. *Frank Leslie's Weekly* (December 12, 1895), 397.

black woman plucking her Christmas turkey, a black man in the up-permost branches of a tree, in pursuit of a fat possum for dinner, and—from an amateur shutterbug in Tennessee—an old black man boastfully returning home with a bird for "Chris'mas dinnah." Old wine in new bottles, with snatches of "darkie" dialogue underneath each one.[79] So long as African-Americans were associated with the faraway, defeated South, they were benign figures, who stood for good cheer in the face of adversity, never-say-die ingenuity, and an indomitable Christmas spirit. Even the unsavory racial humor of the black cartoons by "Zim," used in *Leslie's* in the first decade of the twentieth century, shows the nappy-headed protagonists, however grotesquely drawn, to be industrious, clever, and faithful believers in "Sandy Klaws."[80]

What may have changed the tone of this forgotten group of Black Christmas images for the worse was the Great Migration of African-Americans to the industrial cities of the North, an exodus which

1901: "After the Christmas 'Possum Dinner." *Leslie's Weekly* (December 19, 1901), 571.

Zim's mean-spirited Christmas cartoon, 1908. *Leslie's Weekly* (December 10, 1908), 25.

peaked between 1910 and 1930.[81] Before the diaspora, they were a Southern populace, isolated, subject to draconian Jim Crow laws and Klan terror. Afterwards, they became the butt of "Zim" jokes in national magazines. But it was in the 1870s, 1880s, and early 1890s, while the South remained a "foreign" land and its people exotic natives, that the Black Christmas convention flourished most vigorously. Where did it come from? What did it ultimately signify?

One important clue comes from the 1876 Centennial Exposition, held in Philadelphia to celebrate the one hundredth birthday of the nation and to affirm its industrial coming of age. The Philadelphia Fair included many ethnographic displays that purported to inform visitors about the mores, manners, and material culture of the peoples of the world. People of color figured prominently. Japan, China, and certain colonized parts of Africa were all on display, in "villages" and make-believe environments created through the use of representative architecture and artifacts. While some historical cultures of Western Europe were recreated with waxworks and what amounted to period rooms, contemporary societies often became human zoos, with small groups of live people on display as scientific specimens. This practice continued throughout the nineteenth century: large American fairs at Chicago (1893) and smaller ones at Nashville (1897) and Atlanta (1895) also presented other people— people who were different from the average fairgoer—as so many ethnographic problems to be solved through the methodical observation of their customs and folkways.[82]

In the amusement zones of the great fairs, the theme of pseudo-inquiry was played out in the form of shows and restaurants. At the Centennial Exposition, one such concession, run by a businessman from Atlanta, was called "The South" or the "Southern Restaurant." According to the official guidebook, the visitor was going to see "a band of old-time plantation 'darkies' who will sing their quaint melodies and strum the banjo." Along with the biscuits and gravy, they could expect the "unadulterated 'Essence of Old Virginny' expounded by a hand from a cotton field."[83] The black attraction became a formulaic and expected part of the entertainment district of any fair; at

Nashville, it was called the Old Plantation, a musical extravaganza managed by a refugee from a minstrel show. In Atlanta, President Cleveland made it a point to visit the Old Plantation, whose cabin-like setting matched the rickety architecture shown in the Black Christmas pictures. The historian Robert Rydell, in one of his many studies of the ideology of fairs, states that the black concessions should be understood in the context of Chinese, Japanese, and African villages. Like them, he writes, the "Old Plantation conferred colonial status on its inhabitants."[84]

So long as the South remained a colonized, isolated section of America, Black Christmas images were the pictorial counterparts of Old Plantation displays, reminders of the superiority of white, Northern culture, and gee-whiz curiosities—explorers' reports from some distant foreign frontier. Revived again for the Pan-American Exposition at Buffalo in 1901, the Old Plantation was heralded for showing what daily life was like for the black population of the rural South. But it was also an object lesson in the differences between Northern and Southern Negroes. Urban blacks from the North were happy to play and sing for the audience wearing the costumes of slaves. But "the Southern Negro," according to the omniscient guidebook, "is a stay-at-home darkey, not so much through the dislike of publicity as through the inherent laziness that will not run the risk of the nomadic life."[85] Lazy (or simply slow-moving and rural) in its rhythms, the Black Christmas picture showed an ideal family life ruled by the seasons and untouched by the insistent demands of the industrial order.

Political and economic factors always influence the appearance of works of art. But the greater and more immediate influence often turns out to be the visual culture itself—another work of art. In Europe, before and during the decades in which the Black Christmas picture flourished, peasant scenes in a more or less realistic style were a dominant genre in painting. Jean-François Millet's "Gleaners" of 1857 is a famous example of the type: by his use of monumental form and glowing light, Millet sanctified the hand labor of agricultural workers who were about to be displaced by the machine.

There were many practitioners of the nostalgic peasant mode—including Americans working in rural regions of Europe—whose works were well known in the United States through prints, through exhibitions at World's Fairs, and through inclusion in American collections.[86] The French painter Léon Lhermitte exerted a strong influence on American popular religious imagery through works in which Christ, after his resurrection, appears at the dinner tables of humble farm families.[87] Daniel Ridgeway Knight, an American exile who lived abroad for most of his life, created an aura of idyllic, anti-urban peace and simplicity in pictures of farm girls brandishing simple agricultural implements in the flowering landscapes of neverland. A recent study of art patronage in the city of Pittsburgh during the Gilded Age suggests the enormous appeal this kind of European iconography held for American collectors, many of whom were hard-fisted industrialists engaged in the systematic destruction of the very scenes pictured by their favorite artists.[88]

Evocative paintings of marginalized rural people in France and Holland clearly influenced American magazine pictures of Black Christmas in the South. Just as the Brothers Grimm find their American counterpart in Joel Chandler Harris and the Uncle Remus stories, so the high-art imagery of modern Europe in the late nineteenth century devolves upon the poor black families shown in the illustrations of *Harper's* and *Leslie's*. Unlike satirical or comic depictions of American blacks that appeared in magazines, newspapers, and ads of the period, the prevailing sensibility expressed by these Christmas pictures is benign and respectful. The elevated tone seems to come from genteel painterly sources, many of which were steeped in the rhetoric of religious art. But the underlying issues addressed by the popular image of the Black Christmas are neither religious nor political nor, in the last analysis, racial: Black Christmas is about a kind of homesickness for a past that most members of the reading audience had never experienced, a fictional Old South as compelling as Irving's English Olde Christmas.

Ken Emerson, in his masterful study of the music of Stephen Foster, acknowledges that Foster's evocations of the South affirm the

superiority of the white listener at the same time that they reveal a disaffection with the industrial revolution in progress in cities of the North like Pittsburgh, where the first draft of "My Old Kentucky Home" was written.[89] Like a Foster song, Black Christmas pictures glorify a preindustrial national past that seemed to live on in parts of the backward South. In that world of make-believe, down on the Old Plantation, Christmas is shown to be simple, familial, a part of the cycle of nature. Observed with reverence and joy, Black Christmas is the antithesis of the new Christmas of mechanical store windows and store-bought tree ornaments. Despite the material poverty of Black Christmas and the condescension often shown in the companion texts, this is one case in which somebody else's Christmas just might be superior to one's own.[90]

Interest in other people's Christmases was not limited to nostalgia for the preindustrial South. In the 1880s, with immigration on the rise, Americans began a slow retreat from the political and cultural isolationism of the nineteenth century. That Russians and Belgians, the Irish and the Dutch and the Christian Chinese, all celebrated Christmas suddenly became a matter of interest. The fundamental kinship between people of different customs and costumes was often represented by a group of children in national dress assembled to greet Santa Claus at the finale of a kind of melting-pot pageant.[91] The pictorial alternative was a potpourri of scenes showing unique features of holiday preparations in other lands.[92] The emphasis on the innocence of childhood exempted such seasonal features from prejudice against newcomers with their strange clothes and languages and rituals. Whether the little ones received their gifts in a laundry basket instead of a stocking, as was done in parts of France, was less important than a love of children that transcended the boundaries imposed by nationality.

This did not mean that editors and feature writers endorsed a kind of nineteenth-century multiculturalism, however. For every discussion of Christmas in France, there are hundreds of references to the evolving American package of Christmas symbols. Indeed, the strangeness of what other people did at Christmas helped to estab-

lish the absolute rightness and suitability of the new American way. Because the precise nature of the American Christmas was still a contested issue between the 1880s and World War I, holiday iconography could best be defined by what it was not. It was not like the Parisian Christmas, for example. Paris seemed quite New Yorkish in terms of the brilliantly decorated trees and the store windows, but it was altogether different in the liberated antics of students in the Latin Quarter and the gaudy Christmas street carnivals, with their fakirs and sword-swallowers.[93] French Christmas seemed familiar in many ways, with bells ringing and carolers singing "Noel."[94] But at the same time it was strange, with peasants hauling mistletoe in little donkey-powered "charrettes," and children huddled in terror at the approach of Hans Trapp in the retinue of the Christkindl, searching out their worst transgressions.[95]

In Spain, the favorite Christmas toy was a Nativity set, and presents came in shoes left on the windowsill.[96] In parts of Germany, where the season was marked with picture-cakes and candy babies representing the Christ child, gifts appeared on the Feast of St. Nicholas, three weeks before Christmas.[97] In Italy, shoes instead of stockings were the place where St. Nicholas, or La Befana, left the treats.[98] The latter, the spirit of an old woman who had refused to accompany the three wise men to Bethlehem, made her appearance on Epiphany or Twelfth Night, the day sacred to the memory of the Magi.[99] In Russia, Befana became Babouscka, the feminine bearer of all good things.[100] In Holland, where merchants made a great show of Christmas windows, stores sold "surprises," or hollow cakes of soap in the shape of realistic cuts of meat, fruits, vegetables, and figures, in which tiny gifts could be concealed.[101] In Belgium, children left wooden shoes stuffed with hay for Santa's pony and found toys in return.[102] In Greece, Christmas was a day for churchgoing; on New Year's Day, also called St. Basil's Day, presents were exchanged, calls paid, and a sumptuous buffet set out for guests.[103]

In Europe, it was easy to find resemblances to a Santa-and-Christmas-tree Christmas: Santa might be known as Befana, and he (or she) might come on another night to fill another kind of footwear, but

the principle was the same.[104] In the countries of Asia, however, except for certain pockets of missionary activity, Christmas was a nonevent. Its absence from the calendar struck some turn-of-the-century travelers as doubly strange because Japan was already a major source of the toys Santa brought to American children. Yet there was no Santa-San, no Japanese Santa Claus, and there were no golden-haired Christmas dolls—only various festivals, for girls, for boys, for dolls, that seemed to mimic aspects of the American holiday.[105] Santa Claus would find no chimneys or hearths in Korea, where even Christian-educated Koreans refused to decorate the interiors of their homes for the season.[106] In the markets of Peking, where American infantrymen engaged in the suppression of the Boxer Rebellion tried to find the fixings for a Christmas dinner in 1900, their requests for the trappings of the holiday were met with courteous puzzlement.[107]

Things are apt to be much different in present-day Japan. Along the Ginza, downtown Tokyo's shopping and entertainment district, Marys, Josephs, and artificial snow fill store windows. Customers wear sprigs of plastic holly in their lapels. When the economy booms, crowds stagger out of the major department stores laden down with "Kurisumasu" presents in red-and-green shopping bags. But even when it doesn't, outside the largest and oldest stores, girls' choruses in matching tams, mittens, and woolly scarves twitter "Hark the Herald Angels Sing" and "Rudolph the Red-Nosed Reindeer" in phonetic American English. Bars sell holiday cheer in the form of a poisonous blue drink called a "Holy Night." Santas with expressions of maniacal good cheer on their plastic faces dangle from lampposts. At Tokyo Disneyland, children can be photographed on the lap of a blue-eyed American Santa; the robotic teddy bears in Westernland, reprogrammed for December, perform a country-western "Jingle Bell Jamboree."

At some point in the tangled history of Japanese-American relations, the traditional year-end gift or *seibo*—it is sent to superiors or those to whom some social debt is owing—got itself hopelessly confused with American-style Christmas. Santas, shepherds, angels,

yule logs, and retail sales records were mixed up with this long-standing Japanese ritual by virtue of the common denominator of shopping.[108] The iconography is, for the present-day Japanese, so much exotic atmosphere, foreign make-believe—or what Christmas on the Old Plantation had been to the average American Yankee in the 1890s.

The American reading about other peoples' Christmases during the decade of the Boxer Rebellion could have defined the truly foreign by the absence of Christmas. Blacks had Christmas. Europe had it, even Southern and Eastern Europe, from whence came the Jews and the Catholics, the swarthy, less desirable class of immigrants. Asia, however, did not. And the period of Christmas consolidation in America is neatly bracketed by two pieces of legislation bearing on the treatment of Asians by the United States: the 1882 Chinese Exclusion Act and the Immigration Bill of 1924, which prohibited further Japanese settlement on American soil. Christmas was a litmus test for potential good citizens. Because they believed in Christmas, the children in national costume who rallied around Santa were ready to become good Americans, just as soon as they cast aside their kilts and their strange caps. Aimed for the most part at a child audience, the literature of Christmastime Around the World neatly separated us from them.

Conversely, today's interest in ancestral Christmas customs celebrates who we are by remembering who we once were. A Swedish-American girl wears a crown of candles for Saint Lucia's Day, at the start of the Christmas season.[109] The observance honors the immigrant past as a kind of prelude to the holiday rites of the New World. The crown ritual, in other words, is Christmas in quotation marks— Christmas as it used to be, or a vantage point in personal and familial time from which the realities of Santa Clauses and 50-percent-off sales can be better understood. Swedish Lucia crowns or Polish *Wigilia* (Christmas Eve) dinners stand in sharp contrast to American ways and thus help to define the latter as distinctively American.[110]

The African-American feast of Kwanzaa reflects ongoing tensions between Christmas and ethnicity. Created in 1966 by Maulana

Karenga, founder of the Black Nationalist organization, Kwanzaa is a week-long celebration of family and community which begins on the day after Christmas. Instead of using artifacts and rituals derived from Euro-American holiday practices imposed during the days of slavery, Kwanzaa restores folkloric elements of the African and African-American past: red, black, and green decorations in place of holly and mistletoe; gifts of a noncommercial nature; a menu made up of foodstuffs once created by black Southern cooks, using indigenous ingredients that could be gathered in the fields, without the intervention of owners and overseers.[111]

Although Kwanzaa need not interfere with a Santa Claus Christmas, it is clearly a commentary on it.[112] Kwanzaa is also a rejection of the Black Christmas of nineteenth-century popular culture, or the unsavory proposition that there is something humorous or pitiable about black families attempting to copy the social rituals of their supposed betters. At the very least, the dilemma of black theorists like Karenga in the face of a pervasively *White* Christmas demonstrates the immense power of Christmas ideology and symbolism. Although that power has more to do with Macy's than with mangers, the omnipresence of the standard Christmas package—Santas, red-and-green stuff, presents, and trees, occasionally enlivened by a Wise Man or a Rudolph—also explains the objections of Jews and Muslims assailed every winter by government-sanctioned Christmas displays.[113] Although the cultural and commercial pressures to conform are almost overwhelming, Christmas in America is not for everybody. Nor will blue wrapping paper or Hanukkah bushes make it so.

And then there were the people—the poor, the newcomer, the young, and the helpless—to whom Christmas was an affliction. At Christmastime, "the children's time," the need for nimble little fingers was the greatest in the early 1900s. In big cities, the candymakers, the children of the poor, worked twelve-hour days in the three months before Christmas to fill the nation's stockings with lollipops and chocolates. The grind took its toll on workers scalded by the hot sugar and nauseated by the smells. It also took its toll on the

Christmas for women at a New York bargain counter in 1889. Everybody seems unhappy: shoppers, clerks, and the overworked cash girl. *Frank Leslie's Illustrated Newspaper* (December 14, 1889), 333.

"nice" children who ate the candy made by victims of tuberculosis and diphtheria, working in filthy tenements picking out nutmeats and wrapping up bonbons. The Italian girls and the Jewish boys from Russia and Poland who worked in the candy factories took a dim view of Christmas. Children worked in the box-making industry, too, dropping out of school to paste the corners at three dollars a week to support their families. The lovely pictures on the candy boxes showed Santas and snowmen and happy children who didn't go to work.[114]

So, too, Christmas meant misery to the department-store clerk, stationed behind the counter for fifteen hours a day. Forbidden to sit

on her folding stool, harassed by floorwalkers, her paycheck docked for missing pennies, the retail clerk lost commission earnings every time she paused to restock goods, to rearrange the counter, to address a parcel for an impatient customer.[115] Viewed from the perspective of the sales floor, Christmas looked like some "heathen revel," a saturnalia of getting and spending, meanness and human misery. A settlement house in New York held a Christmas party for a group of poor girls and offered them a plate of Christmas candies. "Ugh!" they shouted. "We don't eat that stuff. We *make* it." The harried store clerk felt the same way about Christmas presents: after selling them, it was hard to think about giving or getting one again.[116] At closing time on Christmas Eve, the store looked like a war zone. "Aisles thinned and the store relaxed into a bacchanalian chaos of trampled debris, merchandise strewn as if a flock of vultures had left their pickings," wrote Fannie Hurst in 1914, "—a battlefield strewn with geegaws and the tinsel of Christmastide."[117]

Christmas may have been less disheartening for those actually at war. During the first winter of World War I, much to the dismay of their commanders, British and German troops dug in on the Western Front observed their own Christmas truce. Piling out of the trenches, soldiers from both sides met in "no man's land," exchanged gifts of tobacco, took snapshots, and played a little football.[118] The fraternization was soon stopped, but the incident alerted military authorities to the singular importance of Christmas for maintaining high morale among soldiers. In addition to packages and letters from home, during World War II the American brass put particular emphasis on providing a hot, home-style meal to every soldier, sailor, and Marine. A Chicago meat packer published the menus for the servicemen's Christmas feasts in 1942: turkey, pie, celery, and everything else, from soup to nut cups, with free after-dinner cigarettes—"all the trimmings he loved at home."[119] The packages from stateside contained packs of Camels or Chesterfields, in boxes with the bows and wrappings and cards printed right on them.[120] There were "Victory" billfolds, the gift "he would choose for himself . . . if he could make his own selection."[121] And watches: a

Hamilton "from the folks back home," an Elgin, the "watch for a real American Christmas!"[122]

Editorials and public service ads placed by firms with no merchandise to sell for the duration all made the same point: that despite the commercialism, and the mass feedings and the same cigarettes in every parcel, American Christmas was specific to one's own home and family. It involved the complicated relationships between parents and children, husbands and wives. And a flood of memories from Christmases past.[123] It was fireworks and gunshots in the South, wreaths of wild cherries in California, Lucia crowns and plum puddings from other lands and other times. It was George Washington crossing the river from Valley Forge on Christmas night and Thomas Nast's weary Civil War officers, opening their boxes from Santa and longing for home.[124] It was a pretty girl in a red hat and whiskers—a lady Santa—filling in temporarily for the handsome GI whose picture stood on her dressing table. "To Americans wherever they may be, in foreign lands or here at home," read the copy for the ad, "Whitman's Chocolates are a precious part of the holiday sentiment! . . . You'll be glad to know that many millions of boxes . . . have gone to Service men and women that they, too, may have Whitman's for Christmas."[125] Everybody's Christmas meant the same sweet things.

THINKING OF YOU
AT CHRISTMAS

Cards or Gifts?

I n the recently colorized version of *It's a Wonderful Life,* circa 1987, a sickly green is paired with an anemic red. In the original black and white, the title art is a crisp period piece, all holly leaves, decorative poinsettias, perky chains of Christmas trees (each one a perfect triangle) and flourishes of satin ribbon—a lavish Christmas card sent from film director Frank Capra to his postwar audience in December 1946.[1] The very first shot is a stylized rendering of a sleighing scene: Grandma Moses with a light sprinkling of Hallmark modernism. An unseen hand turns back the pretty picture and reveals the text inside. *It's a Wonderful Life* instead of "Merry Christmas, from our house to your house." Directed by Frank Capra. From a story by Philip Van Doren Stern.

Capra was fond of saying that the idea for the movie came straight from a Christmas card.[2] The card in question was actually a 24-page holiday story about the misadventures of George Pratt (in the film, the Jimmy Stewart character becomes George Bailey), who is rescued from despair by an angel bearing a Fuller Brush salesman's kit. Stern, whose story was published in a gift book edition in 1943, originally intended it as a privately printed booklet, a Christmas trifle—not quite a gift—mailed to friends in honor of the season.[3] It was, in

other words, a sort of glorified Christmas card, of the kind that artists, poets, and corporations sometimes send to friends, customers, and potential clients. Robert Frost, John Steinbeck, Rockwell Kent, Franz Kline, and the Walt Disney Studios have all prepared pieces intended for Christmas keepsakes; others have found their work mined by publishers for extracts that can do double duty as cards for the elite.

One such hyperbolic Christmas card, a 1982 mailing from a New Jersey ad agency, is a large folder in which is pasted an enclosure containing, printed in red on mock vellum, a facsimile of an 1851 Christmas poem written by eleven-year-old Virginia Garland Webb to her father. The original, never before published, had been glued inside Virginia's own copy of *Kriss Kringle's Raree Show for Good Boys and Girls,* a gift book published by Walker and Gillis of Philadelphia in 1846. Written in the voice of Santa Claus, the poem describes his trip from the frozen north and the dolls and books and other toys he brings to good children asleep in warm beds. It ends with the hope that these lucky children might share their bounty with the less fortunate.[4] Virginia's poem, her own Christmas greeting to her father, is a kind of early, homemade Christmas card.

Historians point to "Christmas pieces," or curlicued handwriting samplers sent by eighteenth-century English schoolchildren to demonstrate their aptitude, as the immediate forerunners of the Christmas card.[5] But it had also been customary, from ancient times, for neighbors to salute one another as the old year ended and the new one began. Notepaper suitable for the purpose appeared in the 1700s, with engraved or lithographed embellishments. The earliest known use of the phrase "merry Christmas and happy New Year" comes in a 1699 holiday letter from Admiral Francis Hosier of Deptford, England, to Robert Smith, a storekeeper on the dock at Woolrich.[6] Print that letter, add a decorative border of holly, colorize everything, and there's the modern Christmas card, almost as Frank Capra depicted it in the opening moments of *It's a Wonderful Life.*

George Buday, in his definitive history of the Christmas card, dates the first example to 1843, which makes the commercial card

the exact contemporary of Dickens's *A Christmas Carol.* Designed by John Calcott Horsley at the bidding of Henry Cole, the original Christmas card was printed in London and hand-colored by a man named Mason. Cole, who aspired to the reform of public taste, would later be associated with the Crystal Palace Exhibition of 1851 and Prince Albert's determination to uplift English standards of design and manufacture. His card, however, hints at social reform, associating the joyous bounty of the holiday with one's obligation to help the needy.

The famous Cole-Horsley card is exactly that: a stiff rectangle of postcard proportions the size of a lady's calling card, without folds or enclosures. The design takes the form of a triptych, a rustic arbor constructed of intertwined vines in the popular "Gartenlaube" style. In the center panel, devoted to secular pursuits, a cheery Victorian family, gathered around a big plum pudding, toasts the recipient of the card ("A Merry Christmas and a Happy New Year to You" reads the banner draped across their section of the trellis). At the right, as if heeding the spirits' admonitions to Scrooge, a woman clothes a ragged child. At the left, a man offers food to the hungry. There is scant provision for the personal greetings of the old Christmas letter. A dotted line above the picture is marked "To" and a shorter one, at the lower right, says "From." In surviving examples, the sender has exerted no little effort in fitting even those scraps of text into the spaces provided.[7] But because it neither requires nor invites much intervention on the part of the sender, the Christmas card implies a new, industrial awareness of time as a precious commodity. It also suggests that Cole and his generation were tied into a wider circle of acquaintances, relatives, and far-flung connections, all requiring special treatment at Christmas.

The Egley card, which came to the attention of scholars in the 1930s, was briefly thought to be the prototype for the Cole-Horsley design. Constructed around a trellis and accompanied by the same greeting displayed on a banner, the Egley card was named for William M. Egley, who designed and etched the plate; the confusion over which card came first arose from the printed date on its face. De-

The first Christmas card, created by John C. Horsley in 1843, includes scenes of Dickensian charity on either side of the family feast. Hallmark Archives, Hallmark Cards, Inc.

fenders of the Egley card read the numbers as 1842 or 1843.[8] But evidence from independent sources later showed that this was the second published card and that the correct date was 1848. As such, the Egley card reflects the growing interest in Christmas, its delights, its history, and its moral obligations.

The rococo trellis now has eight openings, with smaller vignettes perched in the corners above it. The principal themes include a family dinner party, the guests dancing the Roger de Coverly after the feast, a holiday Punch and Judy show, ice skaters, waits or Olde Christmas musicians, and the distribution of alms to the poor. At the top left, a young lady writes an old-fashioned Christmas letter which a young man is reading at the upper right. Mistletoe and holly dangle from the fretwork. The chosen subjects are telling ones. In 1712, for example, the essayist Joseph Addison wrote about the legendary Yuletide hospitality of Sir Roger de Coverly, who always kept open

house at Christmas, in honor of his merry ancestors.[9] And here the dancers cavort to honor him. This card includes Addison scenes, Pickwick scenes, Irving scenes, scenes based on personal observation, and one Dickensian scene, inspired by the moral of *A Christmas Carol*—a comprehensive summary of the Olde and New Christmases being celebrated in 1848. The only thing missing from the picture is Prince Albert's Windsor Castle Christmas tree.

The first American Christmas card appeared between 1850 and 1852.[10] Lithographed in black and white on a rectangle of stiff paper, it resembled the earlier British examples in layout and in the incorporation of narrative vignettes, including a tiny Santa, a fancy ball, heaps of gifts and foodstuffs, and in the center, an American family exchanging presents while a black servant looks on from the background.[11] The sentiments were ready-made: "A Merry Christmas and Happy New Year." And like the English cards, this one too had printed lines to be filled in with the names of sender and recipient. But the American card excluded acts of Christmas charity. Instead, it betrayed an avidly mercantile character, in keeping with the growing shopping component of the holiday in the United States. Issued by R. H. Pease of Albany, New York, the card advertised "Pease's Great Varety [*sic*] Store in the Temple of Fancy" on a strip of printed ribbon unfurled across its midsection; the lovely presents, the clothes, the punchbowls, and the cruets pictured all came from Pease's, which was represented in its multistoried glory at the upper right.[12] What is not clear, however, is whether the Pease card was intended strictly as a greeting from the store to Pease's best customers or whether, like the Egley and Cole-Horsley examples, it was another Christmas novelty for sale in the Temple of Fancy.

For whatever reasons—perhaps the habit of giving things of weight and dimension as presents to those on one's Christmas list—the card-sending habit did not catch on immediately in the United States. In England, cards sold by firms like Marcus Ward and Raphael Tuck in the 1860s, 1870s, and 1880s found a wider audience, although the imagery seems un-Christmasy in comparison with the

Pease card. British publishers favored robins, flowers, and wide-eyed children in various states of undress or overdress; only by reference to Victorian manuals of flower symbolism or to obscure legends about the origin of the robin's red breast do the themes betray any special connection to the season.[13] Instead, the object seems to have been to send something attractive and colorful, a neat specimen of chromolithography, as an expression of the good taste and modernity of both parties to the transaction—the sender and the recipient.

The American indifference to cards was overcome through the heroic efforts of Louis Prang. An exile from the German Revolution of 1848, Prang set up a lithographic shop in Boston in 1856. In the 1870s, he began making Christmas cards for the European market. By some accounts, Prang was inspired by a display of Marcus Ward cards at the 1876 Philadelphia Centennial Exposition. Others believe that he added Christmas greetings to one of his own floral business cards at the suggestion of a clerk in his London office.[14] In any case, his earliest designs were based on spectacular reproductions of the kind of ladies' flower paintings popular at the time, executed in brilliant color against inky black backgrounds.[15]

Between 1880, when Prang inaugurated a series of competitions for Christmas card designs, and 1890, when he gave up the business entirely, Prang cards were a wonder, a fad, a must-have feature of the American Christmas. Elihu Vedder, Thomas Moran, and J. Alden Weir were among the prominent painters chosen to adorn Prang cards; just as Henry Cole, in the 1840s, had seen cards as a means of elevating the public taste, so the Prang cards of the 1880s held out the same promise. But the winners were not all well-known painters. The prize lists also included popular magazine illustrators of the era, such as Walter Satterlee, Will Low, and Harry Beard.[16] And many of those chosen in the Prang contests were women, whose role in the fine arts had been limited by rules of decorum. But in the context of Christmas, the celebratory features of which were being worked out in an unspoken partnership between commercial interests and domestic ones, neither women nor magazine illustrators seemed out of

place. Indeed, this was their natural milieu. Cards manufactured af-
ter designs by Dora Wheeler, Rosina Emmet, Alice Morse, and Flor-
ence Taber were among Prang's best sellers.

Christmas belonged in the feminine sphere of action in the 1880s.
An 1881 review of the Prang competition in *The Nation* asked what
"the exact test of merit in a Christmas card" might be. Its decorative
qualities? Its agreeableness? Being "Christmasy"? Whatever the
standard, Wheeler's angels and Emmet's graceful young mothers
met or exceeded it. In a Christmas card, the distaff virtues of "sweet-
ness and humanity," augmented by a pleasant overlay of decoration,
were very much in keeping with the medium. If the general level of
incompetence among the amateurs in the group illustrated the aes-
thetic poverty that Prang hoped to remedy, his winning pictures were
charming, elegant, delicate, pretty, and altogether suited for their
use on Christmas cards.[17]

Most of the permanent design staff at Prang's plant in suburban
Boston consisted of women whose flowers and snow-covered
churches, whose children and birds and angels matched the expec-
tations of card shoppers. An 1876 ad for Prang's Illuminated Christ-
mas Cards called them "beautiful."[18] And that was undoubtedly part
of the appeal. In 1874, *Godey's* endorsed chromolithographs—
"chromos"—as affordable substitutes for oil paintings, thereby giving
the process itself the cachet of fine art.[19] Chromos demanded scien-
tific acumen, too, for the precise mixture of colors and Prang's suc-
cess reflected favorably on the state of manufactures in America.[20]
But above all, the new Christmas cards were fancy—trimmed like
Christmas trees and decorated like the holiday parlors shown in the
latest issue of *Godey's*.

The Prang cards were gift cards—big, thick, expensive, highly or-
namented artifacts, more like books than like today's typical off-the-
rack Santa card stocked at the drugstore or the boxed, William
Wegman dogs-in-Santa-suits greetings from the Museum Store at
the mall. Prang's Christmas cards were fringed in silk, tasseled, per-
fumed, printed on satin, "flittered" with shimmering glass particles,
and gussied up with detachable calendars, booklets, feathers, and

Louis Prang's American-made fringed Christmas cards of the 1880s had artistic pretensions. This illustration shows Henry Wadsworth Longfellow in front of a fireplace decorated with tiles representing his most famous works. Hallmark Archives, Hallmark Cards, Inc.

spangles. They were highly desirable presents suitable for mounting in albums, for covering the backs of pianos or screens or tabletops, for sewing into quilt squares, for cutting into purses and baskets, for papering the dull wooden panel behind the shelves of the china cabinet. And they were gifts of refinement and intellectual credibility.

Prang's American literature series of the 1880s, based on designs by Lizbeth B. Humphrey, is, perhaps, the most impressive example of the genteel gift card. Printed on weighty stock, the Longfellow card (circa 1883), the first of the group, measures eight inches by almost six, and shows the poet Henry Wadsworth Longfellow telling bedtime stories to three little children. The tiles that surround the fireplace behind them illustrate famous Longfellow characters, from Evangeline to John Alden. An inset verse in the lower left corner identifies the scene as coming from the poet's own "Children's Hour."

The picture is surrounded first by a heavy gold frame in two dimensions and then by a thick, three-dimensional fringe that gives the card the look of a sofa pillow, a piano scarf, or some other item of upholstered household decoration. On the reverse side of the card, in a monochrome palette of greens set against a floral border and overlaid by a diagonal slash of pealing bells, is Longfellow's name and his poem "Christmas Bells."[21] The Longfellow, Whittier, and Bryant cards in the series all exude an aura of tastefulness, national sentiment, burnished domesticity, and cushy luxury.[22]

The double-faced gift card was a memorable present, augmenting the category of items that made suitable offerings for just about anybody at Christmas. In England cards tended to be stocked by upholsterers and drapers, but in the United States they appeared wherever holiday trappings were to be found: stores suspended them from strings in the front window or arranged quantities of cards in patterns, to form pictures of bells and Santas. This was the marketing strategy formerly adopted for small gift books, the predecessor of the card as the always-acceptable Christmas keepsake. Indeed, with their lovely pictures and elevating texts, Prang's cards looked like abbreviated gift books of the type popular since 1825, when a Philadelphia publisher issued *The Atlantic Souvenir.* This volume was an annual compilation of light fiction, verse, and moral essays enhanced by a selection of stunning engravings after the works of the leading artists of the day; in such books, the worth of American belles-lettres was demonstrated by the use of heavy paper, beautiful pictures, and embossed covers inlaid with mother-of-pearl.[23]

More than a thousand annuals were published between 1825 and 1865, along with untold numbers of illustrated volumes for children (*Kriss Kringle's Raree Show for Good Boys and Girls* is an example of the type), engraved devotional books, and pictorial Bibles. Most gift books were exchanged by friends and family members around New Year's Day or, after mid-century, at Christmas. In Louisa May Alcott's *Little Women* (1868–69), set in the Civil War era, Marmee gives each of her four daughters a miniature picture Bible for Christmas, pretty gift books covered in crimson, green, blue, and gray—

and then calls upon them to heed the lessons inside by giving their Christmas breakfast to a poor family.[24] Even when the contents were more frivolous, the point of a gift book was to stir up tender sentiments during the season of goodwill. One publisher described his wares as "messengers of love, tokens of friendship, signs and symbols of affection, luxury, and refinement."[25] A popular annual, published in the 1840s and 1850s, called itself *Christmas Blossoms and New Years Wreath.*[26]

One of the earliest national advertisements for a product specifically intended to be presented as a Christmas gift appeared in *Harper's Weekly* in late November, 1857: the gift in question was the "Harding's Pearl Edition of the Bible" with steel engravings, sold for 75 cents.[27] There were ads for secular books, too, promising premiums to buyers in the form of thimbles, cameos, and pocket pencils. And the editorial cartoon in the same issue spoofed the whole holiday business of half-calf-bindings and embossed covers, books whose contents were less important than a showy appearance.[28] Alongside the growing quantities of toys, jewelry, smoking paraphernalia, and clothing now commended to the subscriber as appropriate Christmas gifts in the 1860s and 1870s, the book still held its position of prominence: suitable for almost any lucky recipient, gift books were easy to buy and easy to give, since their own decorated covers sufficed for holiday embellishment.

Because there was no need to worry about a friend's literary tastes, the card was an even easier solution, however: Prang's keepsakes seemed literate and refined, but demanded nothing in the way of reading. The gift card was a kind of picture of a book, a symbol that stood for values to which both parties to the transaction subscribed, even if immersion in Dickens or the Bible took too much time and effort. At 30 Wall Street, New York City, in 1871, Prang's "American Chromos" were on sale as "Holiday Gifts!" alongside books, cigar cases, Parian statues, and other fancy goods.[29] On the Minnesota frontier in 1882, the congregation of a church at Sauk Center gave the pastor a homemade Christmas card with a design made up of $75.50 in gold and silver coins.[30]

The ideal family Christmas of the 1880s on a Prang card: the tree with candles, the emphasis on children, and the unwrapped toys of a traditional character all help to define the meaning of the occasion. Hallmark Archives, Hallmark Cards, Inc.

Around 1880, when Louis Prang began his Christmas card business in earnest, Americans began to work out a definition of the ideal Christmas gift. With notable exceptions, that gift was something manufactured and purchased, and, like the gift card, something without a great deal of practical function. William Waits, in his detailed study of gift-giving practices associated with Christmas in the United States, calls this first wave of factory-made presents "gimcracks" or "geegaws": low-priced, nonfunctional, poor-quality items, intended strictly as gifts, knickknacks and fripperies that often masqueraded as luxuries.[31] This category would include chromos, silver-plate souvenir spoons, and what we would now call party favors—things that cost a couple of dollars, at most, and represented modernity, a touch of class, or fun. The modern-day equivalents would be drugstore presents: Chia pets, cheap chocolates packed in showy, gold-foil boxes, Santas that wiggle when radios are played nearby.

Although inexpensive novelties already dominated the commercial pages of magazines in the 1860s—items such as "French and English Fancy Goods," holiday presents, and the like, often sold out of storefronts set up exclusively for the Christmas trade—there were other kinds of presents for sale, of a markedly different nature. Cloaks, in cloth or velvet: one size fits all.[32] Pistols, knives, letter-paper, and all kinds of "military goods" for men at arms.[33] Pianos. Sewing machines and brass rods to hold the carpeting in place on the staircase.[34] Spring-action rocking horses and microscopes for children.[35] In other words, while a silver-plate cigar case, a cheap mantle clock that glittered impressively, a velvet album with a mirror inset in the cover, or a needlework holder in the shape of a gaudy bird was a good present, so were items of clothing and other useful things—expensive ones, sometimes—that were nicer than what one might buy for oneself, or simply beyond one's budget.[36] Christmas presents were manufactured luxuries a step or two removed from what the recipient actually needed to keep body and soul together— what the nineteenth century called "comforts." These could range

The holiday giftware—the geegaws—advertised in 1905 were novelties: unusual items made of flashy materials. *Saturday Evening Post* (December 12, 1903), 16.

from a toothbrush to a fur muff, from a silk smoking jacket to a cut-glass candy dish.

Waits contrasts the geegaws of the 1880s with the sparse home-made gifts of an earlier America. For all intents and purposes, however, the homemade gift is part of a Christmas mythology of simpler, better times before capitalism corrupted the purity of a religious holiday. Although some parents did make gifts for their children, and ladies' handicrafts flourished throughout the Victorian era, it is clear that widespread celebration of the holiday and provision of manufactured presents went hand in hand. Frontier children in Minnesota in 1861 got store-bought peppermint sticks and china dolls in their stockings. Gift books, fur-lined gloves, paintings, and "fancy dry goods" were for sale in outposts far from the fashionable shopping streets of New York. A Swedish visitor to St. Paul in the early 1870s was amazed by the stock of gifts in the local stores and by "the number and costliness" of the presents exchanged by the Americans he met.[37] Even in *A Foxfire Christmas,* an exercise in Appalachian nostalgia for the 1930s and 1940s, respondents remember the store-bought sleepy-dolls and china dolls of an impoverished rural childhood with genuine delight; the wooden doll furniture and the corn- and rag-dolls fabricated by family members were make-do gifts, based on the types of merchandise displayed in the windows of a thousand country stores.[38]

Ads for Christmas toys, pocket Bibles, and the *Atlantic Souvenir* appeared in American newspapers in the 1830s.[39] Leigh Eric Schmidt, in his study of consumerism, religion, and holidays, cites evidence showing that, in the 1820s and 1830s, brightly decorated city shops were full of toys for sale on Christmas Eve, the preferred shopping day.[40] There were toy shops in almost every American town in the 1840s: Henry David Thoreau, in the backwoods sixty-three miles north of Bangor, Maine, found a store that stocked "a preponderance of children's toys—dogs to bark, and cats to mew, and trumpets to blow, where natives there hardly are yet." Thoreau seems to have preferred homemade Christmas toys, or no toys at all: "As if a child born into the Maine woods, among the pine cones and cedar

berries," he sniffed, "could not do without such a sugar-man or skip-ping-jack as the young Rothschild has."[41]

"There is no end of pretty toys from Paris and Germany," wrote a newspaper man surveying the Broadway stores in 1857. "Drums, cannons, swords, trumpets, and pistols, for youths of a martial turn of mind—and what American youth is not?—race balloons, dolls that do all that babies do . . . skates, sledges, and magic lanterns, and stereoscopes, and cosmoramas, and villages, and ten-pins. . . . I can assure the little readers . . . that Santa Claus is all right this year."[42] But as the roving reporter suggests, toys were imports and were priced accordingly until after the Civil War. Then, when Americans began to rebuild their family lives, manufacturers began to mass-produce toys in quantity—miniature versions of their adult lines, or playthings that could be made of materials left over from the fabrication of other goods. Publishers printed paper dolls, for example. A maker of farm machinery used the same technology of wood and iron to create the Flexible Flyer sled in 1889.[43]

An 1865 wood engraving in *Harper's* called "Christmas Presents" portrays the range of new merchandise available for the amusement of children: an inexpensive pocket watch, a teething ring, a china doll and a neat doll carriage, picture books, a woolly lamb on wheels, an easel and boxed paint set, a fully equipped tool chest, a drum, and a sword. For the adult members of the household, the presents are sparser. There is a pile of gift books on a table. Father has a pipe and Mother a perfume bottle. The black maid delights in a fancy bonnet.[44] Although girls might paint pictures and go skating, the majority of the manufactured toys in the 1860s—those involving action and machinery—seem to have been meant for boys. The girls' presents are mainly dolls and doll accessories that duplicate the furnishings and fixtures of the home.[45] Thomas Nast's definitive Santa picture—"Santa Claus and His Works" of 1866—is dominated by the jointed Christmas dolly with a wax or china face styled after the prevailing standards of beauty, with a large, fashionable wardrobe made by Mr. Claus himself.[46]

Paper dolls, like Christmas cards, were examples of fine, artistic

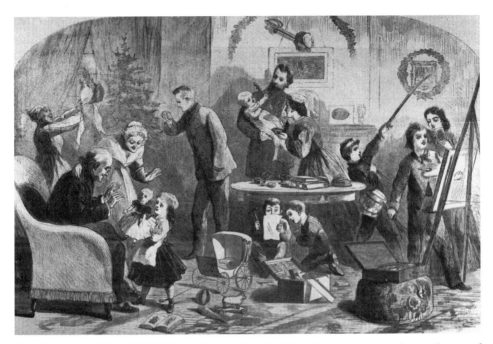

Christmas bounty in 1865: Father is home from the Civil War, and the number and price of the gifts have increased with the coming of peace. *Harper's Weekly* (December 30, 1865), 820.

printing. The first American paper doll, Fanny Gray, was produced in Boston in 1854.[47] She came packaged in a box with a booklet containing edifying stories of her life; a separate head, supplied with the set, could be inserted into the illustrations whenever Fanny made an appearance in the narrative. McLoughlin Brothers of Brooklyn issued "The American Lady" in 1857, with interchangeable outfits and paper doll furniture. There were paper brides with matching grooms. Dennison & Co., future inventors of printed wrapping paper, made jointed paper dolls.[48] But the best present of all was the three-dimensional doll—the real, huggable doll-child which in the early nineteenth century became an infant for the first time, teaching the little girls who changed their babies' clothes and took them for walks about the gender role that society expected them to fill.[49]

There were variations on the theme: dolls that shut their eyes

when put to bed, dolls with papier-mâché heads patented by a Phila-
delphia toymaker in 1872, dolls that walked and said "Mama."[50] Toy
catalogs from Montgomery Ward and Marshall Field show the aston-
ishing variety of dolls available in the 1880s and 1890s, most of
them richly dressed in the hats and coats and muffs and lace
dresses worn by the very nicest little girls.[51] They were, in a sense,
adult representations of the well-turned-out child, images of dolly's
little mother refracted through the loving eyes of a fond uncle or a
doting Papa. Middle-class girls had lots of dolls, too—whole families
of make-believe children that ran the gamut from rag dolls and paper
dolls to boy dolls, mammy dolls, everyday dolls, and the lovely wax
doll from Paris that stayed on a shelf because she was much too nice
to play with.

Grownups were fascinated by dolls, their history, and the techno-
logical advances in their manufacture.[52] *Leslie's* ran a special holi-
day "doll supplement" in the 1890s, full of stories about dolls who
come to life at Christmas.[53] Sentimental Christmas journalism
abounds in images of girls lost in rapture over new dolls from Santa,
or solemnly burdened with the care of new Christmas babies. Con-
versely, poor children are pictured clutching bundles of newspaper
as if they were blue-eyed dolls with flaxen ringlets.[54] Perhaps adults
saw girl children as dolls, who were, after all, exactly what their little
mothers made of them. In "The Dolls' Baby-Show," a *St. Nicholas*
Christmas story from 1880, some of these lucky young ladies, with
large doll families, are persuaded to give up the older, plainer ones
for the sake of orphans who have none. But at the last minute, the
plan changes. "Nobody ever saw, or heard of, or dreamt of a single,
solitary doll . . . that its little mother did not cling to as 'her own dear
child.'" Instead, cash contributions buy fifty identical dolls packed in
cartons like sardines; indulgent relatives supply the beautiful
clothes and bonnets. Put on display in a "baby-show," the massed
spectacle of the Christmas dolls raises enough money to treat the or-
phans to candy.[55]

A doll's reception actually held in a rented hall in New York in
1880—French dolls arranged in tableaux showing them having tea

parties and decorating a Christmas tree—raised money for a charity that provided seaside vacations for poor children.[56] G. Stanley Hall, in his study of the psychology of children's play with dolls, mentions their use in elaborate imaginative dramas of family life, schooldays, weddings, shopping, and paying visits, or private versions of the baby-show.[57] For contextualizing the doll in scenes like these, manufacturers were quick to supply vast quantities of accessories, so-called doll furniture, or scaled-down scenery including houses, luggage, vehicles, tables and chairs, and cooking sets. But there was little consistency of scale between one item and another, or between the dolls and their supposed possessions. The John Wanamaker Christmas Catalogue for 1899, for example, pictures child-size tea and coffee services made of lithographed tin which bear no proportional relationship to the tiny kitchen furniture with which they logically belong.[58]

A little wooden doll chair made of wood and brass, sold in the 1870s, was emblazoned with the name "PET." Too small for the child herself to sit in, the chair presents a text which she faces during play with her doll, a word describing the owner—and the dolly—as a sweet, cherished innocent, a little doll. This reflects a revised understanding of childhood in America that must have influenced the outpouring of Christmas gifts for children in the Victorian era.[59] Toys describe how surrogate Santas understood their children. Utensils and accessories like the "PET" chair are just small enough to represent the adult world in a perfect, jewel-like, miniature version that is often too tiny, too intricate, too dangerous for little fingers to serve the tea—or cook the dinner on a working model of a real cast-iron stove.[60] The gala "Masquerade Doll Party" staged in Macy's 14th Street windows during the 1874 Christmas season had more to do with the feelings of gift-givers than with the sensibilities of the little mothers in attendance.[61]

But the number and variety of children's presents continued to increase. Watches and jack-knives for boys, and later, air rifles and electric trains.[62] Girder sets for future engineers of skyscrapers and bridges.[63] Fur muffs for girls.[64] Bikes.[65] After World War I, and the hi-

atus in the importation of German products, there were more American-made toys.[66] Huge slices of the Sears, Roebuck Christmas "wish book" were eventually given over to blocks, rubber airports, tin trucks, games, cowboy outfits, and dolls that could drink from a bottle and wet their diapers.[67] One of the stories parents always tell at Christmas is about the children who get every fancy toy on the market and wind up playing with the cardboard cartons the presents came in. Toys with motors, toys that do too much, toys based on familiar stories, educators have argued, actually inhibit play: children prefer the boxes because there, imagination has free reign.[68]

Despite ongoing quibbles over the nature of good toys, however, few have ever disputed a boy's or a girl's right to lots of Christmas playthings. It's a simple matter of us versus them. "Christmas is now preeminently the 'home festival,'" *Harper's* observed with some surprise in 1868, leaving New Year's Day, once the major occasion for seasonal gift-giving, as the "away-from-home festival."[69] As such, there was no stinting on holiday gifts for the members of the immediate family. "In the wonderful fruitage of the Christmas tree," declared the *New York Times* in 1872, "there is no gift more valuable than the lesson of domestic affection."[70] Within the confines of the household, however, the selection of a gift—except in the case of youngsters and their toys—was no easy matter.

According to social observers writing in the 1870s, as the great tide of Christmas giving neared full flood, women were relatively easy to buy for. "They are generally fond of personal adornment and the fine decoration of their immediate surroundings"—and the stores were full of notions and trinkets, pincushions and fancy goods and bric-a-brac.[71] But the man of the house was another matter. For one thing, it was his money that was used to purchase his present, an economic fact that blunted the feelings of generosity associated with giving. And except for stocks and bonds, thoroughbred horses, and similar items outside the usual range of holiday gifts, there were "few things that men care[d] for" and could not supply for themselves. A book might do. A knickknack in bronze. But no geegaws, please, and no "common articles of everyday use."[72]

Sociologists like to think about the power relationships expressed in the exchange of gifts: X sends a card to Y, his social superior, in order to curry favor, but does not choose to remember all the Z's in his life—his social inferiors—with a similar token.[73] Within the one-income nineteenth-century family, this sort of reasoning led to highly unsatisfactory conclusions. Although the economic transaction was deliberately clouded by the timely intervention of Santa Claus, what could little boys and girls possibly give their parents in equal return for their heaps of gifts? Good behavior—what Santa expected of his customers—was not exactly a gold necklace or a racehorse. The fact that children could not provide gifts of comparable value put a premium on parental generosity and the worth of a gesture. Little Billy pleased his Mama by painting her a Christmas card.[74] Little Mary pieced together a pincushion out of scraps of fabric or made a pocket calendar for Papa, following the instructions in a magazine; she saved up her pennies to buy a pretty Japanese paper fan.[75]

Men were used to providing for their families, or so the reasoning went. For them, Christmas represented no fundamental change in the order of things. But women, wrote one misogynist in 1879, often made Christmas gifts for their nearest and dearest friends "because they look for presents in return. To give for the sake of giving is benevolent and beautiful; but to give for the sake of receiving is so unworthy and sordid as to destroy the spirit presumed to animate the season of good-will and good-cheer."[76] When gift-giving became a duty or an obligation—when average Americans were suddenly "expected to give Christmas presents of some sort to most of our acquaintances and to all employees, irrespective of sex, race, desert, or condition"—then the meaning of the holiday had changed for the worse. Emerging from the confines of the family circle at the end of the 1870s, the Christmas present fad threatened to beggar the nation: "They expect it because we do it, and we do it because they expect it. . . . But if we have no surplus . . . parting with even so small a sum over and over again is oppressive, and is very apt to make us neglect justice for the sake of appearing generous. . . . To keep

Christmas compacts with our five hundred and one so considered friends is worrying and wanton extravagance."[77]

Negative feelings about the increased quantity of gifts in circulation and a consequent loss of the sentiments once attached to presents led to breast-beating over soulless American materialism and love of luxury. Expensive mechanical toys spoiled children! And what were the little ones to think when their mothers and older sisters whined for big-ticket Christmas loot: "If you can't get me that fur coat or that diamond sunburst, you needn't get me anything—I don't want a lot of trash!"[78] But the minority view held that extravagant, frivolous gifts were the best of all, because nobody—especially prudent housewives—would purchase such things for themselves.[79] "Do not buy your wife . . . the wrap which she needs and would have anyway, nor a chair for the sitting room," advised an experienced husband. "Buy her a vain bauble, something for herself alone, that she wouldn't think of buying unless a fairy godmother suddenly enriched her."[80]

Brass-handled umbrellas, scarves of the latest pattern and weave, the last word in hats or bracelets: every Christmas, the stores were packed with novelties that nobody really needed, but items which, if received as gifts, could be enjoyed in good conscience. Intricate rules of etiquette also made every gift, however delightful, a potential faux pas. Proper young women were not supposed to give presents to unattached men, for instance, unless the gentleman had already brought the lady some keepsake. Otherwise, a "Merry Christmas" had to suffice. Once an exchange had begun, however, her gifts to him had to be artistic, handmade, and inexpensive, expressive of her character, even if he might have preferred a newfangled fountain pen or a stickpin.[81] And "safe," conventional presents proved to be a burden to the recipients when they turned up under the tree for one Christmas too many. "A woman will bear up under handkerchief cases and glove boxes for years, and even smile when she thanks the givers . . . chiefly because they are inexpensive trifles," wrote a lady who had smiled such pained smiles. But eventually, the trifle fails to

convey any sense of the kindly feelings once signified by a gift. "The habit of giving presents which are meaningless or worse is a product of civilization and is as enervating as most of our effete social excrescences."[82]

By 1900 or so, when presents went via express wagon to the very edges of one's social circle, dissatisfaction with Christmas giving had reached crisis proportions. By 1910, the "Gift Problem" was a topic for roundtable discussion, a feature of the holiday as firmly entrenched as Santa Claus. Humorists outdid one another in describing the terrible gifts they had sent and received: "A pair of knitted ear muffs; plate with postage stamps pasted upon it; two pairs of gloves of those quite impossible shades . . . two sizes too small; a workbox, a bead-encrusted sofa pillow (restful for the head) and a pincushion. These three have seen long service, in spite of their bravado air of spurious freshness. They are professionals—tramp gifts that pass from hand to hand in an endless chain."[83] When the present was obligatory, and the lucky recipient far away, what did it matter if the beaded bag, the kimono, or the vanity case went to Aunt Ethel or old Mrs. Jones, whether Uncle George got bedroom slippers, a bargain-counter necktie, or gloves? "Jokes about slippers and neckties as Christmas gifts fill the newspapers every year," quipped a self-styled expert at playing Santa, "yet they probably continue to be among the ten best sellers during the holiday season."[84] Since all those hideous ties were meant to say that the donor was well disposed toward the recipient, maybe a nice Christmas card would do just as well.

It was too easy to blame the retailers for bringing Christmas into disrepute with countersful of "trashy things that no buyer in his senses would at any other time of the year even glance at."[85] It was up to the desperate shopper, the habitual purchaser of jiggumbobs, the midnight wrapper, the mailer of terrible last-minute gifts to put a stop to the madness. "Cards or Gifts?" asked the Christmas humor page in *American Magazine* in 1915. Cards were the rational solution to the very long Christmas list. As opposed to a $10 kimono, the average card cost 10 cents, and saved the family's designated shopper

The Christmas rush in downtown Minneapolis, 1925. The sign on Woolworth's facade reads "Headquarters for Xmas cards." Minnesota Historical Society.

the agony of replenishing this year's stock of unwelcome reading glasses, mufflers, traveling cases, sewing bags, and sample bottles of cheap cologne.[86]

The rising level of ingratitude for poorly chosen gifts that proved a burden to both parties fostered a revival of the Christmas card, underutilized since Prang's defection from the ranks in 1890. In Roman times, when end-of-the-year gifts were part of the Saturnalia festival, these *strenae* often took the form of inscribed clay tablets, wishing the recipient good luck, or copper tokens, adorned with the portrait of Janus, the two-faced New Year's god who looked both forward and backward.[87] Inexpensive trifles, *strenae* were more like

The "Christmas problem" of 1911: a card, or a gift? *Saturday Evening Post* (December 7, 1912), 51.

cards than they were like the formulaic penwipers and handker-
chiefs that American men professed to despise: at least the Roman
gifts stated plainly that they were greetings of the season—nothing
more, nothing less.[88] And when a major revival of the Christmas card
began in America in 1901, it came in the form of Christmas post-
cards that resembled the old Roman plaques.

Stimulated by lower postal rates for cards and improved delivery
service, the postcard fad was one of the first great crazes of the new
century. Although some cards pictured vacation landmarks and lo-
cal scenery, the most highly prized specimens commemorated the
nine legal holidays as well as Easter, Valentine's Day, St. Patrick's
Day, and Halloween, with Christmas the clear favorite.[89] Unlike
nineteenth-century cards, with their pictorial repertory of flowers
and dead robins, the new postals displayed a full range of what were
now the accepted symbols of Christmas: Santas who drove cars and
airplanes and talked on the telephone, children with toys, Christmas
trees, houses and churches in the snow, bells, holly, and poinsettias
(the American Christmas plant, blooming red and green for the holi-
days). Embossed, gilded, and lithographed in color, the Christmas
postals were also a useful form of communication; unlike gift cards,
they provided ample room for a personal message alongside the ad-
dress.[90] The postcard announced its intentions and accomplished its
task, without ambiguity or undue expense.

The time was ripe for expansion in the industry. Between 1900
and 1910, most of the major American greeting card firms were es-
tablished, including small operations in Kansas City that grew into
Rust Craft and Hallmark Cards, and the Gibson Art Company of
Cincinnati. Norcross was incorporated in New York in 1914, just as
World War I put a substantial dent in the postcard business, which
had relied heavily on imports tailored for the U.S. market by German
art lithographers.[91] The new American cards—the first real greeting
cards as we know them—were designed in a folded style, with a pic-
ture and a short text on the outside, and a longer message or verse
on the inside. The layout allowed for a blank page opposite the verse,
for the sender's own best wishes. In 1910, *American Stationer,* the

trade journal of the burgeoning card business, announced that greeting cards had "come to stay. . . . A feature of the holidays was the enormous sale of greeting cards. A large part of the public that formerly used Christmas post cards bought greeting cards this season. . . . Its sale . . . has shown that it fills a long felt want."[92]

The popularity of the new Christmas cards was helped along by the formation of a National Association of Greeting Card Manufacturers in 1913. Five years later, the organization launched a national advertising campaign to encourage the use of cards, regardless of brand name. The ad blitz was one of the business success stories of the era, credited with boosting the production and attractiveness of American cards with the result that Germany never regained its hegemony in the field. The Association also offered help to retailers, including an October newsletter that laid out strategies for increasing Christmas sales. Put cards in the show windows early, the card makers advised. Stock a larger assortment. Advertise in the local papers. Show between-the-features slides in the local movie theaters with pictures of attractive cards.[93]

In the meantime, ads from individual manufacturers addressed the "Christmas Problem" head on. "A 'Davis Quality' Christmas Card costing from 10¢ to 25¢, which carries a sentiment that appeals, will bring more sincere appreciation than a gift costing several dollars," read a full-page advertisement in the *Saturday Evening Post* in 1912.[94] The sentiments from famous authors such as Edwin Markham, Kate Douglas Wiggin, and Henry van Dyke were "a little better" than what the average correspondent could manage. The paper was thick and creamy. The designs—Olde English script, holly, Christmas trees, candles—were so tasteful that A. M. Davis Quality Cards of Boston richly merited the trademark on the back of each one, "the equivalent of the word 'Sterling' on a piece of silver." For 1912, P. F. Volland of Chicago had 25-cent Christmas gift books, calendars, place cards, blotters, and 500 designs in the new folder cards, "engraved, printed, hand-colored, and ribboned." A Volland card always carried a "personal message," albeit one penned by "the best writers of the day" to supply "the cleverest, quaintest, aptest ex-

pression of *yourself* in any mood." Volland cards made "ideal gifts for all occasions, and are particularly appropriate for the holiday season."[95] The Volland slogan? "It is not a gift unless it is myself."

That was the central dilemma—how to assure the buyer of a Christmas card that verses and artwork by somebody else expressed his or her own holiday wishes perfectly, whether the intended recipient was an old friend, a school chum, an important new acquaintance, or the folks back home. In 1913, the A. M. Davis Co. took up the "Christmas Problem" again with an eye toward this fundamental ambiguity, assuring potential customers that "quality people" sent quality cards (which came in boxes of 12 or 19, depending on the size), designed especially for businessmen, for modern couples anxious to avoid the "meaningless sentiment" of old-fashioned Christmas booklets, for those wishing to convey friendly enthusiasm without the taint of "mushy sentimentality." The aura of the brand, and the social aspirations laid out in the ads, determined whether or not the card suited the personality of the sender. In keeping with the classy but up-to-date tenor of the Davis trademark, the cards shown in the company's Christmas ads were vaguely modernistic in their pictorial embellishments, except for a few examples done in the cute, chubby-child style of Grace Drayton, then the last word in contemporary graphic humor.[96]

As time went by, the all-important text gradually yielded to the cover picture and retreated inside, the last vestige of the Christmas letter. Pictures on cards often suggested that the sender was firmly entrenched in the monied upper class through the use of old-tie Olde English motifs, full of stately homes and faithful retainers. The illustrator Helen Sewell created a noteworthy collection of forty cards in this vein for Norcross in the 1920s.[97] Hallmark followed suit. If the pictorial motifs hinted at high status, so did the practice of eliminating the tedious labor involved in sending out one's cards. Printed signatures took the place of hasty lines of handwritten good cheer. In 1924, in response to a flood of Christmas cards, the White House mailed out 3,100 cards of thanks, bearing the Presidential Seal and one of four stock messages, incorporating the names of the Hoo-

Illustrator Helen Sewell made this Olde English watercolor sketch for a Norcross Christmas card around 1925. Track 16 Gallery.

vers.[98] The easier it became to meet familial and social obligations with a mere card, the larger was the crush of holiday mail at the post office. In 1913, the postal service handled 15 million pieces of Christmas mail, of which most were cards or letters to Santa Claus.[99] Even in 1907, at the beginning of the Christmas card boom, the volume of holiday mail threatened to overwhelm a sorting system that had not changed markedly since the Civil War.[100]

If the abundance of factory-made geegaws had triggered the gift-giving crisis of the early twentieth century, then American industry solved the problem with the card. The practice of sending cards to those outside the immediate family circle also helped to sort out who was important in the economy of gifting and who was not. The "nots" got cards, which still left unsolved the question of what to buy for those who remained on the pared-down Christmas list. But again, advertisers and manufacturers came to the rescue with perfect gifts

that could be recognized as such by holiday packaging based on the principle of the card.

Increasingly, the perfect gift was the useful, practical present, a necessity of daily life, like socks or stockings or garters. Despite its intimate connotations, hosiery had been a heavily advertised Christmas gift in the nineteenth century: it was, after all, one's stocking that Santa Claus filled on Christmas Eve. From 1905 on, Holeproof Hosiery promoted its wares almost exclusively at Christmastime, suggesting that socks and stockings, "packed in neat, attractive boxes," made admirable presents.[101] The box was one of the elements that made a pair of socks a desirable gift. In 1911, it was a holly box, with symbols of the season—including a bow and a little gift card—printed illusionistically right on the package.[102] Notaseme Hosiery's snappy slogan conflated the product with the package and the holiday: "The Silky Sox in the Xmas Box."[103] In an odd way, the contents of the package—the perfect gift—were less important than the pictures and the texts. Christmas socks became a slightly-larger-than-usual greeting card.

Practical gifts were part of the drive to reform Christmas giving. Everwear Hosiery in the "Beautiful Poinsettia Box" was supposed to guarantee "a sane Christmas." Inexpensive, durable, "here is a sensible gift which will echo the Christmas spirit for at least six months of the new year—a daily reminder of thoughtful giving." And the box was reusable.[104] Suspenders, fountain pens, pocket knives, garters, and kitchen mops all made the same appeal to long-wearing sentiments packed in lovely holiday boxes.[105] Advertisers congratulated themselves on their ability to convert a household staple into a gift by merely wrapping the item in a glorified card—or a detachable sleeve, bearing holiday wishes, that could be removed by the merchant should the product somehow fail to sell in December.[106]

During the prosperous 1920s, when the geegaw trade might have been expected to flourish, the opposite happened: as one trade journal put it, "each year witnesses less giving of useless gifts and a great increase in the giving of serviceable articles of merchandise."[107] Underwear, monkey wrenches, spark plugs, groceries, carpet sweep-

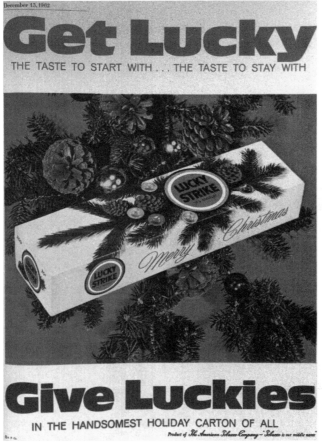

Modern-day *strenae:* cigarettes and other pre-wrapped drug-store items made good gifts when a mere card would not do. The carton *was* a card. *Saturday Evening Post* (December 15, 1962), 39.

ers: practical gifts in holly wreath packages revealed a Puritan streak in American holiday revelry, a sober antidote to the fripperies and vanities of an earlier day.[108] Gillette Safety Razors scored a major merchandising coup in 1928 with a $5 box of extra blades, the most prosaic of gifts, packed in a metal, multi-purpose gift box that was part of the appeal of the purchase. Unlike competing Christmas products, this box was colorful, as befitted the season, but sported no bells or holly. It was a "smart, masculine gift box" readily adapt-

able for use as "a charming cigarette box, stamp box, [or] jewel case."[109] On the theory that what worked for razor blades and long underwear might also work for refrigerators and cars, manufacturers of big-ticket items often showed them tied up in giant ribbons or bursting out of huge boxes.[110]

The move to a certain modest practicality in the gift grab-bag of the 1920s—the thrifty send-'em-a-card mentality—coincides with a campaign to reclaim the religious meaning of Christmas. Although it is clear that the American Christmas never had much to do with observances of the Nativity of Christ, despite the occasional juxtaposition of Santa and the Baby Jesus, calls for a less acquisitive holiday surfaced periodically in the religious press, beginning in the 1880s with the emergence of a full-blown culture of Christmas shopping. But charges of intemperate, pagan consumerism increased in the 1920s.[111] The religious significance of Christmas, charged some critics, was "becoming more and more buried under exploitation by organizations which find in it an opportunity for financial gain."[112] Decades before the famous billboard campaign of 1949 urged shoppers to "Put Christ Back into Christmas," the pious railed against the apparent hegemony of Santa Claus and his minions in the retail trade.[113]

Surprisingly, calls for a less profane Christmas had very little effect on the design of cards. Although the card industry would seem to have been the sector of the economy most readily nudged in the direction of religious motifs, the relative absence of such imagery shows how firmly entrenched was the belief that Christmas was a secular holiday, albeit one that might include churchgoing. A major publisher of cards, in response to a 1923 inquiry from a Pennsylvania parish, stated flatly that its distributors would not stock Madonnas and other religious motifs because the demand was so low. "It will surprise you to know that in the past five or six years it has been almost impossible to interest the dealers in cards of this nature."[114] Indeed, the new trend in Christmas cards in the 1920s was a brittle humor coupled with sleek, sophisticated graphics: Art Deco reindeer leaping through the air like greyhounds and even Santa slimming down for the occasion.

MY CHRISTMAS WISH FOR YOU

Whatever you want on
 Christmas Day
A small town~car done in green and gray~
Good luck at bridge~a new spring bonnet~
A Persian cat~with a blue ribbon on it~
A new fur coat~a permanent wave~
Or a motor boat and a willing slave~
Whatever you want~I'm here to say
 I hope You get it
 Christmas Day

Presents, presents, and more presents! This Christmas card from the go-go 1920s celebrates Christmas greed. Hallmark Archives, Hallmark Cards, Inc.

The typical card of the go-go 1920s, wrote a disapproving observer looking back on the phenomenon from the 1930s, "might have been designed by the President of the Moscow Society of the Godless, so far as any suggestion of the Nativity was concerned."[115] Businesses sent cards by the thousands to suppliers, customers, and potential clients; in their concern to offend nobody by the kind of holiday greeting chosen, big buyers reinforced the drive toward bland, impersonal cards with a modern look suitable for the wide-awake firm.[116] Motifs were also geared to the special interests of the sender, without regard for conventional Christmas symbols of any kind. In 1924, the League of Women Voters held a contest for the design of its annual Christmas card: the prize went to one depicting Abraham Lincoln.[117]

High cost and the dullness and sameness of the commercial product sparked a do-it-yourself movement in card-making after the Crash of 1929.[118] Homemade cards could be printed using linoleum blocks; the medium was especially well suited to the simplified treatment of candles and houses in the snow characteristic of the best modernistic Christmas cards and papers, but the block prints also looked "naive" and quaint—or more sincere and authentic than the usual Gibson and Hallmark cards.[119] If budgetary constraints meant that your Christmas card for 1935 was going to be less impressive than in former years, at least it could be more personal. Draw your own pictures. Send a snapshot of the family hanging their stockings. Or a "newsy, general letter" mailed en masse in decorated envelopes.[120] Ah, the joys of the Christmas letter, now word-processed on red and green stationery, and chock-full of embarrassing details from the past twelve months in the lives of mere acquaintances!

Perhaps the least satisfactory by-product of the ongoing belief that Christmas cards ought to make an important statement about the self and one's values, the Christmas letter of the Depression era introduces a decade-by-decade litany of innovations in the card industry aimed at relentlessly personalizing pre-printed sentiments. In the late 1930s, the American Artists Group was one of several organizations selling cards designed by gallery artists, down on their luck during hard times.[121] Like Louis Prang's beautiful gift cards of the 1880s, these could be saved and framed; they bespoke the excellent taste of both the sender and the recipient.[122] In the 1940s, the patriotic card displaying a love of country was all the rage.[123] During World War II, the business boomed despite draconian cuts in the paper supply mandated by the War Production Board: people needed to keep in touch with their loved ones, and with less and less time to make their own cards, they turned increasingly to the store-bought kind, decorated with holly and military aircraft.[124]

UNICEF international cards, or cards for liberal academics, came along in 1949; by the early 1970s, 26 million cards, or 1 percent of the total number of Christmas cards sent by Americans, came from UNICEF.[125] The funds raised through their sale support United Na-

tions health and nutrition programs for children. And other institutions, from charities to museums, were quick to join the trend to "good deed Christmas cards."[126] The prices were right, the cards numbered the sender among the righteous, and, in the case of museum cards which reproduced Christmas-oriented works in their collections, do-good cards had the effect of making religious cards widely accessible for the first time.[127] In 1958, at the high water mark of the great American Christmas card exchange, the average family mailed a hundred cards, which, depending on the self-perceived character of its members, might be sacred or profane, big and foil-covered, tiny, or homemade in the kitchen from a sliced potato and a stack of green construction paper.[128]

In the 1960s, "sick" cards and "gag" cards were popular.[129] In mass-market cards and wrappings of the late 1950s, the threadbare old Santa had already became a clown, a bit of a bumbler, a funny man who zipped around in a sports car or lay zonked out in front of the television set.[130] The new Santa for a skeptical age echoed Saul Steinberg's witty line drawings of Santa for Hallmark, begun in 1951 and aimed squarely at art-minded iconoclasts.[131] Steinberg's enigmatic designs contrasted sharply with Norman Rockwell's highly traditional card line for Hallmark, and Grandma Moses's folksy one, both perennial Christmas favorites since 1948.[132]

The card market of the 1970s was dominated by the need for intensely personal holiday cards that made an exact match with the sender's social agenda: racially specific cards, cards made from recycled materials, cards from one pet to another, X-rated cards, gay cards, feminist cards, Hanukkah cards, and militantly nonsectarian cards with absolutely no mention of Christmas all found a niche in the display racks.[133] With computers keeping instantaneous records of what sold and what didn't, Christmas cards became a fever chart of the state of the nation. In the 1980s, the demand for religious cards slowly crept upward, to nearly 30 percent of the total. The vulgar and silly Santas of previous years went into a steep decline. Cityscapes and Old Masters were "in." Mimeographed family letters were "out" (briefly). Wyeth-style nostalgia was in vogue, in old-fashioned

scenes covering the full range of U.S. history, from Early American houses to diners of the 1950s; steeped in the innocence of another era, Norman Rockwell cards still outsold all the rest.[134]

In the 1990s, when Vice President Al Gore and family sent nearly 200,000 personal greetings each Christmas to potential political supporters, nostalgia kept its powerful hold on Americans' vision of the Christmas-card perfect Christmas. This pictorial longing for a bygone time found its clearest expression in the Kinkade boom. Thomas Kinkade, "Painter of Light," a California artist who had once done background work for Hollywood films, became the cornerstone of a thriving public corporation selling images of ideal places and times.[135] Signed with intrusive colophons that include his name, a reference to a Gospel verse, and a number indicating how many times he has hidden his wife's initial ("N" for Nanette) in the picture, his scenic paintings turn up in a burgeoning chain of Kinkade shopping mall galleries, on TV shopping channels, on mugs and afghans and commemorative plates, on ornaments, notepaper, calendars, and Christmas cards—and in the most successful line of Christmas gift books published since the genre went out of fashion at the end of the nineteenth century.

It is no accident that Kinkade loves Norman Rockwell—and once managed to spend a vacation painting in Rockwell's old studio in Arlington, Vermont.[136] *Norman Rockwell's Christmas Book,* an expensive anthology of readings punctuated with reproductions of Christmas-themed covers and occasional art, was published in 1977, with the artist's wife listed as editor.[137] Nonetheless, while Rockwell's magazine covers were often happy and family-oriented, they were also topical, reflecting the interests and styles of the day; only after his death, in 1978, did the situations he had portrayed take on the sweet afterglow of nostalgia. Seen in that amber light of retrospection, Rockwell's images of a world seemingly devoid of video games, divorce, greed, or serious interpersonal conflict fed the backward-yearning tastes of the 1980s. Kinkade's nostalgia was almost wholly architectural. He did not paint figural scenes, in the Rockwell

mode. His preserve was the house in the snow, the winding neighborhood street, the English cottage bathed in lamplight, probably inspired by one of Norman Rockwell's only independent studies of place: the long, narrow painting of 1967 known as *Winter in Stockbridge*, an affectionate look at the buildings along the main drag in Rockwell's home town, all dressed up for Christmas.[138]

Rockwell himself called that picture *Home for Christmas*. Kinkade makes home—a heartstring-tugging picture of a cozy house at twilight, softly lit from within—into a fetish, a quasi-religious experience. Paths or tracks in the snow lead straight to the Christmas wreath on the front door. In the cold night air, the lights inside hold out the promise of shelter and warmth. The artist aims the viewer toward the house with tricks of perspective: the facade is often pulled slightly out of position and skewed toward the picture plane, as if the structure were straining to show itself to the person outside the frame. The essence of nostalgia is an unfulfilled longing to walk into the security and pleasures of an imagined past. Kinkade's snug little houses—it is no wonder that Kinkade buildings translate readily into miniature ceramic versions—make that warm-and-fuzzy appeal to people who lead real, complicated lives and wish that they did not, at least at Christmastime.[139] Christmas is, says Kinkade, "my favorite artistic subject. Its spiritual message, its affirmation of faith, its appeal to our best and most generous instincts, all make it a day like no other. . . . Family, security, memories of simpler times, these themes recur in painting after painting."[140]

Thomas Kinkade's 1997 gift book is called *I'll Be Home for Christmas*.[141] Like its nineteenth-century predecessors, this is a pretty little book, a selection of Kinkade houses and villages juxtaposed with fragments from various Christmas texts, some well known and some obscure, awash in seasonal sentiment. The carol of the mice, from *The Wind in the Willows;* the Christmas morning passage from *Little Women;* Irving and Dickens; selections from the Gospels, from poets and greeting-card poets; and the lyrics to the song quoted in the title jostle each other along the edges of paintings full of "N's" and

flickering Christmas lights and windows reflected in the snow. Only 48 pages long, *I'll Be Home for Christmas* will not tax the attention span of the most distracted reader.

Based on a kind of old-fashioned, not-very-expensive present that passed out of favor a hundred years ago, Kinkade's gift book is a Christmas card for people who aspire to new suburban houses with Victorian front porches and working fireplaces. In spite of or because of the New Age piety evoked in the schmaltzy glow of the artist's trademark inner light, his pictures (whose titles are listed in the back of the book, so the smart shopper can ask for them by name at the nearest Kinkade store) do what all good holiday cards have always done. They hope that friends and neighbors, political backers, shirt-tail relatives, business acquaintances, lovers and ex-lovers, will all have a very nice Christmas this year. Christmas in a safe and happy place that smells of apple pies and pine cones—the Christmas cottage of everybody's dreams.

"Should I send my doctor a Christmas card?" asked a participant in a 1961 magazine forum on Christmas card etiquette. "Should I send Christmas cards to tradesmen?" To someone who has suffered a death in the family? Yes, yes, and yes. To Jewish friends? Yes again, but leave off the Magi and the Madonnas. Use colored pens. Sign the children's names, too. Mail early, or late. Write personal notes inside, or over the printed names. Send cards with candles or poinsettias, Santas or holly, pictures of tree ornaments, or snow-covered roofs under an Olde English motto that says "From Our House, To Your House . . . A Very Merry Christmas."[142] Make cards on your printer. Send e-mail cards.[143] Pick a card that uses the word "you" often, for a more intimate effect. Dots are nice: they convey the feeling of a good wish that never ends Exclamation points demonstrate emphatic sincerity![144] Kinkade or Rockwell or Raphael. It's the thought that counts.

DREAMING OF A
WHITE CHRISTMAS

*How Bing Crosby and the Grinch
Almost Stole Christmas*

In 1942, in a clever little film called *Holiday Inn,* Bing Crosby sang "White Christmas." Songwriter Irving Berlin, whose specialty was hummable holiday songs like "Easter Parade," came up with the idea for the movie as a way to showcase his growing stock of seasonal ditties. The premise was simple: a burned-out song-and-dance man with nostalgic longings for the rural life quits the New York nightclub scene and settles in Midville, Connecticut, as the proprietor of a roadhouse open only on American national holidays. Crosby plays the innkeeper and, according to the dialogue, he has planned special shows for fifteen occasions scattered throughout the year. These are a mixture of sanctioned federal holidays and unofficial observances—the school or greeting-card holidays, the popular holidays, or what one recent study of commercial culture calls the "M & M holidays," after the little colored candies that serve as festive markers on the cognitive calendar of the year.[1]

The calendar is a recurring motif in the film. In contrast to the stark numbered pages riffled by the wind that denote the passage of time in other Hollywood productions, *Holiday Inn* uses the kind of calendar that might serve as a nice Christmas gift, one month per page, with each special day highlighted by artwork. As the camera

Bing Crosby's idea? A roadhouse open only on holidays, in the 1942 film *Holiday Inn*. Wisconsin Center for Film and Theater Research.

moves in on the day in question, the calendar block becomes a greeting card, decorated with the accepted symbols of the holiday. Hearts, for example. Flags. Or turkeys. The latter is a cartoon bird that runs frantically from one November Thursday to another, a humorous reference to Franklin Roosevelt's controversial 1939 decision to change the date of Thanksgiving in order to lengthen the Christmas shopping season.[2]

Christmas, the opening shot in the narrative, is represented by a stylized, Christmas-card image of a rural village, slumbering under a coat of fresh snow. Suddenly, poof! The card and the village are gone. The camera zooms in on Fred Astaire, Crosby's partner, standing outside a New York night spot, with a gaggle of dirty-faced newsboys at his left, and a charity Santa with a bell and a kettle at his right. The harsh face of the city on December 24th is forcibly contrasted with the ideal Christmas of home and hearth and pine trees in the snow pictured on the card. President Franklin Roosevelt collected Christmas cards like this one because he loved the pictures.[3]

Paramount's publicity for *Holiday Inn* made much of the fourteen featured Berlin songs, which made the movie, as *Variety* put it, "tops for any tunepic."[4] The gala musical numbers performed in the movie include tributes to New Year's Eve, Lincoln's Birthday, Valentine's Day, Washington's Birthday, Easter Sunday, Independence Day, Thanksgiving, and Christmas. While some critics expected the brand-new Valentine number, "Be Careful, It's My Heart," to be the musical hit of the film, it was the stirring combination of Christmas memories and heart-on-the-sleeve patriotism that set *Holiday Inn* apart from the competition in the summer of 1942.[5] The picture was "a war tonic—and it works!" said the *Motion Picture Herald*.[6] Astaire danced his Fourth of July number to the tattoo of firecrackers that echoed the rhythms of artillery barrages in the Pacific war. In the lazy cadences of "White Christmas," without a single mention of Uncle Sam or the red, white, and blue, Crosby told the GI overseas exactly what he was fighting for.

"White Christmas" is Crosby's first solo in the film; it comes at a quiet moment, as the new entrepreneur tries out his holiday songs

on an audience of one—an aspiring girl singer who has come to Connecticut in search of work. The New York club in the previous scene was tricked out for Christmas in silver and sophistication. In Connecticut, Crosby croons the lyric to a natural pine, decked out in homely Mazda lights and mismatched glass ornaments. When he reaches the refrain, he plays the seven-note bridge by dinging the ornaments with the stem of his pipe. The second chorus is a duet with an adoring Marjorie Reynolds: romance is in the air, along with the fragrance of the Christmas tree.

"White Christmas" is sung again at the very end of *Holiday Inn*. Reynolds has run off to Hollywood with Astaire; the inn is closed; the lovers have been separated by a series of tricks and misunderstandings. Cut from the countryside to a movie backlot and utter fakery—a Connecticut inn set, showered in make-believe snow, that copies the Christmas card scene to a tee. Reynolds begins to sing "White Christmas" as the cameras roll. Without thinking about it, she picks up a pipe off the piano and plays a riff on the ornaments. A pipe?! Suddenly, the light dawns, Crosby appears, and all is well again. Holiday Inn reopens for New Year's Eve. Fade to a long shot of the inn, blanketed in snow, windows all aglow—a Christmas card come to life. Score one for authenticity, home, and white Christmases.

"White Christmas" won the Academy Award for Best Song that year.[7] But, as the music historians Dave Marsh and Steve Propes have observed, it was not a conventional hit. Crosby loved the song; so did Irving Berlin. But after the first New York screening of *Holiday Inn*, Berlin's staff went back to the office believing the boss had a flop on his hands. They were wrong. Perhaps the movie audience was too moved to applaud, for the song scored on the pop charts for seventeen weeks in 1942, eleven of them in first place. In November, "White Christmas" also captured the seventh spot on *Billboard*'s Harlem Hit Parade, proving its appeal to all categories of listeners, regardless of race.[8] Marsh and Propes believe that the success of the song had nothing to do with the movie. The Decca recording was played by Armed Forces Radio, broadcasting to GIs from the Pacific to North Africa. Their requests to hear the record again and again

"White Christmas!" Crosby is about to ring the glass bells on a Christmas tree to accompany the refrain, in the climactic scene from *Holiday Inn*. MOMA Film Stills Archive.

made it a hit. "White Christmas" spoke in simple, direct terms of the past—the Christmases "I used to know"—of children, Christmas cards, purity, trees in the snow, memories of a mythical holiday back home, in a place the soldier in combat might never see again. The longing was palpable in the voices of those who sang along with Bing in mess tents and military hospitals.[9]

In the 1940s, sheet music sales were important to the making of a hit song. The original music, published by Berlin's own company on Seventh Avenue, had a cover showing stills from the film. It also included a snappy, five-line opening recitative in which the singer explains his longing for a snowy Christmas. He is, it seems, in Beverly Hills, where the sun always shines and the palm trees sway. On December 24th, the oddity of his California surroundings—the deviation from standard Christmas-card imagery—accounts for his musi-

cal reverie of snow.[10] But that opening imposed strict limits on the meaning of the song—and on its usefulness to the film scenario. There is no such tropical scene in *Holiday Inn*, for example.[11] Berlin himself wondered if the offhand tone of the lines was responsible for the song's slow start and had them cut from later printings (the covers of which showed a village in the snow).

The missing lines had given the lyric a Hollywood twist; by his own admission, the singer is separated from home and his past for frivolous reasons, involving pleasure, sunshine, and orange groves. By excising the introductory bars, Berlin made "White Christmas" more serious and weighty, allowing the listener to substitute his own dire circumstances and to account for his own passionate wish to be reunited with loved ones at Christmas. Whatever the reason, the change worked. Sales picked up. In sheet music, the new version of the song sold a million copies.[12] Bing Crosby's recording on the Decca label did not begin with California sunshine either. And, until Elton John's tribute to Princess Diana, "Candle in the Wind," was released in the summer of 1997, Crosby's was the best-selling single record of all time—30 million copies by 1968.[13] Because the first pressing had sold out seven times, the die stamp for the record actually wore out with overuse; in 1947, Crosby, the original backup singers, and most of the other musicians reassembled in Los Angeles, in the old Decca studio on Melrose Avenue, and did it again, exactly as they had in 1942, without any mention of California.[14] The demand for the single never abated. In 1952, Crosby recorded it once more, this time for the sound track of a new movie—*White Christmas*—written to capitalize on the sustained popularity of Berlin's song. In 1955, another version, taken from Crosby's annual Christmas radio special, was also issued.[15]

In musical terms, Bing Crosby was the Voice of Christmas for his generation. Over the course of a distinguished career, he recorded more than sixty Christmas songs, ranging from carols and novelty numbers to old standards and new pieces, like Berlin's. The first of these holiday songs, recorded in 1928 with the Paul Whiteman orchestra, was "Silent Night." Until "White Christmas" came along,

Crosby's 1935 version of "Silent Night," with "Adeste Fideles" on the flip side, was the industry's Christmas sales leader.[16] From the beginnings of the record business, secular, sentimental songs from Tin Pan Alley had competed with the ancient carols. "Jingle Bells," another Crosby hit of the 1930s, was an 1857 blackface number, the first American carol, loosely based on the chorus of one of Stephen Foster's minstrel songs.[17] Attributed to James Pierpont (uncle of the financier J. P. Morgan), "Jingle Bells" was one of the first Christmas recordings ever issued, in a 1902 barbershop version. From "Silent Night" to "Jingle Bells," Crosby's Christmas offerings, too, vacillated wildly between the sacred and the profane, the traditional and the up-to-the-minute.

Like the movies, the record business flourished during World War II. Ads for Christmas records from Decca in 1942, when wartime restrictions made civilian travel difficult and most people were expecting to entertain themselves at home for the holidays, recommended a selection of Crosby tunes that ran the gamut from carols to patriotic numbers, including "The Star-Spangled Banner" and Irving Berlin's "God Bless America."[18] Or the *Holiday Inn* album. Another World War II ad—this time, for Christmas radios—described the product as a kind of time machine, steeped in memory and inspiration. Yesterday, the family listened to "Silent Night." Last year, home on a furlough from the service, Dad hummed along with military marches. "Tomorrow will be bad," the copy continued, and "there will be memories that hurt . . . but the children must have a real Christmas," with music, news, and drama from a new Stromberg-Carlson console model radio.[19] Christmas wasn't Christmas without Lionel Barrymore or Ronald Coleman playing Scrooge, Bing Crosby crooning "White Christmas," and a lump-in-the-throat chorus of "God Bless America."[20]

The line between patriotic anthems and carols was very fine indeed in the 1940s. Both summoned up powerful emotions, never far from the surface in time of war. As was typical of Irving Berlin, *Holiday Inn* shamelessly mixed popular observances of American holidays with the solemn duties of citizenship. Easter bonnets and Christmas trees

alternate with tributes to Lincoln and the American armed forces, with Crosby, in an Uncle Sam get-up, solemnly intoning "Freedom's Song" before a montage of troops, battleships, warplanes, assembly lines, and likenesses of FDR and General MacArthur. By the end of the movie, it has become almost un-American not to trim a tree. In *White Christmas* of 1954, which uses many of the same songs and the country hotel setting, the link between Christmas and patriotism is even stronger: the flimsy plot demands that Crosby produce a Christmas show to bolster the fortunes of his old commanding general, now a struggling innkeeper in snowless, postwar Vermont. Old soldiers or Santas? It all amounts to pretty much the same thing.

With its wrenching evocations of home and loved ones and snow and yesterday, "White Christmas" explained what Americans were fighting for in Europe and the Pacific—and later, Korea—as they sent in their requests to hear Crosby's record on Armed Forces Radio. "White Christmas" was the "unofficial national popular song" of its era, according to a recent study of Christmas music.[21] More than just a Christmas song, it spoke in simple, direct language of the state of quasi-religious grace that the American Christmas had always aimed to attain: an ideal combination of nature and culture, trees and cards, memory and anticipation, innocence, and the dream of home. In the Crosby version, the music floats, swoops, and soars over the imagery without effort or impediment; a perfect embodiment of the dream state, it transports the singer into the heart of a perfect Christmas. The song is short. It says nothing about the crush of crowds in the stores, about old anxieties rekindled as families come together, the gifts that Santa didn't bring, the airports clogged with holiday delays—the stuff of Christmas phobias and stress.[22] It conjures up more than it describes, in the gentle snow-sped glide of the melody.

Everybody recorded "White Christmas": Sinatra, Paul Anka, Pat Boone, Ella Fitzgerald, and 350-plus other singers and orchestras.[23] Elvis Presley, who loved Christmas with a poor boy's hunger for a stockingful of presents, included "White Christmas" on his notorious Christmas album of 1957. Some radio stations thought it amounted

Crosby is single-handedly responsible for this Merry Christmas in *White Christmas* (1954). MOMA Film Stills Archive.

to sacrilege to play *any* rock 'n' roll tune at Christmastime, but disk jockeys in the deep South refused to air the "White Christmas" cut because, in Presley's treatment, the unofficial national song sounded "too colored."[24] Yet the same sentiments had already been subject to a great variety of musical and poetic treatments, as the 1940s played endless variations on the theme that fed the Christmas standards of the 1950s. Crosby's poignant "I'll Be Home for Christmas" was a wartime promise in the form of a greeting card from a lonely GI to the folks back home. "The Christmas Song," a ballad written by Mel Tormé and Robert Wells, and later recorded by Crosby and by Nat King Cole, celebrated the comforts of home, and "chestnuts roasting on an open fire."[25] At the end of the Korean War, "Home for the Holidays"—"Oh, there's no place like home for the holidays"—said it all, all over again.

Between 1932 and the mid-1950s, a cadre of prolific songwriters working under the pressure of global chaos wrote most of the American Christmas melodies still sung today, from "Santa Claus Is Comin' to Town" and "Rudolph the Red-Nosed Reindeer" (the second-best-selling Christmas record to date in 1949) to the ubiquitous "White Christmas." When these songs weren't endorsing the kind of pluck that turned ordinary kids into military heroes—the underlying theme of "Rudolph," the unlikely squadron leader with the electric nose—they were pining for a warmth, a reminiscent glow, and a reassurance associated with home and holidays, but lost, somehow, in the complexities of the modern world.[26]

But *White Christmas*—or *Irving Berlin's White Christmas,* as the fine print describes the movie—does not inhabit the Christmas dreamland of *Holiday Inn.* Like our own Christmases, parading by in a rush of years, Christmas of 1954 is very different from its 1942 counterpart, despite manifest similarities in casting, story, and music. The most noticeable change was that from black and white to glorious color. Furthermore, *White Christmas* was made to demonstrate VistaVision, Paramount's new, sharp, wide-screen process. Along with Cinemascope and a host of other technical advances, VistaVision was a way to compete with television by showing a larger, clearer, brighter universe than the one dimly visible in the wavering lines of a small-screen TV set. *White Christmas* was probably chosen as Paramount's first venture into motion picture gimmickry because the story, in its previous telling, was stitched together out of elements that promised to look wonderful in VistaVision: big production numbers, fancy costumes, and a huge stage peopled with headliners and chorus girls. In actual practice, however, changes in the scenario eliminated most of the eye-catching holiday routines that might have featured dancing Valentines and levitating Easter bunnies. This was a movie strictly about Christmas.

And how Christmases ought to be. After a brief flashback to a USO show during World War II, where the male leads meet (and "White Christmas" is sung for the first time), the storyline picks up in Florida, in a series of posh, open-air nightclubs, all neon, fanciful

Miami Beach-style architecture, and palm trees swaying in the breeze. In a matter of minutes, the plot contrives to introduce the boys to the girls and puts them all on a train headed north to Vermont, Christmas, and snow. Nobody sings "White Christmas" at this juncture, but the lyrics are implicit in the scene—Christmases like those the actors and the audience "used to know." The train speeds toward New England in screen-filling VistaVision takes, pausing at last at the Columbia Inn, in Pine Tree, Vermont, where snow, good cheer, and paying customers are all in short supply. The rest of the film shows how to make a workable Christmas out of all the wrong ingredients: no family, no snow, no home of one's own—only a few stray Christmas trees on wheels that are obvious stage props.

Selective use of the title song reinforces the magnitude of the changes in the social climate between World War II and the postwar era of neon, luxurious settings, and lavish Edith Head gowns. "White Christmas" is heard first at the front on Christmas Eve, with bombs raining down on Crosby as he sings: far from home, his audience dreams along with Bing for a moment, remembering, until encroaching reality draws them back into battle. But that is the past. The present is peaceful and serene, except for the turbulent emotional lives of the stars—Crosby and Rosemary Clooney are falling in love fitfully throughout most of the film—and the impending bankruptcy of the old general who owns the inn, a devoted fan of prime-time TV.

The second rendition of "White Christmas" comes in the grand finale, with every problem resolved, everybody onstage in spangled Technicolor Santa Claus suits, and snow, at last, falling softly in the background. Christmas isn't some distant dream, some memory of a perfect past. This Christmas is now, and it is superior to the USO Christmas of a generation earlier. It is modern, unabashedly glitzy, image-driven, the very picture of a Christmas from a greeting card, and it has been conjured up by Crosby out of the lyrics of his song, with very little help from Danny Kaye and the rest of the cast. In the name of Christmas, Crosby will marry Clooney, settle down, and raise a family. The perfect ending: to paraphrase the title song, "May all their Christmases be white."

Multiple Santas: *White Christmas.* Academy of Motion Picture Arts and Sciences.

There are those for whom Christmas would not be Christmas with-out a ritual viewing of Crosby, Clooney, and *White Christmas.* In 1954, however, the critics were less than enthusiastic. The movie was "a bore," said the *New Yorker:* "The plot—if that's the term for it—sneaks in between production numbers."[27] "Crosby just doesn't Bing," said *Time.*[28] But the moviegoing public disagreed. In Novem-ber, helped along by full-page ads listing the stars and the songs all wrapped up in a pretty Christmas package, *White Christmas* "wowed" San Francisco, "cheered" L.A., and set box office records in Cincinnati, Buffalo, Boston, and Detroit. According to the excitable headlines in *Variety,* it was "Great in Cleve. at 27G Despite Snow"—a

freak storm that closed the city down for a crucial weekend, just before the Christmas shopping season distracted paying customers from the movies.[29] What moviegoers were seeing and liking was an affluent, contemporary Christmas, just like the holiday they were reshaping for themselves in the postwar suburbs of America, out of aluminum wrapping paper, Scotch tape, frozen turkey dinners in foil trays, holiday specials on TV, and LP records on the new hi-fi set. The sets and the costumes glistened not with snowflakes but with the plastic glitter and metallic trim that came on expensive Christmas cards. Crosby's song spoke of memories, but what happened in the movie looked nothing like the Christmases that most Americans "used to know."

The changes in Christmas were not entirely the result of postwar prosperity and an insatiable consumer appetite for plastics and electronics by way of presents. The shift was also a matter of attitude, of sophistication, of Santas who no longer pretended to be something other than what they were—pensioners in fuzzy red suits. After a long period of taking Santa Claus seriously, advertisers suddenly began to treat him as a kind of "in" joke for adults, a funny little cartoon character, peeking out from behind a toaster or a vacuum cleaner, or a silly old Dad in false whiskers.[30] The novelty song "I Saw Mommy Kissing Santa Claus," a 1952 hit in which a naive little boy stumbles upon an apparent love triangle under the mistletoe, is typical of the holiday insouciance of the era, which assumed that everybody was in on the big Christmas joke.

The same careless "cool" affected the much-maligned Elvis Presley Christmas album of 1957, in which the young rock 'n' roller betrayed his aspiration to outdo his pop elders by "covering" a whole group of Christmas numbers taken directly from Bing Crosby's playlist, including "Silent Night," "I'll Be Home for Christmas," and "White Christmas." In fact, it was the charge of fooling around with national institutions and tampering with classics that made the LP infamous. In the second chorus of "White Christmas," Elvis toyed with both the melody and the lyrics in a series of bluesy, staccato stutters. When he heard the record, Irving Berlin saw red. With no small success, he

marshaled his staff to call radio stations across the nation, urging them to ban the album. In one instance, a disk jockey in Portland, Oregon, was fired for refusing to honor the boycott.[31] But the worst offenses may have come on cuts based on much newer material. Elvis reduced the Gene Autry version of "Here Comes Santa Claus" to virtual gibberish, albeit happy, upbeat gibberish: his version of the song is so laid back as to be unintelligible. And then there's "Blue Christmas."

Elvis' Christmas Album is a cultural milestone of sorts, coming at the beginning of the craze for Christmas-themed LPs by popular artists, when there was no real body of Christmas music for a young rocker to tackle without straying into hostile territory. Taken in that context, "Blue Christmas"—from the pop side of the album; the flip side was for sacred music—must be seen as the rock generation's riposte to Irving Berlin and "White Christmas." Recorded in California in September 1957, with a premature Christmas tree providing the requisite atmosphere, "Blue Christmas" is a song of loss and rebellion and teenage romance gone sour, undercut by the energy and confidence of the singer. While everyone else is enjoying the red and green decorations on the tree, Elvis moans, he'll be blue this year— as blue as the cold snowflakes of the season. She'll be OK, with her "Christmas of white." But burdened by memories of good times gone forever, he'll have a "blue, blue Christmas."

Elvis Presley didn't write "Blue Christmas" (a 1949 pop song already recorded by country star Ernest Tubb), but he made it his own, with his moody, pseudo-tearful sincerity. "I'll be so blue just thinkin' a-, a-, a-bout you" rolls off his tongue with the vocal assurance of Crosby, crooning along with the tinkle of the Christmas ornaments. While the soldiers who listened to Bing Crosby truly believed they could go home again and live out the memories they cherished, Elvis Presley seems sublimely disinterested in the past. Memories represent yesterday and pain: the red and green Christmas of World War II is over. In both the literal and figurative senses, Elvis Presley's Christmas is blue with an adolescent angst that is also a wail of protest against the stodgy sentimentality of Crosby and

Berlin. Like the master suite Elvis planned for Graceland, his mansion outside Memphis, his Christmas is "the darkest blue there is," redolent of the rhythm and blues of black culture.[32] In other new houses in other suburbs in the 1950s stood whole forests of funky blue plastic trees, trees sprayed blue with synthetic snowflakes, trees with lights of no other color but a cool, inky blue. A blue Christmas was a new Christmas.

A major reconsideration of Christmas began in the 1950s, a movement toward a holiday whose meaning would be profoundly influenced by the media, by grand gestures like "Blue Christmas," and by the Christmas "special" on television. Greeting cards and magazine pictures and wrapping paper are media, too, of course. As conduits through which ideas and beliefs were channeled, these earlier forms of mass culture established the broad-brush outlines of the American Christmas in the nineteenth century. *Godey's* engraving of Prince Albert's Christmas tree; Prang's lithographed cards; the box of hosiery glorified by its festive dress of white tissue and red ribbon: Christmas was pieced together over a hundred-year period from such snippets of authority, artistry, and practicality. But the influence of the television medium has been massive, invasive, and almost universal.

The Norelco Santa speeds along on the floating heads of an electric razor. A "Chia pet" grows a coat of grass fur. The stoic Jack Webb and his partner, in a Christmas episode of *Dragnet,* track down the plaster Baby Jesus kidnapped from a church on Christmas Eve. Raunchy detective Andy Sipowicz of *NYPD Blue* plays Santa at the precinct party.[33] It's all there, every year. The Christmas stuff on network TV diagrams the passing decades, from the 1950s to the 1990s and beyond, with a mixture of ads and cartoon perennials, with hours of song and family togetherness hosted by fading or ex-stars, with remakes of "A Christmas Carol" and showings of old Christmas movies. Out there in the electronic babble of the universe, these fragments of Christmas cheer float in geological layers, each one describing a specific place and time, but all of them present simultaneously during any one Christmas season. Just change the channel, from

The Bob Hope Christmas Show (1954) to *Perry Como's Olde English Christmas* (1977) to *The Bing Crosby Christmas Show* (1962) to *John Denver's Christmas in Aspen* (1988), from *How the Grinch Stole Christmas* (1966) to *A Charlie Brown Christmas* (1965).[34]

The first official Christmas "special" came on Christmas Day, 1950. *One Hour in Wonderland* was produced by Walt Disney to promote his forthcoming animated version of *Alice in Wonderland*. While other Hollywood studios closed ranks against the competition from television, Disney decided to give it a try: the show amounted to an hour-long commercial for *Alice* sponsored by Coca-Cola. The program used a party format. Walt and his daughters welcomed Edgar Bergen and other show-biz guests to a Christmas afternoon celebration of the new film.[35] The party setup became the standard for family Christmas specials intended to convey cozy feelings by means of artificial snow, sets that looked like well-appointed living rooms, big-name guests, and sheepish offspring with forced smiles. Judy Garland's 1963 Christmas show had all these ingredients, mixed into a rich ball of cookie dough that also contained carolers, dancing Santas in costumes by Bob Mackie, and a sprinkling of the usual Christmas numbers, from "Rudolph" to Mel Tormé's "Christmas Song," sung by the composer himself.[36]

In 1990, long after her death, Garland's special was still running on the Disney Channel. Now appearing stilted and forced in their endorsement of a traditional family Christmas, these recurrent holiday specials constitute a weird necrology of defunct pop stars revived every December thanks to the magic of television. In this videotape twilight, the cultural imperatives of Christmases past rattle their chains, like Scrooge's ghosts. But some of the old shows—especially the animated cartoons, in which dead stars are the anonymous voices of characters that never age—have become Christmas classics. Two of the best-known cartoon classics are also among the earliest of the enduring Christmas specials: *A Charlie Brown Christmas* of 1965 and *How the Grinch Stole Christmas* of 1966. Both shows turn up every Christmas, more often than not on CBS; their anniversary screenings (the fact that the Charlie Brown special turned

twenty-eight years old in 1993 was duly noted) become occasions for pinpointing enduring American beliefs about the meaning of Christmas. And the shows are remarkably similar in that respect, gently preaching a gospel of anticommercialism, fellowship, and high ideals well suited to the decade of Woodstock and the New Frontier.

A *Charlie Brown Christmas* was based on the long-running newspaper cartoon strip, "Peanuts," by Charles M. Schultz. In Schultz's TV script, as Charlie Brown's friends look forward to their presents, Charlie is depressed by Christmas. On the advice of Lucy, his amateur psychiatrist, Charlie decides to get involved by directing the church Christmas play. But the tree he brings to brighten up the set is small and scraggly, and the cast makes fun of him for choosing it. The decisive moment in the story comes when Linus recites the Nativity story from the Gospel of Luke and Charlie finally understands what Christmas is all about. "I won't let all this commercialism spoil my Christmas," he vows. In the finale, everybody comes together to decorate the poor little tree. Charlie adds a single blue ornament. Linus swaddles it in his blanket. The greater the attention, the more beautiful the tree becomes. End of story. "A Merry Christmas to All," says Charlie Brown.[37]

The longest-running cartoon special in TV history, *A Charlie Brown Christmas* won every major award the industry had to offer. While there is no real family component—Schultz's world is the parentless Youth Culture in miniature—the program struck several responsive chords. With its innocent appeal to the Gospels, *A Charlie Brown Christmas* manages to give the material trappings of Christmas a thin veneer of religious significance, effecting a compromise between the secular and the sacred that cures Charlie's overdose of consumerism. The words of the Christmas pageant redeem the little tree—and, presumably, the Christmas pitches from the sponsors: Coca-Cola, McDonald's, and Nabisco in 1965. Although the theology is better disguised, this is also the message of the new holiday show for the following year, *How the Grinch Stole Christmas*.

The *Grinch* was based on a slender book by children's author Dr. Seuss (a.k.a. Ted Geisel), which had been a 1957 Christmas best-

seller. The first printing, in excess of fifty thousand copies, set a new record for children's book sales.[38] In New York City on December 10th of that year, Macy's recorded the first two-million-dollar day in department store history, much of it spent in the Santa's Village toyland, where Dr. Seuss's new book was available. *How the Grinch Stole Christmas!* was another remarkable by-product of a thriving economy and the postwar baby boom. The boomers' parents—and later, their children—were captivated by Seuss's dastardly villain, the harem-scarem rush of the poetic meter, and the charming illustrations showing the soft-and-cuddly houses of the town of Whoville.[39]

The enduring popularity of the story was guaranteed by the 1966 TV special, produced by the legendary cartoon genius Chuck Jones, in close collaboration with the author.[40] Geisel himself worried about being too churchly: the Grinch, who thought he had ruined Christmas for the Whos when he stole their trees and presents and puddings, discovers that Christmas "doesn't come from a store. Maybe Christmas . . . perhaps . . . means a little bit more!"[41] And the good doctor was not pleased when reviewers professed to find "all kinds of . . . biblical connotations" in the book. "When you write a kid's book," he explained, "somebody's got to win."[42] While Geisel was working on the *Grinch,* a protest against the over-commercialization of the holiday, he agonized about the ending, wanting to avoid the ministerial tone of the pulpit. "I got into a situation where I sounded like a second-rate preacher or some biblical truism," he remembered. "Finally, in desperation . . . I showed the Grinch and the Whos together at the table. . . . I had gone through thousands of religious choices, and . . . it came out like that."[43]

He also scrapped Jones's plan to end the TV version with the Star of Bethlehem shining down over the landscape; without the star or traditional carols that echoed the Bible story, the televised *Grinch* became one of only a handful of Christmas specials of the 1960s to omit all reference to the Nativity. This scrupulous avoidance of iconographic symbols of the Christian holiday aligns Seuss with a particularly American mode of Yuletide observance, grounded in the

protections of the First Amendment. Yet a religious journalist who dared to confess reservations about the sadistic tone of the voice-over by actor Boris Karloff (the Grinch) conceded that his opposition would be "considered heretical in some Catholic circles" in which the Dr. Seuss special marked a suitable beginning for the liturgical season of Advent.[44]

Dr. Seuss's dismay at moralized readings of his work is easy to understand. *How the Grinch Stole Christmas!*—on TV, the Grinch is a delicious, malevolent green—is almost militantly secular in its deliberate omission of religious rhetoric. But Seuss uses the established American symbols of Christmas to transcend their secular origins. His Santa is Clement Moore's and his Grinch is Dickens's Mr. Scrooge; as for the rest—the gifts, the tree, the Christmas dinner—they come directly from the popular tradition, as it was handed down through countless television specials. Yet through these means, the story reaches for an unnamed, ineffable something, the sense of meaning and belonging that Charlie Brown was also seeking, or whatever stands behind the holly, the ornaments, and the mistletoe.

The Dickensian Grinch hates Christmas. He is finally redeemed by the innocent happiness of the Whos and, in particular, little Cindy-Lou Who, the only eyewitness to his theft of the holiday goodies (and the female counterpart to Tiny Tim). What she sees on Christmas Eve when she stumbles out of bed for a drink of water is Santa Claus, the stocking-filling elf of Clement Moore's poem, whooshing up the chimney with the tree, the lights, the ornaments, the roller skates, the bicycles, and the groceries, right down to the smallest crumb of Who pudding, in a larcenous inversion of his customary role. (She should have known something was fishy: whereas good Santas are always fat, the mean old Grinch is wafer-thin. Children always notice the difference!) When the Whos manage to celebrate without the missing accessories, Santa/Grinch brings the stuff back and the feast begins in earnest. Like Charles Schultz, then, Dr. Seuss managed to tap the residual unease of well-off viewers gathered in perfect Judy Garland/Perry Como/Bing Crosby living rooms, viewers torn between the desire to deck themselves in the red-and-

green trappings of the good life and the suspicion—the fervent wish—that there might be "a little bit more" to the American Christmas than met the eye.

The 1960s were the Golden Age of the Christmas animated special. *Rudolph the Red-Nosed Reindeer* (1964), *Frosty the Snowman* (1969), and *Santa Claus Is Comin' to Town* (1970) were only the most popular of the many stop-motion Christmas shows from the Rankin/Bass studio, based on novelty songs.[45] In 1995, decades after its premiere, *Rudolph* still drew 23 million viewers, beating out the classics and a crop of newer holiday shows. Cartoons don't age the way old singers do; the pleasure of watching *Frosty* (voiced by Jimmy Durante) or *Rudolph* (Burl Ives) is only marginally increased by identifying the star behind the character. Besides, every year these children's shows attract a whole new audience of children and of parents who like to remember their old Christmas favorites.[46]

The direct appeal of animation to a child audience has also created problems, however, as toy companies market their products aggressively through cartoon shows pitched at the little consumers who give Santa Claus his orders. In a revealing study of the toy industry, the historian Gary Cross identifies a whole genre of TV toys created to imitate the plots and characters of prime-time shows for children.[47] In the early 1950s, these took the form of games featuring sci-fi and cowboy heroes. In 1955, with the advent of Disney's *Mickey Mouse Club,* the focus shifted to themed toys advertised directly to children on the shows in question. Such ads, Cross argues, bypassed parental guidance and plugged directly into the television-generated fantasies of their offspring.

Eventually, in the 1960s and 1970s, the products spawned their own shows, which amounted to informercials for Barbie and GI Joe. *The Cabbage Patch Kids' First Christmas,* a 1984 special, was a showcase for a line of lumpish dolls created by Xavier Roberts and licensed to Coleco—the sponsor—by Appalachian Artwork. The premise of the product was that every doll was unique; they came with names and histories and adoption papers. Thanks to ads and the Christmas show, demand soon outstripped production. The "hot" toy

item of 1984, Cabbage Patch dolls had frantic Moms and Dads camping out overnight in front of Toys-R-Us and Kmart to fulfill the advertising-driven dreams of little girls. The TV special, in which some dolls are adopted because others helped the cause, was supposed to teach children that the Spirit of Christmas was something you felt when you made someone else happy, according to the producers.[48] At the end of the fiscal year, Coleco executives were probably happier than most parents.

Santabear's First Christmas of 1986 was another effort to market a Christmas product as a must-have entry on children's wish lists.[49] Santabear was a fifteen-inch plush teddy bear sold in a department store chain in seven Midwestern states in 1985 as a "purchase-with-purchase" item—something the customer could buy only if he or she bought something else, from the regular line of merchandise. This in itself was a sales gimmick: a $25 bear (or so the ads claimed) cost a mere $10 upon presentation of $50 in receipts. Within three weeks, before Thanksgiving and the start of the shopping season, 400,000 bears were sold. But Santabear was only the latest wrinkle in the story of the teddy bear as a fad item. Legend has it that a New York toy buyer, in Germany on a pre-Christmas foray, showed a *Washington Post* editorial cartoon to Margarette Steiff of Wurtenburg, a maker of stuffed plush animals. Based on a news photo of Teddy Roosevelt after a bear hunt in the Rockies, with a live cub at his feet, the Clifford Berryman cartoon—a reference to a recent border dispute between Louisiana and Mississippi—capitalized on Roosevelt's refusal to shoot the plump little fellow. Hence, "Teddy" bears. Steiff began to make the fuzzy bears that took America by storm because they were cute and because they alluded cheekily to a flamboyant public figure.[50]

The real story is almost as interesting. Steiff had actually made a line of thin-limbed bears for some years when the cartoon appeared. Indeed, a persistent strain of bear humor had already found its way into the Christmas card industry in the 1880s, when Prang's catalog listed dancing bears, owls reading books, and a tortoise and hare scene designed by W. H. Beard, an American artist whose specialty

The Dayton's Santabear, 1986. Dayton's.

was the graphic equivalent of the Uncle Remus stories—paintings of animals whose antics satirized human behavior.[51] Bears by Beard and others were also popular as Christmas illustrations in pictorial journals. A double-page spread by F. S. Church in *Harper's* Christmas issue for 1885 shows a pretty girl dancing along with a troop of smiling polar bears who play musical instruments or, dressed as chefs, usher in the Christmas pudding.[52] A *Harper's Young People* cover for the same year has eight chubby bear cubs dancing around a snow-covered pine tree deep in the forest—a kind of Christmas *au naturel*.[53] Plainly, the time was ripe for more and better bears.

HARPER'S

YOUNG PEOPLE

AN ILLUSTRATED WEEKLY.

OL. VII.—NO. 320 PUBLISHED BY HARPER & BROTHERS, NEW YORK. PRICE FIVE CENT

ESDAY, DECEMBER 15, 1885. Copyright, 1885, by Harper & Brothers. $2.00 PER YEAR, IN ADVANC

"THE WIND IS CHILL; BUT LET IT WHISTLE AS IT WILL, WE'LL KEEP OUR MERRY CHRISTMAS STILL."

The incipient Christmas teddy bear, 1885. *Harper's Young People* (December 15, 1885), 101.

Most of these early bears were full-grown animals, like the dancing bears in the circus. The humor of their activities arose from the fact that they behaved like overgrown, hairy adults afflicted with uncertain balance. But the little fellows were roly-poly versions of babies and toddlers, the unofficial mascots of the Christmas season. The cuddly bear in the Berryman cartoon prompted Morris Michtom, founder of the Ideal Toy Company (one of a growing number of American toy magnates), to write to Roosevelt, asking for permission to make a bear cub and to call it "Teddy's bear." Although the President doubted that his name would be of much use in the toy business, he agreed. Ideal sent a sample bear to the White House and, in 1903, sold every "Teddy" they could make to avid wholesalers.[54]

The Teddy Bear was the Cabbage Patch Kid of 1903. It was a craze, a fad, a fashion—but one that never really disappeared, thanks to the inherent appeal of the little round bears which, unlike dollies, seemed as suitable for boys' gifts as for girls'. Santabear was another classic teddy—squat, furry, and white, with shiny black eyes, a black nose, and an accessory item that dated the year of purchase. In 1986, the date was knitted into the bear's cap, from which cunning plush ears protruded. By dating the bear, the Dayton Hudson stores suggested that it was a collectible, a part of an investment-worthy future set. The dating—and the fact that the costume changes from year to year—also meant that Santabear was not a one-time purchase; even if the family already had last year's bear, the new one was clearly different.

During the summer of 1986, Santabear began to make the move from mere toy to famous character. People in Santabear costumes joined in parades and festivals. Meanwhile, at corporate headquarters in Minneapolis, a senior copywriter had finished work on a "backstory," sketching the history of the bear and his association with Christmas. As this was being illustrated and prepared for publication in storybook form, an ABC daytime children's special was being edited, based on the artwork and the text and using a quick-and-dirty technique called "illustration-dissolve animation" in which the camera fades in and out on pictures that do not actually move.[55] The

stores were stocked with 120 separate "private label" products based on the Santabear theme: placemats, towels, cookie jars, men's boxer shorts, women's slippers, and a Santabear ice scraper for the windshield (at a mere $10).[56] Every Santabear "event" was listed on a master calendar, every cookie jar on a master plan for stimulating business "and feature coverage (free publicity) which keeps our name and our Santabear products at the top of our customers' minds."[57] Print ads were placed, direct mailings posted. And other companies were enlisted to push Santabears: a bookstore chain would feature the storybook, a cereal company would put the bear's picture on every package, and ABC would run promotions for the show during prime time.

The 30-minute TV special, *Santabear's First Christmas,* played during the Saturday morning kids' slot on November 22, 1986. The plot was rudimentary: an orphan polar bear, taken in by a poor but kindly family, repays them by asking Santa Claus for wood for their fireplace instead of gifts for himself. Santa names him "Santabear." Thereafter, every Christmas Eve, he brings toys to the woodland animals.[58] Thus the story has a bit of a moral, a happy ending, and just enough of an explanation of a pretty ordinary white teddy bear to keep up the demand for plush and sweatshirts: Santabear wasn't Frosty or Rudolph yet, but he now had most of the credentials of the holiday big boys, including go-with merchandise and a TV special.[59]

Santabear's First Christmas did not make the list of the top Christmas specials available on video during the 1980s (although a videotape had appeared in the stores even before the special aired). The hands-down favorites were *Rudolph;* Crosby's *White Christmas; Frosty; Santa Claus Is Comin' to Town;* and *It's a Wonderful Life*—or two ancient films and three elderly cartoons. The number 5 video best-seller, Frank Capra's *It's a Wonderful Life,* was shown for free no fewer than twenty-nine times on various New York TV channels during December of 1989. The copyright on the movie had expired in 1983, clearing the way for the moment when Jimmy Stewart slips the petals from Zu-zu's Christmas rose into his vest pocket to play at any hour of the day or night on some television set, somewhere in

the United States, for the entire Christmas season. Charlie Brown and Rudolph were back in the 1980s. So were George C. Scott, Albert Finney, Reginald Owen, Alistair Sim, Michael Caine, and Bill Murray as a fine bunch of Scrooges: the costs to the networks for rerunning old specials and old movies were far below the price of new, prime-time programming. Some stations honored the holiday even more cheaply by broadcasting a continuous picture of a roaring fireplace between dawn and dusk, with carols tinkling in the background, for a kind of Andy Warhol-at-home effect.[60]

Christmas hadn't quite turned into a day on the couch, however. A report from N. W. Ayer, the advertising agency, showed that in the 1990s television viewing dropped precipitously during the holidays. On Christmas Eve, for example, 34 percent of the usual viewers trimmed their trees instead, or tried to put together Barbie's Dream House. But even with a massive defection from the ranks, that still left 41 million living rooms aglow with the cold blue light of the picture tube.[61] And in homes where that radiance was as much a part of the holiday decor as the lights on the tree, there was plenty to watch. Newer movies began popping up: Chevy Chase as the almost fatally inept Dad, stringing the outdoor lights, in *National Lampoon's Christmas Vacation* (1989); *Santa Claus: The Movie* (1985), with David Huddleston in the title role, and his elves thwarting an evil toy manufacturer; *The Santa Clause* (1994), in which sitcom star Tim Allen is plucked from the suburbs and turned into Santa himself.[62] In 1994, Chevy Chase was back for his third Christmas outing on ABC, having grabbed a mid-20s share of the audience in two previous years. His ratings weren't bad, but the movie-to-television hit of the decade was *Home Alone* (1990).

In 1993, the story of the intrepid little boy—Macaulay Culkin—left behind when his family goes to Paris for Christmas pulled a whopping 36 share on NBC. The movie had everything: an adorable child star, lots of action (as he single-handedly thwarts a gang of housebreakers), a brief semi-religious interlude (as the little hero pauses at an outdoor crèche to reflect on his situation), and a child alone in a big, empty house, in a temporary reversal of the way things ought to

be at Christmas. Like *Christmas Vacation, The Santa Clause,* and virtually every other Christmas movie made during the past twenty years, *Home Alone* affirmed a family Christmas, with the house decorated to the nines, no expense spared. Tinsel, glass balls, wrapping paper, presents under the tree—these served as outward signs of a special bond of affection that found its season for expression at Christmas.

And then there was *Jingle All the Way* (1996) with Arnold Schwarzenegger, filmed in part at the Mall of America, where the frenzy of Christmas Eve shopping was simulated for the cameras on a blistering midsummer weekend. Schwarzenegger is a shopper, bent on finding that season's must-have toy for his neglected son. In *Home Alone,* the violence is mitigated by the fact that a child succeeds in defending himself against larcenous adults. But *Jingle All the Way* is a thoroughly unpleasant film in which the desperate father bullies and attacks the retail world relentlessly for eighty-five minutes in his effort to get the last "Turbo Man" action figure. In a way, Schwarzenegger's role is a parody of the wham-bang brutes he has always played in the movies: he *is* "Turbo Man," a Hollywood action figure. But the real target of the satire, if the movie can be described as satire, seems to be the terrible, empty materialism of Christmas, which the film ultimately endorses.[63]

This fundamental misunderstanding of the role of material culture in the American Christmas may account for why *Home Alone* was an enormous success across the board—on video and television and in theatrical release—while *Jingle All the Way* was not. Most of *Home Alone* takes place in a beautifully appointed upper-middle-class house; in that context, however, the film treats the rich material trappings of Christmas as mere means to a larger celebratory end. The child trims a tree and hangs his stocking like the devotee of some Pacific island cargo cult, hoping all the while that the presents and the tinsel will magically conjure up his family. What Americans celebrate at Christmas—whether it is the birth of Jesus, a family reunion, a safe home with a Christmas tree, lovely memories of other Christmases, or the pleasures of giving and receiving—depends

on whether the tree-trimmer is Macaulay Culkin or Arnold Schwarzenegger. But Christmas is not a teddy bear or an action figure—or rather, it is not just a teddy bear or an action figure. Nor is it enough to growl "Bah, Humbug" in a German accent, and dismiss the season as a protracted riot in a mall. The viewing audience knows what Christmas is. And every year (albeit not on Christmas Eve), Americans continue to watch *A Charlie Brown Christmas* and *How the Grinch Stole Christmas, White Christmas* and *Home Alone.*

Christmas films, like their TV counterparts, are generally twinkly and sentimental, and they almost always have happy endings. The exception is a growing number of counterintuitive Christmas movies, crime and horror films that use the emotional warmth of the season to redouble the trials of the protagonists. In *Silent Night, Deadly Night* (1984), a child watches his parents being slaughtered by an intruder dressed as Santa Claus; years later, asked to don the red suit himself, he snaps and becomes a "Killer Santa." *Gremlins* (1984), one of the best of the lot, has small-town America torn apart by toothy little monsters, spawned by a misguided Christmas gift, a furry, teddy-bearish pet with a penchant for rapid reproduction. Christmas gives the demons a chance to wear Santa Claus hats, visit a satanic toystore where the Barbie dolls grow fangs, and spoil the perfection of a Christmas-card-pretty Main Street. *Gremlins* is *It's A Wonderful Life* gone terribly wrong.[64] Kingston Falls is Bedford Falls turned inside out and then devoured by its own good Christmas wishes.[65]

In *Die Hard* (1988), an action picture released in mid-July to attract the out-of-school crowd, Christmas is almost incidental to the blood-and-guts hostage crisis in a Los Angeles skyscraper. A holiday reunion is merely the plot mechanism necessary to get a tough New York cop and his long-distance wife together at the office party that is the terrorists' target.[66] The use of Christmas and Christmas decorations as vivid background material helps to create the sense that crime and criminals exist in a horrific world of their own, a parallel universe in which the rules and the timetables of everyday life do not apply. "Peace on Earth" prevails around the tree—except at Christmas parties attended by Bruce Willis. If the "Coming Attractions"

clips are to be believed, Christmas gore is particularly effective with a home-for-vacation audience in search of a break from too much holiday togetherness. In contemporary detective fiction, too, Christmas becomes a marketing tool: lurid paperback covers show pools of blood under Christmas trees and sinister figures lurking outside snug houses all dressed up for the holidays.[67]

One noteworthy exception to the Hollywood practice of pairing horrific acts with tender celebratory occasions is *One True Thing*, a 1998 film based on a novel by Anna Quiden. Starring Meryl Streep and Renee Zellweger as a mother and daughter finally brought together by the former's terminal illness, the movie offers an extended discussion of holidays and their role in nourishing family life and friendships. Streep belongs to a women's group that decorates the town for Christmas. She, like the other ladies, also arranges the birthday parties, the costume parties, the dinners, and the decorations that define the rhythms of family life for her errant husband, her son, and her careerist daughter, who finds Streep's round of stay-at-home activities trivial. In the midst of stories of infidelity and betrayal that play themselves out during the crisis occasioned by Streep's struggle with cancer, however, Zellweger comes to realize that her generation's definition of womanhood is not the only valid one. Her mother's work is also demanding, difficult, and important. It is the hot-glue that holds the family and the community together.

One True Thing oversimplifies the clash of values between mother and daughter, between Martha Stewart's emblematic glue gun and Gloria Steinem's briefcase. Nonetheless, Streep's effective portrayal of a tireless Mother Christmas does expose a glaring anomaly in most of the previous depictions of how to make the season merry. Apart from Meryl Streep, where are the women? From Bing Crosby to Santabear, from the Grinch to Chevy Chase, men make (or unmake) Christmas with very little help from the rest of humankind. Christmas means Elvis, Arnold, Jimmy Stewart, good ol' Charlie Brown. But where *are* the women? It's a bizarre omission.

Sociologists are just about unanimous in concluding that women do most of the grunt work involved in standard Christmas practices:

they buy and wrap the presents, trim the tree, plan the gatherings, cook the food. Theodore Caplow, in his groundbreaking studies of Christmas gift exchange and other holiday observances in "Middletown," U.S.A., documents women's hegemony as makers and shapers of celebratory rituals.[68] In industrial societies, it is women who define and maintain the sorts of relationships within the family and between the family and the culture that Christmas effectively diagrams with presents and strings of lights.[69] Who are our friends? Our social superiors? What are our obligations to the community? Yet, because Christmas is a family holiday, the actual work of mothers and aunts and grandmothers is rarely differentiated from the lesser roles of others. Nor are acts performed for love and not for money commonly recognized as "work."[70]

Both tradition and intuition assign certain gender roles at Christmas, often reinforced by media stereotypes and the pictures on Christmas cards. Men are supposed to put up the outdoor lights and pare down the tree to fit its stand. Children save their pennies, visit Santa Claus, and try to keep secrets. And all the rest is what the women do. Mrs. Cratchit worries over the plum pudding; Scrooge merely looks on in wonder. Bing Crosby directs the big Christmas show, but without Louise Beavers and Mary Wickes, the faithful housekeepers, the inn would already have closed down. Mothers shop for toys and wrap the gifts—and Santa gets all the credit. The Grinch didn't steal Christmas. Men did, beginning with Clement Moore's Santa Claus! If the sociologists are right, the patriarchy always seizes positions of power and economic importance for itself. If men make the money to buy the presents and the suet for the pudding, then they, by rights, should be the Santa Clauses. Never mind that they couldn't tie a seemly bow or bake a Christmas cookie to save their necks!

In the real world, where life goes on without Moms who look like Meryl Streep and Dads borrowed from popular sitcoms, all of this is hopelessly muddled, partly by changes in the relative economic contributions of husbands and wives to the family income. Men do wrap presents nicely, and women occasionally burn cookies. In single-

parent families, in childless households, in the homes of people without spouses or children, in gay family units, new traditions have evolved to apportion the holiday duties that still seem pertinent to today's Christmas. But the norms embodied in Christmas movies and Christmas specials remain resolutely old-fashioned and retrospective. In the plaintive refrain of "White Christmas," the singer longs for a Christmas "just like the ones I used to know." And, despite changes in American families, and in living-room observances of the holiday, the public face of Christmas still wears a big white beard.

The few historical exceptions that violate the Hollywood Santa Rule manage to do so because the women involved are young, unattached, or otherwise ineligible for the supporting role of mother (Ms. Santa).[71] The Christmas scene in the several screen versions of *Little Women* can be dominated by Elizabeth Taylor (1947) or Winona Ryder (1994), for example, because Louisa May Alcott's novel concerns adolescent girls, the children of a Civil-War-era household from which the father is absent.[72] The big Christmas sequence in *Meet Me in St. Louis* (1944)—a grand dance around the Christmas tree as the orchestra plays "There's No Place Like Home" and Judy Garland sings "Have Yourself a Merry Little Christmas" to her distraught little sister—comes at the climax of a year in the life of the not-quite-grownups in a Midwestern family, circa 1903. Treated with the same indulgence granted to children at Christmastime, these girl-heroines are special cases—and these are not full-fledged Christmas movies.

Although it seems to praise the independent female, *Christmas in Connecticut* reinforces the operative stereotypes with the story of a single woman, a high-powered magazine editor forced to impersonate a married homebody for Christmas. The improbable scenario has Barbara Stanwyck entertaining a wounded soldier in rural Connecticut, in a "real" American home, although she can't boil water.[73] Nor does Stanwyck seem very interested in doing so, except to keep her job at *Smart Housekeeping*. Released in July, 1945, *Christmas in Connecticut* was a hit because it endorsed the vision of home and

An anachronism (white tissue paper) in a scene from RKO's 1933 version of *Little Women*, with Katharine Hepburn. Wisconsin Center for Film and Theater Research.

family cherished by the returning GI by making fun of single girls, smart city apartments, dining out, swank cellophane Christmas trees on cocktail tables—anything that contradicted the picture of the ideal suburban home in its holiday garnish. During and after World War II, Christmas movies were training films in how to succeed in civilian life on the domestic front. *Holiday Inn* and *White Christmas* recommend marriage; *Christmas in Connecticut* conjures up Christmases to come, with Barbara Stanwyck invisible in the kitchen and a veteran-husband ensconced by the fireplace, tapping his pipe thoughtfully on a Christmas ornament.

Come to the Stable (1949), based on a story by Clare Booth Luce but written by Sally Benson (whose 1943 *New Yorker* stories formed the basis for *Meet Me in St. Louis*) took a radically different approach to Christmas: women were the stars, but only by virtue of being

nuns, who stood outside the system of normal American familial relationships. The story begins one snowy night in rural Pennsylvania, as two black-robed sisters arrive at the studio of a lady-artist who specializes in religious subjects. The nuns, it soon develops, have come from France to build a charity hospital on a hill they first saw in one of her paintings. That image on a picture-postcard, they say, "was . . . like the star of Bethlehem," guiding them to the spot. Armed with their heavenly vision, Loretta Young and Celeste Holm set out to build a hospital. They are self-motivated, pushy, direct, and—as nuns and foreigners—indifferent to the niceties of the American social hierarchy. So, unlike the self-effacing, absent, or beside-the-point women so often portrayed in Hollywood Christmas movies, they get the job done. The choir sings a carol. "The End."[74]

Even in the nineteenth century, when custom decreed that females should not be represented in the higher professions, women still exerted an enormous influence on cultural affairs. Louisa May Alcott and her contemporaries wrote about the domestic scene, often as a metaphor for the larger arenas of American life; Prang's female artists depicted hearth and home on Christmas cards. Women were the primary custodians of tradition, firmly in charge of the American heritage in its tangible, material manifestations. Sarah Hale made the case for observing Thanksgiving and showed America how to trim a tree. Women saved the homes of the Founding Fathers for national shrines, beginning with Mount Vernon, the Virginia home of George Washington, and so created the historic preservation movement.[75] The mainstays of local historical societies, women saved grandma's wedding dress alongside deeds and wills and written documents. As members of the Daughters of the American Revolution and other ancestral organizations, they wore grandma's finery to their annual heritage teas. They packed away the family pictures, the report cards, the letters—and the Christmas ornaments. They remembered where the mistletoe was always hung, the family recipe for Christmas pudding, the words to all the carols, and what the little ones wanted Santa to bring them. The question is not whether Christmas has been women's work, but why the modern media have

taken such pains to deny the fact. Is it because we imagine women to have kept to their kitchens in the "good old days"? Or that we find no value in the work that transpires within the home? Or is it because Christmas is simply too important to have been wrested from masculine hands?

It may be that the problems of the modern Christmas—sexual, economic, religious—are too complicated and nebulous to stand up to the straightforward myth-making of *White Christmas*. If the movies, the television specials, and the hit songs that become holiday classics have one lesson to teach, it is this: Christmas is not the time to tinker with tradition, to make radical new beginnings.[76] When the cards start to pile up in the mailbox and there are cookies to be sliced from a tube of extruded dough, fluttery nuns are better than militant feminists and intact families with Donna Reed Moms and Jimmy Stewart Dads are better than any other kind. Recently, an old holiday favorite, *The Bishop's Wife* (1947), was remade with an all-black cast. In the original, Cary Grant was a Christmas angel sent to earth to repair the faltering marriage of an Episcopal clergyman. Grant made a wonderful, pleasure-loving angel who peered intently into store windows to see the Christmas decorations, and trimmed a tree with a mere wave of the hand; the artifacts of Christmas proved irresistible, even to a member of the heavenly host. In the remake (*The Preacher's Wife*, 1996), Denzel Washington plays an inner-city angel with the same relish for Christmas stuff. Indeed, except for the racial makeup of the cast—and Whitney Houston's show-stopping turn with the church choir—almost nothing has changed. The movie may be a piece of sentimental tinsel that falsifies the nature of the black experience in America; but it is a fine specimen of Christmas rhetoric. Old Christmas movies shouldn't ever change.

Christmases always look backward, toward how things used to be or should have been—toward magical childhoods and the "good old days" before race, class, and gender intruded themselves upon the national consciousness. Christmas aspires to be apolitical. But because it is about memory and yesterdays—personal identity at its very point of origin—Christmas speaks to the national identity, too.

George Bailey and family gathered around the Christmas tree in *It's a Wonderful Life* (1946), America's favorite Christmas-movie-on-TV. Wisconsin Center for Film and Theater Research.

If the Fourth of July, with its fireworks and parades and Uncle Sams-on-stilts, is the most patriotic of all the holidays in its red-white-and-blue symbolism, then Christmas is the most American in its red-and-green essence. Christmas speaks to dreams that come true, to comfort, generosity, and the sheltering warmth of home—to the elusive American Dream.

Christmas never quite grows up. Always, at first light on Christmas morning, comes the burst of sugar-frosted joy, the wild flutter of anticipation. Americans love Christmas enough to stretch the celebration from autumn into mid-January. Nobody wants to take down the lights and the tree, and wreaths often linger on front doors well into springtime. Americans are sometimes accused of forgetting history, but when we honor Christmas we honor a kind of personal history compounded of images that may or may not belong to ourselves

alone. American images. Bing and Elvis. Mother—a mother, any mother, a Norman Rockwell mother bearing a turkey on a big white platter.[77] Mrs. Cratchit with her pudding. Stockings, holly, trees, the Grinch, and a Christmas teddy bear with a big red bow and a shiny nose. And speaking of shiny noses, there's Rudolph, too. Ho, ho, ho! Forget Uncle Sam. Santa Claus ought to be our national mascot.

The patriotic slant of *White Christmas* still seems perfect for our Christmases, half a century after the end of World War II; we still warm to the wartime sentimentality of the theme song, with its "sleigh bells in the snow." Except on television, which of us has actually heard a sleigh bell? But who could fail to recognize the jingle as essential, somehow, to Christmas? Christmas makes its connections to the past through *things*—things seen, imagined, half-remembered: colored paper, cards dusted in glitter, cute little houses snuggled under the tree, Zu-zu's rose petals, electric trains, the taste of a gingerbread Santa, the smells of pine and cinnamon, the sound of sleigh bells, or Bing Crosby singing about them.

Christmas is all about stores and shopping: the department-store Santa Claus of *Miracle on 34th Street* (1947); the store-bought Christmas dolls lavished upon an orphaned Shirley Temple in *Bright Eyes* (1934); the carnivalesque Christmas of *The Great Ziegfeld* (1936), in which one of the several family Christmas trees is all but hidden under heaps of dolls and stuffed animals, tops and music boxes, and mysterious packages, wrapped in tissue and holly paper and tied up with bows.[78] But the things we buy in our annual Christmas frenzy represent more than material trappings. Dr. Seuss and the Grinch were careful to restore the gifts at the end of the story because Christmas purchases offer mute witness to values so difficult to articulate that dolls and tinsel must do it for us most of the time. A Christmas present is love in a box—giving something to bring pleasure and comfort to others. Even if the gift has been chosen to proclaim the excellence of the donor, it is, for good or ill, the self tied up in ribbons.

Although it taps many of the same feelings, religion remains the guilty secret of the American Christmas. It is a medieval Madonna on

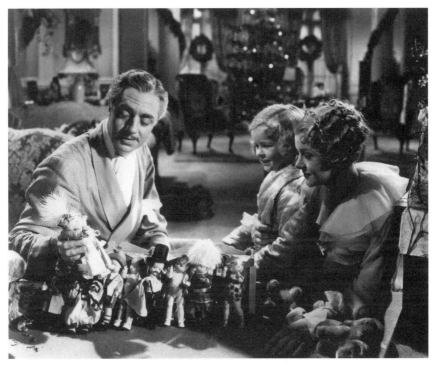

Dolls: the perfect gift for any little girl. William Powell and Myrna Loy in *The Great Ziegfeld* (1936). Wisconsin Center for Film and Theater Research.

a postage stamp, a famous Nativity scene on a card from a museum gift shop. It is *Amahl and the Night Visitors* (1951), the Gian Carlo Menotti opera about the Magi that was the first Hallmark Hall of Fame offering. It is the sonorous language of the Gospel of Luke recited by a cartoon character on Charlie Brown's Christmas special. This is religion in quotation marks, faintly high-cultural, even medicinal, like Tchaikovsky's *Nutcracker* ballet performed badly in a church hall.[79] The elevated language, the art—they're good for you, in some ineffable, inexplicable way. But the ribbons and the packages are prettier.

The manger has never been the mainstay of the American Christmas. Winslow Homer's jubilant Christmas picture for *Harper's Weekly* lays out the important features of the holiday in 1859.

There's a riotous party in progress, a splendid Christmas tree, a black servant girl holding an excited Christmas baby (white). There are vignettes of what the rich do at Christmas on Fifth Avenue and how the poor make do on 59th Street. Although it figures at the center of the grand design, the Holy Family in the stable at Bethlehem seems almost an afterthought. In some dim, tenuous way, the presents and the Christmas tree are connected to that holy picture.[80] But even in 1859, the precise nature of the linkage was very much in doubt. Holly-in-the-hatband benevolence has already displaced the Christian obligation to give alms; good feelings have edged out the sterner theological virtues. Do charitable deeds; then get down to business. Shop and party and deck the halls!

Many of today's Christmas campaigns to provide for the needy ask contributors to buy the cranberry sauce and the Nintendo set instead of sending in a check or dropping spare change in the kettle. And there's a good reason. Buying a toy means giving a present to a child. It means sharing one's own Christmas in a way that is viscerally apparent to the donor. A shadowy somebody—needy, worthy— suddenly has the face of somebody on your Christmas list. The little girl who gets the doll could be your little girl, dancing the part of a mouse in a Christmas Eve production of the *Nutcracker.* The folks who gather the presents under the auspices of "Toys for Tots" and "Santa Anonymous" have grasped a difficult, fundamental truth. Christmas is not an abstraction, a virtue, a cause. Christmas is daughters and sons, drums and dolls.

A MEDITATION ON CHRISTMAS COOKIES

E very November some spoilsport dietitian, some medical expert somewhere, issues the annual warning about the probable weight gain of the average American during the holidays—the season of office-party eggnog, ribbon candy, candy canes, fruitcake, gooey cookies, and all the other sugarplums that dance in our dreams at Christmastime. Eight pounds, they say. Make it ten. An even dozen. They don't call thirteen a baker's dozen for nothing! Comics joke about fruitcake but we eat it all the same, with rum sauce and gobs of premium ice cream. Christmas is the season of self-indulgence, a glorious caloric binge that turns January into a purgatory of Stairmasters and Slim-Fast.

Folklorists argue that our gluttonous ways have been bred into the species by long generations of agricultural practice: killing and eating the choicest parts of animals that could not survive the winter; warming the chill of a dark, bleak December with flaming puddings and hot toddies; coming together around the table for human warmth and companionship. Many of the dishes that newcomers brought with them from the Old World reflect those ancient customs. Swedish lutefisk and lingonberries. German pfeffernüsse and

anisplätzchen. Polish kolacky. Dutch oly-koek—doughnuts in festive dress. Italian fish dinners on Christmas Eve.

The special holiday tastes and smells linger among us long after the languages and the ancestors who spoke them have been forgotten. A special ornament nestled in pungent pine branches, a Lucia wreath ablaze with fragrant candles, the scent of cardamom, a plump Bob Cratchit goose savored once a year, only on Christmas Day—these are the enduring reminders of once-upon-a-time ethnicity for most American families.

Of all the holiday goodies from abroad, the Christmas cookie has proved the easiest to domesticate. Along with candy canes and packages of sweets, cookies were used as tree decorations in the nineteenth century. Today, Martha Stewart provides directions for making flawless pastel-glazed shapes for just that purpose, and will sell you expensive sets of handcrafted, old-fashioned cookie cutters to achieve the desired result. The alternative is the slice-and-bake tubes of extruded dough in your grocer's freezer. But most of us, I suspect, fall somewhere in between. Our cookies, while special in shape and recipe, are for eating or giving or bringing to the annual cookie exchange at the PTA. Even mothers who *never* bake have a Christmas cookie recipe or two tucked away in the back of the kitchen junk drawer, along with the screwdriver, the warranty for the microwave, expired pizza coupons from Domino's, and old rubber bands.

In my family (with a mother who cooked and baked very well indeed), cookie-making was a way of sharing the holiday preparations with the children, and teaching them that Christmas consists of something more than a magical Santa-ex-machina who produces treats without the slightest effort on anybody's part. So, with lots of coaching from the sidelines, my little brothers and I made the cookies on December 8th, the Feast of the Immaculate Conception, which was a parochial school holiday. Right after Mass, we assembled in the kitchen, wearing a ragtag assortment of aprons and smocks. The gas oven was heated to 375°. Pans were laid out, at the ready. The rolling pin was wrapped in the cuff of one of our father's old socks.

The flour canister, white painted tin, decorated with cheerful red and green strawberries, migrated to the kitchen table. Brown paper grocery bags were smoothed and flattened, for cooling hot cookies.

The mighty Mixmaster emerged from its shroud, and one by one, the ingredients listed in the *Betty Crocker Picture Cookbook*—heading: Sugar Cookies—were measured and eased into the bowl. Powdered sugar (which flew everywhere, to our profound delight), butter, vanilla, a slippery egg, flour, baking soda from a yellow cardboard box, and cream of tartar, in its tiny metal can, with a cunning lid that smoothed off the top of a precise teaspoonful. Mix: burr, burr. Stop. Scrape the bowl. Mix again. Chill. Wait, endlessly, during which time we raided the spice drawer, in the depths of the pantry, in search of ancient, crusted bottles of food coloring (left over from the annual dyeing of the Easter eggs), extracts, jimmies, sprinkles, and the beautiful little silver balls known as "dragées." Wax paper, crinkly and faintly mysterious, with a wicked serrated edge on the box: inevitably, someone cut a finger and needed a Band-Aid.

Despite mild parental protest, we ferreted out every cookie cutter in the house: a donkey and a camel, a Santa, a boot (all with wooden handles, all hard to get the dough out of), a star and a moon, a huge tree, an enormous bird (the fabled "Partridge in a Pear Tree"), a whale bought on a trip to New England, a hatchet for Washington's Birthday ("I cannot tell a lie"), and a heart for Valentine's Day. Roll. Cut. Bake. Wait. Cool. Wait some more. Make the butter frosting. Blue is anise-flavored. Yellow is lemon. Red is cinnamon. Green is almond. All in little bowls, with wide, flat knives in each one. Red Santas. Yellow stars. Blue moons and birds. Green trees. On go the balls and the sprinkles: one silver eye for every Santa Claus and camel and donkey, and everything in the decorative repertory for the tree, because our own Christmas tree was always adorned to its absolute capacity—and beyond.

Fights occasionally broke out over the custody of one or another color. Much raw dough was consumed on the sly, while doing the cutting, and many cookies deliberately stuck in the cutters so as to excuse the pilferage. Often, the day after December 8th turned out to

be a school vacation day, too, thanks to a lethal combination of dough, burned cookies, globs of frosting, anise flavoring licked straight from the bottle cap, and the glorious excitement of it all. On Christmas afternoon, when our father made the solemn trip to the basement, opened one of the big stoneware crocks, rustled through the wax paper, and emerged with a plate of cookies, each one prettier than the last, softened to a melting delicacy by their recent hibernation, the bakers and the decorators could hardly bear to eat their handiwork, for the sheer wonderment of it all.

One of my brothers makes the cookies now, if not on December 8th, then close to that date. The custodian of our Christmas rituals, he still favors an intensely flavored, brightly colored cookie—electric, blazing blue, for example, with a dose of anise you can smell in the next room. The trouble with using that much extract is that during the curing process, the blue birds tend to turn a peculiar, unappetizing gray. The Santas and trees take on a mottled appearance. The hatchets develop a kind of poxy bloom on the surface, thanks to an overdose of lemon oil. My brother says that this was a deliberate strategy to keep company—and other grownups—from eating our cookies: the stranger and uglier they were, the better our chances of getting most of them in the end. Hence the gray birds with wings composed of dozens of bullet-hard, filling-chipping dragées lined up in rows to deter the casual snacker. Leave the conventionally pretty cookies to somebody else—grandmas or bakeries. Ours remained a dismal gray by calculated design.

So we eat cut-out Christmas cookies of a repellent color and texture: it's an old and cherished family tradition! Over the years, I remember perfect bourbon balls and spritz and thumb-print cookies with candied cherries in the middle. I remember making elegant little pressed cookies, with colored dough, using an ingenious machine with fancy nozzles on one end. I remember the year I made burgundy wine jelly for presents. I poured it into stemmed glasses from the dime store and sealed the tops with wax and sparkly confetti; the idea came from *Woman's Day* magazine and struck me (at age 13) as the last word in chic and sophistication. I remember a Christmas of

dates variously stuffed with peanut butter and fondant, courtesy of one of the Christmas-crafts-for-children books I loved. But these were mere novelties, culinary fads that came and went. The gray birds have persisted, Christmas after Christmas, for almost fifty years.

The fruitcakes and the suet puddings were made around the time of the annual Marling bake-off, because they needed to brood in their cheesecloth wrappings for a while, wet with ablutions of rum and brandy. Our Christmas menu, as these rich, heavy dessert courses suggest, had a Dickensian flavor, despite the fact that nobody in the household would own up to being British. Perhaps the Englishisms—the beef, the sprouts, the popovers—were the last word in fashion when our mother began cooking for her own family, in the 1940s. My two grandmothers, in any event, supplied large doses of heritage over the holidays in the form of savory German pork roasts and plump hand-plucked turkeys with pies and oyster stew and all the traditional country trimmings. Chicken soup with homemade noodles and pools of golden fat afloat in the broth. Radishes cut into the shape of roses. Celery stalks standing upright in a cut-glass vase, like exotic Christmas palm trees. Nut cups. After-dinner mints, rolled in confectioner's sugar. We ate our way through the holidays like juvenile famine victims, but we never went to bed without a couple of motley gray birds to keep the rest of the groceries company.

Proust knew that cookies made for powerful memories. I cannot smell a lemon, or see a frosted and decorated cookie in a bakery window, without thinking of Christmas, and home, and the people I love. I can't hear the song about the partridge in a pear tree without tasting one of those big gray birds—without being nine or ten again, in a warm kitchen on a snowy day, standing in a magical shower of powdered sugar that dances in the light.

NOTES

1. Wrapping Paper Unwrapped

1. "Christmas '97: Tradition with a Twist," *Gifts and Decorative Accessories* (April 1997), 134.
2. Martha Stewart, *Christmas* (New York: C. N. Potter, 1989), unpaginated; Stewart, *Handmade Christmas* (New York: Clarkson Potter, 1995), 114.
3. Patricia Davis, "Mom, Stop Saving the Wrapping Paper! We Can Buy More," *Wall Street Journal,* December 24, 1997.
4. "Christmas '97," 134, 136.
5. Candy Spelling, discussed in Davis, "Mom, Stop Saving the Wrapping Paper!"
6. Quoted in Mary Evans Seeley, *Season's Greetings From the White House* (New York: Mastermedia, 1996), 159.
7. Illustrated in Jan Cohn, *Covers of the "Saturday Evening Post"* (New York: Viking, 1995), 257.
8. Theodore Caplow's rule is cited by James G. Carrier, "The Rituals of Christmas Giving," in Daniel Miller, ed., *Unwrapping Christmas* (New York: Oxford University Press, 1995), 60.
9. Thomas Nast, "Santa Claus in Camp," *Harper's Weekly* (January 3, 1863), 1. See Chapters 5 and 6 below.
10. "The Christmas Tree," *Godey's Magazine and Lady's Book* (December 1850), 327; the same illustration (originally printed in London in 1848) ran again in *Godey's* in 1860.
11. Marion Harland, "A Christmas Talk With Mothers," *Godey's* (November

1865), 401. She repeats the same message in fictional form in "Nettie's Prayer," *Godey's* (December 1865), 485–493.

12. E.g., "Santa Claus Paying His Usual Christmas Visit To His Young Friends In the United States," *Harper's Weekly* (December 25, 1858), 817.

13. E.g., Thomas Nast, "Christmas 1862," *Harper's Weekly* (January 3, 1863), 8–9.

14. E.g., "Christmas-Day, 1860," *Harper's Weekly* (December 29, 1860), 817.

15. E.g., "Dressing the Christmas Tree," *Godey's* (December 1877), 455.

16. Lizzie M'Intyre, "The Christmas Tree," *Godey's* (December 1860), 506.

17. Ibid., 506.

18. Phillip Snyder, *December 25th: the Joys of Christmas Past* (New York: Dodd, Mead, 1985), 97.

19. Fannie Roper Feudge, "Christmas in the Far East," *St. Nicholas* (January 1876), 166.

20. "Dressing Mary Ann," *St. Nicholas* (December 1879), 167.

21. Marion Conant, "How Joe Brought Down the House," *St. Nicholas* (December 1879), 171.

22. Lucy Larcom, "Visiting Santa Claus," *St. Nicholas* (December 1884), 84.

23. John R. Coryell, "A Scheming Old Santa Claus," *St. Nicholas* (December 1886), 131.

24. "Holiday Times in New York—A Character Sketch of 14th Street," *Frank Leslie's Illustrated Newspaper* (December 26, 1885), 309.

25. W. St. John Harper, "Christmas Contrasts," *Harper's Weekly* (December 27, 1884), 867.

26. "Making Christmas Purchases at a Street Bazaar on the East Side, New York City," *Frank Leslie's Weekly* (December 5, 1891), 286.

27. "New York City—The Centennial Holiday Festivities—A Christmas Package Party," *Frank Leslie's Illustrated Newspaper* (January 13, 1877), 312.

28. Penne L. Restad, *Christmas in America: A History* (New York: Oxford University Press, 1995), 129, raises the issue of the Victorian "decorative impulse."

29. Ella A. Drinkwater, "Debby's Christmas," *St. Nicholas* (January 1878), 223–228.

30. See illustration, "A Young Man Beset at a Ladies' Fair—Don't You Pity Him?" *Frank Leslie's Christmas Book* (New York: Mrs. Frank Leslie, 1888), 176; the picture suggests other social implications of the fairs. See also Russell W. Belk, "Materialism and the Making of the Modern American Christmas," in Miller, *Unwrapping Christmas*, 90.

31. Candace Wheeler, "Chapters on Christmas Gifts," *Harper's Young People,* supplement (November 20, 1888), 10.

32. "One Hundred Christmas Presents and How to Make Them," *St. Nicholas* (December 1875), 103–116.

33. "Novelties for Christmas Presents," *Godey's* (December 1879), 558–560.

34. "Milly Cone's Christmas Presents," *Harper's Young People* (November 4, 1884), 11, and ibid. (December 9, 1884), 92–93; Alice M. Kellogg, "Brightie's Christmas Club," *Harper's Young People* (November 10, 1885), 19–20, and ibid. (November 17, 1885), 35–38; Alice M. Kellogg, "The Christmas Work-Basket," *Harper's Young People* (November 9, 1886), 28; Ella S. Welch, "Home-Made Christmas Gifts," *St. Nicholas* (November 1885), 61–68. See also Fantasia, "Bertie's Christmas Party," *Godey's* (December 1878), 509.

35. Wheeler, "Chapters on Christmas Gifts," 53–56.

36. Some students of the subject believe that the first Christmas gifts as well as the first tree ornaments were edibles: cookies and candy certainly served those functions in many cultures, including the Dutch and the German. See Robert Brenner, *Christmas Past,* 3rd ed. (Atglen, Pa.: Schiffer, 1996), 32.

37. Nada Gray, in *Holidays: Victorian Women Celebrate in Pennsylvania* (University Park: Pennsylvania State University Press, 1983), 14, 23, quotes the *Bucks County Intelligencer* for December 22, 1874, and the *Muncy* (Pennsylvania) *Luminary* for December 12, 1874, on the subject of cornucopias.

38. Quoted in Gray, *Holidays,* 24.

39. Quoted in Brenner, *Christmas Past,* 43. See also "Novelties for Christmas Presents," *Godey's* (December 1879), 558–560.

40. Gray, in *Holidays,* 25, quotes *The Youth's Companion* for December 18, 1879.

41. Brenner, *Christmas Past,* 57.

42. Pressed cotton and papier-mâché were also used to create masks, Santa's boots, and other hollow containers for use as party favors and tree ornaments.

43. Robert Brenner, *Christmas Revisited* (West Chester, Pa.: Schiffer, 1986), 42.

44. Alexander Weaver, *Paper, Wasps and Packages: The Romantic Story of Paper and Its Influence on the Course of History* (Chicago: Container Corporation of America, 1937), 59–62.

45. Massachusetts Minimum Wage Commission, *Wages of Women in the Paper-Box Factories in Massachusetts* (Boston: Wright and Potter, 1915), 5.

46. Joseph J. Schroeder, Jr., ed., *The Wonderful World of Toys, Games and Dolls, 1860–1930* (Northfield, Ill.: Digest Books, 1971), reproduces pages from the *Ladies' Home Journal,* 1888 (tea set), 26; and Montgomery Ward & Co. catalog, 1889 (engine and doll furniture in pasteboard boxes), 30, 34.

47. Schroeder, *The Wonderful World of Toys:* see pyramid of nesting A-B-C

blocks and other maps and games from Marshall Field catalog, 1892, 70–78.

48. Schroeder, *The Wonderful World of Toys:* see Butler Brothers' catalog, 1895, 98.

49. For the toy industry in New York, see "The Manufacture of Toys and Dolls," *Scientific American* (December 6, 1902), 376.

50. The best account of sweated work is found in V. de Vesselitsky, *The Homeworkers and the Outlook: A Descriptive Study of Tailoresses and Boxmakers* (London: G. Bell and Sons, 1916), 3, 10.

51. Senator Wagner, quoted in "Wages for Making Paper Boxes and Candy," *Survey* (February 28, 1914), 665.

52. *Third Report of the Factory Investigating Commission, State of New York* (Albany: J. B. Lyon, 1914), 107.

53. "The Gift of the Magi" appeared in O. Henry's 1906 collection, *The Four Million,* but was first published in 1905 in the *Sunday World.*

54. *Second Report of the Factory Investigating Commission, State of New York* (Albany: J. B. Lyon, 1913), 1220–1222, 1232.

55. Ralph M. Hower, *A History of Macy's of New York, 1858–1919* (Cambridge, Mass.: Harvard University Press, 1943), 165–166.

56. Ibid., 333.

57. Emilie E. Hoffman, "The Christmas Tree," *Good Housekeeping* (December 1896), 253.

58. *1897 Sears, Roebuck Catalogue* (Philadelphia: Chelsea House, 1993), 332. Red tissue paper cost more than three times what white or other colors did.

59. Ruth J. Katz, *Wrap It Up!* (Garden City, N.Y.: Doubleday, 1983), 4.

60. Mary E. Bradley, "Cousin's Jane's Mistake," *St. Nicholas* (December 1897), 113.

61. Carolyn Benedict Burrell, "A Christmas Pony," *St. Nicholas* (December 1900), illus. 103; Charles Perez Murphy, "Instructions to Santa Claus," *St. Nicholas* (December 1900), illus. 141; Carolyn Benedict Burrell, "A Christmas Bag," *St. Nicholas* (December 1899), 223; Marion Ames Taggart, "Beth of Queerin Place," *St. Nicholas* (December 1902), 146; Izola L. Forrester, "A Snowbound Santa Claus," *St. Nicholas* (December 1905), 117; and Temple Bailey, "A Night Before Christmas," *St. Nicholas* (December 1907), 164.

62. Lilian B. Miner, "Santa Claus's Note-Book," *St. Nicholas* (December 1908), 161.

63. Gertrude Crownfield, "The Bayberry Candle," *St. Nicholas* (January 1912), 196; see also illus., Charlotte Sedgwick, "Judy's Idea," *St. Nicholas* (December 1910), 155.

64. Josephine Scribner Gates, "Anna Belle's Christmas Eve," *St. Nicholas* (December 1915), 145.

65. "How We Can Have a Happy Christmas," *Ladies' Home Journal* (December 1908), 28.

66. "Gifts Which Embarrass: A Protest from Men," *Good Housekeeping* (December 1910), 653.

67. Ibid., 655–656. Sinclair Lewis, in *Main Street* (New York: Grosset & Dunlap, 1920), 195, describes Doc Kennicott, the unsatisfactory husband of his madcap heroine, who is baffled by her insistence on "the ribbons and gilt seals and hidden messages" at Christmas.

68. The original article by Miss Salmon, "On Economy," was the subject of a stinging reply from Florence Hull Winterburn, "Money Well Spent," *Good Housekeeping* (March 1911), 374–375.

69. Stephen Nissenbaum, *The Battle for Christmas* (New York: Knopf, 1996), 173.

70. William B. Waits, *The Modern Christmas in America* (New York: New York University Press, 1993), 25, 27.

71. Restad, *Christmas in America,* 129.

72. Gray, *Holidays,* 40 and passim.

73. Lévi-Strauss quoted by Carrier, "The Rituals of Christmas Giving," in Miller, ed., *Unwrapping Christmas,* 60.

74. Mrs. Wilson Woodrow, "The Humors of Christmas," *Good Housekeeping* (December 1911), 750.

75. Conklin's ad, *Saturday Evening Post* (December 5, 1908), 53.

76. Waterman's ad, *Leslie's Illustrated Weekly* (December 8, 1910), unpaginated advertising section.

77. See ads for Parker pens, *Saturday Evening Post* (December 3, 1910), 31; ShurEdge Knives, *Saturday Evening Post* (December 3, 1910), inside front cover; Brighton garters, *Saturday Evening Post* (December 3, 1910), 32; Williams soap, *Saturday Evening Post* (December 10, 1910), 43; Caloric cookstove, *Ladies' Home Journal* (December 1911), 80; Larter shirt studs, *Ladies' Home Journal* (December 1911), 75; Everwear hosiery, *Saturday Evening Post* (December 2, 1911), 73; Notaseme hosiery, *Saturday Evening Post* (December 9, 1911), 61; Holeproof hosiery, *Saturday Evening Post* (December 9, 1911), 2; Shawknit socks, *Saturday Evening Post* (December 9, 1911), 28; Ironclad socks, *Saturday Evening Post* (December 9, 1911), 50; Shirley suspenders, *Ladies' Home Journal* (December 1912), 64; Cawston plumes, *Ladies' Home Journal* (December 1912), 76.

78. Waits, *The Modern Christmas in America,* 27–28.

79. See, for example, ad for collars, gloves, and garters, *Harper's Weekly* (December 28, 1861), 832. Holiday ads in the 1860s were few and ran very

late in the season by modern-day standards. They rarely mentioned Christmas, either. A gift was a "holiday present," suitable for New Year's (old style) or Christmas (new).

80. John Allen Murphy, "How Manufacturers Are Getting Their Goods into Santa Claus' Pack," *Printers' Ink* (November 2, 1922), 18.

81. "Avery Dennison," *International Directory of Company Histories,* vol. 4 (Chicago: St. James Press, 1991), 251.

82. Ad, Dennison's Crepe Paper, *Ladies' Home Journal* (November 1905), inside cover.

83. Luna Frances Lambert, "The Seasonal Trade: Gift Cards and Chromolithography in America, 1874–1910," doctoral dissertation (George Washington University, 1980), 54.

84. Ad, Dennison's Christmas Novelties, *Saturday Evening Post* (December 1, 1906), 31.

85. Ad, Dennison's Holiday Joys, *Ladies' Home Journal* (November 1906), 44.

86. Ad, Dennison's Gift Dressings, *Saturday Evening Post* (December 5, 1908), 42.

87. E.g., Westclox ad, *Saturday Evening Post* (December 14, 1929), 1.

88. Charles Dickens, *The Christmas Books,* vol. 1 (New York: Penguin, 1971), 96. Dickens gave public readings of the *Carol* in the United States in 1867.

89. Henry C. Watrous, "A History of Christmas," *Frank Leslie's Illustrated Newspaper* (December 26, 1857), 60–61.

90. "Doesticks' Description of the Christmas Party at His Friend Medarty's," *Frank Leslie's Illustrated Newspaper* (January 2, 1858), 75, and illustrations, 72–73.

91. "Christmas Greens," *Harper's Weekly* (December 25, 1875). Miss Margaret Coxe, "The Winter Flower," *Godey's* (January 1843), 11, treats the decoration of churches with greens as a custom limited to the Episcopal church and derived from the English practice—and more distantly, from the Hebrew Feast of Tabernacles.

92. "Christmas Greens," *Harper's Weekly* (December 25, 1875), 1050.

93. Thomas Nast, "'Hello! Santa Claus!'" *Harper's Weekly* (December 20, 1884), 842.

94. Thomas Nast, "A Christmas Box," *Harper's Weekly* (December 26, 1885), 856–857. Winslow Homer also depicted the delivery of Christmas boxes to the troops in his *Harper's* dispatches from the Union battlefields.

95. Thomas Nast, "Santa Claus's Route," *Harper's Weekly* (December 19, 1885), 841–842.

96. See Prang cards in the collection of the Hallmark Historical Collection and Archives, Kansas City.

97. See, e.g., W. H. Shelton, "Christmas Shopping," *Harper's Weekly* (Decem-

ber 23, 1882), 817; W. St. John Harper, "Christmas Contrasts," *Harper's Weekly*, supplement (December 27, 1884), 867; and "Holiday Times in New York—A Character Sketch of 14th Street," *Frank Leslie's Illustrated Newspaper* (December 26, 1885), 309.

98. See T. De Thulstrup, "Making Wreaths," *Harper's Weekly* (December 25, 1880), 831, and Snyder, *December 25th*, 117–119.

99. Ino Churchill, "The Holly Wreath," *Godey's* (December 1875), 511–513.

100. Ibid., 512.

101. "Christmas Trees and Greens," *New York Tribune*, December 22, 1882; "Christmas Greens," *New York Tribune*, December 25, 1878.

102. Gray, *Holidays*, 16–22, cites articles on making such ornaments in the *Ladies' Home Journal* (1887), *Demorest's* (1866), and a variety of other contemporary literature.

103. Lee James, "Holiday Decorations," *Godey's* (December 1895), 591, 597–598.

104. John S. Babbitt, "Emily Bissell and the Christmas Seal Story," *Stamps* (December 24, 1994), 1, 4–5.

105. Munson Paddock, "Christmas Eve in a New York Subway Car," *Leslie's Illustrated Weekly* (December 6, 1909), unpaginated Christmas section.

106. Temple Bailey, "A Night Before Christmas," *St. Nicholas* (December 1907), 100.

107. Joyce C. Hall with Curtiss Anderson, *When You Care Enough* (Kansas City: Hallmark, 1992), 55. A memo to the files (December 17, 1972) on which this passage was based mentions Dennison by name and dates the envelope-lining incident to 1918; Hallmark Historical Collection and Archives, Kansas City.

108. Boxes B2F.1 and GW 578, Hallmark Historical Collection and Archives. See also the Hallmark website at http://www.hallmark.com/our company_bin/corporate/hismuch.asp.

109. Marjorie Lawrence, "Wrapping your Christmas Packages," *American Home* (December 1928), 220, 279.

110. Marion K. Sanders, "It's Not the Gift, It's the Wrapping," *Harper's* (December 1959), 86–87.

111. "Not To Be Opened Till Christmas!" *Ladies' Home Journal* (December 1934), 29; cellophane ad, *Saturday Evening Post* (December 5, 1936), 109.

112. "Wrap it with Imagination," *Sunset* (December 1939), 16–17.

113. Harriet Wilson, "Holiday Wrapping Papers," *Design* (December 1933), 22–23.

114. *Sears Christmas Book* (Chicago: Sears, Roebuck, 1937), 2; ibid., 1939, 3; ibid., 1942, 4.

115. "Gift Supplies—Not Out But Scarce," *Modern Packaging* (May 1943), 46.

116. Ibid., 47–49, 114, 116.

117. Whitman's ad, "Tie it up!" *Ladies' Home Journal* (December 1944), 13.

118. "We asked 10,000 families, 'What do you want for Christmas?'" *Saturday Evening Post* (December 6, 1941), 126.

119. Ribonette ad, *Modern Packaging* (May 1943), 29.

120. Marvellum packaging ad, *Modern Packaging* (December 1944), 167.

121. "Gift Wrapping the Texas Way," *Modern Packaging* (December 1944), 102.

122. "The Little Gift Wrap with the Big Style Punch," *Sales Management* (September 1, 1952), 44, 46, 48.

123. "After-The-Sale Advertising: Wrapping Papers," *Print* (July/August 1959), 41–42. Scotch tapes were manufactured in a variety of seasonal patterns in the 1950s, for those who persisted in wrapping gifts at home; see Scotch tape ad, *Better Homes and Gardens* (December 1951), 150.

124. Drucella Lowrie, "The Art of Wrapping Gifts" (New York: Studio Publications, 1950), 5.

125. Dorothy Harkins, "Gay Holiday Wrappings," *Design* (December 1953), 76.

126. "Family 'production line': A gift is more fun in a decorated box," *Sunset* (December 1956), 58–59.

127. Karal Ann Marling, *As Seen on TV: The Visual Culture of Everyday Life in the 1950s* (Cambridge, Mass.: Harvard University Press, 1994), 51–84.

128. See Cohn, *Covers:* Moore (December 23, 1905), 30; Leyendecker (December 7, 1909), 41; Stilwell-Weber (December 5, 1914), 70; Rockwell (December 9, 1916), 76; McMein (December 13, 1919), 85; Jackson (December 9, 1922), 105.

129. Cohn, *Covers:* Jackson (December 27, 1924), 111.

130. John Kirk, *Christmas with Norman Rockwell* (Edison, N.J.: Chartwell Books, 1997), 79, showing cover for December 25, 1937.

131. Tom Rockwell, "Christmas with My Father," *Ladies' Home Journal* (December 1988), 152.

132. Kirk, *Christmas with Norman Rockwell,* 77, showing cover for December 28, 1940.

133. Ibid., 27, showing cover for December 23, 1944.

134. Ibid., 69, showing cover for December 25, 1948, and 76, showing cover for December 27, 1947.

135. Cohn, *Covers:* Alajalov (December 10, 1949), 213; Sargent (December 7, 1957), 251; Hughes (December 10, 1960), 272.

136. *The "Saturday Evening Post" Magazine Covers from 1946 to 1962,* vol. 2 (Tokyo: Treville Co., 1994), unpaginated. Dohanos did his cover in September; the Post noted that it ought to encourage the practice of shopping early.

137. "Why not a package as much fun as what's inside?" *Sunset* (December 1967), 58–9.

138. Russell Belk, "Materialism and the American Christmas," in Miller, ed., *Unwrapping Christmas*, 89, quoting Daniel Boorstin and Claude Lévi-Strauss.

139. E.g., "Bold wrapping paper stamped with fruits and vegetables," *Sunset* (December 1977), 104; "The Wrapping is the Present," *House and Garden* (November 1977), 154–155; "Glamour Guide: Eco-friendly wrapping and packaging," *Glamour* (December 1990), 92.

140. Dr. Dre, "How to wrap like a pro," *Men's Health* (December 1995), 130.

2. The Christmas Business

1. See Nora Archibald Smith, "Christmas, Past and Present," *Godey's* (December 1895), 614–617.

2. Lee James, "Holiday Decorations," *Godey's* (December 1895), 591–598, singles out church decorations in the South for special praise.

3. Francis X. Weiser, *The Christmas Book* (New York: Harcourt, Brace & World, 1952), 44–48; "Christmas, and its Suggestions," *Frank Leslie's Illustrated Newspaper* (Christmas number, 1886), 318.

4. Sarah J. Pritchard, "The First Christmas Tree in New England," *St. Nicholas* (December 1887), 130–134.

5. Lillie E. Barr, "The Puritan Doll," *Harper's Young People* (January 15, 1894), 164.

6. See W. J. Enright cover illustration, *Leslie's Weekly* (December 19, 1901), 578.

7. Ino Churchill, "The Holly Wreath," *Godey's* (December 1875), 511–517.

8. See Frank R. Stockton, "The Sprig of Holly," *St. Nicholas* (January 1880), 255–257, a short story about rural children who refuse to barter a sprig of holly for the riches offered by a magical dwarf.

9. Charles Poole Cleaves, "The Bald Brow Christmas Trees," *St. Nicholas* (December 1907), 108–111.

10. T. De Thulstrup, "Making Wreaths," *Harper's Weekly* (December 25, 1880), 831, 821.

11. "Christmas Greens," *Harper's Weekly* (December 25, 1875), 1050, and W. L. Sheppard, "Selling Christmas Greens—a Scene in Richmond, Virginia," 1037.

12. Margaret Bertha Wright, "Mistletoe-Gathering in Normandy," *St. Nicholas* (December 1878), 117–119.

13. Edmund Collins, "Holly and Mistletoe," *Harper's Young People* (December 22, 1891), 141. Most of the French crop went to English-speaking countries, fueling speculation that the connection between kissing,

mistletoe, and Christmas was an echo of a Druid practice. With a bit of Freudian imagination, it is possible to see the long mistletoe leaf as a masculine symbol; traditionally, for the same reasons, the spiky holly leaf has been seen as the masculine opposite to the clinging and therefore feminine ivy; "Christmas Folklore," *The Quarterly Review* (January 1935), 40–41.

14. Hallmark Historical Collection and Archives, Kansas City, Missouri; C3.0.1.

15. Hallmark Historical Collection, C3.0.

16. Thomas Nast, "'Twas the Night Before Christmas," *Harper's Weekly* (December 25, 1886), cover. See also the closely related "Santa Claus's Route," ca. 1885, in *Thomas Nast's Christmas Drawings* (New York: Dover, 1978), 3 and passim.

17. E.g., "Mr. Bimley's Wonderful Terpsichorean Feats in the Quadrille," *Frank Leslie's Illustrated Newspaper* (January 2, 1858), 73. For folk memory of fastening greens to mantles, chandeliers, and pictures in the nineteenth century, see Nada Gray, *Holidays: Victorian Women Celebrate in Pennsylvania* (University Park, Pa.: Keystone Books, 1983), 21.

18. Thomas Nast, "Christmas 1862," *Harper's Weekly* (January 3, 1863), 8–9, and "Santa in Camp," 1.

19. Phillip Snyder, *December 25th: The Joys of Christmas Past* (New York: Dodd, Mead, 1985), 117.

20. Thomas Nast, "Christmas Greens," in *Thomas Nast's Christmas Drawings,* 60.

21. James, "Holiday Decorations," *Godey's* (December 1895), 591–598, and Miss Margaret Coxe, "The Winter Flower," *Godey's* (January 1843), 11–12.

22. *Ladies' Home Journal* (December 1888), cited in Gray, *Holidays,* 9.

23. For a Sunday school tree, see Laura Ingalls Wilder, "Surprise," in *A Little House Christmas: Holiday Stories from the Little House Books* (New York: HarperCollins, 1994), 57–69.

24. "The Christmas Tree," *Godey's* (December 1855), 528. See also Tristram Potter Coffin, *The Book of Christmas Folklore* (New York: Seabury Press, 1973), 20–21.

25. Penne L. Restad, *Christmas in America: A History* (New York: Oxford University Press, 1995), 63.

26. J. Becker, "The 'Christmas-Tree'—From the Forest to the Home," *Frank Leslie's Illustrated Newspaper* (December 21, 1889), 352.

27. Hemment, "The Christmas Season—The Traffic in Christmas-Trees and Decorations on the Hudson River Front, New York City," *Frank Leslie's Weekly* (December 29, 1892), 452; "Christmas-Trees for Thousands of Homes Piled up near New York Dock," *Leslie's Weekly* (December 25, 1901), 721; Mrs. Alice Barber Stephens, "The Christmas Season—Impro-

vised Market for Christmas-Trees in Front of the New City Hall, Philadelphia," *Frank Leslie's Weekly* (December 29, 1892), 470.

28. "Characteristic Sights of the Holiday Season in New York," *Leslie's Weekly* (December 17, 1908), 608.

29. Elizabeth Howard Westwood, "Rosalie's First Christmas in New York," *Leslie's Weekly* (December 13, 1906), 574.

30. Mora Evans, "Commerce in Conifers," *Saturday Evening Post* (December 13, 1930), 33.

31. Walter Clark Nichols, "A Berkshire Santa Claus," *Harper's Young People* (December 26, 1893), 159; Agnes Carr Sage, "Chips From a Yule-Log: The Growth of the Christmas-Tree," *Harper's Young People* (November 9, 1886), 27.

32. Beverley Buchanan, "The Millions of Christmas Trees and Our Forests," *Leslie's Weekly* (December 17, 1908), 638–639.

33. J. M. Golby and A. W. Purdue, *The Making of the Modern Christmas* (Athens: University of Georgia Press, 1986), 62.

34. George Johnson, *Christmas Ornaments, Lights and Decorations* (Paducah, Ky.: Collector Books, 1987), 15, 17.

35. Irena Chalmers, *All About Christmas* (New York: Seafarer Books, 1994), 154.

36. Robert Lincoln O'Brien, quoted in Robert Brenner, *Christmas Past* (Atglen, Pa.: Schiffer Publishing, 1996), 18–19.

37. "The Material Side of Christmas," *Leslie's Illustrated Weekly Newspaper* (December 19, 1912), 637.

38. See Lizzie M'Intyre, "The Christmas Tree," *Godey's* (December 1860), 505–506.

39. Johnson, *Christmas Ornaments*, 17.

40. Ad, "Electric Lighting Outfit," *Saturday Evening Post* (December 5, 1903), 24.

41. Ad, "Safety First!" *Saturday Evening Post* (November 28, 1914), 21.

42. Carolyn Wells, "A Christmas Celebration," *St. Nicholas* (December 1910), 142.

43. Ad, "Bright New G-E Christmas Tree Lamps Are Back Again," *Saturday Evening Post* (December 8, 1945), 38.

44. Ad, "Four Bright Ways to Say Merry Christmas," *Saturday Evening Post* (December 6, 1947), 13.

45. "Turning on Christmas," *Newsweek* (December 29, 1969), 8; Sadacca's family business gradually evolved into or was absorbed by Noma, the National Outfit Manufacturers Association, founded in 1926 by a merger of fifteen small firms. Noma's best-seller was the bubble light: see ad, "Look! They Bubble," *Saturday Evening Post* (December 13, 1947), 8; "Don't Forget Noma Lights," *Saturday Evening Post* (December 11, 1948), 152.

46. Margaret and Kenn Whitmyer, *Christmas Collectibles*, 2nd ed. (Paducah, Ky.: Collector Books, 1994), 37–42.

47. Goose feather trees are still made today in sizes up to seven feet (and in a variety of colors) and have special appeal to collectors of rare or antique ornaments; see ad, "Goosefeather Christmas Trees," *Country Living* (December 1997), 188; Winterthur Museum Christmas catalog for 1997, 30, offering a 24-inch artificial feather tree (made of nylon) with ornaments, for $24.

48. Johnson, *Christmas Ornaments*, 17–18.

49. Phillip Snyder, *The Christmas Tree Book* (New York: Viking, 1976), 169.

50. "It's a Fact," from http://www.dreamsville.com/CSN/Wardo/1127.html.

51. Karal Ann Marling, *As Seen on TV: The Visual Culture of Everyday Life in the 1950s* (Cambridge, Mass.: Harvard University Press, 1994), 4–5.

52. "For a Brighter, Merry Christmas," *House and Garden* (November 1949), 113; "Nothing Like It!" *Better Homes and Gardens* (November 1950), 298; "Frosted Branch Plastic Tree," *House and Garden* (November 1955), 46; "Revolving Musical Christmas Tree," *House and Garden* (December 1955), 14; "Frosty-Glow Visca Pine Tree with Ornaments," *Ladies' Home Journal* (December 1957), 19.

53. Karal Ann Marling, "Elvis Presley's Graceland, or the Aesthetic of Rock 'n' Roll Heaven," *American Art* (Fall 1993), 84.

54. For the decor of Graceland, see Karal Ann Marling, *Graceland: Going Home with Elvis* (Cambridge, Mass.: Harvard University Press, 1996), 173–183.

55. "The 'Wall Street Journal' Looks at the Christmas Tree Situation," *American Christmas Tree Growers Journal* (November 1961), 18.

56. Ad, "Smart Idea!" *Saturday Evening Post* (December 10, 1949), 113.

57. Untitled article on flocking, *Better Homes and Gardens* (December 1959), 38.

58. John E. Hibbard, "The Christmas Tree Ban in Connecticut and It's [*sic*] Resolution," *American Christmas Tree Journal* (November 1974), 7.

59. John K. Trocke, "What Consumers Think About Christmas Trees," *American Christmas Tree Journal* (May 1975), 39–40.

60. All the modern manufacturers maintain elaborate Web sites. See also John L. Ahrens, "Christmas Trees—Real—Artificial—or Fake," *Christmas Trees* (October 1995), 18; Craig R. McKinley, "Top Ten Myths in Selling Christmas Trees," *American Christmas Tree Growers Journal* (October 1997), 4–5; John K. Trocke, "Survey Shows Young Consumers Prefer Real Christmas Trees," *American Christmas Tree Journal* (November 1975), 10–11; David Baumann, "The Gallup Poll Revisited," *American Christmas Tree Journal* (July 1996), 5–6.

61. Sally Apgar, "Ceramics dynamics," *Minneapolis Star Tribune*, December 22, 1995.

62. Annual Report, Department 56 Inc. (1996), 2, 12.

63. *1998 Village Brochure* (Eden Prairie, Minn.: Department 56, 1998), 1; James P. Wickesberg, *The Original Snow Village Collector's Album, 1976–1990* (Minneapolis: Department 56, 1990), 3.

64. Peter and Jeanne George, *Collecting Department 56: The Fun—The Facts—The Tradition* (n.p.: The Collectible Source, 1997), 12–13.

65. *Greenbook Guide to Department 56 Villages,* 6th ed. (East Setauket, N.Y.: Greenbook, 1996), 16–17.

66. Russell W. Belk, Melanie Wallendorf, John F. Sherry, Jr., and Morris B. Holbrook, "Collecting in a Consumer Culture," in Russell W. Belk, ed., *Highways and Byways: Naturalistic Research from the Consumer Behavior Odyssey* (n.p.: Association for Consumer Research, 1991), 186.

67. Judann Pol, "Department 56," *Advertising Age* (June 26–July 3, 1995), 37.

68. This is the term used in *Department 56 Quarterly* (Fall 1998), 11.

69. Michael Anthony, "A Small-Town Christmas," *Saturday Evening Post* (November–December 1995), 32.

70. Dorothy Hamill and Joy Philbin have occasionally served as corporate spokespersons for Department 56 villages; both have appeared on QVC, a cable shopping channel, promoting the product. See "D56 on QVC," *The Village Chronicle* (November–December 1997), 41.

71. Karal Ann Marling, "Imagineering the Disney Theme Parks," in Marling, ed., *Designing Disney's Theme Parks: The Architecture of Reassurance* (Paris: Flammarion, 1997), 79–90. It is ironic that the only failed village in the history of Department 56 was one based on the Disney theme parks; six buildings in the series were introduced and abruptly discontinued between 1994 and 1996.

72. Jeanne Whalen, "Tiny villages, big-time lure," *Advertising Age* (November 28, 1994), 41.

73. See cover of 1997 newspaper advertising supplement for Mervyn's, a subsidiary (like Target) of Dayton Hudson (now Target Co.).

74. *Christmas to Remember, 1995 Third Issue Introductions* (n.p.: Enesco Corporation, 1995), 6–8.

75. *The Coca-Cola Collector's Catalog, Holiday 1997* (Chattanooga, Tenn.: Coca-Cola, 1997), 6–7.

76. *1998 Village Brochure,* 11.

77. Ken Schwartz, "A Christmas Carol Reading by Charles Dickens," *The Village Chronicle* (July–August 1997), 8–9. See also untitled note on the Dickens visit, *Harper's Weekly* (December 28, 1867), 829. The complete set of Department 56 figures showing Dickens reading, an audience reacting, and a small boy with a sandwich-board sign advertising the event was $75 (in a "limited edition" of 42,500); *Heritage Village Collection, 1997* (Eden Prairie, Minn.: Department 56, 1997), 2–5.

78. Patsy Fryberger, "Since When Must Charity Involve Greed?" *The Village Chronicle* (July–August 1997), 30.

79. William E. Studwell, "A Commentary on the English Christmas Carol; A Partial History of American Christmas Carols," *The American Organist* (December 1990), 63; the song was written by Haven Gillespie and John Frederick Coots. See also Valerie Wolzien, *Deck the Halls With Murder* (New York: Fawcett Gold Medal, 1998), 1; this murder mystery opens with a team of contractors building a miniature Christmas village that represents historical structures in their community. Wolzien quotes the song.

80. Alfred L. Shoemaker, *Christmas in Pennsylvania: A Folk-Cultural Study* (Kutztown, Pa.: Pennsylvania Folklife Society, 1959), 110–111.

81. George E. Nitzsche, "The Christmas Putz of the Pennsylvania Germans," in *The Pennsylvania German Folklore Society*, vol. 6 (Allentown, Pa.: Pennsylvania German Folklore Society, 1941), 20–23.

82. Mrs. W. J. Hays, "A Christmas Chat," *Harper's Young People* (December 1, 1885), 79.

83. Raymond Walters, "The Moravian Christmas Festival at Bethlehem, Penn.," *Leslie's Weekly* (December 13, 1906), 582–583.

84. Clifford Howard, "How Uncle Sam Observes Christmas," *St. Nicholas* (December 1902), 153.

85. Gray, *Holidays*, 5.

86. Brenner, *Christmas Past*, 26.

87. Mrs. S. B. C. Samuels, "Christmas City," *St. Nicholas* (May 1874), 405–407.

88. Quoted in Gray, *Holidays*, 50.

89. Ken Schwartz, "In the Beginning," *The Village Chronicle* (November–December 1997), 6.

90. Ibid., 6–7.

91. Whitmyer, *Chirstmas Collectibles*, 193–201.

92. Brenner, *Christmas Past*, 26.

93. Ron Hollander, *All Aboard!* (New York: Workman, 1981), 41.

94. Mrs. Arthur W. Dunn, "Ingenious and Beautiful Christmas Attraction," *Leslie's Weekly* (December 19, 1907), 598; on the edge of the amusement zone, on the rim of a splashing fountain, sat "two little 'pickaninnies,'" under an umbrella, dangling their feet in the water.

95. Mary Abbe, "How the Grinch Stole Dayton's," *Minneapolis Star Tribune*, November 6, 1998. This was the theme of all the flagship stores in the Dayton Hudson department store group for 1998, including Dayton's (Minneapolis) and Marshall Field (Chicago).

96. See, e.g., Martha Stewart, *Decorating for the Holidays* (New York: Clarkson Potter, 1998).

97. Christina Patoski, *Merry Christmas America: A Front Yard View of the Holidays* (Charlottesville, Va.: Thomasson-Grant, 1994), 7–8.

98. Colleen Sheehy, "Illuminating American Spaces," in *Deck the Halls,* brochure accompanying an exhibition of holiday photos by Roger Mertin and Christina Patoski, November 19, 1995–March 3, 1996 (Frederick R. Weisman Art Museum, University of Minnesota), unpaginated.

99. For St. Francis and the Italian crib, for example, see Nesta De Robeck, *The Christmas Crib* (Milwaukee: Bruce Publishing, 1956), 45–94. For the English tradition of collectible "cottages" without a Christmas theme, see Deborah Scott, *The Cottages of Lilliput Land* (Huntington, N.Y.: Portfolio Press, 1991).

100. Maria Cassano, "She'll Never Forget Pop's 'Prescipio,'" in *The Christmases We Used to Know* (Greendale, Wis.: Reminisce Books, 1996), 53.

101. For "boomers" and their collections, see Carole Kismaric and Marvin Heiferman, *The Mysterious Case of Nancy Drew and the Hardy Boys* (New York: Simon & Schuster, 1998), 129.

102. A. D. Olmsted, "Collecting: Leisure, Investment or Obsession?" in Floyd W. Rudmin, ed., *To Have Possessions: A Handbook on Ownership and Property,* special issue of *Journal of Social Behavior and Personality,* vol. 6 (1991), 288, 297, 301.

103. The term "baby house" was used to describe miniature or "doll's houses" in the sixteenth, seventeenth, and eighteenth centuries; see Nora Earnshaw, *Collecting Doll's Houses and Miniatures* (Tampa, Fla.: Pincushion Press, 1993), 10, 20–22; Lillian Baker, *Creative and Collectible Miniatures* (Paducauh, Ky.: Collector Books, 1984), 9.

104. Robert Brenner, *Christmas Revisited* (West Chester, Pa.: Schiffer Publishing, 1986), 89.

105. For a pre-1925 salesman's catalog of these items, including a selection of "glistening Christmas houses," see *Holiday Decorations: Toys and Favors* (Gas City, Ind.: L-W Book Sales, 1994).

106. Candy boxes in the shape of churches, suitable for favors to be dispensed at Sunday schools, are pictured in the March Brothers' catalog for 1911 and the Butler Brothers' catalog for 1923; see Robert Brenner, *Christmas Past,* 3rd ed. (Atglen, Pa.: Schiffer Publishing, 1996), 34.

107. George Johnson, *Christmas Ornaments, Lights, and Decorations,* vol. III (Paducah, Ky.: Collector Books, 1997), 18–19, 110–111.

108. George Johnson, *Christmas Ornaments* (1987), 100–101.

109. Ibid., 15.

110. Ibid., 32–33.

111. "How Christmas-Tree Decorations Are Made," *Leslie's Illustrated Weekly Newspaper* (December 18, 1913), 887.

112. This was another nineteenth-century industry, like the candy business, that depended on the invention of cheap cardboard boxes. For the delivery of ornaments to the station, see Christopher Radko, *Christopher Radko: The First Decade, 1986–1995* (Dobbs Ferry, N.Y.: Starad, 1995), 19.

113. John K. Winkler, *Five and Ten: The Fabulous Life of F. W. Woolworth* (New York: Robert M. McBride, 1940), 56–57.

114. Ibid., 89.

115. Brenner, *Christmas Revisited,* 150, reprints a page from the 1905 Butler Brothers catalog showing glass figures of the Palmer Cox brownies along with policemen, comical old gents, and so forth. Sold at 42 cents per dozen, these larger ornaments were packed in lots of six for retail display "in spaced box."

116. Johnson, *Christmas Ornaments* (1987), 34.

117. "They Trim a Million Christmas Trees," *Saturday Evening Post* (December 20, 1947), 42

118. Janet L. Willen, "A Glow From Christmas Past," *Nation's Business* (December 1994), 15.

119. "Tree Chic," *People* (December 15, 1997), 117.

120. Radko, *Christopher Radko: The First Decade,* 7.

121. "About Christopher Radko," www.radko.com.

122. Radko, *Christopher Radko,* 22–38.

123. See *1998 Private Invitation,* brochure describing the benefits of joining the "Starlight Family of Collectors, Ltd." A $50 annual membership fee brings with it a club pin, a free Radko ornament (small), and the right to buy a special members-only ornament (large).

124. My observations on Polonaise ornaments are based on shopping trips and field work in Poland in the spring of 1998.

125. See Margaret Schiffer, *Christmas Ornaments: A Festive Study* (Atglen, Pa.: Schiffer Publishing, 1995), 125. Hallmark ornaments, introduced in 1973, may have inspired some of the marketing devices adopted by Radko and Polonaise, including retirement of pieces and topical subjects. Hallmark subjects include Barbie, Disney characters, Marilyn Monroe, Lionel trains, and Star Trek. Hallmark also makes dated ornaments, which trace the serial memories of a child's growing-up years. See Rosie Wells, *The Ornament Collector's Official Price Guide for Past Years' Hallmark Ornaments* (Canton, Ill.: Rosie Wells, 1997), 41.

3. Window Shopping

1. Shirley O'Hara, "Miracle in Herald Square," *New Republic* (June 2, 1947), 36.

2. Valentine Davies, *Miracle on 34th Street* (New York: Harcourt, Brace, 1947), 4.

3. Leigh Eric Schmidt, *Consumer Rites: The Buying and Selling of American Holidays* (Princeton, N.J.: Princeton University Press, 1995), 127, 171, notes that the window scene at the beginning of the film frames "a con-

demnation and a celebration of the commercial, consumer-oriented Christmas."

4. On framing, windows, and the movies, see Anne Friedberg, *Window Shopping: Cinema and the Postmodern* (Berkeley: University of California Press, 1993), 65–66.

5. Sara K. Scheider, *Vital Mummies: Performance Design for the Show-Window Mannequin* (New Haven: Yale University Press, 1995), 167, argues (wrongly, I think) against American windows—except Christmas ones—creating a social transaction between the scene and the observer.

6. Annie Fraust, "Christmas for Rich and Poor," *Godey's Lady's Book and Magazine* (December 1858), 515, and illustration, 510–511.

7. L. G. M., "Pete," *St. Nicholas* (January 1874), 118.

8. Josephine Scribner Gates, "Anna Belle's Christmas Eve," *St. Nicholas* (December 1915), 142.

9. Sophie Swett, "The Crust of the Christmas Pie," *Harper's Young People* (January 8, 1884), 149.

10. N. I. N., "What a Christmas-Box Brought," *Harper's Young People* (December 9, 1884), 82.

11. Emma K. Parrish, "Jack's Christmas," *St. Nicholas* (December 1877), 125.

12. Washington Gladden, "Santa Claus on a Lark," *St. Nicholas* (December 1885), 97.

13. John R. Coryell, "A Scheming Old Santa," *St. Nicholas* (December 1886), 126.

14. Eliot McCormick, "Jimmie the Duke," *Harper's Young People* (November 18, 1884), 34.

15. William Leach, *Land of Desire: Merchants, Power, and the Rise of a New American Culture* (New York: Pantheon, 1993), 62.

16. "Holiday Times in New York—A Character Sketch on Fourteenth Street," *Frank Leslie's Illustrated Newspaper* (December 26, 1885), 309.

17. John P. Fritts, "New York's Street Fakirs: A Picturesque Calling," *Leslie's Weekly* (December 21, 1905), 600. See also photographs of fakirs on Sixth Avenue and 23rd Street, 601.

18. Elizabeth Howard Westwood, "Rosalie's First Christmas in New York," *Leslie's Weekly* (December 13, 1906), 574, with photographic illustrations, and "Height of the Christmas Season in New York," *Leslie's Weekly* (December 24, 1903), 621–622.

19. Schmidt, *Consumer Rites*, 126–129.

20. Penne L. Restad, *Christmas in America: A History* (New York: Oxford University Press, 1995), 128.

21. Phillip Snyder, *December 25th: The Joys of Christmas Past* (New York: Dodd, Mead, 1985), 67.

22. Schmidt, *Consumer Rites*, 160.

23. Snyder, *December 25th*, 88–89.

24. "The Shop Windows," with illustrations by Jessie McDermott, *Harper's Young People* (December 27, 1881), 140–141.

25. Aunt Marjorie Precept, "The Toy-Shop Windows," *Harper's Young People* (January 2, 1883), 131–132.

26. Jessie Shephard illustration, "The Christmas Window," *Harper's Young People* (December 21, 1886), 121.

27. Daniel Pool, *Christmas in New York* (New York: Seven Stories Press, 1997), 12.

28. "A Holiday Spectacle at 'Macy's,'" *Frank Leslie's Illustrated Newspaper* (December 20, 1884), 283–284.

29. Schmidt, *Consumer Rites*, 161.

30. Lizzie W. Champney, "Santa Claus's Workshop," *Harper's Young People* (December 21, 1886), 122.

31. Snyder, *December 25th*, 88–89.

32. *The Art of Decorating Show Windows and Interiors*, 4th ed. (Chicago: The Merchants Record Co., 1906–1909), 266.

33. Karal Ann Marling, "'She Brought Forth Butter in a Lordly Dish': The Origins of Minnesota Butter Sculpture," *Minnesota History* 50 (Summer 1987), 219–228. See also J. S. Ingram, *The Centennial Exhibition Described and Illustrated* (Philadelphia: Hubbard Bros., 1876), unpaginated illustrations. For a doll display at the Philadelphia Centennial that clearly derives from retail practice (there is a Christmas tree in the case), see Theodore R. Davis, "The Children's Corner at the Centennial—Exhibition of Dolls and Toys," in Clarence P. Hornung, ed., *An Old-Fashioned Christmas*, 2nd ed. (New York: Dover, 1975), 89.

34. Quoted in Stuart Culver, "What Manikins Want: *The Wonderful Wizard of Oz* and *The Art of Decorating Dry Goods Windows*," *Representations* 1 (Winter 1988), 97, 106–107.

35. Anne O'Hagan, "Behind the Scenes in the Big Stores," *Munsey's Magazine* (January 1900), 537.

36. *The Christmases We Used to Know* (Greendale, Wis.: Reminisce Books, 1996), 21–25.

37. Charlotte Sedgwick, "Judy's Idea," *St. Nicholas* (December 1910), 153.

38. Information on Dayton's display history comes from the Dayton Hudson Archive and Research Center in Minneapolis, Minnesota, unless otherwise noted.

39. Unattributed clipping (ca. December 1966), Dayton Hudson Archive, 03.00.30.003.

40. Bruce B. Dayton and Ellen B. Green, *George Draper Dayton: A Man of Parts* (Minneapolis: privately printed, 1997), 246.

41. Untitled clipping, *Minneapolis Star,* February 3, 1951, Dayton Hudson Archive, 03.00.40.020.

42. Gloria C. Hogan, "'Many Things still to be done in Display,' says Dean," *Women's Wear Daily,* November 28, 1950, Dayton Hudson Archive, 03.00.40.020.

43. "Christmas All Over the World," *The Daytonews* (December 1928), 4.

44. George Grim, "I Like It Here," undated and unidentified clipping (ca. 1950), Dayton Hudson Archive, 10.37.18.011.

45. "Policy on Christmas Window Display," broadside reprinted from *The Dayton News* (December 1952), Dayton Hudson Archive, 03.37.18.011.

46. "Breaks Precedent," unidentified clipping (ca. December 8, 1952), Dayton Hudson Archive, 10, 37, 18.011.

47. Undated memo (1962) on windows in the St. Paul and Minneapolis stores, Dayton Hudson Archive, 02.00.40.028. See also "He Gives Chicago its Christmas Look," *Saturday Evening Post* (December 20, 1952), 26–27, 38.

48. On Babar, see memo from Joe Wright re obtaining permission from Random House to use the character for windows (September 11, 1959), Dayton Hudson Archive, 03.00.40.002; and for reuse of that Babar window display, see "It's Christmas Everywhere at Dayton's," *Dayton News* (November 1960), 4.

49. On holiday sales figures, see "Holiday Bell Ringers," *Greater Minneapolis* (December 1967), Dayton Hudson Archive, 03.00.40.004.

50. For the 1965 decoration budget, see JRW, undated memo: "Christmas 65 Actual vs. Budget," Dayton Hudson Archive, 03.00.40.003.

51. Untitled clipping, *Business Week,* December 3, 1966, Dayton Hudson Archive, 03.00.30.003.

52. Untitled clipping, *Women's Wear Daily,* December 6, 1966, Dayton Hudson Archive, 03.00.30.003.

53. Untitled clipping, *Rochester* [Minn.] *Bulletin,* November 7, 1966, Dayton Hudson Archive, 03.00.30.003.

54. Untitled clipping, *Minneapolis Star,* December 26, 1966, Dayton Hudson Archive, 03.00.30.003.

55. Untitled clipping, *Christian Science Monitor,* December 26, 1966, Dayton Hudson Archive, 03.00.30.003.

56. Untitled clipping, *Women's Wear Daily,* December 6, 1966, Dayton Hudson Archive.

57. See internal memo, "Schedule of Animated Figures for Dickens' Village, 1966" (September 3, 1966), Dayton Hudson Archive, 03.00.30.003.

58. Untitled clipping, [London] *Daily Telegraph,* December 1, 1966, Dayton Hudson Archive, 03.00.40.004.

59. "On the Cover," *Dayton News* (November 1961), 15; "Coveralls Contrast

with Fairy Tale Atmosphere," *Dayton News* (November 1956), 6; Elaine Berman, "Huguenot Display Artist Stages Dickens of a Holiday Show," *New York Times*, October 9, 1966. See also George Grim, interview with Mrs. Rowland, *Minneapolis Tribune*, November 25, 1966.

60. "Schedule of Animated Figures for Dickens' Village 1966" (September 3, 1966), Dayton Hudson Archive, 03.00.30.003.

61. Untitled clipping, *Minneapolis Star,* November 11, 1966, Dayton Hudson Archive, 03.00.30.003.

62. Karal Ann Marling, "Imagineering the Disney Theme Parks," in Marling, ed., *Designing Disney's Theme Parks: The Architecture of Reassurance* (Paris: Flammarion, 1997), 79–84.

63. "Dickens' London Towne," *The Datonian* (December 1966), unpaginated 4-page picture article, Dayton Hudson Archive, bound volume.

64. *Dayton's Dickens' London Towne* (ca. 1966), 4-page brochure, Dayton Hudson Archive, 03.00.30.003.

65. "Our Animated Windows—A Delight to Behold," *Dayton News* (December 1963), 7–8, Dayton Hudson Archive, 03.00.50.007.

66. *Dickens' London Towne '67* (1967), 4-page brochure, Dayton Hudson Archive, 03.00.40.004.

67. Memo, Thomas Holm to Joseph Wright, on Dickens' Village evaluation (November 15, 1969), Dayton Hudson Archive, 03.00.40.004.

68. Untitled clipping, *Visual Merchandising* (September 1974), Dayton Hudson Archive, 12.00.30.007. Other notable walk-throughs of the period included "Santa's Toy Workshop" (1970), "Santa's Television Studio" (1971), "Joy to the World," a joint project with UNICEF (1972), and the "Nutcracker Story" (1975).

69. Untitled clipping, *Visual Merchandising* (July 1975), 22–23, Dayton Hudson Archive, 12.00.30.007.

70. Richard Martin, *Fashion and Surrealism* (New York: Rizzoli, 1987), 212–213. See also Pool, *Christmas in New York*, 55–56.

71. See *A Lionel Christmas* (New Buffalo, Mich.: TM Video, 1995).

72. *A Christmas Story* (1984), a nostalgia film set in the Midwest in the 1940s and based on a Jean Shepherd novel, uses the windows of Higbee's in Cleveland's Public Square to establish the theme. The window is full of brand-name toys (including the air rifle coveted by the hero) and electric trains.

73. The window photography in the establishing shots of *The Bishop's Wife* (1947) was the work of cinematographer Gregg Toland. See also "Movie of the Week: *The Bishop's Wife*," *Life* (January 12, 1948), 71–72.

74. Ron Hollander, *All Aboard! The Story of Joshua Lionel Cowen and His Lionel Train Company* (New York: Workman, 1981), 39–40.

75. Ibid., 72, 100, 118, 140.

76. See *Toy Trains and Christmas* (New Buffalo, Mich.: TM Video, 1997), with footage of a contemporary Christmas layout at the Hancock Building in Chicago.

77. "Movie of the Week: *Miracle on 34th Street*," *Life* (June 16, 1947), 66.

78. David Sedaris, "SantaLand Diaries," in *Barrel Fever* (New York: Little, Brown, 1994), 173. See also Sedaris, *Holidays on Ice* (New York: Little, Brown, 1997), 3–44.

79. *The Art of Decorating Show Windows and Interiors* (Chicago: Merchants Record Company, 1906–1909), 177–178, 266, 283.

80. See, e.g., *Christmas at the Dayton Company* (1933), back cover, Dayton Hudson Archive, 03.00.40.020.

81. Untitled article, *St. Paul Sun* (December 16, 1968), Dayton Hudson Archive, 03.50.01.017.

82. Untitled, undated memo (ca. 1962) re the Christmas trim in the St. Paul store, Dayton Hudson Archive, 03.00.40.021.

83. "The Xmas $pirit," *Independent* (January 7, 1928), 4.

84. Avis D. Carlson, in "Our Barbaric Christmas," *North American Review* (January 1931), 69, complains about a Christmas window display that made a single, spotlit refrigerator much too attractive. Buyers so seduced, the journalist argued, could easily confuse the monthly installment price (listed on the price tag in the window) with the total cost.

85. "Edison Phonographs," *Saturday Evening Post* (December 9, 1911), back cover.

86. "Give Candy at Christmas," *Saturday Evening Post* (December 20, 1930), 95.

87. For Louis Prang cards, see Hallmark Historical Collection and Hallmark Archives, Hallmark Cards, Kansas City, Missouri, C3.0.1, ca. 1880–1890, with verses by Whittier, Longfellow, and others. A window-like configuration of a blazing fire surrounded by the chimney-piece and stockings is another favorite theme.

88. See W. S. L. Jewett, "Not for Us," *Harper's Weekly* (January 4, 1868), 8; M. Woolf, "Faith—Waiting for Santa Claus," *Harper's Weekly* (December 26, 1874), cover.

89. Lucy Larcom, "Poems and Carols of Winter," *St. Nicholas* (December 1876), 72.

90. See Ellen Stern, *The Very Best From Hallmark* (New York: Harry N. Abrams, 1988), 146. The reverse treatment of the window—the cosy room seen from a distance, lost in darkness and snow—is also popular. The 1981 Presidential Christmas card designed for Nancy Reagan by Jamie Wyeth and produced by Hallmark shows the White House by night with only one upstairs light burning. Mrs. Reagan said she liked to think it was the window of her dressing room and that she was up late, wrapping gifts

for her family; Mary Evans Seeley, *Season's Greetings from the White House* (New York: Mastermedia, 1996), 159.

91. Donald R. Stoltz and Marshall L. Stoltz, *Norman Rockwell and the 'Saturday Evening Post,'* vol. 2 (New York: MJF Books, 1994), 191–192.

92. These are, of course, complementary colors: the blue and the orange, when juxtaposed, have the effect of enhancing each other's intensity.

93. The film was based on a story by Clare Boothe Luce, a recent convert to Catholicism. See reviews, *Newsweek* (August 8, 1949), 68–69; *Time* (August 1, 1949), 64; *New Yorker* (August 6, 1949), 38–39.

94. Thomas Nast, "The Dear Little Boy That Thought That Christmas Came Oftener," *Harper's* (January 1, 1881), in Hornung, ed., *An Old-Fashioned Christmas,* 55.

95. Barry Van Lenten, "Windows 96," *Daily News Record,* November 25, 1996.

96. Pool, *Christmas in New York,* 31.

97. James Poling, "Windows to Your Wallet," *Nation's Business* (December 1950), 53.

98. Leach, *Land of Desire,* 332; Robert Hendrickson, *The Grand Emporiums: The Illustrated History of America's Great Department Stores* (New York: Stein and Day, 1979), 300.

99. "Introducing Tony Sarg," unidentified clipping, Anthony Frederick Sarg Papers, Archives of American Art, Detroit.

100. F. J. McIsaac, *The Tony Sarg Marionette Book* (New York: Viking, 1937), 3–6; for Sarg as an illustrator, see Tony Sarg, *Tony Sarg's New York* (New York: Greenberg, 1937), a collection of whimsical views of New York neighborhoods and landmarks.

101. The first edition of the popular *Marionette Book* was published in November 1921.

102. Broadside ad for "An Evening with Tony Sarg," ca. 1924, Sarg Papers, Archives of American Art.

103. Leach, *Land of Desire,* 335.

104. Untitled clipping, *Red Star,* November 24, 1923, Tony Sarg Papers, Archives of American Art.

105. The fact that Sarg preserved the 1923 publicity releases among his personal papers reinforces the notion that he worked on Macy's windows that year.

106. Ads, *New York Times,* November 27, 1924; *New York Times,* November 28, 1924.

107. "Greet Santa Claus as 'King of Kiddies,'" *New York Times,* November 28, 1924.

108. F. F. Purdy, "Notes from New York," *Merchants Record and Show Window* (December 1924), 24–25.

109. McIsaac, *The Tony Sarg Marionette Book*, 10.

110. "Macy to Continue Yearly Toy Parade," *Retail Ledger* (December 2, 1924), 1.

111. Ads, *New York Times*, November 26, 1925; November 27, 1925.

112. "Santa Claus Appears In Christmas Parade," *New York Times*, November 27, 1925. See also photo of caterpillar in *New York Herald Tribune*, November 27, 1925.

113. "Object To Parade On Thanksgiving Day," *New York Times*, November 11, 1926.

114. Ad, *New York Times*, November 25, 1926. See also "Alters Macy Parade Plan," *New York Times*, November 23, 1936; F. F. Purdy, "Macy's Christmas Parade," *Merchants Record and Show Window* (December 1926), 22–23.

115. "Christmas Parade Staged in Broadway," *New York Times*, November 25, 1927.

116. See, e.g., "Four Macy Balloons Land," *New York Times*, December 1, 1928; "Reward Balloon Retrievers Today," *New York Times*, December 10, 1928.

117. Untitled ad, Sarg Papers, Archives of American Art.

118. Ad, *New York Herald Tribune*, November 24, 1927.

119. Signed contract between Sarg and R. H. Macy & Co., September 18, 1928, Sarg Papers, Archives of American Art. Sarg's fee was $18,500 a year, and he assigned Macy's the exclusive right to use his name in advertising connected with the parade gala.

120. "Movie Miracle on 76th Street: No Complaints," *New York Times*, April 17, 1994.

121. "Carnival Scenes Out Up At Macy's," *New York Times*, November 21, 1959.

122. "TV Parades Stir Legal Disputes," *New York Times*, November 25, 1959.

4. Olde Christmas

1. Michael Hancher, Department of English, University of Minnesota, first called my attention to the physical properties of the book. I am grateful to him for sharing his ideas with me. For a reasonable facsimile of the original edition, see Cedric Dickens, *Christmas with Dickens* (Arlington, Va.: Belvedere Press, 1993). For a discussion of the design of the first edition and a record of sales, see Dan Malan, *Charles Dickens' "A Christmas Carol"* (St. Louis: MCE Publishing, 1996), 23.

2. Paul Davis, *The Life and Times of Ebenezer Scrooge* (New Haven: Yale University Press, 1990), 9.

3. In *Mickey's Christmas Carol* (1983), Disney characters play the familiar Dickens roles: Scrooge McDuck is Scrooge; Donald Duck is his nephew,

Fred; Mickey and Minnie are the Cratchits; and Goofy is Marley's Ghost. For more Dickensian movies, see Frank Thompson, *Great Christmas Movies* (Dallas, Tex.: Taylor Publishing, 1998), chap. 2.

4. J. M. Golby and A. W. Purdue, *The Making of the Modern Christmas* (Athens: University of Georgia Press, 1986), 61.

5. Russell Belk, "Materialism and the Making of the Modern American Christmas," in Daniel Miller, ed., *Unwrapping Christmas* (Oxford: Clarendon Press, 1995), 85. For the castle tree, see Chapter 5.

6. James Barnett, *The American Christmas: A Study of National Culture* (New York: Macmillan, 1954), 15–16.

7. Rebecca Harding Davis, "Some Old-Time Christmases," *Saturday Evening Post* (December 3, 1904), 7.

8. "The Dickens Christmas," *New York Tribune*, December 26, 1900.

9. "Mr. Warner on Washington Irving," *The Critic* (April 8, 1893), 220–221.

10. Curtis Dahl, "The Sunny Master of Sunnyside," *American Heritage* (December 1961), 39.

11. "Washington Irving," *Temple Bar* (November 1892), 335.

12. Washington Irving, *History, Tales and Sketches* (New York: The Library of America, 1983), 911–962.

13. See, e.g., Washington Irving, *Christmas Day*, with illustrations by Cecil Aldin (New York: Hodder & Stoughton, 1900); Washington Irving, *The Keeping of Christmas at Bracebridge Hall*, with illustrations by C. E. Brock (London: J. M. Dent, 1906); and Washington Irving, *Old Christmas From the Sketch-Book of Washington Irving*, illustrated by Randolph J. Caldecott (London: Macmillan, 1875).

14. "The Lounger," *Harper's Weekly* (December 17, 1859), 803.

15. E., "Review: *The Sketch-Book of Geoffrey Crayon, Gent.*," *Western Review* (February 1820), 253.

16. "Art. III.—*The Sketch-Book of Geoffrey Crayon, Gent.*," *Quarterly Review* (April and July, 1821), 58.

17. Van Wyck Brooks, *The World of Washington Irving* (New York: Dutton, 1944), 199, 202.

18. Adam W. Sweeting, "'A Very Pleasant Patriarchal Life': Professional Authors and Amateur Architects in the Hudson Valley, 1835–1870," *Journal of American Studies* (April 1995), 36–38.

19. Scott's *Marmion*, quoted in Golby and Purdue, *The Making of the Modern Christmas*, 13. See also William Henry Davenport, *Scenes of The Olden Time* (London: T. Nelson, 1867), 123–126. On Irving at Abbotsford, see Evert A. Duyckinck, "Memoranda of the Literary Career of Washington Irving," in *Irvingiana: A Memorial of Washington Irving* (New York: Charles B. Richardson, 1860), ix.

20. See Lydia F. Emmet, "Bringing in the Yule Log," *Harper's Young People* (December 17, 1889), 119.

21. *The Vindication of Christmas: Pages from the Notebook of Washington Irving* (n.p.: Cornelia and Waller Barrett, 1961), 7. See also Stanley T. Williams, ed., *Notes While Preparing Sketch Book & c. 1817 by Washington Irving* (New Haven: Yale University Press, 1927), 13–14, and a letter from Irving to his brother about his research in the British Museum, in Pierre M. Irving, *The Life and Letters of Washington Irving*, vol. 1 (New York: Putnam, 1862), 447–448.

22. Washington Irving, *The Sketch-Book of Geoffrey Crayon, Gent.* (New York: Oxford University Press, 1996), 173.

23. Ibid., 192.

24. George William Curtis, "Christmas," *Harper's New Monthly Magazine* (December 1883), 3.

25. Garret Van Arkel, "The House of the Four Chimneys," *New England Magazine* (September 1902), 59. See also Ben Harris McClary, "A Bracebridge-Hall Christmas for Van Buren: An Unpublished Irving Letter," *English Language Notes* (September 1970), 20–22.

26. Anne Freemantle, "Christmas in Literature," *Commonweal* (December 7, 1945), 186.

27. Irving, *The Sketch-Book*, 165.

28. In fact, Irving was often found in England in the company of painters from Washington Allston's circle; see Johanna Johnston, *The Heart That Would Not Hold: A Biography of Washington Irving* (New York: Lippincott, 1971), 136.

29. "Classy Getaways in America the Beautiful," *Business Week* (May 2, 1988), 141.

30. Queen Elizabeth II was a guest in 1983; see Steve Lawson, "The Gift of Nature," *Town & Country* (December 1993), 138.

31. Brendan Gill, "Ansel Adams' Forgotten Ahwahnee," *Architectural Digest* (June 1993), 147.

32. Carl Nolte, "Yosemite Cancels First Two Dinners," *San Francisco Chronicle*, December 22, 1995.

33. Edwin Kiester, Jr., "A Christmas That Never Was," *Modern Maturity* (December 1991–January 1992), 31.

34. Frank Riley and Elfriede Riley, "Christmas in Yosemite," *Los Angeles Magazine* (December 1988), 264–265. For a text of the modern pageant, see Sylvia Thompson, "Christmas at Bracebridge Hall," *Gourmet* (December 1991), 122, 218–227.

35. Kiester, "A Christmas That Never Was," 34.

36. Gill, "Ansel Adams' Forgotten Ahwahnee," 147. See also Paul Lasley and

Elizabeth Harryman, "Yosemite's Famous Holiday Dinner," *Los Angeles Times,* December 13, 1992.

37. Jane E. Zarem, "Yosemite Feast Recalls Old England," *Boston Globe,* December 16, 1990; Florence Fabricant, "Old World Pageantry at Yosemite Park," *New York Times,* December 26, 1990.

38. Debra Kroon, "The Ahwahnee Hotel," *American West* (November-December 1981), 22. See also Gordon Cotler, "Castle in the Wild," *Travel Holiday* (February 1993), 77–81.

39. "Holiday Hideways," *Dynamic Years* (November-December 1983), 17.

40. Charles Dickens, *The Pickwick Papers* (New York: Signet, 1964), 414–437.

41. Ibid., 414–415.

42. Dickens's mistletoe passage is discussed in Tristram Potter Coffin, *The Book of Christmas Folklore* (New York: Seabury Press, 1973), 24–25.

43. One of the earliest examples of this nostalgia literature is Henry C. Watson, "A Brief Chat About Christmas," *Frank Leslie's Illustrated Newspaper* (December 26, 1857), 60–61, which begins as follows: "Let us invoke the spirit of Old Christmas, and turning our back upon the matter-of-fact present, dwell for a while upon the hearty realities which meet us at every turn as we contemplate the past of the joyful Christmas season." Watson goes on to praise American and British versions of Old Christmas.

44. Alister Burford, "An Old Time English Christmas, in Town and Country at Yule-Tide," *Saturday Evening Post* (December 24, 1898), 414.

45. Agnes Carr Sage, "An Old-Time Christmas," *Harper's Young People* (December 23, 1884), 114–115.

46. Mrs. W. J. Hays, "A Christmas Chat," *Harper's Young People* (December 1, 1885), 79; Rev. Thomas U. Dudley, "Christmas Morning," *Harper's Young People* (December 25, 1883), 123; Agnes C. Sage, "Twelfth-Night Revels," *Harper's Young People* (January 5, 1886), 151.

47. Zitella Cocke, "A Queen's Christmas Gifts," *St. Nicholas* (December 1902), 236. See also Melville Egleston, "St. Nicholas Day and the Child-Bishops of Salisbury," *St. Nicholas* (June 1877), 532–534. The Brandywine School illustrator Howard Pyle, who specialized in British romantic fiction, was one of the chief architects of the quaint Olde Christmas and a major source of inspiration for lesser writers and illustrators; see Howard Pyle, "Christmas-Time, Two Hundred Years Ago," *Harper's Weekly* (December 9, 1882), 779–781.

48. Nora Archibald Smith, "Christmas in Old England," *St. Nicholas* (December 1905), 156–160.

49. Emily Lovett Eaton, "An Old English Christmas," *St. Nicholas* (December 1920), 163–167. See also Edith M. Thomas, "Ye Merrie Christmas Feast," *St. Nicholas* (January 1887), 163–165; Charles A. Murdock, "A 16th Century Christmas," *St. Nicholas* (December 1888), 145–149; Nora Archibald

Smith, "Christmas, Past and Present," *Godey's* (December 1895), 615–617.

50. See Leyendecker Christmas covers for 1905, 1924, 1926, 1929, 1931, 1932, 1933, and 1934 in Jan Cohn, *Covers of the "Saturday Evening Post"* (New York: Viking Studio, 1995), 29 and passim.

51. See Karal Ann Marling, *George Washington Slept Here: Colonial Revivals and American Culture, 1876–1986* (Cambridge, Mass.: Harvard University Press, 1998), 291–324.

52. Karal Ann Marling, *Norman Rockwell* (New York: Harry N. Abrams, 1997), 47–61.

53. Norman Rockwell, *My Adventures as an Illustrator* (New York: Harry N. Abrams, 1994), 27–28.

54. Rufus Jarman, "Profiles: U.S. Artist," *New Yorker* (March 24, 1945), 38.

55. See also Karal Ann Marling, "Norman Rockwell's Christmas," in *Norman Rockwell: Pictures for the American People* (New York: Harry N. Abrams, 1999), 155–167.

56. See Cohn, *Covers of the "Saturday Evening Post,"* for Rockwell's Dickensian work: 1921, 1925, 1929, 1932, 1938.

57. An exception is Rockwell's "To Father Christmas," an inside-the-book illustration of a passage from *Pickwick*, published in the *Ladies' Home Journal* (December 1931), 3. A second *Pickwick* scene appeared in the *Saturday Evening Post* (December 28, 1935), 18–19.

58. Charles Dickens, *A Christmas Carol, The Original Manuscript: A Facsimile of the Manuscript in the Pierpont Morgan Library with a Transcript of the First Edition and John Leech's Illustrations* (New York: Dover, 1967), xii.

59. Charles Dickens, *The Christmas Books,* vol. 1 (New York: Penguin, 1971), 38, 77.

60. Malan, *Charles Dickens' "A Christmas Carol,"* 70, 74, and 80, reproduces these illustrations.

61. For the cards, see Laurie Norton Moffatt, *Norman Rockwell: A Definitive Catalogue,* vol. 1 (Stockbridge, Mass.: The Norman Rockwell Museum at Stockbridge, 1986), 417–429. See also "Christmas Card Design: The Story Behind One of Our Leading Art Industries," *Design* (December 1948), 7–8, 19.

62. See Hallmark Historical Collection and Archives, Kansas City, Missouri: Folder, "Art Deco Cards," 132E.1, for example. See also Folder: "Christmas 1925," B2E.1; Folder, "Christmas, 1928–9; Folder, "Christmas, 1930–32," B2E.2, etc.

63. For an announcement of a forthcoming serialization, see *Harper's Weekly* (December 24, 1859), unpaginated ad.

64. Untitled note, *Harper's Weekly* (December 7, 1867), 782. Dickens was everywhere. An ad (*Harper's Weekly,* December 21, 1867, 814) described a

"Christmas Game of Dickens," suitable for young and old alike and ready for shipping on December 12th.

65. Untitled note, *Harper's Weekly* (December 28, 1867), 829.

66. Kate Field, *Pen Photographs of Charles Dickens's Readings* (Boston: Loring, 1868), 5–7.

67. Raymund Fitzsimons, *The Charles Dickens Show: An Account of his Public Readings, 1858–1870* (London: Geoffrey Bles, 1970), 111.

68. Golby and Purdue, *The Making of the Modern Christmas,* 48.

69. Quoted in W. W. Watt, "Christmas, 1943—A Dickens Centenary," *Saturday Review of Literature* (December 4, 1943), 18.

70. The churchly could find some comfort in the *Carol,* however. Margaret E. Sangster, "On the Track of Christmas," *Harper's Young People* (December 16, 1884), 106, insists that Dickens's message is both secular and religious: "Like jolly Bob Cratchit and Tiny Tim, the thought in our hearts is not 'Merry Christmas' only, but 'God bless us every one!'"

71. See William Makepeace Thackeray, *The Christmas Books of Mr. M. A. Titmarsh* (New York: Scribner's, 1911).

72. Quoted in *Harper's Weekly* (November 30, 1867), 757.

73. Field, *Pen Photographs of Charles Dickens's Readings,* 9.

74. Davis, *The Life and Times of Ebenezer Scrooge,* 13.

75. Charles Dickens, *A Christmas Carol,* in Joseph D. Cusumano, *Transforming Scrooge* (St. Paul: Llewellyn, 1996), 121.

76. G. K. Chesterton, *Charles Dickens: A Critical Study* (New York: Dodd Mead, 1911), 172. See also Chesterton's *The Thing: Why I Am a Catholic* (New York: Dodd Mead, 1930), 249–251.

77. This is Mrs. Cratchit's description of her husband's employer: Dickens, *A Christmas Carol,* in Cusumano, *Transforming Scrooge,* 72.

78. Dickens's only previous extended description of a Christmas dinner—"A Christmas family-party!"—came in *Sketches by Boz* (1836), another work dependent on Irving. See Ruth F. Glancy, "Dickens and Christmas: His Framed-Tale Themes," *Nineteenth-Century Fiction* (June 1980), 53.

79. E.g., Charles Dickens, *Their Christmas Dinner* (New York: George R. Lockwood, 1884). Another kind of gift book included short extracts from all the works in which Dickens mentioned Christmas; a splendid modern example, illustrated by the American painter Everett Shinn, is *Christmas in Dickens* (Garden City, N.Y.: Garden City Publishing, 1941).

80. "Christmas Charity," *Frank Leslie's Illustrated Newspaper* (December 24, 1887), 306. The author also mentions Irving as the source of the good cheeer of the season.

81. Louisa May Alcott, "Christmas at Orchard House," in James Charlton and Barbara Gilson, eds., *A Christmas Treasury of Yuletide Stories and Poems* (New York: Galahad Books, 1992), 204–216.

82. Louisa M. Alcott, "A Christmas Dream and How It Came True," *Harper's Young People* (December 5, 1882), 65–67.

83. "Remember the Poor," *Godey's* (December 1870), 493.

84. Christian Reid, "Alice's Christmas Gift," *Godey's* (December 1884), 575, 577.

85. "Christmas Charity," *Leslie's* (December 24, 1887), 306.

86. See, for example, "The Chimes" of 1844. This issue is discussed in Chesterton, *Dickens and Christmas,* 174–175.

87. Edward E. Hale, "Christmas in Boston," *New England Magazine* (December 1889), 362–364.

88. Ella S. Sargent, "Children's Christmas Club," *St. Nicholas* (December 1883), 174–178. See also Richard Harding Davis, "The Christmas Society," *Harper's Weekly* (December 19, 1891), 1020, about a dinner where the rich paid $20 each to watch the poor dine.

89. Edmund Alton, "The Children's Christmas Club of Washington City," *St. Nicholas* (December 1887), 146–149.

90. Eliot McCormick, "Jimmie the Duke," *Harper's Young People* (November 18, 1884), 35.

91. See rotogravure page, "The Crush of Holiday Shoppers in New York City," *Leslie's Weekly* (December 30, 1899), 531.

92. "New York's Season of Charity," *Leslie's Weekly* (December 26, 1901), 600–602.

93. Proportionally smaller dinners were held in other cities, of course. Photographs in the Minneapolis Collection of the Minneapolis Public Library show lassies in bonnets standing alongside kettles on the streets of that city, ca. 1890–1910. The sign on the kettle states that the funds collected will go to a "Xmas Dinner" for "3,000 Poor."

94. "Soup, Soap, Salvation," *Newsweek* (March 21, 1955), 64.

95. Sallie Tisdale, "Good Soldiers," *New Republic* (January 3, 1994), 24.

96. Edith Townsend Kaufmann, "Salvation Army Santa Claus," *Leslie's Weekly* (December 5, 1912), 590–591.

97. "Mercenaries for Christ," *Newsweek* (December 27, 1971), 50; Verne Becker, "Saved by the Bell," *Christianity Today* (December 17, 1990), 19; "The Hallelujah Army Observes Its 75th U.S. Christmas," *Life* (December 27, 1954), 5–6.

98. "The Greatest Christmas Dinner of the Closing Century," *Leslie's Weekly* (January 12, 1901), 32. See also rotogravure page, "Height of the Christmas Season in New York," *Leslie's Weekly* (December 24, 1903), 620.

99. David Traxel, *1898: The Birth of the American Century* (New York: Knopf, 1998), 305.

100. Frederick Booth-Tucker, *The Salvation Army in America: Selected Reports, 1899–1903* (New York: Arno Press, 1972), 28.

101. Dixon Wecter, *The Saga of American Society* (New York: Scribner's, 1970), 368.

102. Harry Beardsley, "Mrs. Gould's Christmas Treat for Poor Children," *Leslie's Weekly* (December 18, 1902), 692.

103. "A Pleasing Christmas Event in New York," *Leslie's Weekly* (January 11, 1906), 31, describes a doll dinner given by Mrs. Frank Tilford at the Murray Hill Lyceum in New York. Christmas fairs sometimes made or raised money for Christmas dolls; see Mrs. W. J. Hays, "One Touch of Nature," *Harper's Young People* (December 16, 1879), 49–50.

104. "Notable Events of the Holiday Season in New York," *Leslie's Weekly* (January 9, 1908), 41.

105. "Sullivan Dines the Bowery," *New York Times*, December 26, 1911.

106. "Christmas Feasts Gladden City's Poor," *New York Times*, December 26, 1911.

107. Untitled editorial, *Saturday Evening Post* (December 8, 1900), 14.

108. See Owen Kildare, "Christmas With Us in the Tenements," *Ladies' Home Journal* (December 1906), 26; "Helping the Poor at Christmastide," *Ladies' Home Journal* (December 1909), 44.

109. "Santa Claus, Please Take a Look," *New York Times*, December 15, 1912.

110. "Reflections on the Hundred Cases," *New York Times*, December 17, 1912.

111. "Quick Response for 100 Neediest Cases," *New York Times*, December 18, 1912.

112. "Helped Givers as Well as Recipients," *New York Times*, December 21, 1912.

113. "A Year's Christmas for '100 Neediest,'" *New York Times*, December 25, 1912.

114. "Public Instructed by 'Neediest Cases,'" *New York Times* December 23, 1913.

115. "Pleased by Gifts to Aid the Needy" and "Throws Coins to Crowd," *New York Times*, December 30, 1913.

116. Paul Davis, "Retelling *a Christmas Carol*: Text and Culture-Text," *American Scholar* (Winter 1990), 109.

117. See ads for the Barrymore broadcast in *Saturday Evening Post* (December 26, 1936), 26, and ibid. (December 28, 1935), 25. Barrymore performed the *Carol* on the radio from 1934 until the 1950s.

118. Davis, *The Life and Times of Ebenezer Scrooge*, 152, analyzes the radio scripts.

119. Quoted in Mary Evans Seeley, *Season's Greetings from the White House* (New York: Mastermedia, 1996), 32.

120. Ibid., 37.

121. See, e.g., untitled review, *Scholastic* (January 7, 1939), 35.

122. "The New Pictures," *Time* (December 19, 1938), 21.

123. Philip Hartung, "'God Bless Us, Every One!' Say Tiny Tim and Errol Flynn," *Commonweal* (December 30, 1938), 273.

124. Thompson, *Great Christmas Movies*, 22.

125. See J. C. Suarès and J. Spencer Beck, *Hollywood Christmas* (Charlottesville, Va.: Thomasson-Grant, 1994), 60–61.

126. Patricia King Hanson, ed., *The American Film Institute Catalogue of Motion Pictures Produced in the United States: Feature Films, 1931–1940* (Berkeley: University of California Press, 1993), 347, discusses Barrymore's role in promoting the film.

127. William L. Hedges, *Washington Irving: An American Study, 1802–1832* (Baltimore: Johns Hopkins Press, 1965), 168.

128. James Munson, "The Old English Christmas of Washington Irving," *Contemporary Review* (December 1994), 324–326. The first Christmas cards, including the very first, designed in 1846 by J. C. Horsley for Sir Henry Cole, showed scenes of feasting, juxtaposed with acts of charity or portrayals of need; see Nancy Cooper, "Chats on Antiques," *House Beautiful* (December 1929), 728; George Buday, *The History of Christmas Cards* (London: Spring Books, 1954), 6–9.

129. In the year MGM's film was released, Barrymore contributed an introduction to a famous edition of the *Carol* illustrated by Everett Shinn; Charles Dickens, *A Christmas Carol* (Philadelphia: John C. Winston, 1938). This is an early example of merchandising tie-ins between literature and the movies. *Gone With the Wind*, released in 1939, prompted Margaret Mitchell's publishers to issue special "movie" editions of her novel.

130. J. D. Salinger, *The Catcher in the Rye* (New York: New American Library, 1953), 136, 124–127.

131. Ibid., 100–101, 177.

132. Sandra Salmans, "Golden Oldies: Some Shades of Christmas Past," *New York Times*, December 22, 1985.

133. "A Merry Christmas for Convicts' Destitute Families," *Leslie's Weekly* (December 24, 1903), 613.

134. "Conversation with a Sidewalk Santa," in Irena Chalmers, *All About Christmas* (New York: Seafarer Books, 1994), 144.

135. The 1951 Paramount film was a remake of a 1934 picture with the same title. See "New Picture," *Time* (April 2, 1951), 96; "The Lemon Drop Kid," *Newsweek* (April 2, 1951), 86. Contemporary reviews do not mention the music.

136. Roger Ebert, "Scrooged," *Chicago Sun-Times*, November 23, 1988.

137. *Sixth Greenbook Guide to Department 56 Villages* (East Setauket, N.Y.: Greenbook, 1996), 95–122. In its New England Village series, Depart-

ment 56 also includes Washington Irving houses. For revivals of eighteenth-century recipes, see *Christmas Edition: Cold Medal Flour Cook Book* (Minneapolis: General Mills, 1977), a reprint of a 1904 original.

5. O Tannenbaum

1. Stephen Nissenbaum, *The Battle for Christmas* (New York: Knopf, 1996), 178–187.

2. Ibid., 189–195.

3. Francis X. Weiser, *The Christmas Book* (New York: Harcourt, Brace & World, 1952), 121. See Chapter 2 above.

4. Alfred L. Shoemaker, *Christmas in Pennsylvania: A Folk-Cultural Study* (Kutztown, Pa.: Pennsylvania Folklife Society, 1959), 53–54.

5. Francis J. Grund, "Christmas and New Year in France and Germany," *Godey's* (January 1848), 6–7.

6. Mary Howitt, "Madame Goetzenberger's Christmas Eve," *Godey's* (December 1853), 505, 510–511.

7. Robert Brenner, *Christmas Past,* 3rd ed. (Atglen, Pa.: Schiffer Publishing, 1996), 13.

8. Nissenbaum, *The Battle for Christmas,* 187.

9. Beverly Gordon, *Bazaars and Fair Ladies: The History of the American Fundraising Fair* (Knoxville: University of Tennessee Press, 1998), 43.

10. Ella A. Drinkwater, "Debby's Christmas," *St. Nicholas* (January 1878), 227.

11. Gordon, *Bazaars and Fair Ladies,* 110–111.

12. Hope Leyard, "The Wrong Promise," *St. Nicholas* (January 1881), 177.

13. C. A. C. Hadselle, "Using Other People's Gold," *Godey's* (December 1870), 531; Virginia De Forrest, "How Effie Hamilton Spent Christmas," *Godey's* (December 1857), 536; S. Annie Frost, "A Tale of Christmas," *Godey's* (December 1873), 542.

14. Hezekiah Butterworth, "A Christmas Tree That Talked," *Harper's Young People* (December 18, 1888), 119.

15. Shoemaker, *Christmas in Pennsylvania,* 46–47.

16. Diana Karter Appelbaum, *Thanksgiving: An American Holiday, An American History* (New York: Facts on File, 1985), 113–114.

17. Webb Garrison, *A Treasury of Christmas Stories* (Nashville: Rutledge Hill Press, 1990), 73–74.

18. "The Christmas Tree," *Godey's* (December 1850), 327. For the Windsor Castle tree, see also Chapter 1 above.

19. G. W. Haskins, "The Ingle Nook: A Simple Story for Christmas," *Godey's* (December 1850), 331.

20. "The Christmas Tree," *Godey's* (December 1860), 481.

21. Lizzie M'Intyre, "The Christmas Tree," *Godey's* (December 1860), 505–506.

22. For a scene of surprise, see Rosalie Lee, "Bachelor Rogers' Christmas Party," *Godey's* (December 1881), 525.

23. James H. Barnett, *The American Christmas: A Study in National Culture* (New York: Macmillan, 1954), 20.

24. "The Christmas Tree," *Godey's* (December 1861), 457.

25. For the English version, see J. M. Golby and A. W. Purdue, *The Making of the Modern Christmas* (Athens: University of Georgia Press, 1986), 51. For the American version, see Shoemaker, *Christmas in Pennsylvania*, 59. The original version of the picture by J. A. Pasquier appeared in the *Illustrated London News* for December 25, 1858. This was a frequent source for *Godey's* pictures.

26. "Christmas Tree," *Godey's* (December 1876), 557.

27. See Clement Clarke Moore, *The Night Before Christmas or A Visit from St. Nicholas* (New York: Putnam and Grosset, 1997), a facsimile of an edition of circa 1870.

28. Thomas Nast, "His Works," *Harper's Weekly* (December 29, 1866), 824–825.

29. *Thomas Nast's Christmas Drawings* (New York: Dover, 1978), 18–19.

30. "Christmas-Day, 1860," *Harper's Weekly* (December 29, 1860), 817.

31. "Santa Claus," *Harper's Weekly* (December 22, 1860), 809.

32. Sol Eytinge, "Christmas Presents," *Harper's Weekly* (December 30, 1865), 820. See also "The Christmas Tree," *Harper's Weekly* (January 1, 1870), 5, again showing a father, a mother, and children gathered around a tree. Exceptionally for the date, there are many small toys hanging on the tree, as well as large ones (and a Christmas village) underneath.

33. Henry C. Watson, "A Brief Chat About Christmas," *Frank Leslie's Illustrated Newspaper* (December 26, 1857), 60–61.

34. "Christmas—1863," *Frank Leslie's Illustrated Newspaper* (January 2, 1864), 232–233.

35. In the left corner of the Victoria and Albert picture sits an older woman, presumably the grandmother of the children; American versions of the grouping often added a second elderly couple, to suggest a continuity of generations.

36. See ad for H. R. Dieseldorph and Co., 691 Broadway, in *Harper's Weekly* (December 11, 1858), 800; "Youth's Chemical Cabinets," *Harper's Weekly* (December 10, 1859), 799; "Automaton Negro Dancer," *Harper's Weekly* (December 17, 1864), 814; ad for rocking horses, *Harper's Weekly* (December 13, 1862), 799; "Holiday Basket," *Harper's Weekly* (December 27, 1862), 832.

37. Louisa May Alcott, "Sophie's Secret—A Christmas Story," *St. Nicholas* (De-

cember 1883), 117, is out of step with the times when she recommends a "Christmas-tree as the prettiest way of exchanging gifts and providing jokes for the evening in the shape of delusive bottles, animals full of candy, and every sort of musical instrument to be used in an impromptu concert afterward." This kind of party—the notion that a Christmas tree *was* a party—was becoming old-fashioned in 1883.

38. See, e.g., Olive Thorne, "May's Christmas Tree," *St. Nicholas* (January 1875), 179–182.

39. Rebecca Harding Davis, "Some Old-Time Christmases," *Saturday Evening Post* (December 3, 1904), 7.

40. Phillip Snyder, *December 25th: The Joys of Christmas Past* (New York: Dodd, Mead, 1985), 99.

41. Leigh Eric Schmidt, *Consumer Rites: The Buying and Selling of American Holidays* (Princeton: Princeton University Press, 1995), 153–154.

42. "The Christmas Tree," *Godey's* (December 1855), 515.

43. Garrison, *A Treasury of Christmas Stories*, 75–78; according to legend, this was the first occasion on which Mrs. Pierce was known to have smiled in Washington. She was in mourning for her son Bennie, killed several years before in a railroad accident. Ella S. Sargent, "Children's Christmas Club," *St. Nicholas* (December 1883), 174–178, describes a similar charity event staged in Portland, Maine.

44. The picture is reproduced in Shoemaker, *Christmas in Pennsylvania*, 62. J. L. Harbour, "Christmas Customs, New and Old," *Leslie's Weekly* (December 25, 1902), 720, discusses the Luther picture: "One will find all over Germany rude prints representing Martin Luther and his family sitting around their Christmas-tree." Frida Davidson, "How Our Christmas Customs Came," *Natural History* (November 11, 1928), 622, is more skeptical about the Luther legend. See also Earl W. Count and Alice Lawson Count, *4000 Years of Christmas* (Berkeley, Calif.: Ulysses Press, 1997), 83–86.

45. Katherine Lambert Richards, *How Christmas Came to the Sunday-Schools* (New York: Dodd, Mead, 1934), 114–127. A "Sunday-school festival" involving a tree full of gifts figures in Frances Cole Burr, "A Snow-Bound Christmas," *St. Nicholas* (December 1896), 104.

46. See illustration, "The Sunday School Christmas Tree," *Harper's Young People* (December 8, 1885), 89. The 1998 film *Simon Birch* used a Nativity pageant as the centerpiece of the plot. The titular hero, suspended from the ceiling on a rope, falls into the manger and seems to attack Mary.

47. "Benighted Children Taught to Celebrate Christmas," *Leslie's Weekly* (December 7, 1905), 545.

48. G. A. Davis, "The Work of the Salvation Army in the Slums of New York—Christmas Day at the Cherry Street Crèche," *Frank Leslie's Weekly* (undated Christmas number, 1893), 418.

49. "Christmas at the New Orleans Exposition," *Frank Leslie's Illustrated Newspaper* (January 10, 1885), 341.

50. Eliot McCormick, "The New Orleans Christmas Tree," *Harper's Young People* (January 13, 1885), 170.

51. "Christmas at the New Orleans Exposition," *Leslie's*, 341.

52. McCormick, "The New Orleans Christmas Tree," 170.

53. "Xmas Tree in Madison Square," *New York Times*, December 18, 1912.

54. "What They Will Do At Park Xmas Tree," *New York Times*, December 22, 1912.

55. "Great Xmas Tree Ready To Be Set Up," *New York Times*, December 21, 1912.

56. "Public's Xmas Tree To Stand For A Week," *New York Times*, December 19, 1912.

57. "Huge Tree Of Light Beckons Thousands," *New York Times*, December 25, 1912. See also Grace Humphrey, "The Children of the Tree of Light," *St. Nicholas* (December 1917), 142–146.

58. "Star of Bethlehem First Light On Tree," *New York Times*, December 24, 1912.

59. Jacob A. Riis, *Is There a Santa Claus?* (New York: Macmillan, 1904), unpaginated.

60. Jacob A. Riis, "The New Christmas," *Ladies' Home Journal* (December 1913), 16. See also "What the Tree in the Square Heard," *Ladies' Home Journal* (December 1913), 11.

61. "A Saner Merry Christmas," *The Outlook* (January 4, 1913), 1. The unsigned article states that Riis started the practice of using a Christmas tree to promote a sober New Year's on the lawn of his own home in Richmond Hill.

62. Mary Evans Seeley, *Season's Greetings from the White House* (New York: Mastermedia, 1996), 9.

63. *Christmas in Washington, D.C.* (Chicago: World Book, 1988), 14–15. See also "Christmas Carols at the White House," *New York Times*, December 25, 1923; "Middlebury Sends Tree to Coolidge," *New York Times*, December 13, 1923; and "A Christmas Good-Will Offering to the Nation," *Printers' Ink* (December 10, 1925), 148, 150–151.

64. Seeley, *Season's Greetings*, 12–13.

65. *Christmas in Washington, D.C.*, 14.

66. Stephen M. Feldman, *Please Don't Wish Me a Merry Christmas* (New York: New York University Press, 1997), 234–286, summarizes the legal challenges to the use of religious and quasi-religious iconography in state-sponsored holiday decorations. During the Nixon administration, a court challenge to the Nativity scene at the Pageant of Peace site led to the decision to cede that portion of the decorations to a private group, which put it up nearby.

67. David Comfort, *Just Say Noel!* (New York: Simon & Schuster, 1995), 89.

68. Daniel Pool, *Christmas in New York* (New York: Seven Stories Press, 1997), 42–43.

69. Ibid., 43.

70. Carla Torsilieri D'Agostino and Byron Keith Byrd, *The Christmas Tree at Rockefeller Center* (New York: Lickle Publishing, 1997), 19.

71. Lloyd Wendt and Herman Kogan, *Give the Lady What She Wants! The Story of Marshall Field & Company* (Chicago: Rand McNally, 1952), 366–367.

72. "Annette Lewin" (obituary), *Chicago Tribune,* July 2, 1986.

73. "The Tree at Fields," *Chicago Tribune,* December 16, 1979; see also Robert Ostermann, "The Business Behind the Gift: Backstage at Marshall Field's," in Irena Chalmers, *All About Christmas* (New York: Seafarer Books, 1994), 66–67.

74. From interviews by Nance Longley with her brother, Dick Parker. Nance was a student in my 1998 class on Christmas at the University of Minnesota.

75. Earl W. Count and Alice Lawson Count, in *4000 Years of Christmas* (Berkeley, Calif.: Ulysses Press, 1997), 83–84, relate the Christmas tree to the biblical Tree of Life in the Garden of Eden. In parts of Germany in the eighteenth and nineteenth centuries, figures of Adam, Eve, and the serpent were sold as tree decorations.

76. "Department Store Dining Even a Scrooge Could Love," *Chicago Tribune,* November 22, 1991.

77. Genevieve Buck, "Can crown jewel's luster be restored?" *Chicago Tribune,* December 35, 1995.

78. Charles Dickens, "A Christmas Tree," in *The Christmas Stories* (New York: Barnes and Noble, 1994), 1–2.

79. William Dean Howells, *Christmas Every Day* (New York: Simon & Schuster, 1996), 17–18.

80. Quoted in The Editors of *Life, The Pageantry of Christmas,* vol. 2 (New York: Time Inc., 1963), 73.

81. Hamlin Garland, "My First Christmas Tree," in *Country Christmas* (Nashville: Ideals Publishing, 1992), 86–89.

82. Mary E. Wilkins, "Where the Christmas-tree Grew," *St. Nicholas* (January 1888), 205.

83. Mary Mapes Dodge, "The Bloom of the Christmas Tree," *St. Nicholas* (December 1892), 89.

84. Janet Sanderson, "The Best Tree," *St. Nicholas* (December 1899), 164.

85. Dodge, "The Bloom of the Christmas Tree," 89. For glass ornaments, see Tim Merck and Beth Merck, *Christmas Ornament Legends* (Spokane, Wash.: Old World Christmas, 1995).

86. M. Knox, "A Christmas Elephant," *Harper's Young People* (November 28, 1887), 68.

87. "O Christmas Tree!" in Holly Pell McConnaughy, *O Christmas Tree! A Celebration of the Festive Season* (New York: Barnes and Noble, 1996), 16.

88. Hans Christian Andersen, "The Fir Tree," in *Christmas Classics from the Modern Library* (New York: Modern Library, 1997), 84.

89. George Meredith, *When What to My Wondering Eyes: Art and Literature Celebrate Christmas* (Santa Monica: Smart Art Press, 1997), 77.

90. Robert Frost, "Christmas Trees: A Christmas Circular Letter," in Debra Starr, *The Book of Christmas: A Collection of Holiday Verse, Prose, and Carols* (Ann Arbor: Borders Press, n.d.), 126–128.

91. Truman Capote, *A Christmas Memory*, in *A Christmas Memory, One Christmas, and The Thanksgiving Visitor* (New York: Modern Library, 1996), 21.

92. Oscar Hijuelos, *Mr. Ives' Christmas* (New York: HarperCollins, 1995), 115.

93. Ibid., 131.

94. See Rochelle Gurson, untitled article, *Saturday Review of Literature* (May 11, 1957), 52.

95. Theodor Geisel, *How the Grinch Stole Christmas!* (New York: Random House, 1957), unpaginated.

96. See Susan B. Thistlethwaite, "Dr. Seuss: Getting Christmas Back," *Christianity and Crisis* (December 16, 1991), 379, and Neil Morgan and Judith Morgan, *Dr. Seuss and Mr. Geisel* (New York: Random House, 1995), 137–138.

97. Lyric quoted in Frank Thompson, *Tim Burton's Nightmare Before Christmas: The Film, The Art, The Vision* (New York: Hyperion, 1993), 49.

98. Richard Corliss, "A Sweet and Scary Treat," *Time* (October 11, 1993), 79–81. For artificial trees, see Jane and Michael Stern, *The Encyclopedia of Bad Taste* (New York: HarperCollins, 1990), 84–85.

6. Santa Claus Is Comin' to Town

1. "Passages," *People* (February 16, 1998), 150.

2. "Deaths," *People* (July 20, 1998), 91.

3. Chuck Haga, "Donald Johnson dies; was Santa Claus to many," *Minneapolis Star Tribune*, February 22, 1998.

4. "Standard Santas," *Fortune* (December 1937), 12.

5. David Brown and Ernest Lehman, "The Santa Claus Industry," *American Mercury* (January 1940), 27.

6. See Ruth Chin, "In Santa Claus, Indiana, It's Christmas Every Day," *Trailer Life* (December 1982), 70, and promotional pamphlet, Santa Claus Area Chamber of Commerce, November 11, 1997. See also "The Wrongs of Santa Claus (Ind.)," *Literary Digest* (January 16, 1932), 36–37, and

Howard M. Rudeaux, "Believe It or Not, There Is a Santa Claus," *American Magazine* (December 1930), 78.

7. Brown and Lehman, "The Santa Claus Industry," 27.

8. "Standard Santas," 12.

9. Brown and Lehman, "The Santa Claus Industry," 28.

10. "Santa Supply," *Literary Digest* (December 11, 1937), 19. See also "Christmas Scenes in New York City," with photo of two Santas in peculiar Arctic parkas tending a Salvation Army kettle in New York at the turn of the century; Peters Collection, New-York Historical Society. For contemporary Santas from the Volunteers of America, see "Dear Santas: A Jolly Old Scrapbook," *New York Times Magazine* (December 23, 1990), 15.

11. P. K. Crocker, "Some Christmas Ideas to Pass On to Retailers," *Printers' Ink* (October 7, 1926), 97.

12. Louise Price Bell, "There IS a Santa Claus," *American Home* (December 1935), 43.

13. B. Y. Williams, "Stand-Ins for Santa Claus," *Saturday Evening Post* (December 16, 1944), 79.

14. C .R. S., "Short Tales, Memorabilious," *Saturday Evening Post* (December 26, 1925), 24.

15. Arthur L. Lippmann, "Short Turns . . . Commercial Clauses," *Saturday Evening Post* (December 19, 1925), 26.

16. Newman Levy, "There Aren't Any Santa Clauses," *Saturday Evening Post* (December 19, 1925), 54.

17. Quoted in James H. Barnett, *The American Christmas: A Study in National Culture* (New York: Macmillan, 1954), 34.

18. Phillip Snyder, *December 25th: The Joys of Christmas Past* (New York: Dodd, Mead, 1985), 232.

19. The Brockton story is included in Webb Garrison, *A Treasury of Christmas Stories* (Nashville: Rutledge Hill Press, 1990), 61–62. See also his story of Jim Yellig playing Santa, 121.

20. "The Curse of Christmas," *Independent* (December 18, 1926), 697.

21. Magner White, "Experiences of a Department Store Santa," *American Magazine* (December 1925), 45.

22. Betty Thornley, "A Morning Off with Santa Claus," *Country Life* (December 1929), 94.

23. William B. Waits, *The Modern Christmas in America: A Cultural History of Gift Giving* (New York: New York University Press, 1993), 130.

24. Charles W. Jones, "Knickerbocker Santa Claus," *The New-York Historical Society Quarterly* (October 1954), 359–360.

25. See Robert Brenner, *Christmas Revisited* (West Chester, Pa.: Schiffer Publishing, 1986), 152. See also Arthur Stringer, "The Spellbinder," *Saturday*

Evening Post (December 7, 1912), 18. In this short story, the hero sells cheap Santa masks and teddy bears in the streets around Sixth Avenue from a pushcart.

26. See "Santa Claus's Unwelcome Reception," *Leslie's Weekly* (December 28, 1905), 623.

27. Starkey Flythe, Jr., *Norman Rockwell and the Saturday Evening Post,* vol. 1 (New York: MJF Books, 1994), 13–14.

28. Donald R. Stoltz and Marshall L. Stoltz, *Norman Rockwell and the Saturday Evening Post,* vol. 2 (New York: MJF Books, 1994), 179–180.

29. Donald R. Stoltz and Marshall L. Stoltz, *Norman Rockwell and the Saturday Evening Post,* vol. 3 (New York: MJF Books, 1994), 19–20.

30. Marion Harland, "A Christmas Talk with Mothers," *Godey's Lady's Book and Magazine* (November 1865), 401–402.

31. Marion Harland, "Nettie's Prayer," *Godey's* (December 1865), 486.

32. "The Curse of Christmas," *Independent* (December 18, 1926), 697.

33. "This Xmas $pirit," *Independent* (January 7, 1928), 4.

34. *Collier's* (December 15, 1923), 10, quoted in Barnett, *The American Christmas,* 37.

35. Bell, "There IS a Santa Claus," 49.

36. "Santa Supply," *Literary Digest,* 18.

37. Renzo Sereno, "Some Observations on the Santa Claus Custom," *Psychiatry* (November 1951), 390–392. Ernest Jones, also writing in 1951, was less critical of Santa, noting only that his appearance marked the point when Christmas became a children's or family festival; Ernest Jones, *Essays in Psychoanalysis,* vol. 2 (London: Hogarth Press, 1951), 223–224.

38. Most of *A Christmas Story* was filmed in Canada. Narrated by the humorist Jean Shepherd, who wrote the screenplay from his own novel, the story is supposed to be taking place in Toledo, Ohio.

39. See also a generally unfavorable review, *People* (December 12, 1984), 12, which singles out the Santa scene for praise.

40. David Sedaris, *Holidays on Ice* (New York: Little, Brown, 1997), 8.

41. Penne L. Restad, *Christmas in America: A History* (New York: Oxford University Press, 1995), 162, and Lloyd Wendt and Herman Kogan, *Give the Lady What She Wants!* (New York: Rand McNally, 1952), 368–369.

42. "Mistletoe Mania," *Chicago Tribune Sunday Magazine* (December 24, 1995), 8.

43. See Field's ad, *Chicago Tribune,* November 23, 1961.

44. Chuck Sweeny, "Real Santa to stay at Marshall Field's," *Rockford* (Ill.) *Register Star,* April 24, 1990.

45. "Of Course, There's a Santa Claus," *Dayton News* (December 20, 1947), 17.

46. See "Christmas Everywhere at Dayton's," ca. November 1960, unidentified clipping from company publication, in Dayton Hudson Archive, Minneapolis.

47. "Visit to Santa Brings $17000 Suit," unidentified clipping, June 9, 1948, Dayton Hudson Archive, 02.37.18.011. In 1948, the Boston City Council asked the mayor to ban all Santas but one from the center city area to avoid confusing children; see Daniel J. Boorstin, *The Americans: The Democratic Experience* (New York: Random House, 1973), 160–161.

48. Jones, "Knickerbocker Santa Claus," 360.

49. Immanuel Levy, "From Santa Claus to Santa Stooge," *Life* (December 17, 1951), 32–33.

50. Marc Musacchio, "Santas share their stories," *Minneapolis Star Tribune,* November 26, 1998.

51. Andrea Adelson, "The Beard Is Real. The Joy Is Real. (Shhh: So Is He!)" *New York Times,* December 25, 1994. On the trials of Santas, see Robin Crichton, *Who's Santa Claus? The True Story Behind a Living Legend* (London: Canongate, 1987), 97–98.

52. Ad, "Food for Thought," *Leslie's Weekly* (December 10, 1903), 579.

53. Ad, "An Unexpected Reception," *Leslie's Weekly* (December 16, 1897), 406.

54. Ad for Waterman's pens, *Leslie's Weekly* (December 10, 1903), 584, and *Saturday Evening Post* (December 6, 1902), 27.

55. Ads for Robeson cutlery, *Saturday Evening Post* (December 3, 1910), inside front cover; Campbell's soup (December 24, 1910), 33; York socks (December 3, 1904), 30; spoons (December 2, 1905), 43; Victor gramophone (December 15, 1906), back cover; Rubberset shaving brush (December 7, 1907), 27; and Thermos bottle (December 19, 1908), 23.

56. John S. Babbitt, "Emily Bissell and the Christmas Seal Story," *Stamps* (December 24, 1994), 1, 5; "A Brief History of Christmas Seals," *Stamps* (November 11, 1995), 4.

57. See ad, "Red Cross Seals," *Leslie's Illustrated Weekly Newspaper* (December 3, 1914), 535; "Christmas Seal Your Christmas Mail" (December 3, 1921), back cover; "All Hands for HEALTH for ALL" (December 10, 1921), back cover.

58. A. L. Townsend, "What Has Christmas Done to Another Year of Advertising?" *Printers' Ink* (December 20, 1923), 103–104, 107–108.

59. For cards of the period ca. 1900 to World War I, see Suzanne Presley, ed., *Old-Fashioned Santa Claus Postcards* (New York: Dover, 1990).

60. See Tony van Renterghem, *When Santa Was a Shaman* (St. Paul: Llewellyn Publications, 1995), 52–53; Garrison, *A Treasury of Christmas Stories,*

66–67. On the general subject of advertising and Christmas, see Jack Santino, *New Old-Fashioned Ways: Holidays and Popular Culture* (Knoxville: University of Tennessee Press, 1996), esp. 22.

61. For the 1931 Coke Santa, see *Saturday Evening Post* (December 26, 1931), 1. The position of the full-color ad within the magazine lent great prominence to the beginning of the new Christmas campaign.

62. For the first illustrated edition of the 1822 poem (1843), see Clarence P. Hornung, ed., *An Old-Fashioned Christmas in Illustration and Decoration,* 2nd ed. (New York: Dover, 1975), 114–120.

63. Mark Pendergast, *For God, Country and Coca Cola* (New York: Scribner's, 1993), 181.

64. [Barbara Fahs Charles and Robert Staples], *Dream of Santa: Haddon Sundblom's Vision* (Washington, D.C.: Staples & Charles, 1992), 16. See also Angela Howell, "The Man Who Invented Santa Claus," *Collector's Mart* (November-December 1993), 80–83; Gordon Walek, "Yes, Virginia, Santa really is Pop Art," [Kansas City] *Daily Herald,* December 15, 1990.

65. With words by Haven Gillespie and music by J. Fred Coots, the song was published in 1934. See *Santa Claus Is Comin' To Town* (Atlanta: Coca-Cola Company, 1996), a pop-up book for children mating Sundblom Santas to the lyrics.

66. Ad, Whitman's chocolates, *Saturday Evening Post* (December 24, 1932), 2.

67. Ad, Whitman's chocolates, *Saturday Evening Post* (December 22, 1934), inside front cover. The text suggested sending chocolates to distant friends via parcel post.

68. See *The Coca-Cola Santas* (Memphis: St. Luke's Press, 1990). The Whitman's ads bear the copyright of S. F. W. & Son.

69. See Richard S. Tedlow, *New and Improved: The Story of Mass Marketing in America* (New York: Basic Books, 1990), 22–111.

70. See *Post* covers by J. C. Leyendecker (December 3, 1904), J. C. Leyendecker (December 18, 1909), Harrison Fisher (December 12, 1908), and J. J. Gould and Guernsey Moore (December 6, 1902).

71. See *Post* covers by J. C. Leyendecker (December 4, 1909, and December 7, 1907); and Guernsey Moore (December 23, 1905).

72. See *Post* covers by J. C. Leyendecker (December 3, 1910, and December 7, 1912).

73. J. C. Leyendecker cover, *Saturday Evening Post* (December 27, 1919).

74. For Leyendecker's holiday work, see Roger T. Reed, *J. C. Leyendecker,* unpaginated gallery brochure for an exhibition held at the Norman Rockwell Museum, Stockbridge, Mass., November 8, 1997–May 25, 1998.

75. See, e.g., Kuppenheimer ad from the *Post,* December 2, 1922, in Waits, *The Modern Christmas in America,* 118.

76. See J. C. Leyendecker cover, *Saturday Evening Post* (December 26, 1925).

77. See *Post* covers by Norman Rockwell (December 4, 1920, December 2, 1922, and December 4, 1926).

78. See *Post* covers by Norman Rockwell (December 17, 1921, and December 6, 1924).

79. J. C. Leyendecker cover, *Saturday Evening Post* (December 20, 1930).

80. See George Hinke, *Jolly Old Santa Claus* (Nashville: Candy Cane Press, 1996). The heavy bells of Hinke's Santa are borrowed from Rockwell.

81. Howard Finster, *The Night Before Christmas, Clement C. Moore* (Atlanta: Turner Publishing, 1996), frontispiece.

82. Kenneth A. Lohf, "Clement Clarke Moore and His Christmas Poem," in *A Visit from St. Nicholas by Clement C. Moore, A Facsimile of the Original 1848 Book* (New York: Wanderer Books, 1971), unpaginated.

83. Editor Orville Holley, quoted in Burton Stevenson, *Famous Single Poems and the Controversies Which Have Raged Around Them* (New York: Dodd, Mead, 1935), 54.

84. Jones, "Knickerbocker Santa Claus," 363–368.

85. Alexander J. Wall, Jr., "St. Nicholas at the Society," *New-York Historical Society Quarterly Bulletin* (January 1941), 12.

86. Jones, "Knickerbocker Santa Claus," 377.

87. Lohf, "Clement Clarke Moore," unpaginated.

88. Donald Hall, "Dancer, Dasher, Prancer, and Vixen: Whose Reindeer Are They?" *New York Times Book Review* (December 23, 1984), 18. See also Stevenson, *Famous Single Poems,* 62–63, for an 1862 letter to the New-York Historical Society purporting to include an interview with Moore on the subject of the gardener.

89. Brian McGinty, "Santa Claus," *Early American Life* (December 1979), 103. For the complete set of illustrations from the 1821 book, see Duncan Emrich, "A Certain Nicholas of Patara," *American Heritage* (December 1960), 22–26. This "Santeclaus" has the tall headgear of a bishop or a saint.

90. Stephen Nissenbaum, *The Battle for Christmas* (New York: Knopf, 1996), 76–78.

91. McGinty, "Santa Claus," 103.

92. Henry Litchfield West, "Who Wrote 'Twas the Night Before Christmas'?" *The Bookman* (December 1920), 300–305. "'A Visit from St. Nicholas,'" *St. Nicholas* (January 1875), 160–161, reprints an autograph copy of the poem and accepts Moore as the author without reservation.

93. *A Visit from St. Nicholas . . . A Facsimile of the Original,* unpaginated, contains the Boyd illustrations.

94. Nissenbaum, *The Battle for Christmas,* 78–81

95. For the Darley version of Moore, see *Yankee Doodle's Sampler of Prose, Poetry, & Pictures* (New York: Thomas Y. Crowell, 1974), 168–175.

96. *Quidor* (New York: Brooklyn Museum Press, 1942), 6–8.

97. This work is in the collection of the Munson-Williams-Proctor Institute, Museum of Art, Utica, New York. See also William H. Gerdts, *Robert Weir: Artist and Teacher of West Point* (West Point: Cadet Fine Arts Forum of the U.S. Corps of Cadets, 1976), 17–18, 29.

98. David M. Sokol, *John Quidor: Painter of American Legend* (Wichita: Wichita Art Museum, 1973), 28.

99. Christopher Kent Wilson, "The Life and Work of John Quidor," doctoral dissertation (Yale University, 1982), 162–164.

100. R. W. G. Vail, "Santa Claus Visits the Hudson," *New-York Historical Society Quarterly* (October 1951), 337–338.

101. R. W. G. Vail, "An Encore for Santa Claus," *New-York Historical Society Quarterly* (October 1953), 326–330.

102. See W. Martin, *Jan Steen* (Amsterdam: J. M. Meulenhoff, 1954), unpaginated.

103. Woven through the hood of the cape is a second clay pipe; the painting is in the collection of the New-York Historical Society (gift of George A. Zabriskie, 1951). The Weir Santa was not soon forgotten. It forms the basis for a Christmas puzzle by the artist J. C. Beard; see "Choose Your Christmas Gift," *St. Nicholas* (December 1892), 156–157.

104. Adam Gopnik, "The Man Who Invented Santa Claus," *New Yorker* (December 15, 1997), 84.

105. Thomas Nast, "Santa in Camp," *Harper's Weekly* (January 3, 1863), 1.

106. See Albert Bigelow Paine, *Th. Nast: His Period and His Pictures* (New York: Harper and Brothers, 1904), 96, and J. Chal Vinson, *Thomas Nast: Political Cartoonist* (Athens: University of Georgia Press, 1967), 6.

107. "The Wonders of Santa-Claus," *Harper's Weekly* (December 26, 1857), 820–821.

108. "Santa Claus Paying His Usual Christmas Visit to his Young Friends in the United States," *Harper's Weekly* (December 25, 1858), cover.

109. "Christmas-Day, 1860," *Harper's Weekly* (December 29, 1860), 817.

110. "Christmas Day—Then and Now," *Harper's Weekly* (December 22, 1860), 808.

111. "Santa Claus: Dreams and Reality," *Harper's Weekly* (December 22, 1860), 809.

112. Thomas Nast St. Hill, quoted in Garrison, *A Treasury of Christmas Stories*, 63. See Thomas Nast St. Hill, intro., *Thomas Nast's Christmas Drawings* (New York: Dover, 1978). A large oil painting of Santa by Nast—*Jolly Good Fellow of 1874*—in the collection of the Margaret

Woodbury Strong Museum, Rochester, New York, depicts the Germanic type with a clay pipe and a beer stein. He also wears a brown suit. See General Object Report, *A Jolly Good Fellow,* 77.784, Margaret Woodbury Strong Museum, April 2, 1998.

113. For the use of holly to decorate pictures, see untitled illustration, *Godey's Magazine and Lady's Book* (December 1849), unpaginated.

114. The drum behind Santa on the sleigh may indicate that the boys in the foreground are drummer boys, attached to the military. But toy drums were also popular Christmas gifts for boys throughout the rest of the century.

115. Rebecca Harding Davis, "Some Old-Time Christmases," *Saturday Evening Post* (December 3, 1904), 7, dates a new zeal for Christmas celebrations specifically to the Civil War period and the provision of gifts for soldiers. Socks were one of the earliest manufactured products to come packaged in a decorated box, ready for giving; see ad, Holeproof Hosiery, *Saturday Evening Post* (December 10, 1910), 2. For socks, see also Chapter 1 above.

116. Thomas Nast, "Christmas Eve 1862," *Harper's Weekly* (January 3, 1863), 8–9.

117. As early as 1857, acceptable categories of Christmas toys were apparently fixed; see "Bohemian Walks and Talks," *Harper's Weekly* (November 21, 1857), 804, which lists swords, trumpets, and pistols for boys and dolls for girls.

118. Thomas Nast, "Christmas, 1863," *Harper's Weekly* (December 26, 1863), in Hornung, ed., *An Old-Fashioned Christmas in Illustration and Decoration,* unpaginated.

119. See ad for Automaton Negro Dancer, *Harper's Weekly* (December 17, 1864), 814; "Santa Claus's Wish Council," *Harper's* (December 24, 1864), 823; "The Lesson of Santa Claus," *Harper's* (December 30, 1865), 822. In 1865, General Sherman was shown as Santa in a Union uniform, putting Savannah into Uncle Sam's Christmas stocking in a cartoon predicated on the general's boast that he was giving the city to Lincoln for a Christmas present; see cartoon, *Frank Leslie's Illustrated Newspaper* (January 14, 1865), 272. Nast's "Merry Christmas to All," another Santa scene with Civil War overtones, is also wholly domestic. The late war is suggested by the kinds of toys received by the little boy—a bugle, a toy rifle—and by a comic Christmas pageant being enacted at the bottom of the plate, entitled "Ulysses the Giant Killer," celebrating the political acumen of President Ulysses S. Grant; see Thomas Nast St. Hill, *Thomas Nast's Christmas Drawings,* 21.

120. Thomas Nast, "Santa Claus—His Works," *Harper's Weekly* (December 29, 1866), 824–825. Clement Moore's "A Visit from St. Nicholas" ap-

peared on the next page. In the 1860s, fine artists also took up the Santa theme, following in Weir's footsteps. William Holbrook Beard's undated *Santa Claus* is in the collection of the Rhode Island School of Design. Best known for his animal pictures, Beard showed Santa paintings in public exhibitions in 1863 and 1876.

121. Snyder, *December 25th,* 226.

122. See Charles W. Jones, *Saint Nicholas of Myra, Bari, and Manhattan: Biography of a Legend* (Chicago: University of Chicago Press, 1978), 354–356. The claim for Nast's invention of Santa's North Pole home is advanced vigorously in Thomas Nast St. Hill, *Thomas Nast's Christmas Drawings,* vi.

123. See John Maxtone-Graham, *Safe Return Doubtful: The Heroic Age of Polar Exploration* (New York: Barnes & Noble, 1988), 1–22.

124. "The Wonders of Santa Claus," *Harper's Weekly* (December 26, 1857), 820–821.

125. Thomas Nast, "Hello! Little One!" *Harper's Weekly* (December 20, 1884), 842–843.

126. Thomas Nast, "A Christmas Box," *Harper's Weekly* (December 26, 1885), 856–857.

127. Thomas Nast, "Santa Claus's Route," *Harper's Weekly* (December 19, 1885), 841–842.

128. E. S. Brooks, "The False Sir Santa Claus," *St. Nicholas* (November 1882), 68

129. See unsigned cartoon, "Santa Claus: 'Here's a State of Things! How in the world am I ever to get down there?'" *St. Nicholas* (December 1884), 160, and "Through the Register," *St. Nicholas* (December 1885), 148–149. See also Julie M. Lippmann, "A New-Fashioned Christmas," *St. Nicholas* (January 1890), 265–266, in which the sled, the chimney, and the trees are discarded as outdated.

130. See Charles Perez Murphy, "Instructions to Santa Claus," *St. Nicholas* (December 1901), 140–141; Edwin L. Sabin, "A Christmas Mistake," *St. Nicholas* (December 1902), 98–101; Carolyn Wells, "An Interrupted Auction," *St. Nicholas* (December 1903), 99–102; Pauline Frances Camp, "A Topsyturvy Christmas," *St. Nicholas* (January 1912), 251.

131. See Charles G. Bush, "Santa Claus," *Harper's Weekly* (December 28, 1867), 820, and unsigned illustration, "Old Father Christmas," *Godey's Lady's Book* (December 1867), unpaginated plate.

132. See unsigned illustration, "The Workshop of Santa Claus, 1873," *Godey's Lady's Book* (December 1873), 488. A similar costume appears in the unsigned illustration, "Christmas," *Godey's Lady's Book* (December 1871), 492.

133. Joseph J. Schroeder, Jr., *The Wonderful World of Toys, Games & Dolls, 1860–1930* (Northfield, Ill.: Digest Books, 1971), 13.

134. Unsigned illustration, "Santa Claus at Home—About Time to Start," *Harper's Young People* (December 23, 1879), unpaginated plate.

135. Snyder, *December 25th*, 235; see also *Santa Claus*, an Arts and Entertainment Biography video (1994), in which Bates and Louisa May Alcott are both given credit for Mrs. Santa.

136. Margaret Eytinge, "Mistress Santa Claus," *Harper's Young People* (December 20, 1881), 119.

137. Sarah J. Burke, "Mrs. Santa Claus Asserts Herself," *Harper's Young People* (January 1, 1884), 132.

138. Lucy Larcom, "Visiting Santa Claus," *St. Nicholas* (December 1884), 82–84. See also Edith M. Thomas, "Mrs. Kriss Kringle," *St. Nicholas* (December 1885), 138; "Concerning Mrs. Santa Claus," *Frank Leslie's Weekly* (December 25, 1902), 716.

139. Cobb compares Santa to Andrew Carnegie, robber baron and philanthropist; see Irvin S. Cobb, "Holidays," *Saturday Evening Post* (December 21, 1912), 46. See also Carl Werner, "The Night Before Christmas," *Saturday Evening Post* (December 7, 1907), 18.

140. Michael O. Riley, *Oz and Beyond: The Fantasy World of L. Frank Baum* (Lawrence, Kan.: University Press of Kansas, 1997), 47.

141. L. Frank Baum, *The Life and Adventures of Santa Claus* (New York: Dover, 1976), 32 and passim.

142. Ibid., 166–167.

143. Ibid., 204.

144. Martin Ebon, *Saint Nicholas: Life and Legend* (New York: Harper & Row, 1975), 105, quoting O'Hanlon's later recollections before a group of students from Hunter College.

145. Quoted in Mark Neuzil, "In newspapers we don't trust anymore, Virginia," *Minneapolis Star Tribune*, December 18, 1997.

146. Quoted in Snyder, *December 25th*, 106. Church was not revealed as the author of the editorial until his death in 1906.

147. "Dear Abby: What About Santa?" *Minneapolis Star Tribune*, November 14, 1997.

7. Somebody Else's Christmas

1. These titles are part of a prominent series. See *Christmas in Ireland* (Chicago: World Book Encyclopedia, 1985).

2. Wallace Webster, "Christmas with Royalty," *Saturday Evening Post* (December 2, 1905), 21–22. See also Harold MacFarlane, "Christmas at Court," *Saturday Evening Post* (December 5, 1903), 26.

3. See "The Christmas Tree," *Godey's* (December 1850), 327.

4. Daniel J. Foley, *The Christmas Tree* (Philadelphia: Chilton, 1960), 57–58. Foley notes that Victoria had first seen a Christmas tree in the residence of her Aunt Sophia in 1832, when she was thirteen years old. The custom did not become widespread until the unpopular Albert linked the tree with a special family occasion.

5. The feature consisted of four juxtaposed essays: Gwen Robyns, "Princess Diana: A Royal House Party"; Alex Haley, "Michael Jackson: A Different Kind of Celebration"; Beth Charles, "Elizabeth Taylor: The End of a Tough Year"; and Cliff Jahr, "Dolly Parton: A Down Home Christmas," *Ladies' Home Journal* (December 1984), 126–127, 165, 167, 170, 172.

6. Ethel Merman with George Eells, *Merman* (New York: Simon and Schuster, 1978), 12.

7. Dolly Parton, *Dolly: My Life and Other Unfinished Business* (New York: HarperCollins, 1994), 54.

8. Tammy Wynette with Joan Dew, *Stand By Your Man* (New York: Simon and Schuster, 1979), 22–23.

9. Lana Turner, *Lana* (New York: Dutton, 1982), 155.

10. Christina Crawford, *Mommie Dearest* (New York: William Morrow, 1978), 76–81.

11. Ibid., 82–88.

12. Bob Thomas, *Liberace: The True Story* (New York: St. Martin's, 1987), 159. Jane Stern and Michael Stern, in *The Encyclopedia of Bad Taste* (New York: HarperCollins, 1990), 85, discuss some notable Liberace Christmases.

13. Liberace, *The Things I Love* (New York: Grosset & Dunlap, 1976), unpaginated, and Thomas, *Liberace,* 160.

14. See "Holiday Season of 1908 Most Prosperous Ever Known," *Leslie's Weekly* (January 7, 1909), 15.

15. Harriet Quimby, "How the People Behind the Scenes Spend Christmas," *Leslie's Weekly* (December 12, 1907), 580.

16. Harriet Quimby, "Santa Claus in Stageland," *Leslie's Weekly* (December 9, 1909), 24, 29.

17. See, e.g., Claire H. Gurney, "A Stop-Over Christmas," *St. Nicholas* (December 1908), 148–151, and J. L. Harbour, "Christmas on the Singing River," *St. Nicholas* (December 1902), 113–119.

18. J. H. Woodbury, "Christmas in the Arctic Regions," *St. Nicholas* (January 1876), 157–160.

19. H. H. Bennett, "The Christmas Ship," *St. Nicholas* (December 1897), 126–131.

20. George Wallace Melville, "Christmas in the Ice-Bound Arctic," *Leslie's Weekly* (December 19, 1901), 581, 586.

21. Bret Harte, "How Santa Claus Came to Simpson's Bar," in James Charlton and Barbara Gilson, eds., *A Christmas Treasury of Yuletide Stories and Poems* (New York: Galahad Books, 1976), 126–142.

22. H. H., "Christmas in the Pink Boarding House: A Story of Two Mining Camps," *St. Nicholas* (January 1884), 187–200. The illustration by Mary Hallock Foote on the facing page shows a young woman slumped by the fire, with a heavy outdoor coat crumpled around her. The title: "Away From Home on Christmas-Day."

23. See Leonard M. Prince, U.S.A., "Tim Sheridan and His Christmas Goose," *St. Nicholas* (January 1895), 234–238, and Gwendolen Overton, "Esther's Christmas," *St. Nicholas* (January 1910), 227–231.

24. F. Newell, "Shooting the Wishbone: Christmas in the Far West," *Frank Leslie's Weekly* (December 5, 1891), 291.

25. Charles Russell, "Christmas at the Line Camp," *Leslie's Weekly* (December 8, 1904), 541.

26. Charles Russell, "Christmas Dinner for the Men on the Trail," *Leslie's Weekly* (December 14, 1905), unpaginated plate.

27. Charles Russell, "The Red Man's Christmas Gift," *Leslie's Weekly* (December 13, 1906), 572–573.

28. Remington Schuyler, "Christmas at the Reservation: The Post Trader Giving Popcorn and Candy to the Indian Children," *Leslie's Weekly* (December 9, 1909), unpaginated plate.

29. A variation on the type showed Eastern outdoorsmen trying to approximate the canonical Christmas dinner over a campfire. See A. B. Frost, "Christmas in Camp: Tying Up the Pudding," *Harper's Weekly* (December 12, 1885), supplement, 828–829. Frost was a major figure, best known for his illustrations in the 1895 edition of the Joel Chandler Harris *Uncle Remus* stories.

30. B. West Clinedinst, "Christmas in Different Sections of the United States," *Frank Leslie's Weekly* (December 5, 1891), unpaginated plate.

31. Harriet Prescott Spofford, "Nancy's Southern Christmas," *St. Nicholas* (December 1912), 161–164.

32. A naughty cartoon, "His First Christmas in Hawaii," *Leslie's Weekly* (1898 Christmas issue), 477, shows a Yankee soldier ogled by a bare-breasted maiden in a hula skirt standing under the mistletoe.

33. Ad, Libby's Peerless Plum Pudding, *Saturday Evening Post* (December 22, 1900), inside front cover.

34. Frederick A. Ober, "Christmas in Porto Rico," *Leslie's Weekly* (December 19, 1901), 580.

35. Sibyl Thornton, "Merry Christmas Ideas," *Sunset Magazine* (December 1930), 28.

36. Lester Rowntree, "Let's Use Our Native Greens for Yuletide Decorations,"

Sunset Magazine (December 1930), 9, 11–12; "Christmas Fruit Trees You Make Yourself," *Sunset* (December 1977), 74–75; "You Can Decorate with Succulents," *Sunset* (December 1956), 154.

37. Mimi Pond, "Wanted: Winter," *Los Angeles Times Magazine* (November 23, 1997), 23.

38. Joe Dziemianowicz, "Loni Anderson's California," *McCall's* (December 1996), 46–48.

39. "Luminarias for Holiday Tables," *Sunset* (December 1995), 84–85.

40. Bob Pool, "The Lights Brigade," *Los Angeles Times*, December 19, 1996. L.A., home of the freeway, also seems to have invented the automobile Christmas decoration: see Michael Quintanilla, "Driving Home the Spirit of the Holiday Season," *Los Angeles Times*, December 19, 1989.

41. Amy Pyle, "Neighbors Carry on Tradition of Christmas Tree Lane," *Los Angeles Times*, December 14, 1997.

42. Dade Hayes, "A Friendly Battle for Bragging Rights," *Los Angeles Times*, December 5, 1989.

43. Scott Harris, "Getting with the Holiday Program," *Los Angeles Times*, December 14, 1995.

44. See Don Arturo Dandini, *Navidad: A Christmas Day with the Early Californians* (San Francisco: California Historical Society, 1958), 21; Joseph J. McCloskey and Hermann J. Sharmann, *Christmas in the Gold Fields, 1849* (San Francisco: California Historical Society, 1959), 35; "Daily Life in Early Los Angeles: Holiday Celebrations," *Historical Society of Southern California Quarterly* (June 1954), 125–127.

45. Joe Hendrickson, *Tournament of Roses: The First 100 Years* (Los Angeles: Knapp Press, 1989), 2–8.

46. Bruce T. Torrence, *Hollywood: The First Hundred Years* (New York: New York Zoetrope, 1982), 112.

47. See KTLA TV, Los Angeles (1997), Web page.

48. William Studwell, *The Christmas Carol Reader* (New York: Harrington Park Press, 1995), 175.

49. Actually, Autry co-wrote the 1946 hit with Oakley Haldeman, a local composer.

50. See *Hollywood Christmas Parade, 1996 Celebrity Souvenir Program.*

51. E. M. S., "A Southern Christmas Eve," *St. Nicholas* (December 1876), 183.

52. Alice Maude Ewell, "One Christmas Eve at Master Muffet's," *St. Nicholas* (January 1899), 238–245.

53. Stephen Nissenbaum, *The Battle for Christmas* (New York: Knopf, 1996), 260–261.

54. Jane A. Stewart, "Christmas in the Sunny Southland," *Leslie's Weekly* (December 24, 1903), 618.

55. Tristram Potter Coffin, *The Book of Christmas Folklore* (New York: Seabury

Press, 1973), 45–46. See also Roscoe Conklin Bruce, "Letter to Mrs. Josephine Bruce" (1903), in Paula L. Woods and Felix H. Liddell, *Merry Christmas, Baby: A Christmas and Kwanzaa Treasury* (New York: HarperCollins, 1996), 6–9.

56. B. West Clinedinst, "Christmas Eve on a Louisiana Plantation," *Leslie's Weekly* (1894 Christmas issue), unpaginated plate.

57. W. L. Sheppard, "Christmas in the South—Egg-Nog Party," *Harper's Weekly* (December 31, 1870), 868.

58. W. L. Sheppard, "Holiday Festivities at the South—An Egg-Nogg Party in Richmond, Virginia—The Critical Moment," *Frank Leslie's Weekly* (December 29, 1892), 470.

59. "Winter Holidays in the Southern States: Plantation Frolic on Christmas Eve," *Frank Leslie's Illustrated Newspaper* (December 26, 1857), 64.

60. "Topics and Pictures Fifty Years Ago," *Leslie's Weekly* (December 26, 1907), 628.

61. Nissenbaum, *The Battle for Christmas*, 258–259; *Godey's*, "Christmas in Camp" (December 1864), 477.

62. Thomas Worth, "Preparing for Christmas," *Harper's Weekly* (December 26, 1868), 829.

63. For Eytinge, see Dan Malan, *Charles Dickens' "A Christmas Carol"* (St. Louis: MCE Publishing, 1996), 23.

64. Sol Eytinge, Jr., "Wide Awake—Christmas-Eve," *Harper's Weekly* (December 28, 1872), 1029.

65. Sol Eytinge, Jr., "Christmas-Time—Won at a Turkey Raffle," *Harper's Weekly* (January 3, 1874), 8.

66. Sol Eytinge, Jr., "No Small Breed Fer Yer Uncle Abe Dis Chris'mas! Ain't He a Cherub?" *Harper's Weekly* (January 1, 1876), 5.

67. W. L. Sheppard, "The Christmas Dinner Gone!" *Harper's Weekly* (January 4, 1873), 1.

68. W. L. Sheppard, "The Christmas Dinner Safe," *Harper's Weekly* (January 3, 1874), 5.

69. W. L. Sheppard, "Kitch He Hoof, Marse Grex! Kitch He Hoof!" *Harper's Young People* (December 27, 1887), 141. The picture goes with a story about the holidays in the South written in the same dialect.

70. Robert Hemenway, intro., Joel Chandler Harris, *Uncle Remus: His Songs and His Sayings* (New York: Penguin, 1982), 20. For Harris, Kemble, and Frost, see Simon Bronner, *Following Tradition: Folklore in the Discourse of American Culture* (Logan, Utah: University Press of Utah, 1998), 110–114.

71. A. B. Frost, who created the best-known set of illustrations for the Harris text in 1895, used an authoritative linear style similar to Sheppard's. Sheppard's hunting scene was a perennial favorite. It clearly inspired Charles Graham's "Christmas in the South," *Harper's Young People* (De-

cember 17, 1889), 121, which appeared over the following caption: "Ole Mammy and de Pickaninnies Hab Deir Krismus Turkey Sho' 'Nuff Now."

72. W. L. Sheppard, "Selling Christmas Greens—A Scene in Richmond, Virginia," *Harper's Weekly* (December 25, 1875), 1037. The caption material, printed elsewhere in the magazine ("Christmas Greens," 1050), does not really describe the picture or enlarge on Sheppard's intentions. Sheppard drew the same scene again in 1892: the only thing that changed over the years was the fashionable dress of the holly buyer; see W. L. Sheppard, "Christmas in the South—A Market Scene," *Harper's Young People* (December 13, 1892), 129. The gradual shift of Sheppard's work from *Harper's* to its counterpart for children suggests that Virginia and blacks had become somewhat less pertinent to the interests of the adult readership between the 1870s and early 80s and the 1890s.

73. W. L. Sheppard, "Getting Ready for Christmas," *Harper's Weekly* (December 16, 1882), cover.

74. Walter Satterlee, "Christmas Eve—Getting Ready for Santa Claus," *Harper's Weekly* (December 30, 1876), 1052.

75. Untitled description of pictures, *Harper's Weekly* (December 30, 1876), 1057–1058.

76. "Christmas Morning in Virginia," *Frank Leslie's Illustrated Newspaper* (December 3, 1887), 241.

77. Joseph Becker, "Christmas Eve—A Strong Temptation," *Frank Leslie's Illustrated Newspaper* (1888 Christmas issue), 280.

78. Howard Helmick, "Christmas in the South—Old Mammy's Christmas Cake," *Leslie's Weekly* (December 14, 1893), 386; "Uncle Ned's Dilemma—'How Shall the Christmas Stockings Be Filled?'" (December 13, 1894), 384; "Invoking a Blessing on the Christmas Turkey" (December 24, 1895), 397; and "Old Aunt Sally's Christmas-Eve Ghost Story" (December 24, 1896), 420.

79. R. Eickemeyer, Jr., "The Christmas Turkey," *Leslie's Weekly* (January 2, 1896), 14, above a dialect poem, "Dat Christmas Turkey"; "After the Christmas 'Possum Dinner," *Leslie's Weekly* (December 19, 1901), 571; "Christmas Photo Contest—Ohio and California Divide," *Leslie's Weekly* (December 10, 1903), unpaginated rotogravure page.

80. Zim, "The Chicken's Merry Christmas," *Leslie's Weekly* (December 12, 1907), 579, and "Christmas Among the Southern Pines," *Leslie's Weekly* (December 10, 1908), xxv.

81. Peter J. Ling, *America and the Automobile* (New York: Manchester University Press, 1990), 85.

82. See Paul Greenhalgh, *Ephemeral Vistas: The Expositions Universelles, Great Exhibitions, and World's Fairs, 1851–1939* (New York: Manchester University Press, 1988), 82–111.

83. Robert W. Rydell, *All the World's a Fair: Visions of Empire at American International Expositions, 1876–1916* (Chicago: University of Chicago Press, 1984), 28–29. Rydell also reprints a *Harper's Weekly* plate from 1893, one of several cartoons in the "Zim" manner showing a black family visiting the Chicago Fair of 1893. The picture ridicules their aspirations to move out of the realm of display into the life-style of the average white middle-class American; see 53–54.

84. Rydell, *All the World's a Fair,* 87–88.

85. Greenhalgh, *Ephemeral Vistas,* 99.

86. Lois Marie Fink, *American Art at the Nineteenth-Century Paris Salons* (Washington, D.C.: National Museum of American Art, 1990), 196–213.

87. David Morgan, *Visual Piety: A History and Theory of Popular Religious Images* (Berkeley: University of California Press, 1998), 162.

88. Gabriel P. Weisberg, DeCourcy E. McIntosh, and Alison McQueen, *Collecting in the Gilded Age* (Pittsburgh: Frick Art and Historical Center, 1997), 135–137 and passim.

89. Ken Emerson, *Doo-dah! Stephen Foster and the Rise of American Popular Culture* (New York: Simon & Schuster, 1997), 189–190.

90. Some historians of advertising think that the Coca-Cola Santa Claus is the ultimate Southern Christmas symbol—that the Atlanta-based soft drink company commissioned Haddon Sundblom to create a character so lovable that he would overcome Yankee resistance to drinking cold beverages in the middle of the winter. James B. Twitchell, *Lead Us Into Temptation: The Triumph of American Materialism* (New York: Columbia University Press, 1999), 25.

91. Lagarde(?), "Grand Welcome to Santa Claus," *Leslie's Weekly* (1886 Christmas issue), unpaginated plate.

92. Jane A. Stewart, "Christmas in Foreign Lands," *Leslie's Weekly* (December 22, 1904), 594–595, and "Selections from the Christmas Pictures of the Foreign Illustrated Press," *Leslie's Weekly* (1894 Christmas issue), unpaginated plate.

93. C. F. Bertelli, "Christmas Eve in Naughty Paris," *Leslie's Illustrated Weekly* (1912 Christmas issue), 583, 595.

94. See Esther W. Ayres, "In Paris at Christmastide," *St. Nicholas* (December 24, 1913), 170–171.

95. "Christmas Ceremonies in France—The Visitation of Christkindel and Hans Trapp," *Frank Leslie's Illustrated Newspaper* (January 29, 1859), 130. See also Francis J. Grund, "Christmas and New Year in France and Germany," *Godey's* (January 1848), 6–10, and Margaret Bertha Wright, "Mistle-toe Gathering in Normandy," *St. Nicholas* (December 1878), 117–118. See also Nadine Cretin, *Le Livre de Noël: Fêtes et Traditions de l'Avent à la Chandeleur* (Paris: Flammarion, 1997).

96. John Hay, "Christmas in Spain," *St. Nicholas* (January 1874), 123.

97. Julia S. Tutwiler, "St. Nicholas Day in Germany," *St. Nicholas* (December 1875), 97.

98. Celia Thaxter, "Piccola," *St. Nicholas* (January 1876), 142–143.

99. "Concerning Mrs. Santa Claus," *Leslie's Weekly* (December 25, 1902), 716. See also E. Cavazza, "Christmas in Italy," *Harper's Young People* (December 6, 1887), 94–95.

100. Edith M. Thomas, "Babouscka, A Russian Legend of Christmas," *St. Nicholas* (January 1898), 233–235.

101. Annie C. Kuiper, "St. Nicholas Day in Holland," *St. Nicholas* (January 1897), 253–254.

102. Ella F. Mosby, "Santa Claus's Pony," *St. Nicholas* (December 1896), 132.

103. Demetra Kenneth Brown, "Christmas on the Sea of Marmora," *Leslie's Weekly* (December 13, 1906), 568.

104. Only England seemed genuinely foreign, thanks to unique institutions like the London pantomime shows, staged especially for Christmas, and the fun-house slides or "helter-skelters" installed by London stores for the pleasure of holiday shoppers. Despite the best efforts of Broadway producers, and patronage from an Anglophile elite, the "panto" never caught on in New York, which eventually opted for a Santa Claus parade on Thanskgiving morning instead. "Holiday Sights and Doings in London," *Leslie's Weekly* (December 17, 1908), 641. The British also formed turkey clubs—the forerunners of American Christmas clubs at savings banks. Members put in a small amount every week and received a Christmas turkey in return. Sir Arthur Conan Doyle's "The Blue Carbuncle," a Sherlock Holmes story, is set against the background of such a club. See also Elizabeth Robins Pennell, "London Christmas Pantomimes," *St. Nicholas* (January 1888), 180–189; "Remarkable Scenic Effects of a New York Christmas Pantomime," *Leslie's Weekly* (December 22, 1904), 617.

105. Eleanor Franklin, "A Toyland Without a Christmas," *Leslie's Weekly* (December 8, 1904), 448. See also Adis Dunbar, "O Santa San," *St. Nicholas* (December 1902), 216.

106. Wheeler Sammons, "How They Keep Christmas in Strange Korea," *Leslie's Weekly* (January 7, 1909), 16, 22.

107. Sydney Adamson, "A Christmas Reminiscence of the Campaign in China," *Leslie's Weekly* (December 18, 1902), 693.

108. Karal Ann Marling, "Letter from Japan: *Kenbei* vs. All-American *Kawaii* at Tokyo Disneyland," *American Art* (Spring 1992), 102–103. See also David W. Plath, "The Japanese Popular Christmas: Coping with Modernity," *Journal of American Folklore* (October-December 1963), 309–317, and Jim Stenzel, "Western Christmas—in a Japanese Sense," *Christian Century* (December 24, 1975), 1183–1185.

109. See Janet Shaw, *Kirsten's Surprise: A Christmas Story* (Middleton, Wis.:

Pleasant Company, 1986), 11–21. This volume is Book Three in one story from a series of book sets that constitute the American Girls Collection. Each set tells about Christmas from the point of view of a historical character: a Swedish immigrant girl of the 1850s, a black child seeking freedom during the Civil War, a Victorian girl, and so on. The fact that each set contains such a volume illustrates the ongoing importance of Christmas, especially in the imaginative lives of children.

110. *Christmas in Poland* (Chicago: World Book, 1989), 31–47.

111. Emyl Jenkins, ed., *The Book of American Traditions: Stories, Customs, and Rites of Passage to Celebrate Our Cultural Heritage* (New York: Crown, 1996), 120–126.

112. For a first-hand account of the celebration as it has evolved through the 1970s and 1980s, see Paula L. Woods and Felix H. Liddell, afterword, in Woods and Liddell, eds., *Merry Christmas, Baby*, 181–188.

113. See Stephen M. Feldman, *Please Don't Wish Me a Merry Christmas: A Critical History of the Separation of Church and State* (New York: New York University Press, 1997), 239–242, 281–286.

114. Edwin Markham, "The Grind Behind the Holidays," *Cosmopolitan* (December 1906), 143–150.

115. Rheta Childe Dorr, "Christmas From Behind the Counter," *Independent* (December 5, 1907), 1340–1347.

116. Ibid., 1340.

117. Fannie Hurst, "The Nth Commandment," *Saturday Evening Post* (December 5, 1914), 13.

118. J. M. Golby and A. W. Purdue, *The Making of the Modern Christmas* (Athens, Ga.: University of Georgia Press, 1986), 119–124.

119. Armour and Company ad, *Saturday Evening Post* (December 5, 1942), inside front cover.

120. See Santa ad for Camels, e.g., *Saturday Evening Post* (December 5, 1942), 60.

121. Rolfs' leather goods ad, *Saturday Evening Post* (December 5, 1942), 85.

122. Watch ads, *Saturday Evening Post* (December 12, 1942), 79, 84.

123. See, e.g., "American Christmas," *House Beautiful* (December 1940), 43.

124. Hamilton watch ad, "We shall ride this storm through!" *Saturday Evening Post* (December 12, 1942), 84.

125. Whitman's ad, *Saturday Evening Post* (December 16, 1944), 8.

8. Thinking of You at Christmas

1. See "Movie of the Week: *It's a Wonderful Life*," *Life* (December 30, 1946), 68–73.

2. "Capra's Christmas Carol," *Newsweek* (December 30, 1946), 72.

3. The original 1943–44 edition, published by David McKay, was reissued in the 1950s with illustrations by Rafaello Busoni for use as an elaborate Christmas card.

4. Gianettino and Meredith Advertising (Mountainside, N.J.), *Season's Greetings,* 1982.

5. Octavia Goodbar, "Cards," *Current History* (December 1937), 57.

6. Fridolf Johnson, "Artists' Christmas Cards," *American Artist* (November 1963), 45. The words "Merry Christmas" first appear together in English in a travel book written by Fynes Moryson and published in 1617.

7. George Buday, *The History of the Christmas Card* (London: Rockliff, n.d.), 6–11. There are many editions of this book, including the 1954 volume, published by Spring Books, London.

8. Goodbar, "Cards," 56, written just after the Egley was discovered, accepts it as the first card. Clementine Paddleford, "The Same to You!" *American Home* (December 1935), 9, does not mention it, however.

9. Hal W. Trovillion, *An Adventure in Christmas Cards* (Herrin, Ill.: Trovillion Private Press, 1955), unpaginated. The author was in the business of making booklet-style cards from extracts by famous authors.

10. Bevis Hillier, "Greetings from Christmas Past," *Good Housekeeping* (December 1982), 128.

11. Ernest Dudley Chase, *The Romance of Greeting Cards* (n.p.: Rust Craft Publishers, 1956), 196. Chase reproduces the Pease card.

12. Penne L. Restad, *Christmas in America: A History* (New York: Oxford University Press, 1995), 119, 198–199, makes too much of the trade-card features of the Pease example, quoting a description by Buday, who had not actually seen the card.

13. Nancy Cooper, "Chats on Antiques," *House Beautiful* (December 1929), 728.

14. Paul McPharlin, "Christmas Cards as Popular Art," *Magazine of Art* (December 1945), 317.

15. Lynne Cheney, "You Can Thank Louis Prang for All Those Cards," *Smithsonian* (December 1977), 122.

16. Luna Frances Lambert, "The Seasonal Trade: Gift Cards and Chromolithography in America, 1874–1910," doctoral dissertation (George Washington University, 1980), 152–162.

17. Untitled editorial, *The Nation* (March 3, 1881), 150.

18. Ad, *Harper's Weekly* (December 2, 1876), 978.

19. Quoted in Lambert, "The Seasonal Trade," 156.

20. Edward E. Hale, "Christmas in Boston," *New England Magazine* (December 1889), 366–367.

21. Katherine Morrison McClinton, *The Chromolithographs of Louis Prang* (New York: Clarkson Potter, 1973), 84.

22. The Longfellow and Whittier ("Snowbound") cards are in the Hallmark Historical Collection, Kansas City, Kansas.

23. Richard Bushman, *The Refinement of America: Persons, Houses, Cities* (New York: Vintage, 1992), 284.

24. Louisa May Alcott, excerpt from *Little Women*, Chapter 2, in *Christmas Classics from the Modern Library* (New York: Modern Library, 1997), 52–53.

25. Katherine Martinez, "'Messengers of Love, Tokens of Friendship': Gift-Book Illustrations by John Sartain," in Gerald W. R. Ward, ed., *The American Illustrated Book in the Nineteenth Century* (Winterthur, Del.: Henry Francis duPont Winterthur Museum, 1987), 93.

26. Martinez, "'Messengers of Love,'" 110–111.

27. Ad, *Harper's Weekly* (November 21, 1857), 815.

28. Ad and cartoon, *Harper's Weekly* (November 21, 1857), 816.

29. Ad, *New York Times*, December 14, 1871.

30. Bertha L. Heilbron, "Christmas and New Year's on the Frontier," *Minnesota History* 16 (December 1935), 383.

31. William B. Waits, *The Modern Christmas in America: A Cultural History of Gift-Giving* (New York: New York University Press, 1993), 50.

32. Ad, *Harper's Weekly* (December 29, 1860), 831. See also ad, *Frank Leslie's Illustrated Newspaper* (January 4, 1862), 111.

33. Ad, *Harper's Weekly* (November 15, 1862), 752. See also ad, *Frank Leslie's Illustrated Newspaper* (December 12, 1963), 190.

34. Ads, *Harper's Weekly* (December 27, 1962), 832; ibid. (December 21, 1867), 816.

35. Ads, *Harper's Weekly* (December 6, 1862), 783; ibid. (December 13, 1862), 799. See also "Beautiful Holiday Gifts," *Saturday Evening Post* (December 12, 1903), 16.

36. Ad, *Harper's Weekly* (December 27, 1862), 831.

37. Heilbron, "Christmas and New Year's on the Frontier," 381–383.

38. Eliot Wigginton et al., eds., *A Foxfire Christmas* (Chapel Hill: University of North Carolina Press, 1996), 35–72.

39. Inez McClintock and Marshall McClintock, *Toys in America* (Washington, D.C.: Public Affairs Press, 1961), 57.

40. Leigh Eric Schmidt, *Consumer Rites: The Buying and Selling of American Holidays* (Princeton: Princeton University Press, 1995), 127.

41. Quoted in McClintock and McClintock, *Toys in America*, 144.

42. "Bohemian Walks and Talks," *Harper's Weekly* (November 21, 1857), 804.

43. Gary Cross, *Kids' Stuff: Toys and the Changing World of American Childhood* (Cambridge, Mass.: Harvard University Press, 1997), 21.

44. Sol Eytinge, "Christmas Presents," *Harper's Weekly* (December 30, 1865), 820.

45. "Christmas Toys—A Quiet Hint to Uncle John," *Harper's Weekly* (December 28, 1867), 821.

46. Thomas Nast, "Santa Claus and His Works," *Harper's Weekly* (December 29, 1866), 824–825.

47. Some argue that Jenny Lind paper dolls, in the 1820s, are the first of their kind; see Ruth Freeman and Larry Freeman, *Cavalcade of Toys* (New York: Century House, 1942), 36–7. On paper dolls, see also William C. Ketchum, Jr., *The Collections of the Margaret Woodbury Strong Museum* (Rochester, N.Y.: Margaret Woodbury Strong Museum, 1982), 64–65.

48. McClintock and McClintock, *Toys in America*, 170, 217–221. *Godey's* printed paper dolls in its pages in 1859; see Freeman and Freeman, *Cavalcade of Toys*, 36–38.

49. Lois Rostow Kuznets, *When Toys Come Alive: Narratives of Animation, Metamorphosis, and Development* (New Haven: Yale University Press, 1994), 16.

50. Antonia Fraser, *A History of Toys* (London: Weidenfeld & Nicholson, 1966), 160–167.

51. Joseph J. Schroeder, Jr., ed., *The Wonderful World of Toys, Games, and Dolls, 1860–1930* (Northfield, Ill.: Digest Books, 1971), 40–44.

52. The fascination never ends. See Eliza Putnam Heaton, "In Toyland where the Children's Playthings Are Made," *Saturday Evening Post* (December 24, 1898), 411, and J. A. Goodman and Albert Rice, "Mother, Buy Me That!" *Saturday Evening Post* (December 15, 1934), 16–17. See also "Where Santa Claus Gets All His Toys," *Leslie's Illustrated Weekly* (December 22, 1900), unpaginated picture story.

53. Doll Supplement, *Frank Leslie's Illustrated Newspaper* (January 3, 1891), 421–424.

54. Florence E. Nosworthy, "Christmas, the Children's Favorite Festival," *Leslie's Weekly* (December 13, 1906), 569.

55. B. M. B., "The Dolls' Baby-Show," *St. Nicholas* (January 1880), 199–204.

56. "A Dolls' Reception," *Harper's Young People* (December 28, 1880), 132–133.

57. Theodate L. Smith, ed., *Aspects of Child Life and Education by G. Stanley Hall* (Boston: Athenaeum Press, 1912), 180.

58. Freeman and Freeman, *Cavalcade of Toys*, 82–83.

59. Mary Lynn Stevens Heininger, "Children, Childhood, and Change in America, 1820–1920," in *A Century of Childhood, 1820–1920* (Rochester, N.Y.: The Margaret Woodbury Strong Museum, 1984), 15.

60. Bill Brown, *The Material Unconscious: American Amusement, Stephen Crane, and the Economies of Play* (Cambridge, Mass.: Harvard University Press, 1996), 169. See also Constance Eileen King, *The Encyclopedia of Toys* (New York: Crown, 1978), 44.

61. Ad, R. H. Macy & Co., *New York Times*, December 23, 1874.

62. Ad, Remington Repeating Arms Co., *Saturday Evening Post* (December 8, 1917), 797; ad, Ives trains, *Saturday Evening Post* (December 6, 1924), 215; ad, Ingersoll Dollar Watch, *Saturday Evening Post* (December 3, 1904), inside front cover.

63. Ad, American Mechanical Toy Co., *Saturday Evening Post* (December 7, 1912), 57.

64. Kendrick Ferris, "Vida's Gray Muff," *St. Nicholas* (December 1906), 161–163. See also ad, Ladies' Supply Co., *Saturday Evening Post* (December 3, 1898), 368.

65. Ad, Cycle Trades of America, *Saturday Evening Post* (December 13, 1930), 95.

66. Ad, Toy Manufacturers of the U.S.A., *Saturday Evening Post* (December 20, 1919), 72.

67. *Sears Christmas Book* (Chicago: Sears, Roebuck, 1939), 30–81.

68. See Edward Bok, "Are We Fair to Our Children at Christmas?" *Ladies' Home Journal* (December 1902), 18, and John Burroughs, "Corrupting the Innocents," *Independent* (December 13, 1906), 1424–1425.

69. Untitled editorial, *Harper's Weekly* (January 4, 1868), 1.

70. "Christmas Gifts," *New York Times*, December 25, 1872.

71. "Christmas Gifts for Men," *New York Times*, December 21, 1878. See also "Christmas Is Coming," *New York Times*, December 17, 1876; S. Annje Frost, "Little Shops—A Christmas Story," *Godey's Lady's Book and Magazine* (December 1871), 541.

72. "Christmas Gifts for Men," *New York Times*, December 21, 1878.

73. Sheila K. Johnson, "Sociology of Christmas Cards," *Trans-Action* 8 (January 1971), 27–29; Sheila K. Johnson, "The Christmas Card Syndrome," *New York Times Magazine* (December 5, 1971), 38–39, 147–149, 151, 154, 158, 163; Phillip R. Kunz, "Season's Greetings: From My Status to Yours," *Social Science Research* 5 (1976), 269–278.

74. Anne Warner, "Billy's Mama's Christmas Present," *St. Nicholas* (January 1904), 226–227.

75. M. B. M., "Chips From a Yule Log: Christmas Suggestions for City Girls," *Harper's Young People* (December 14, 1886), 102; see also Mary V. Worstell, "The Month Before Christmas," *St. Nicholas* (November 1889), 89–91.

76. "Christmas Giving," *New York Times*, December 24, 1879.

77. Ibid.

78. Carroll Townsend, "Christmas Then and Now," *Leslie's Weekly* (December 12, 1912), unpaginated.

79. "Gifts," *New York Times*, December 23, 1876.

80. "Your Wife's Christmas Gift," *Saturday Evening Post* (December 7, 1907), 16.

81. Harvey Green, *The Light of the Home: An Intimate View of the Lives of Women in Victorian America* (New York: Pantheon, 1983), 14–15. See also ad, Waterman's Ideal Fountain Pen, *Leslie's Weekly* (December 8, 1910), unpaginated.

82. Lillian Bell, "Those Gifts You Get and the Art of Giving Other Ones," *Saturday Evening Post* (December 2, 1905), 20.

83. Mrs. Wilson Woodrow, "The Humors of Christmas," *Good Housekeeping* (December 1911), 749.

84. H. I. Phillips, "I'm Strong for Christmas, But—" *American Magazine* (December 1924), 178–179.

85. "Your Home, The Choosing of Christmas Gifts," *Saturday Evening Post* (December 21, 1907), 23.

86. Edwin L. Sabin, "Cards or Gifts? Our Annual Christmas Farce," *American Magazine* (December 1915), 44–45, 85.

87. George Buday, *The Story of the Christmas Card* (London: Odhams Press, 1951), 10; Frida Davidson, "How Our Christmas Customs Came," *Natural History* (November 11, 1928), 618–619; Chase, *The Romance of Greeting Cards,* 10–11.

88. "Gifts Which Embarrass: A Protest from Men," *Good Housekeeping* (December 1910), 653–658.

89. William J. Peterson, "Postcard Holiday Greetings," *The Palimpsest* (December 1967), 570–571.

90. Lambert, "The Seasonal Trade," 27–28.

91. Chase, *The Romance of Greeting Cards,* 189–213.

92. Quoted in Lambert, "The Seasonal Trade," 29.

93. R. W. Hicks, "Advertising Helped Quintuple Greeting Card Sales," *Printers' Ink* (April 14, 1927), 160–161, 164.

94. Ad, A. M. Davis Co., *Saturday Evening Post* (December 7, 1912), 51.

95. Ad, P. F. Volland & Co., *Saturday Evening Post* (December 7, 1912), 55.

96. Ad, A. M. Davis Co., *Saturday Evening Post* (December 6, 1913), 43.

97. George Meredith, *When What to My Wondering Eyes* (Santa Monica, Calif.: Smart Art Press, 1997), 34–35.

98. Mary Evans Seeley, *Season's Greetings From the White House* (New York: Mastermedia, 1996), 23–24.

99. Robert D. Heinl, "'Uncle Sam' the Greatest Santa of Them All," *Leslie's Illustrated Weekly Newspaper* (December 4, 1913), 540. Those "dead letters" to Santa were often distributed to charities which attempted to provide gifts for the needy.

100. "Growth of One of the World's Greatest Post-Offices," *Leslie's Weekly* (January 3, 1907), 13.

101. Ad, Holeproof Hosiery, *Saturday Evening Post* (December 16, 1905), 28.

102. Ad, Holeproof Hosiery, *Saturday Evening Post* (December 9, 1911), 2.

103. Ad, Notaseme Hosiery, *Saturday Evening Post* (December 9, 1911), 61.

104. Ad, Everwear Hosiery, *Saturday Evening Post* (December 2, 1911), 73.

105. See ads in the *Saturday Evening Post:* President Suspenders (December 5, 1908), 35; Conklin's Fountain Pens (December 5, 1908), 53; Parker Fountain Pens (December 3, 1910), 31; Roberson Cutlery (December 3, 1910), inside front cover; Brighton Garters (December 3, 1910), 32; Shawknit Socks (December 9, 1911), 28; Iron Clad Socks (December 9, 1911), 50; Boston Garters (December 7, 1912), 50; O-Cedar Mops (December 7, 1912), 52; Black Cat Hosiery (December 6, 1913), 34. Similar ads appeared in the *Ladies' Home Journal.*

106. "Check-Points for Christmas," *Printers' Ink* (September 3, 1936), 83.

107. John Allen Murphy, "How Manufacturers Are Getting Their Goods into Santa Claus' Pack," *Printers' Ink* (November 2, 1922), 17.

108. John Burt Hardee, "'Twas the Month Before Christmas," *Printers' Ink* (November 28, 1929), 149; A. L. Townsend, "What Has Christmas Done to Another Year of Advertising?" *Printers' Ink* (December 20, 1923), 1104.

109. Oscar De Camp, "Gillette Blade Package Becomes $5 Gift Item," *Printers' Ink* (December 27, 1928), 57–58. For the ad, see *Saturday Evening Post* (December 14, 1929), 156.

110. Hardee, "'Twas the Month Before Christmas," 68.

111. Schmidt, *Consumer Rites,* 184–189.

112. "This Xmas $pirit," *Independent* (January 7, 1928), 4.

113. "The Curse of Christmas," *Independent* (December 18, 1926), 697.

114. "Religious Cards for Christmas," *Literary Digest* (September 8, 1923), 35.

115. Paddleford, "The Same to You!" *American Home,* 64.

116. Jules Freedman, "Merry Christmas," *Printers' Ink* (January 5, 1928), 11. For a kind of religious/business card, personalized with a photo of the Lutheran dignitary who sent it, see B. Spear, "The Angel and the Shepherds," *History of Photography* 8 (April-June 1984), 146. In the 1940s, religious groups were still insisting that if their members demanded religious cards, dealers would stock them: see Auleen Bordeaux Eberhardt, "Religious Christmas Cards," *Catholic World* (October 1940), 96–97.

117. Lou W. McCulloch, *Paper Americana: A Collector's Guide* (San Diego: A. S. Barnes, 1980), 59.

118. R. Randolph Karch, "Printing Christmas Cards in the School Shop," *Industrial Arts and Vocational Education* 18 (December 1929), 460.

119. Frances Wyman Mohr, "Gala Christmas Cards You Can Make," *Better Homes and Gardens* (November 1932), 44.

120. Gretchen Harshbarger, "Cards by You," *Better Homes and Gardens* (December 1935), 14. See also Mary Bell Merritt, "Leaden Alloy Christmas Cards," *School Arts Magazine* 37 (November 1937), 72–73; Edith M. Jewell, "Camel Christmas Card," *School Arts Magazine* 39 (September

1939), 34; May Lillian Lampe, "Brilliant Colored Christmas Cards," *Industrial Arts and Vocational Education* 28 (November 1939), 375–376.

121. "Christmas Cards," *Time* (November 18, 1940), 58.

122. Elizabeth Gordon, "What You Can Do With Your Best Christmas Cards," *Good Housekeeping* (January 1941), 85.

123. "Christmas Cards," *New Yorker* (November 2, 1940), 48.

124. "Merry Christmas," *Newsweek* (October 25, 1943), 80; "Greetings to All," *Business Week* (November 21, 1942), 92.

125. Jack Harrison Pollack, "Cards That Fight Disease," *Today's Health* 39 (December 1961), 38; Johnson, "The Christmas Card Syndrome," 148.

126. "Good Deed Christmas Cards," *Good Housekeeping* (November 1961), 134.

127. "Christmas Cards," *Consumer Reports* (October 1960), 541. See also "In the Cards," *Newsweek* (December 20, 1948), 80, for early examples of Madonna cards from the Metropolitan Museum of Art, New York.

128. "Sentimental Profits," *The Economist* (December 22, 1984), 68. See also Diana Serra Cary, "Christmas Cards with Soft-Sell," *Catholic World* (December 1959), 174–175, 177–179; Billee Eckert Martin, "Our Christmas Cards Should Honor Christ," *America* (March 21, 1953), 678–680.

129. "Christmas Card Blast," *America* (December 23, 1961), 409.

130. See Santa designs for 1952, 1953, and 1957, Hallmark Historical Collection and Archives, Kansas City, Missouri.

131. "Santa Takes a Holiday," *Design* (November 1955), 60.

132. "Christmas Card Design," *Design* (December 1948), 7–8, 19.

133. "A Card for Every- and No-Taste," *Time* (December 6, 1976), 73–74; "Christmas in a Black Hue," *Black Enterprise* (December 1983), 34.

134. Wolf Von Eckardt, "Mirroring American Taste," *Time* (December 14, 1981), 57–58.

135. Thomas Kinkade and Philippa Reed, *Paintings of Radiant Light* (New York: Abbeville, 1995), 19.

136. Ibid., 20–22.

137. Molly Rockwell, ed., *Norman Rockwell's Christmas Book* (New York: Harry N. Abrams, 1977).

138. Karal Ann Marling, *Norman Rockwell* (New York: Harry N. Abrams, 1997), 146–147. There are other precedents for Kinkade's style, including the work of Aston Knight, an American who painted abroad in the early twentieth century, and whose speciality was the cozy cottage enhanced by light effects. Given Kinkade's interest in Victorian sentimentality, it is entirely possible that he could have seen some of Knight's work. Terry Redlin, a South Dakota wildlife artist who has turned to evocative architectural scenes, is also a one-man nostalgia industry: see

Keith G. Olson, *Terry Redlin: Master of Memories* (Bloomington, Minn.: Hadley House, 1997).

139. Ad for a light-up resin sculpture of a Kinkade house in *USA Weekend* (January 1–2, 1999), unpaginated picture spread. With battery-powered lights in the windows, the 3¼-inch house was available for three easy payments of $16.65 each, plus tax and shipping.

140. Kinkade and Reed, *Paintings of Radiant Light,* 181.

141. Anne Christian Buchanan, ed., *Thomas Kinkade: I'll Be Home for Christmas* (Eugene, Oreg.: Harvest House, 1997).

142. Jack Harrison Pollack, "Answers to Your Christmas Card Questions," *Today's Health* (December 1961), 41, 70–71.

143. "High-tech Christmas cards," *Fortune* (January 7, 1985), 10–11.

144. Tad Friend, "Wishing It Was Just the Thought: The Business of Christmas Cards," *Harper's* (December 1987), 68–69; John Gross, "The Season's Greetings," *New Statesman* (December 28, 1962), 935.

9. Dreaming of a White Christmas

1. Jack Santino, *New Old-Fashioned Ways: Holidays and Popular Culture* (Knoxville: University of Tennessee Press, 1996), 33–34, 45.

2. Leigh Eric Schmidt, *Consumer Rites: The Buying and Selling of American Holidays* (Princeton: Princeton University Press, 1995), 292. Many film reviewers commented on the "cute calendar business" with the animated turkey.

3. The President's hobby was spotlighted by *Life* in 1940; see Mary Evans Seeley, *Season's Greetings from the White House* (New York: Mastermedia, 1996), 45–46, who notes that FDR had more than 3,000 cards at that date, including the kinds of patriotic cards that tended to appear in times of war.

4. "Berlin's 14 Ditties, Tops For Any Tunepic," *Variety,* October 22, 1941.

5. Review of *Holiday Inn, Variety,* June 17, 1942. See also William Studwell, *The Christmas Carol Reader* (New York: Harrington Park Press, 1995), 204.

6. Paramount ad section, *Variety,* June 17, 1942.

7. Frank Thompson, *Great Christmas Movies* (Dallas: Taylor Publishing, 1998), 109. See also Barbara Salsini, *Irving Berlin* (Charlottesville, N.Y.: Santtar Press, 1972), 27.

8. Dave Marsh and Steve Propes, *Merry Christmas, Baby: Holiday Music from Bing to Sting* (Boston: Little, Brown, 1993), 6–7.

9. Ibid., 7.

10. The sheet music was published and copyrighted by Irving Berlin, Inc., 799 Seventh Avenue, New York, in 1942.

11. On the other hand, the 1954 *White Christmas,* for which the song provides the title, does open in sunny Florida; the cast assembles there and then leaves for Vermont in search of snow. But the opening lines of the song are not restored.

12. Richard R. Lingeman, *Don't You Know There's a War On?* (New York: G. P. Putnam's, 1970), 214.

13. Joseph Murrells, *Million Selling Records, From the 1900s to the 1980s* (New York: Arco Publishing, 1984), 35. The Elton John statistic is cited in Jimmy Johnson's syndicated comic strip, "Arlo 'N' Janis," for December 9, 1997. "Don't lecture me about the holiday spirit!" Arlo tells Janis. "I'm the one who got mad when that Princess Diana thing outsold *White Christmas!*"

14. Laurence J. Zwisohn, *Bing Crosby: A Lifetime of Music* (Los Angeles: Palm Tree Library, 1978), 48, quoting backup singer Ken Darby.

15. Ibid., 48.

16. David Ewen, *American Songwriters* (New York: H. W. Wilson, 1987), 38.

17. See "Jingle Bells or the One Horse Open Sleigh," in Richard Jackson, ed., *Popular Songs of the Nineteenth Century* (New York: Dover, 1976), 93–96, and Ken Emerson, *Doo-dah! Stephen Foster and the Rise of American Popular Culture* (New York: Simon and Schuster, 1997), 161. Crosby recorded "Jingle Bells" again, with the Andrews Sisters, in 1943.

18. Decca ad, *Saturday Evening Post* (December 5, 1942), 75.

19. Stromberg-Carlson ad, *Saturday Evening Post* (December 18, 1943), 65.

20. For the ubiquitous Barrymore performance (also available on records), see a "Hazel" cartoon, *Saturday Evening Post* (December 23, 1943), 30, in which the maid is telling a bedtime story to a child: ". . . and then Tiny Tim says to Lionel Barrymore." The Coleman Scrooge was available on the Decca label; see ad, *Life* (December 14, 1942), 115.

21. Studwell, *The Christmas Carol Reader,* 205.

22. Christmas anxiety is a new cottage industry for therapists and gurus: see Elaine St. James, *Simplify Your Christmas* (Kansas City: Andrews McMeel, 1998), and Alana Baroni with Vicki Webster, *Simplify the Holidays: How to Enjoy the Season Without the Stress* (Pleasantville, N.Y.: The Reader's Digest Association, 1998).

23. Salsini, *Irving Berlin,* 27.

24. Patricia Jobe Pierce, *The Ultimate Elvis: Elvis Presley Day by Day* (New York: Simon & Schuster, 1994), 149.

25. William E. Studwell, "A Commentary on the English Carol: A Partial History of American Christmas Carols," *American Organist* 24 (December 1990), 63.

26. Based on a story developed by Robert L. May for a Montgomery Ward ad promotion in 1939, "Rudolph" was written by May's brother-in-law,

Johnny Marks, and first recorded by Gene Autry. See Barbara Rowes, "Johnny Marks Has Made Millions Off 'Rudolph' But the Songwriter Still Says Humbug," *People* (December 22, 1980), 110–111.

27. John McCarten, untitled review, *New Yorker* (October 23, 1954), 162.

28. "White Christmas," *Time* (October 25, 1954), 87. The dislike was almost unanimous, although critics disagreed about what was wrong with the movie. *Newsweek,* for example, focused only on the evocations of World War II, calling it a "dated, sentimental story": "White Christmas," *Newsweek* (October 11, 1954), 110.

29. "Picture Grosses," *Variety,* November 3, 1954.

30. The trend began slowly, in the early 1940s, with cartoon-style ads for Kleenex and gasoline, and blossomed after World War II: see, e.g., *Saturday Evening Post* (December 20, 1941, 75; December 5, 1945, 5; and December 27, 1947, 13).

31. Charles Wolfe, album notes for *Elvis Presley: If Every Day Was Like Christmas* (RCA Records), remastered version, 1994.

32. Karal Ann Marling, *Graceland: Going Home with Elvis* (Cambridge, Mass.: Harvard University Press, 1996), 148.

33. John J. O'Connor, "O Holy Rating: A Television Christmas," *New York Times,* December 19, 1993.

34. Vincent Terrace, *Television Specials: 3,201 Entertainment Spectaculars, 1939–1993* (Jefferson, N.C.: McFarland, 1995), 46, 52, 87, 137, 219, 322.

35. Bill Cotter, *The Wonderful World of Disney Television: A Complete History* (New York: Hyperion, 1997), 37.

36. John J. O'Connor, "Christmas With Everyone From Garland to Belushi," *New York Times,* December 19, 1990.

37. George W. Woolery, *Animated TV Specials* (Metuchen, N.J.: Scarecrow Press, 1989), 69.

38. Neil Morgan and Judith Morgan, *Dr. Seuss and Mr. Geisel* (New York: Random House, 1995), 194.

39. Thomas A. Burns, "Dr. Seuss' *How the Grinch Stole Christmas:* Its Recent Acceptance into the American Popular Christmas Tradition," *New York Folklore* (Winter 1976), 195.

40. "*The Grinch*—It Not Only Stole Xmas But Picked CBS' Pocket for $315,000," *Variety,* October 5, 1966. A stage version opened at the Children's Theatre Company in Minneapolis in 1994; Ted Simons, "Designing Dr. Seuss," *American Theatre* 11 (1994), 10–11.

41. Dr. Seuss, *How the Grinch Stole Christmas!* (New York: Random House, 1957), unpaginated.

42. Untitled interview with Geisel, *U.S. News and World Report* (April 14, 1986), 69.

43. Morgan and Morgan, *Dr. Seuss and Mr. Geisel,* 137–138. See also Susan B.

Thistlethwaite, "Dr. Seuss: Getting Christmas Back," *Christianity and Crisis* (December 16, 1991), 379.

44. James Martin, "A Christmas Video Hall of Fame," *America* (December 16, 1955), 22.

45. A. J. Jacobs, "Their stocking is empty," *Entertainment Weekly* (December 22, 1995), 16.

46. Woolery, *Animated TV Specials*, 165, identifies four Christmas animated classics: *Frosty, Rudolph*, the *Grinch*, and *A Charlie Brown Christmas*. Others would probably include *The Little Drummer Boy* (1967), also from Rankin/Bass.

47. Gary Cross, *Kids' Stuff: Toys and the Changing World of American Childhood* (Cambridge, Mass.: Harvard University Press, 1997), 162–171.

48. Woolery, *Animated TV Specials*, 54.

49. Ibid., 361; Terrace, *Television Specials*, 356–357.

50. Ruth Freeman and Larry Freeman, *Cavalcade of Toys* (New York: Century House, 1942), 24. See also Sydney Ladensohn Stern and Ted Schoenhaus, *Toyland: The High Stakes Game of the Toy Industry* (Chicago: Contemporary Books, 1990), 142–143.

51. Katharine Morrison McClinton, *The Chromolithographs of Louis Prang* (New York: Clarkson N. Potter, 1973), 84.

52. F. S. Church, "A Christmas Fantasy," *Harper's Weekly* (December 12, 1885), 816–817.

53. "The wind is chill; but let it whistle as it will, we'll keep our Merry Christmas still," *Harper's Young People* (December 15, 1885), 101.

54. Antonia Fraser, *A History of Toys* (London: Weidenfeld & Nicholson, 1966),181–183.

55. See undated press release, ca. October 17, 1986, "The People Behind *Santabear's First Christmas* Book and Television Special," Dayton Hudson Corporate Archives, Minneapolis.

56. Undated list, ca. October 1986, "Santabear Private Label Products," Dayton Hudson Archives.

57. Memo, "Christmas Media Package," Barbara Grigsby to 22 corporate executives (October 17, 1986), 4 pp.; Dayton Hudson Corporate Archives.

58. Woolery, *Animated TV Specials*, 360.

59. These other characters have spawned their share of merchandise, from radios to coloring books; see Annie North Bedford, *Frosty the Snow Man* (New York: Barnes and Noble, 1997), a reissue of an earlier book illustrated by Golden Book stalwart Corinne Malvern and based on the 1950 song. "Frosty the Snowman was born in 1950 as the subject of a phonograph record, and soon after appeared in many different forms," says the explanatory note on the inside cover. "He has been in numerous Thanksgiving Day and Christmas Parades." Dayton Hudson's discount

subsidiary, Target (the entire company changed its name to Target in 2000), has created a new Christmas character using the blueprint for the Santabear campaign; called Snowden, he is clearly based on Frosty.

60. See Jeremy Gerard, "TV Perennials Bring Holiday Cheer and Profits," *New York Times*, December 25, 1989.

61. "TV's Star Dims On Holidays," *New York Times*, December 24, 1992.

62. See Jay E. Rosen, "TV's Beginning to Look a Lot Like Christmas," *New York Times*, December 1, 1991; "Christmas week not merry for webs as their numbers hit lowest point," *Variety*, January 3, 1990; Bruce Fretts, "The Week," *Entertainment Weekly*, December 16, 1994, 56; Thomas Walsh, "A Christmas Traditional," *Variety*, November 7–13, 1994, 29, 35.

63. See Barbara Shulgasser, "Arnold: Don't Toy With Us," *San Francisco Examiner*, November 22, 1996.

64. David Chute, "Dante's Inferno," *Film Comment* (June 1984), 22–27. See also David Ansen, "Little Toyshop of Horrors," *Newsweek* (June 18, 1984), 90, 92.

65. Lawrence O'Toole, "A nasty visit from charming devils," *McLean's* (June 4, 1984), 48.

66. Roger Ebert, "*Die Hard*," *Chicago Sun-Times*, July 15, 1988.

67. See, e.g., Jennifer Jordan, *Murder Under the Mistletoe* (New York: Worldwide, 1998); Valerie Wolzien, *Deck the Halls with Murder* (New York: Fawcett Gold Medal, 1998); Ellen Hart, *Murder in the Air* (New York: Ballantine Books, 1997); Lydia Adamson, *A Cat on Jingle Bell Rock* (New York: Signet, 1997); Lee Harris, *The Christmas Night Murder* (New York: Fawcett Gold Medal, 1994); Mary Higgins Clark, *Silent Night* (New York: Pocket Star Books, 1995). And the list goes on. Jane Haddam, *A Stillness in Bethlehem* (New York: Bantam, 1992), a Gregor Demarkian holiday mystery, is one of the few books that actively engages the rites of the season in the commission of a crime and its solution. More recently, romance fiction has also appeared in Christmas covers: see Victoria Alexander, Sandra Hill, Darla Joy, and Nelle McFather, *The Night Before Christmas* (New York: Love Spell, 1996).

68. See, e.g., Theodore Caplow, "Christmas Gifts and Kin Networks," *American Sociological Review* 47 (1982), 383–392, and "Rule Enforcement with Visible Means: Christmas Gift Giving in Middletown," *American Journal of Sociology* 89 (1984), 1306–1323. See also Theodore Caplow, Howard M. Bahr, Bruce A. Chadwick, Reuben Hill, and Margaret Holmes Williamson, *Middletown Families: Fifty Years of Change and Continuity* (Minneapolis: University of Minnesota Press, 1982), 234.

69. James G. Carrier, "The Rituals of Christmas Giving," in Daniel Miller, ed., *Unwrapping Christmas* (Oxford: Clarendon Press, 1993), 60.

70. Adam Kuper, "The English Christmas and the Family," in Miller, ed., *Unwrapping Christmas*, 171.

71. *Mrs. Santa Claus* (1996), a made-for-TV movie musical with Angela Lansbury, is not a major contribution to Christmas history, but it does justify the emergency intervention of a woman in the holiday because she is Santa's wife.

72. The 1949 version of *Little Women* (MGM) featured Elizabeth Taylor as Amy; Winona Ryder starred as Jo in the 1994 version, released by Columbia.

73. *Christmas in Connecticut* (1945) was a major hit when it was released; Barbara Stanwyck starred as the "Diary of a Housewife" columnist forced to cook and decorate for Christmas.

74. *Come to the Stable*, which the director described as "a little nun fairy tale," reflected Clare Booth Luce's conversion to Catholicism. Although it is seldom shown on television today, it garnered seven Oscar nominations.

75. Karal Ann Marling, *George Washington Slept Here: Colonial Revivals and American Culture, 1876–1986* (Cambridge, Mass.: Harvard University Press, 1988), 44. See also Steven D. Hoelscher, *Heritage on Stage: The Invention of Ethnic Place in America's Little Switzerland* (Madison: University of Wisconsin Press, 1998), 102.

76. Tradition itself is a slippery concept, of course. Is it folklore, false memory, wish, or fact? Or all of the above? See Simon J. Bronner, *Following Tradition: Folklore in the Discourse of American Culture* (Logan, Utah: Utah State University Press, 1998), 1–8.

77. Karal Ann Marling, *Norman Rockwell* (New York: Harry N. Abrams, 1998), 102–103.

78. See J. C. Suarès, ed., *Hollywood Christmas* (Charlottesville, Va.: Thomasson-Grant, 1994), 36, 48, 50.

79. For the George Balanchine *Nutcracker*, see Daniel Pool, *Christmas in New York* (New York: Seven Stories Press, 1997), 94–98. This is a perennial favorite of dancing schools and amateur companies. It has also been performed recently by touring ice shows starring various champion skaters. For *Amahl*, see Alan Dundes, "Christmas as a Reflection of American Culture," *California Monthly* (December 1967), 13.

80. Homer's "A Merry Christmas and a Happy New Year" (*Harper's Weekly*, December 24, 1859, 824) is in the collection of the Minneapolis Institute of Arts.

ACKNOWLEDGMENTS

One last, crucial Christmas ritual remains: sending thank-you notes to distant friends and relatives, in which gifts are praised for their special merits. The hideous blue sweater—my favorite shade. The calculator that remembers addresses and plays an annoying tune on the hour—just what I always needed. In the case of the people who helped me gather ideas and materials about Christmas for this book, however, my gratitude is absolutely sincere.

Lindsay Waters and Aida Donald of Harvard University Press made encouraging noises when I proposed the topic over lunch, almost five years ago. Mary Ellen Geer edited the book with good sense and good cheer. Zachary Taylor, Charles Eldredge, and Michael Stern offered helpful comments on the manuscript.

At various times and places, Adam Harris, Todd Rowan, Terra Rathai, Kim Lacroix, and Hawon Ku Kim of the University of Minnesota served as graduate research assistants on the project. A McKnight Research Award from the university sustained us all for three years.

Michael Hancher, Associate Dean, College of Liberal Arts, University of Minnesota, kindly shared with me his work on *A Christmas Carol* as an artifact and a commodity.

ACKNOWLEDGMENTS

At the beginning of 1998, just after Christmas, I taught a seminar for undergraduates (and a few graduate students) on research methods in material culture; we used Christmas as our thematic focus. The students in that class—Heather Bjorgan, Jeanne Gohlke, Elizabeth Johnson, Jennifer Koontz, Kim Lacroix, Katie Larson, Nance Longley, Nicole Mohns, and Libby Nickel—did extraordinary work on a series of difficult problems. Their insights and their data have been helpful at every stage in the final preparation of the manuscript. (And a nice young man, who didn't leave his name, came for a couple of classes, dropped out, but sent me three boxes of amazing slides of the "Holidazzle" Christmas parade in downtown Minneapolis.)

Michael Kammen organized a symposium—"Popular Culture: America and the World"—at the Woodrow Wilson Center in the fall of 1998 at which I first presented some of my musings about Christmas. I benefited from the insightful commentary of Michael Schudson and from the enthusiasm of the audience. Larry Bird, of the Museum of American History, Smithsonian Institution, a Christmas-tree-ornament buff, was particularly inspirational. He also sent me, as a Christmas present, a pair of rare plastic whirly-gig ornaments that spin around when exposed to the heat of a light bulb on the tree. What a great gift!

In Minneapolis, Colleen Sheehy, Ellen Zissler, and Steve Benson variously shopped with me for old Christmas items, lent slides, or collected clippings. Stan Christiansen, who tells his own syrup-pitcher story better than I can, has listened to my Christmas stories for years with every appearance of interest. Marilyn McGriff, bee-keeper, pie-baker, and freelance historian, looked into Department 56 sales trends on my behalf. Gabe and Yvonne Weisberg helped with all matters French. Ashley Wilkes took the photographs from printed material in the O. Meredith Wilson Library, the Kerlan Collection, and the Walter Library, University of Minnesota.

Tom Patchett, genial Santa Claus of the Smart Art Press, Santa Monica, California, first alerted me to the sheer volume of Christmas paper ephemera. M. Sue Kendall, independent scholar and Main Line flea-market maven, sent me books, ads, catalogs, old cards,

Christmas jewelry—a quantity of stuff that confirmed my growing belief that Christmas is a (if not *the*) central feature of American life. Duncan Harris, at the University of Wyoming, collected bad Internet poetry about Martha Stewart, and my Martha Stewart study group in the Material Culture Caucus of the American Studies Association, chaired by Shirley Wajda, has added to the collection. Anne Troise, of the Canadian Centre for Architecture, took a picture of a "ride-in-Santa's-sleigh" kiddie ride on the Santa Monica Pier when I needed one. Robert Anderson of Montreal, designer and part-time sleuth, shared the chilling story of that city's "Santa Claus murders." Tara Reddy, a former student in one of my classes at Harvard, sent along a tasteful Christmas ashtray, circa 1958, straight from the pages of *Better Homes and Gardens,* with an abstract tree in gold and turquoise set off against a smoky glass background.

Sharman Robertson of Hallmark Cards, Kansas City, graciously allowed me access to that company's archive and historical collection. Michael R. Francis of Dayton's/Hudson's/Marshall Field's (now the Target Company) let me use the rich collections in Minneapolis.

Although Easter is the major holiday in Poland, my colleagues there bent over backward to feign interest in Christmas. Agnieszka Bender, Catholic University of Lublin, helped me track down the revived glass ornament industry in Krakow; Jan-Wiktor Sienkiewicz, my warm-hearted host at the Catholic University, took me shopping for Polish Christmas cards. Aleksandra Kedzierska, Christopher and Monika Garbowski, and Jerzy Kutnik of the Maria Curie-Sklodowski University contributed insights on national differences in celebratory practices. By some odd coincidence, most of the academics I met in Eastern Poland seem to have passed through Frankenmuth, Michigan, one of several self-proclaimed "Christmas Capitals of the World," and were quick to dredge up their memories of visits to that unforgettable site. Kate Delaney, then Cultural Attaché at the U.S. Embassy, Warsaw, provided the literary miscellany that convinced me that all books are really Christmas books.

Finally, I want to thank my family: my late grandparents, true Fezziwigs, all of them; my mother, for making my Christmases bright

ACKNOWLEDGMENTS

with almond-paste bread and dress-up dolls; my father, for remembering the stories of long-dead relatives attached to every Christmas ornament in our attic; my brother Steve, who used to do all his Christmas shopping in ten minutes or less at Spencer Gifts; my uncle Don, who loves blue wrapping paper—a chronic saver of worse-for-wear bows from other people's packages; and my brother Greg, once known as "The Grinch," now the guardian of all the Marling Christmas lore.

"It was always said of him, that he knew how to keep Christmas well," Dickens wrote about the reformed Scrooge. To all the friends and colleagues and students who kept Christmas so well on my behalf as I was writing this book, what can I say, but a heartfelt "Merry Christmas!"

INDEX